12/96

# LOST EARTH

*A Life of Cézanne*

# LOST EARTH

*A Life of Cézanne*

# PHILIP CALLOW

IVAN R. DEE

*Chicago    1995*

Excerpts from *The Masterpiece* by Émile Zola, as translated by Thomas Walton, are used with the kind permission of the University of Michigan Press.

Library of Congress Cataloging in Publication Data:
Callow, Philip.
    Lost earth : a life of Cézanne / Philip Callow.
       p.     cm.
    Includes bibliographical references and index.
    ISBN 1-56663-084-3
    1. Cézanne, Paul, 1839–1906.  2. Painters—France—Biography.
I.  Title.
ND553.C33C3   1995
759.4—dc20
[B]                                     95-10065

*Dedicated with love*

*to the memory of my stepdaughter*

*Kate Elizabeth Golby*

*1969–1989*

# CONTENTS

# ACKNOWLEDGMENTS

It seems to have taken me a lifetime to get to grips with the art of Cézanne. At the opposite pole to Van Gogh, he reveals himself by degrees, as if one has to earn his trust. Even more so is this true of his life. James Lord, who in the fifties single-handedly set up the little Cézanne studio-museum in Aix-en-Provence which operates to this day, tells me that in his view "Cézanne's life is *exceedingly* difficult to write about, because he kept himself so very intensely to himself." I have found this out to my cost. There has been much pioneering work, notably by John Rewald, whose *Cézanne et Zola* was a landmark, and by Gerstle Mack and Henri Perruchot. The critic Meyer Schapiro is as always illuminating, providing valuable insights. Nevertheless, only one book has managed to bring this artist alive for me. Jack Lindsay's somewhat neglected biography has stimulated me no end, so much so that I was inspired to attempt this life. I am indebted to him.

My thanks to my publishers in London and Chicago, to Peter Day for his enthusiasm and Ivan Dee for vital help with books difficult to obtain, and for his skillful editing. I would like to thank my friend David Stoker for immediately making his Cézanne file available to me. I am fortunate in having Elizabeth Fairbairn as an agent, whose work in helping to steer the book through to its final state proved so invaluable. Finally I am grateful once again to the Authors' Foundation for their award of a grant toward my research expenses.

# FOREWORD

It is astonishing to think that modern art began in 1866, invented by Cézanne armed with a palette knife. His utterances, his shapes, came out of what Lawrence Gowing calls "the paint stuff itself." The rude thrusts toward a destination spun from its own logic carried him on, and in the process changed the very blood of art.

The cost in terms of suffering was at times—as with so many nineteenth-century artists—terrible. His way seems sometimes to be the way of brokenness. Wave after wave of intense misery, of blackness of soul, threatened to capsize him. The kind of majesty normally associated with tragedy came from his enormous effort toward wholeness. His was a humanity that could still yearn for and bitterly regret paradise. He was never interested in anyone else's solutions, since, no matter how obscurely, he felt himself to be chosen. His canvases repeated themes that were so crucial for him that he painted variations of them all his life. His nudes always contained, in one way or another, the naked body of himself. As he got older he became tormented by a realization that what he had begun could never be fully carried through, or at any rate not single-handedly. The overarching theme of fulfillment had become a gigantic web that more and more entangled him.

In his young manhood, bedeviled by the idea of women and his dread of real women, he seems to have been possessed by a romantic nightmare which left him hanging for years in a horrible conviction of his own inadequacy, lying at the core of him like a canker. His primitive fury as he thrashed about in this self-sprung trap of rottenness led him to paint autobiographically, caught up in the deathly passion that kept enveloping all things in darkness. Nature both thrilled him with its completeness and was frightening, like the approach of women, full

of unknown chaos. When he gave himself up and fell into the arms of nature it was with the gratitude of someone finding an entity more masterful than anything he could have imagined. He set out to reclaim piece by piece the promised land he stumbled on and then lost in the glimmering thickets of his youth.

It is surely no coincidence that Cézanne truly came into his own after his break with Émile Zola in 1886. These two romantic natures had shared intoxicating past times, enshrined afterward in memory as a lost wilderness of groves and streams and rocks they had discovered for themselves as boys and thought of as holy. Zola's betrayal, the publication of his novel *The Masterpiece* (*L'Oeuvre*), must have made his old comrade feel violated, but in fact the sundering of his dependence on the famous writer was a liberation, a pure gift. Zola's loyalty and supportiveness for so long was in the end maternally reproachful. It was the last impediment to the artist's final development. Now he was free to soar.

To journey through the world of Cézanne is to move, more and more often toward the end, through empty stretches of time, silent featureless places where no word reaches us. Without signals, with no messages, starved of the least scrap of gossip, the biographer falls back on that occupational hazard, conjecture. Standing stock still in these regions where nothing stirs, and without the solace, or curse, of human habitation, one becomes aware that what seemed lifeless in fact teems with life, but invisibly, under the soles of your feet. Paintings break out suddenly, inexplicably, like cactus flowers, mocking our bad faith. Are they there to guide us, or just there? Somewhere, hidden out of sight, lurks the hermit-artist, nourished on nothing but nature, who has for years cultivated the art of being oneself. Of course he must eat and drink, take shelter, warm himself, but to all intents and purposes he has cut his ties and gone native. The paintings stop coming. The artist has disappeared: but now we know he is there because something has been left behind. We are led on, to the brink of God knows what, following his work like footprints.

Behind us the landscape is somehow changed. Something absolutely vital and terribly precious has been restored to us, that we did not even know was lost. We feel in touch with life. We feel hope. We are elated. The paradox, sitting on the horizon for us to marvel at, is simply this: by painting us out quite deliberately, our humanness, our distraction, he has begun to give us back creation itself—the unnamed constellations, the virgin earth, mountains, waters, and that revolu-

tionary apple with which he hoped to astound Paris. Can it be that we are being offered, with this common apple, the twin symbol of our downfall and salvation?

There are some painters who, rather than being discovered, discover you. Cézanne has that uncanny quality. His paintings take hold of you with extraordinary authority. You are commanded to look, to enter—so far and no farther. His mistrust earned him the reputation of one who shuns contact with others. Called a primitive, his savagery is in fact a new naiveté, part of his instinctive certainty that we must rejoin the past if we are ever to begin again.

Art does not lie down on the bed that
is made for it; it runs away as soon
as one says its name; it loves to be
incognito. Its best moments are when
it forgets what it is called.
—Jean Dubuffet

How ugly we are growing,
from being unable to think well of ourselves!
—J. M. Coetze, *Age of Iron*

I am working obstinately,
for I am beginning to see the promised land.
—Paul Cézanne in old age

# LOST EARTH

*A Life of Cézanne*

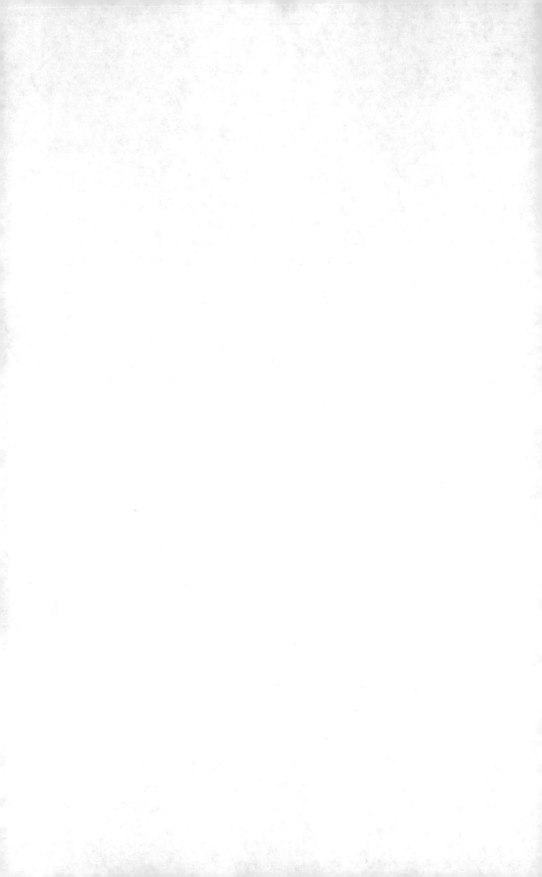

# 1 CAESAR'S PROVENCE

The character of Cézanne becomes a little less mysterious when one starts to appreciate the mystery of Provence, for out of its womb of mountain gorges, green glades, and golden-blond summers issues a perennial dissent. It is a country more Roman than French, more Greek than Roman. Because of the life and art of that timid man, Cézanne, one is reminded all the time of the dissent of art. A shy dissident, mostly invisible, Cézanne would plunge, starting in boyhood and for the rest of his life, into the great green masses of foliage in dim dales, where he would stand without stirring like a tree or be stupefied by the magnificence of a spectacle from the aerial view of some knoll. He would go off as a youth with a companion or two, free as air, and not come back for days. Later he succumbed to a mania for solitude. Rediscovering the mountain paths to the wild he had known in boyhood was to him a form of secret worship, his art a religion of the eyes. He would leave the house at daybreak, entering the narrow streets that hemmed the town, drawn to the light spreading over the roofs and the tops of trees.

It was a light unique to Provence. Again and again travelers to this land have felt themselves arriving in a strange place. Prosper Mérimée, making his first visit to Avignon in 1834, thought as he stepped onto the quay that he was in a foreign country. It seemed Andalusian rather than French. The natives spoke in a thick patois, they were swarthy,

dark-haired, dark-eyed, dozing in the streets at midday, where curtains hung motionless in front of doorways. It was September.

He soon found that the inhabitants were as suspicious of *étrangers* as they were contemptuous of the Parisians, usually dismissed as *parigot*. They lacked any real sense of time. They lived, in their paradise, in a permanent state of destabilization which could be called pagan, and their mercurial natures made it possible for them to swing alarmingly from exuberance to melancholy in a matter of minutes. With the same unpredictability they had embraced the French Revolution and then turned against Napoleon, welcoming the return of the monarchy as enthusiastically as they had the slogan Liberty, Equality, Fraternity.

Another traveler, James Pope-Hennessy, coming down a valley tumbling with waterfalls in his approach to Avignon, noticed how the landscape stiffened into one he felt was "classical and angular," with statuesque cypresses, cube houses with bright orange roofs, cone-shaped hillocks crested with turreted churches. He reached Nîmes with its Roman arena, and then at Beaucaire had come upon the wide swirling waters of the Rhône.

◈ When Ambrose Vollard made himself Cézanne's dealer in 1894, the elusive fifty-five-year-old artist was nowhere to be found. Vollard had planned Cézanne's one-man show with the help of the artist's son, who told him his father had retreated to Aix. The dealer went off for his first encounter with the man and his region, the backlands of the Midi. He caught the express to Marseilles and then the local train to Aix. This final lap of the journey, which Stendhal had once found ugly, was to him magical. As he puts it, "The tracks of the railroad seemed to run straight through the canvases of Cézanne."[1]

Joachim Gasquet, son of a baker in Aix who had been a schoolmate of Cézanne's, was an intellectual, given to poetic excesses, and with their common background was well placed to be one of the artist's first biographers. He wrote a personal memoir exalting Cézanne as "a rustic and noble" Provençal artist as part of his effort to revive an ancient Mediterranean culture, steeping himself in a study of the land and language of Provence. Many contemporaries came to agree with him that Cézanne's art was classical "by way of nature." Becoming intimate with the old artist for a time he saw him as a new Poussin. And he wrote eloquently in his ornate biographical sketch of his native land's two faces:

4

The country is one which Poussin would have loved, with its groups of trees, the rational line of its hills, its horizons stirring with sea-air; when the eye runs over it as a whole it is a classical landscape. . . . The Arc Valley, quivering with poplars and willows, makes its leisurely descent, crisscrossed by white roads, through emerald vineyards, great yellow squares of wheat and dusty almond orchards, to the lakes and salt marshes of Berre, beyond the pink plowlands and slopes of Roquefavor. . . . A pervasive Virgilian charm of mood, gracious, temperate, and blue, contributes to its peacefulness and its spell.

But to the north of the town the country becomes wild and, as it were, violent; above Le Tholonet the gorge of the Infernets opens to reveal a chaos of giant rocks, the plateaus of Vauvenargues extend in a desolation of stony scrub, the horizon becomes harsh, and the disturbing effect fades only when, at the turning of a track, Mont Sainte-Victoire appears in its massive entirety, radiant as a blue altar.[2]

The writer Posidonius, historian of the second century B.C., wrote, "The country is wild." It was semimythical then, and still is to this day. The smiling, delightful Provençaux can erupt in passionately emotional outbursts, consumed by black violence. Writers have tended to blame the influence of the mistral. It is curious that Cézanne hardly mentions it—perhaps because it was so familiar. Stendhal called the mistral "the great drawback to all the pleasures that one can find in Provence. . . . When the mistral rules Provence, one does not know where to take refuge; there is in fact fine sunshine, but a cold, insupportable wind penetrates in the most carefully closed room, and aggravates the nerves to a degree which exasperates the very calmest people." Gertrude Stein warned a contemporary, "You'll find you're getting nervous down there. You'll find you're suddenly having a terrific fight with your very greatest friend. . . . You won't be able to help it."

The sun-filled life of the Mediterranean has always mattered more in Provençal history than any influences brought from the north. Its countryside high in the sky, swaying with trees, under skies of "that special wounded blue one finds sometimes in Mantegna's skies,"[3] with its black cypresses and baked-tile roofs, its mossy fountains tinkling under plane trees, is speaking always with the ancient voices of the great past.

It was christened "The Province" by Caesar, being the largest of his

provinces outside Italy, and was the southeastern part of Gaul, named Gallia by the Romans. Many of the people spoke Latin and wore Roman dress. The culture of Greece and Syria had arrived, along with trade, in ships calling at Massilia, a port as great as Carthage, now called Marseilles. Centuries before Caesar the merchants flooded in from Egypt, Greece, Syria, Africa, and Rome, bringing wine, iron goods, weapons, armor, spices, and clothes into Gaul, returning with woolen robes, fine cured hams, mountain cheeses, great dogs. In Caesar's time, Provence was Romanized, with its flourishing cities of Massilia, Toulouse, Arles, and Aix, while to the north lay Gallic lands torn by the savagery of warring tribes. Gradually Provence became Italian, its port of Massilia a center of Greek learning, a true cosmopolitan city of the Mediterranean world.

◈   Before Caesar there was a name as widely celebrated, namely that of the general Marius, a military genius revered far and wide for having saved the civilized world from total destruction. This tough little plebeian who rose through the ranks was from the little we know of him a man of few words, a free-born Latin, son of a farmer. To this day half the male population of Provence seems to have been named Marius after him—it is estimated that one in four actually are. As for his exploits, Plutarch and Tacitus tell us all that is recorded. The barbarian hordes, the Ambron and Cimbri tribes, spilling over central Germany and meeting little resistance, began moving southward in earnest in 111 B.C. Their immense numbers, coupled with their ferocity, made them a terrible foe. Flowing west into the Swiss valleys they finally swept into Gaul in 110 B.C. and came to the Rhône. They demanded lands from Silanus, the Roman governor, who instead attacked them. He was badly defeated. Roman might was not only being challenged but demoralized by these fearsome Nordics with their matted locks and bloodcurdling screams. They were huge blond ogres, and the disciplined Roman troops, small of stature, panicked in battle. In one counterattack 200,000 Romans were massacred. Rome was filled with terror as the barbarians drew closer. Unaware of their strength, they turned aside, ravaged Spain, then swung back and halted for the winter, still with the Rhône barring the way to continental Italy.

Marius saw his task as first of all restoring morale before risking a major engagement. He had been called from Africa, where he was con-

sul, to check this series of disasters. His very presence seemed to put heart into the Roman forces, but he hung back, refusing to send his regiments into battle. This refusal to engage puts one in mind of the real-life Russian general Kutuzov, immortalized by Tolstoy in *War and Peace*. He too made doing nothing a military art. Unlike him, however, Marius was not waiting for a winter to come to his aid, but like Kutuzov he turned a deaf ear to his advisers and did nothing, biding his time until he was ready as he shadowed the enemy in the direction of Orgon. He saw the solution as a psychological one, familiarizing his legionnaires with the invaders until their fears were overcome by their frustration at being restrained month after month.

At Les Milles, four miles to the south of Aix, where cliffs of red sandstone rise above the Arc (Cézanne's river), the water curves in green meadows, looping among a host of springs—in those days many of them were hot. In this idyllic spot Marius attacked the Ambrons and Teutons on two fronts—he had detached a force of 3,000 men to move in from the north of Mont Sainte-Victoire and spring his trap shut from the rear. It was a scene of dreadful carnage. Bodies choked the little river. Plutarch writes of 100,000 enemy dead, with half that number taken prisoner. These barbarian slaves were set to work in quarries from which the stones of the Roman city of Aix were hewn and triumphal arches and monuments built. Folklore attributes to these slaves and their fate the atmosphere of the hillside forests and mountain ravines, which are said to be haunted. Like Kutuzov again, a simple man who trusted to instinct, Marius may have been superstitious by nature, for Plutarch tells us that on his campaigns "he had with him, apart from his wife Julia, a Syrian woman named Martha who was said to have the gift of prophecy. She was carried about in a litter with great solemnity, and the sacrifices which he offered were all supervised under her direction. When she assisted at such sacrifices she wore a double purple robe, while in her hand she held a ceremonial spear adorned with ribbons and garlands."

◆ The "Province" fell from favor at the time of Rome's civil war in 50 B.C. after backing the claims of Pompeius against Caesar. A year later Caesar surrounded Massilia, and after a six-month siege it fell. The whole of the south of France became a Roman province with Arles as its capital. It was not until the days of Augustus that Provence

regained its primacy in Gaul. The Gallic chieftains were invited to Italy. Augustus created a new capital, Lyons, split the whole country into four provinces, and built a vast road system raying out from Lyons, four Roman roads, the fourth running south to Massilia and Narbonne on the Mediterranean.

As the Roman Empire foundered, Gaul degenerated into an enormous wasteland, a place of terror. Only the Christian bishops kept a foothold in all the flux. The Dark Ages saw the rise of the popes to power, the beginning of the Holy Roman Empire. Little by little a new open society was taking root. "Provence was in Europe before France existed" is a Provençal boast, and in the early Middle Ages Europe was one single realm called Christendom. There was a multitude of small states, but a man counted himself first and foremost a Christian. As Bishop Glaber wrote, "Three years after the year 1000, the Earth was covered with a white robe of churches."

The history of Provence is a bloody one, a record of violence, pillage, and destruction, the land a prey to conquest by numberless foes—Visigoths, Franks, Vandals, Saracens, as well as nameless barbarians like packs of wolves—all raging to and fro across this Garden of Eden, wave on wave. Only the light of Christianity went on flickering like a candle in a storm, keeping hope alive. Peace when it did descend in merciful lulls was mute and fearful, a creaking silence such as the winter brought, enjoyed by the mountain and hill people rather than in the valleys and green glades, where naked war still poked about with terrible iron blows, striking sparks and fires.

As the sea of Saracen hordes slowly ebbed, Avignon, the old town on the Rhône, began skillfully to extricate itself from the internecine struggles of warring families in the south seeking to rule Provence. In 1206 it achieved the status of an autonomous republic.

Then in 1305 the pope and his cardinals, fleeing from the chaos of Rome and northern Italy, came to Provence, beginning an era of prosperity lasting seventy years. Clement V, crowned Pope at Lyons, finally chose Avignon as the papacy's holy city. Then in 1376 the papal court returned to Rome, although urged to stay by the king of France. Yet Avignon remained papal property for a further four hundred years.

The ancient independent country of Provence with its proud civilization was united to the French crown only in 1486, an annexation that has never been spiritually accepted. The most benign ruler of Provence, Good King René, an affable monarch who made Aix his capital, was disastrous as a warrior. A lover of the arts and a scholar

fluent in Latin, Greek, Italian, Hebrew, and Catalan, he was a musician and painter. He it was who decreed that the height of the Aix fountains should be determined by the sheep who came to drink from them. He was an idealist, a philosopher who, noted the king's chronicler, "nourished a secret aim: to assemble political parties, families, social castes, the great, the lowly, friends and enemies in one joyous crowd. A monarch's duty was to bring about this reconciliation, to force them by means of a general happiness to get to know and love each other. . . ."

Soon after René's death Provence was annexed to France. Such was the cultural renown of Aix that it became the capital of the province, seat of the États Provinçiaux. The great houses of Aix were occupied by the aristocracy who found it fashionable to have homes there. At the top of its principal thoroughfare is a statue of René, his long hair reaching to his shoulders, a heap of books at his feet. He rises on the column of a fountain with stone lions at its four corners, water spilling from their gaping mouths.

James Pope-Hennessy calls Avignon the antithesis of Aix. In Avignon people look you straight in the eye, as if they woke up cheerfully every morning. Aix is a web of shadowy streets and mossy fountains, "of old ladies dressed in black on long, late Sunday afternoons": there is an air of secrecy. This is Cézanne's town.

In Arles there stands a large statue in green bronze of the celebrated poet of Provence, Frédéric Mistral, bearded and middle aged, carrying a stick and wearing a broad-brimmed hat. His stance suggests he has come striding in that very moment, a cloak slung over his arm. The publication of his epic poem *Mireille* in 1859 was a great triumph. By then he had already established, with five others, a brotherhood dedicated to the preservation of Provençal customs and the Provençal language itself. The Félibrige set out to make Provence conscious and proud of itself. The success and failure of the movement at least left people knowing what the word Provençal meant. The name Mistral has become a word for the soul of Provence. The inscription on Mistral's sundial reads:

> Gay lizard, drink of the sun,
> Time passes only too quickly . . .
> And tomorrow perhaps it will rain.

The composer Charles Gounod was enchanted by his friend Mistral and by the Provence he discovered while visiting the poet. Mistral took him on foot through country which struck Gounod as "a marvel

of savagery." Sitting at his hotel window he wrote, "Near here, twenty minutes from Saint-Remy, there is the most beautiful mountain valley that you could see anywhere. It is pure Italy; it is even Greece."

The north-south divide exists now just as it has always. The synthesis of the two has never been more than half achieved, so that Nietzsche could write of the French temperament as "periodically turning toward the south and away from the south in which the Provençal and Ligurian blood from time to time foams over, and preserves them from dreary northern grey-on-grey and sunless concept-ghoulishness and anaemia."[4]

In *Mes origines*, Mistral's account of his childhood and youth, he recalls the epic journeys made by the wagoners of his day, heroic in their blue shirts, corduroy breeches, and gaiters, great woolen capes riding the wind behind them. They sang songs as they went, fought with rivals coming from the opposite direction, trudging the immense distances in stages from Marseilles to Lyons, then on from Lyons to Paris. As they drove northward they would be up to the axles in mud on impossible roads, the rain pelting down. Reaching the outskirts of the capital they would be jubilant, cracking their whips, yelling and singing. Parisians clapped their hands to their ears and cried out, *"Allons! les Provençaux arrivent!"*

It was in Provence, writes Gasquet, that Cézanne "fell in love with the structure of the earth. He read its geological message. . . . The composition of the world became clear to him." This was where he evolved his "poetry of the exact" and where his innate classicism took root. "It was only here, in Provence, that he would rid himself of the romanticism that was a distraction to him. He painted in the presence of the classical sea. Those waves had brought civilization to the ancient Celtic forests: order, measure, wisdom. Those roads he walked with his easel on his back he owed to the great practicality of Rome. It was no good dreaming with brush in hand, he had to learn reality like Virgil. He too, the Platonic positivist among the war veterans, had polished his first eclogues during a national upheaval. The countryside restored his equilibrium."[5]

# 2 FAMILIES

It seems certain that the Cézanne family came originally from the little mountain town of Cesena in western Piedmont, and could well have been of Italian origin. In the seventeenth century and earlier, surnames were often taken from place names. Fifteen miles over the frontier into France is Briancon, and the Cézannes emigrated there in 1650. The parish records show the residence there of a master shoemaker, Blaise Cézanne. Blaise married twice, each time fathering five children.

One branch of the family turned up before 1700 in Aix-en-Provence. The Cézanne line seems to have come down in Aix from the union of Denis and Catherine Marguerite, although nothing is known of this Denis: he may have been an elder son of Blaise. Another son was André, born in 1712. He made wigs and was also a hairdresser. A son of his was a tailor, Thomas François Xavier Cézanne, who married Rose Rebuffat and moved out to a place much smaller, Saint Zacharie, in the department of Var. His only known son was a sickly child, Louis-Auguste. This was the painter's father. Looking back we can see that Paul came from an unbroken line of craftsmen.

Louis-Auguste Cézanne was born on June 28, 1798. Delicate to begin with, he threw off his frailty before reaching adolescence. Short, stocky, he grew up to be strong physically and tenacious in character, a blend of toughness and irony. His heavy, clean-shaven features and receding hairline give an impression of unrelenting frugality. He had

risen from dire poverty and saw money-making and the accumulation of property as the obvious way forward. What other meaning to life was there? It was a passion with him to make every sou yield its maximum value. Leaving home in his early teens he doubled back on the family tracks and got work with Dethès, a firm of wool merchants. There was no money to be made in obscure Saint Zacharie. Marseilles was a thriving city and would have given him even more scope, but Aix meant connections: it was where his family had lived for more than a hundred years.

Casting about restlessly for a promising source of wealth, he decided on the hat trade. Aix was a center for the manufacture of felt hats. Made in local workshops, they were exported nationally and overseas. Farmers in the surrounding countryside bred rabbits, and their fur was converted into felt. Presumably Louis-Auguste could have learned to be a hatter in Aix, but for some reason took himself off to Paris in 1821. He was employed as an unskilled worker by a hatmaker in the capital for three years, then was made salesman. He was handsome, an intelligent, energetic lad who impressed his employer. Apparently his employer's wife found him charming. If there was an affair, no details are known. Romance would have come second for this hard worker who was out to learn everything while in Paris that he could carry back home and apply in Aix.

His apprenticeship over, by 1825 he was setting up business with a hatter by the name of Martin. Needing more capital, the partners brought in a third, Coupin, a peppery character who was said to be more short-tempered than Louis-Auguste himself. They had no workshop and were only interested in selling and exporting hats. The shop in Aix was at 55 the Cours, later the Cours Mirabeau. Over it the signwriter had announced in bold letters the firm of Martin, Coupin and Cezánne. The derisive locals, suspicious of change and enterprise, concocted a joke among themselves, a play on the name Cézanne (*seize ânes*—eighteen animals all told, including Martin and Coupin). The asses, however, were far from stupid. Ridiculed or not, the firm prospered until about 1845, when the shrewd trio went their separate ways. Louis-Auguste went on selling hats alone for a few more years. Before he wound up his shopkeeping for good he made sure he possessed enough headgear for his own use, including top hats for formal occasions and the caps with peaks and flaps which he favored for everyday use. Jokers used to refer to his cap as "Cézanne's spade"—we can see it in his son's portrait of him.

It was while still a shopkeeper that he began trying his hand as a moneylender on the side. The rabbit farmers supplying skins to the workshops were often hard-pressed financially until they were paid. Louis-Auguste advanced them small loans at a high enough rate of interest to bring him, before long, more revenue than did the hat trade. All the same, to give up his shop completely and dive into banking took considerable nerve. How audacious it must have seemed. He was clever, but with his lowly background and next to no financial experience, the risk he took was the biggest gamble of his life.

He set up business with Joseph Cabassol, an adroit move, as Cabassol was the former cashier of the Banque Bargès. This was the only bank in Aix, and it had just failed. Provincial banks with their crude financing were having to suspend payment as one national crisis followed another. The bad harvests of 1845–1846 forced up prices, the supply of money faltered, and speculation sent prices higher still. France was moving toward the revolution of 1848 and the famous "springtime of peoples," a wave of connected revolutions which would convulse Europe. Alexis de Tocqueville warned the Chamber of Deputies, "We are sleeping on a volcano . . . the storm is on the horizon." When the storm broke, Adolphe Thiers, who had played a leading role in establishing the July Monarchy in 1830, was instrumental in having Louis Napoleon elected president. The February and June revolutions of 1848 ushered in an epoch far from revolutionary.

Louis-Auguste, absorbing these events, probably had read the widely circulated book by Étienne Cabet, *Voyage en Icarie*. This socialist fable, a bulky novel of six hundred pages, was read avidly by workers everywhere—and Cabet himself came from the working class. His dream country, which he called Icarie, described a land of plenty brought about by common ownership.[1]

The coarse-grained little hat-seller rightly calculated that the Commune would fail. Farmers and workshop owners around Aix would soon be looking for credit again. The field was wide open for his new venture. With Louis-Auguste's accumulated capital he and his hardheaded partner set up the bank of Cézanne and Cabassol. The partnership was established for an initial run of five years. Cabassol had no finances but contributed the expertise. Cézanne put up 100,000 francs and received 5 percent interest on his investment. Each partner would draw 2,000 francs a year for his personal use. Things went so well that in 1853 the agreement was renewed. It lasted until the old age of both men, when another crisis swept through France in 1870. The

bank's offices were at 24 rue des Cordeliers, then in a house at 13 rue Boulegon which was owned by the Cabassol family.

Louis-Auguste issued loans that were invariably short-term. With his intimate knowledge of the district and its people he could judge which needy borrower to trust and which to avoid. He was sharp and tough but dealt fairly with his clients. There was nothing to choose between him and Cabassol when it came to driving a hard bargain, yet by the standards of the time they were honorable men. Louis-Auguste would find time for genuine cases and was ruthless in his dealings with feckless, lazy, or incompetent debtors. If he thought someone was a bad risk he would keep him waiting while he called cunningly to his partner, "What do *you* say, Cabassol?" This was the cue for Cabassol to shake his head sadly and say "No."

Louis-Auguste's character comes across in the local gossip circulating about him, even when allowance is made for exaggeration and malice. One story concerns a man in Marseilles who was advanced a large sum and then found to be prodigal. Soon he was teetering on the edge of bankruptcy. Louis-Auguste simply moved in with him bag and baggage, installed himself in the man's home, and took over the family budget, even supervising the details of the food they could afford to buy. He applied his remedy for two years, though one can't imagine him actually living there constantly without driving the poor devil mad. But the tale goes that the cure worked. The man's solvency was restored and the banker reclaimed his loan, plus interest of course.

It was while Louis-Auguste was still dealing in hats that he met a young man called Louis Aubert, who may have been employed in the shop of Cézanne, Martin and Coupin. Cézanne, obsessed with his passion for money-making, lifted up his head and noticed Aubert's sister, Anne Elizabeth Honorine. After all, he was nearing forty. The tall attractive young woman was sixteen years his junior. Unsentimental all his life, no doubt he weighed the pros and cons of a relationship as carefully as he would a business contract.

What kind of proposition was he for her? Obviously a good catch, with excellent prospects, his material success turning him already into a respected member of the Aix bourgeoisie, but what was he like as a man—what did he look like? He did have a certain interest in women, but not if it meant wasting his precious cash. In his thirties he seemed already as stingy as the old man he would become, wearing untanned leather boots to save the money—and time—involved in polishing. In the two portraits of him by his son he is sixty and sixty-eight. The

younger shows him wearing his customary peaked cap, on a hard chair with one leg thrown over the other, devouring the print of a newspaper with characteristic ferocity. The face in profile is heavy, brutal, powerfully beaked, the body compact and strong, as if carved out of dark rock. Paul would be ambivalent in his feelings for this unassailable father throughout his life.

Louis-Auguste persuaded Elizabeth Aubert to move in and live with him. They had two children, Paul and Marie, before getting round to marriage in January 1844. There was apparently nothing too terrible in postponing the ceremony until after the birth of a child or two. Providing the children were registered at the *marie* on the day of their birth there was no stigma of illegitimacy. In this way Paul was entered in the Aix records on January 19, 1839. The father lived over the hat shop at 55 Cours Mirabeau, yet for some reason Elizabeth gave birth to her son at a different address, 28 rue de l'Opera, possibly to subdue gossip. Soon, though, she transferred to the upstairs apartment above the shop where Louis-Auguste lived and worked. This was where her daughter Marie was born two years later, in July 1841. In 1854, ten years after her marriage, she gave birth to a second girl, Rose.

Elizabeth, born in Aix in 1814, came from generations of craftsmen: her father Joseph Claude Aubert was a chairmaker. On her mother's side the genealogy of the Girard family of Marseilles was confused, the family claiming connection with a Napoleonic general who commanded an expeditionary force to the West Indies. According to family legend he brought back a Caribbean wife. Hence we read in Vollard's book on Cézanne that the painter's mother was "of remote Creole origin." In fact Elizabeth's mother, Anne Rose Girard, was born thirteen years before the Santo Domingo campaign. Her father wasn't a general but a laborer in a saltpeter works.

Paul Cézanne lived his first years in the Cours, until his father moved them, not long before his marriage, to a quieter, twisting street half in shadow, the rue de la Glacière. The Cours was, and remains, the main street of Aix. In Paul's day the wide boulevard had a double row of elms, replaced later by massive plane trees. The Cézanne house was small, unlike the crumbling mansions on the other side, built by the great families of this once splendid Provençal city in the seventeenth and eighteenth centuries, before the Industrial Revolution arrived and Aix was eclipsed by the rapid expansion of trade and manufacture in nearby Marseilles. Descendants of those once-grand families still lived there in faded splendor, unable to accept the changes. King Louis

Philippe had introduced a college and a school of arts and crafts, together with gas lamps and a cattle market. Old elements still remained. Aix is called Plassans in the novels of Zola, who grew up there himself and wrote that "No town kept more fully the devout and aristocratic character that distinguished the old Provençal cities." Devout it certainly still was. Church towers and belfries rose over the terra-cotta tiles of the houses huddling for shade. In the Cours walked canons and priests, mingling with lawyers and academics. Franciscans and Jesuits were everywhere. At night there was still more paraffin lighting than gas, shedding its softer light over the straight and winding streets overgrown with grass in some quarters.

In his novel *The Conquest of Plassans* Zola described the stratification of Aix-Plassans into class in his—and Cézanne's—youth. There were, he says, three quite distinct boroughs, each with its own churches, promenades, and customs. The nobility in their faded drawing rooms and old furniture were "hermetically immured" in one. They had retreated there ever since the demise of Charles X, and if they went out at all it was only to hurry back from the hostile world outside to their gloomy interiors. They were visited by priests and viewed enviously by social climbers who dreamt of being invited to their houses but knew this was unlikely. Professionals and tradesmen often called themselves freethinkers and Republicans, and it meant little. In reality they were "firm friends of the authorities, ready to rush into the arms of the first deliverer on the least sign of popular discontent."[2] Then there was the class at the bottom, laborers, craftsmen, retailers. You could see the three strands moving along the Cours boulevard on a Sunday after Vespers, as together as they would ever be, and maintaining as they went their absolute separation. On the south side where the mansions stood the nobility strolled. The bourgeois passed down the middle while the lower class kept to the north side with its cafés and inns. Cézanne senior was one of these supposed freethinking Republicans who seized his chance and cashed in when the convulsions of 1848 brought revolution and the Bonapartist coup which was its reactionary aftermath.

◈ Paul was baptized when he was only a month old, at the church of Sainte-Madeleine. His grandmother, Anne Rose Aubert, acted as godmother, and his uncle Louis Aubert was godfather. He grew up a happy, amenable lad, subject to outbreaks of violent tantrums which

were soon over. These outcries for no particular reason occurred throughout his life, shocking and frightening his friends. They happened whether he was in company or alone. There were many witnesses to his falling on a failed picture in a fury and slashing it to ribbons with a palette knife.

He always described himself in later years as "helpless" in the face of life. His sister Marie soon became aware of this timidity and derived great satisfaction, as soon as she could walk, from looking after him. Though two years older, and much stronger physically, he always regarded her as the eldest, and submitted to this female management quite meekly. The power his sister derived from this submission led her to manage and bully him as part of her protection. The relationship, once established, remained unchanged for the rest of his life. Writing one or two reminiscences of their childhood to Paul's son in the form of a letter, five years after the painter's death, she recorded: "My earliest memory is this (perhaps you have heard the story from your grandmother): your father must have been about five years old; he had drawn on the wall, with a piece of charcoal, a drawing representing a bridge, and M. Perron, Tho. Valentin's grandfather, exclaimed when he saw it: 'Why, it's the Pont de Mirabeau.' The future painter was already discernible."[3]

This was naive. He was invisible, except to a few friends from childhood, for many years longer than he should have been. Though there was a part of him that always wanted to retreat and disappear. From almost the beginning he was a "separate" person, whose instinct was to hold himself apart.

Paul went with his determined little protector to a primary school in the rue des Épinaux. He was there till he was ten. "Your father," remembered Marie, "looked after me carefully; he was always very gentle and probably had a sweeter disposition than I, who, it seems, was not very nice to him; no doubt I provoked him, but as I was the weaker, he was satisfied with saying, 'Shut up, child. If I slapped you I'd hurt you.'"

A gentle, sweet-tempered boy he got to know at the primary school was Philippe Solari, born in Aix of poor parents. His father was a stonemason, so that when he became a sculptor it was a natural progression. When Cézanne enrolled at thirteen at the Collège Bourbon and became friends with Baptistin Baille and Émile Zola, Solari was somehow left out of things. He would have been too unquestioning to object or feel resentful. Of all Cézanne's boyhood acquaintances, Solari

was probably the most sympathetic. He stayed on friendly terms with Paul, asked nothing of him, never reacted to his violent rages, and was in contact with him to the end of his life. Cézanne for his part didn't make him the target of his mad irritability as he did at times with everyone else. His affection for the man shines through in a letter to Zola on June 19, 1880. "I have seen the very excellent Solari. Tomorrow I shall visit him, he has come to my house three times, but I was always out. Tomorrow, Sunday, I shall go to clasp his hand. Nothing is going well for him, he cannot make good fortune turn in his direction. With less ability, how many lucky rascals are successful."

In Paris, Solari was always struggling to survive, forced more than once to take on marble-cutting and plastering jobs and churn out religious statuettes. He was even a stonemason now and then like his father, and helped repair the stonework on the Louvre. He carved chimney pieces and worked on various theatre façades. One of his own sculptures that has survived is the bust he modeled of his friend Zola: it adorns the grave of the writer in the cemetery at Montmartre. A copy of this piece, cast in bronze, was set on a stone base and erected in the place Ganay at Aix. He was a sincere, run-of-the-mill artist, academic in style. Zola made use of him for the character Mahoudeau in his novel *The Masterpiece*: "He was small, thin, with a bony face already lined with wrinkles at the age of twenty-seven; his coarse black hair was tumbled over a very low forehead; and in his yellow face, terrifyingly ugly, appeared the eyes of a child, clear and open, which smiled with a charming boyishness."[4]

Whether this was in fact how Solari looked is not clear, though certainly his sweetness of nature rings true. So does one of the tragicomic incidents in the novel. Mahoudeau has labored for months over a vast figure of a naked woman. Instead of propping it up by means of an iron armature which he needed but couldn't afford, he improvised with a contraption made of broomsticks. His friends arrive, and while he is joyfully unveiling his creation in his drafty shed of a studio, the heat of the stove—going full blast to combat the freezing winter weather—softens the clay of the giant figure, and in a nightmarish scene it droops and disintegrates on the plank floor.

What really happened, according to Joachim Gasquet, was bad enough, but not nearly as heartbreaking as the incident in Zola's novel: "It was a huge Negro struggling with some dogs, the same one who posed for Cézanne's famous painting of the Negro in blue trousers, owned by Monet. Manet, Cézanne, and Zola walked round the gigan-

tic figure. 'The War of Independence,' said Solari, delighted. They were shivering. He lit the fire. Then a dreadful thing happened. The framework of the statue, made of old bits of chairs and broomsticks, cracked in the heat. The Negro collapsed—Solari had to send him to the Salon, still being bitten by the dogs, but lying down."[5]

In Zola's version of the disaster, says Gasquet, the Negro turned into a bacchante. The whole object of the novelist's scene was to show the artist's struggle with reality as hopelessly doomed and pitiful, a tearing, endless battle that could only end in defeat. This was how Zola saw his own fate. Solari, though, was too mild-mannered and equable to despair for long. Undaunted, he altered the title of his work and sent it off to the Salon of 1868 as a reclining figure. In the catalog it is listed as *Nègre endormi, plâtre*.

Cézanne's main playmate between the ages of five and ten seems to have been Philippe Solari. They took their time wandering home together after school, diving into side streets and back again to the busy thoroughfare of the Cours, dawdling at the fountains, watching the clouds of dust rise as coaches rolled in from Avignon and Marseilles. Cowmen and shepherds in blue smocks drove their animals before them on market days, bringing with them the whiff of another world. On summer days of stunning heat the town retreated behind shuttered windows, the narrow streets as hushed as if night had descended. The walls of the houses breathed warmth. The stone caryatids, if you stared hard enough, seemed to stir their limbs. A few workmen, like survivors of some plague, sat on the café terraces over card games, struck dumb, smoking clay pipes.

Paul's sister Marie remembered that "When he was about ten he was sent as a half-boarder to the school of Saint-Joseph, run by a priest, the Abbé Savourin, and his lay brother. It was while he was there, I think, that your father made his first communion at the church of Sainte-Madeleine. A quiet and docile student, he worked hard; he had a good mind, but did not reveal any remarkable qualities. He was criticized for his weakness of character; probably he allowed himself to be influenced too easily. Saint-Joseph's School was soon closed: the directors, I believe, did not make a success of it."[6]

While a pupil at Saint-Joseph's he was taught drawing by a Spanish monk, so the story goes. It was around now that Paul's mother is said to have conceived the idea that her son would be a great artist. Whether this is true or not, she was a woman of some sensibility, and he must have sensed her closeness to him from an early age. The *Magasin Pit-*

*19*

*toresque* was a periodical subscribed to by the family at the instigation of the mother. The first art images Paul set eyes on were in these pages. As the interest in drawing and painting slowly took hold of him, Paul set about coloring the illustrations in this magazine. The art dealer Vollard says that the boy's father, who was always buying merchandise in the hope of making a profit, bought a job lot from a traveling salesman, and among the miscellaneous odds and ends was an old paint box. He passed it on to his son—presumably because he could see no value in it.

Marie, who admitted that art was a riddle to her, perhaps meant Veronese rather than Rembrandt when she says in the letter to her nephew: "I remember hearing Mamma mention the names of Paul Rembrandt and Paul Rubens, calling our attention to the similarity between the Christian names of these great artists and that of your father. She must have been aware of your father's ambitions; he loved her dearly and was no doubt less afraid of her than of our father, who was not a tyrant but was unable to understand anyone except persons who worked in order to get rich."[7]

Jack Lindsay in his life of Cézanne draws attention to the intimate knowledge Zola had of the Cézanne family. When Paul met him at the Collège Bourbon and their long friendship began he was thirteen, a little older than Zola, who was small and frightened, had a lisp and a strange accent (not local), and was promptly picked on by the other boys who sized him up at once as a mother's boy.

Long before he got to know the Cézanne household firsthand he was hearing stories about the parents from Paul himself. In his preliminary notes for *The Masterpiece* Zola mapped out the outline of the character Claude Lantier, based to some extent on Paul: "Born in 1842—mixture, fusion—moral and physical preponderance of the mother; heredity of a neurosis turning into genius. Painter." Elizabeth Aubert, although semiliterate at the time of her marriage, was imaginative, with a quick mind and an interior life which she kept secret from her husband. She knew yearnings which she transferred to her son in the form of aspirations, was interested in the arts, wanted her daughter to be a lady, and did her best to encourage Paul in the direction she sensed he wanted to go. A romance by J. J. Marmontel, *Les Incas ou destruction de l'Empire du Pérou*, inscribed H. Aubert and kept by her son, was found in his studio after his death.

Notes by Zola for his novel *The Conquest of Plassans* tell us explicitly that Louis-Auguste is the model for his character François Mouret.

"Take the type of C's father, banterer, republican, bourgeois, cold, meticulous, avaricious; picture of the interior; he refuses luxuries to his wife, etc. He is further a chatterbox, supported by fortune, and jeers at everyone."

This thoroughly unattractive portrait has its surprises. Who would have expected the skinflint to be a chatterbox, for instance? And surely there was something positive to be said about him? An early biographer, Gustave Coquoit, redresses the balance to a certain extent when he writes, "For some, old Cézanne was a sort of Père Goriot, authoritarian, very shrewd and miserly. . . . For others he was on the contrary a human specimen of the rarest kind."[8] It would be interesting to know who these "others" were.

In Zola's novel, the opening pages introduce us to Mouret's overbearing treatment of his wife. He intends to take in a tenant and make some extra money by allowing a priest to rent the upper floor. His wife's evident dislike of the idea he finds irrelevant:

> He took his stand in front of her and interrupted her with a sharp motion of the hand.
>
> "There, that will do," he said. "I've let the rooms, don't let's say anything more about the matter." Then in the bantering tones of a bourgeois who thinks he has done a good stroke of business, he added, "At any rate one thing is certain, and that is I'm to get a hundred and fifty francs rent, and we shall have those extra hundred and fifty francs to spend on the house every year."
>
> Martha bent her head and made no further protests except by vaguely wringing her hands and gently closing her eyes as if to prevent the escape of tears already swelling beneath her eyelids. Then she cast a furtive glance at her children, who hadn't appeared to hear anything of her discussion with their father. They were indeed accustomed to scenes of this sort in which Mouret, with his bantering nature, delighted to indulge.
>
> "You can come in now if you'd like something to eat," said the servant Rose in her crabby voice as she came up the steps.
>
> "Ah, that's right, come along, children, to your soup!" called Mouret gaily, without appearing to retain any trace of temper.[9]

If we think of the son listening to these evidences of friction, and witnessing the bullying his father indulged in from time to time, it is easy to see how his sympathy would have run to his mother, how he would have identified with her, and how his later chronic fear of his

father developed. He would also have been impressed, in spite of himself, by a strong, seemingly omnipotent being. The stresses and strains of family life would have been intensified by their social isolation in Aix, suggests Lindsay. This may well have been so. Louis-Auguste was an outsider in more ways than one. Flouting the conventions, he had lived with a common-law wife for some years and fathered two illegitimate offspring. He was an *arriviste*, thrusting up from the working class into a position of some prominence, upsetting people with his republicanism, and stepping on plenty of toes on the way up. He had a sharp tongue and was inclined to mock. Nor would he have bothered to disguise his contempt for those less energetic than himself, especially the privileged and aristocratic. He would have been aware of enemies, of resentments, so that when he got home to the security of his family, any kind of opposition or disagreement was an attack from within, against the vulnerable, exposed part of himself. Paul for his part was no doubt soon aware of being set apart from those boys whose backgrounds were altogether more soundly based.

Zola too, through his analysis of the Mouret household, emphasizes the fortresslike nature of the Cézanne home. They entertained hardly at all. Instead the wife had to sit down to endless bouts of a card game for two, piquet. Mouret prefers her constantly at home, whether he is there or not, and to keep her a virtual prisoner he gives her next to no money. Zola must have heard so much about Louis-Auguste from Paul that one can imagine his figure towering ever higher and more menacingly over the new friend's life. The shadows he cast, the fear and anxiety he caused, become at least partly understandable in the light of Mouret's wife's protestations in *The Conquest of Plassans*:

> Martha loved her husband with a sober unimpassioned love, but with her affection was mingled considerable fear of his jokes and pleasantries, his perpetual teasing. She was hurt too by his selfishness, and the loneliness in which he left her; she felt a vague grudge against him for the quietude in which she lived—that very manner of life which she said made her happy. When she spoke of him, she said, "He is very good to us. You've heard him, I daresay, get angry at times, but that arises from his passion for seeing everything in order, which he often carries to an almost ridiculous extent. He gets quite vexed if he sees a flowerpot a little out of place in the garden or a plaything lying about on the floor; but in other matters he does quite right in pleasing himself. I know he's not very popu-

lar, because he has managed to accumulate some money and still goes on doing a good stroke of business now and then; but he only laughs at what people say of him. They say nasty things too of him in connection with me. They say he's a miser and won't let me go out anywhere, even deprives me of boots. But that's all quite untrue. I'm entirely free. He certainly prefers to see me here when he comes home instead of finding me always off somewhere paying calls and walking on the promenade. But he knows quite well what my tastes are. What indeed should I go out for?"

As she defended Mouret against the gossip of Plassans, Martha's voice assumed a sudden animation, as though she felt the need of defending him quite as much from the secret accusation that arose within her own mind; and she kept reverting with nervous uneasiness to the subject of social life.[10]

Here we are confronted with the unbending father, his outer life organized so efficiently that he can't bear to see a thing out of place. No wonder Paul's rebellion—the only one he dared to mount against this jeering, scowling ogre, who never seemed so terrible at close quarters—took the form later on of chaotic living quarters and disorderly studios.

# 3 CALL OF THE WILD

In 1852 Paul enrolled as a boarder at the Collège Bourbon, called now the Lycée Mignet. This was where the son of an up-and-coming citizen should go, a big lugubrious building stretching along the rue Cardinale. Why, when he lived so near, he was made a boarder, is unclear. He doesn't seem to have minded much. Perhaps he was glad at least to escape the oppressive atmosphere at home and the unspoken conflict between his mother and father. The college had once been a convent, and nuns were still there, running the sick bay and taking care of the laundry. If the outside of the place was forbidding, the interior was worse: peeling and sweating plaster in the classrooms, a refectory that reeked of rancid fat and washing-up water. The nuns in their black habits and white coifs gliding about were a soothing influence. Zola in his novel remembered Sister Angèle, "the one with the virginal face who played such havoc with the hearts of the seniors and ran away with Hermeline, the fat boy in the top form who was so much in love that he used to deliberately cut his fingers so as to be able to go up and have her dress them for him."[1]

The college stretched as far as the town ramparts and had two courtyards serving as playgrounds, cool in the heat of summer under great plane trees. There was a large muddy pond with a skin of green slime where the boys learned to swim, and a dim chapel, modeled it was said after a design by Puget, pungent with incense and the smell of damp. Cézanne suffered all his life from an abhorrence of physical

contact, especially if it was unexpected, and during his years at this school something happened which he blamed afterward for his phobia. A boy sliding down the banister behind him crashed into him as he was descending the stairs, nearly throwing him off balance. To give this as the cause of so much later fear raises the question of his vulnerability at that time, and what might have brought it about.

In *The Masterpiece* Zola ridicules the staff, in his memory "a terrible, a grotesque, a lamentable cavalcade of ill-natured and long-suffering figures." There was the headmaster who ran himself into debt throwing parties in the hope of marrying off his daughters, two girls who inspired obscene drawings and graffiti; the deputy head, whose nickname was "Snitcher" because of his nose like a slender cannon and his habit of standing behind classroom doors waiting to pounce on culprits. Junior teachers all had their ludicrous nicknames, such as "Rhadamanthus" who never smiled, "Machine-Oil" who made chair backs greasy by smearing them with the movements of his head. The cruelest was "Adèle-how-could-you" for the luckless physics master, cuckolded by his wife of that name, caught *flagrante delicto*, so rumor had it, in the arms of a cavalryman. A terrifying usher, Spontini, liked to flourish and exhibit a Corsican dagger which he claimed was stained with the blood of three cousins. Then there were two unfortunates, both misshapen, Paraboulomenos and Paralleluca, a kitchen boy and a scullery maid, always being found courting among the peelings and saucepans.

In this most autobiographical of his novels, Zola describes the practical jokes, "the memory of which could still reduce them to helpless mirth. Oh, the morning when they lit the stove with the boots of the boy who used to supply the whole class with snuff, 'Bones-the-Day-Boy,' otherwise known as 'Death-Warmed-Up,' he was so thin!" One winter evening they crept into the chapel to steal matches in order to light the homemade pipes which were stuffed with chestnut leaves. And there was the day when Claude (Cézanne) tried the experiment of roasting cockchafers in the bottom of his desk, thinking they were good to eat when cooked. So much smoke poured out that the usher came hurrying in with a water jug to put out the fire.

As an old man Cézanne was apparently disgusted by the extensions and improvements to his old college since his day. His young friend and admirer Gasquet has him standing in front of the building in a mounting rage, shouting:

The pigs! Look what they've done to our old school! We are living under the thumb of the bureaucrats. It's the kingdom of the engineers, the republic of straight lines. Tell me, is there a single straight line in nature? They make everything conform to rule, the city as well as the country. Where is Aix, my old Aix of Zola and Baille, the fine streets in the old suburbs, the grass between the cobblestones, the oil lamps? Yes, oil lamps instead of your crude electricity that destroys mystery, while our old lamps gilded it, warmed it, brought it to life a la Rembrandt. . . . The acacias drooped over the walls, the moon touched the portal of Saint-Jean with silver, and we were fifteen years old. We expected to swallow the world at that time! . . . But in this beastly school nothing is left of those days.[2]

The idiom here may be suspect—Gasquet was inclined to embroider—but the sentiments are perfectly true. Cézanne's hatred of change and progress contradict any superficial notions we might have of him as the iconoclast who inaugurated modern art single-handedly.

During his six years at the Collège Bourbon, four as a boarder and his final two as a day boy, he was a hard worker, concentrating "painfully" and never sure of his final results. He loved Latin translations and won book-prizes for classics, and yet—unsurprisingly, since he was such a late developer—he did badly in art. Zola, no draftsman, and in later life an unreliable judge of painting, carried off prizes for drawing and painting as well as religion. Cézanne, innately devout, was not as good as his friend, the skeptical Zola, when it came to scripture. The same went for music. A tutor visited Paul at home and failed to make any progress. His sister Marie says "he took no interest whatever in the music taught by a professor at home and often the descent of a violin bow on his fingers bore witness to M. Poncet's displeasure." Nevertheless he must have mastered enough of the rudiments to take part in the school band formed by a classmate, Marguery. They played at festivals and for processions, and were paid in cakes. Marguery was on first cornet, Cézanne the second, and Zola on clarinet. Zola and Paul once serenaded a pretty girl of the quarter who owned a green parrot, their din driving the bird half crazy.

Though it is not true that he was unaffected by music, he wasn't drawn to it as passionately as he was to literature. As a young man Wagner's music stirred him deeply. In 1866 he painted a picture, *Overture to Tannhäuser*. A girl is at the piano, her father in an armchair, and in the background a child with a "stupid" expression listens vacantly. A

second version a year later gets rid of the father and child, and a woman, probably the painter's mother, sits knitting on a sofa. Young Gasquet's widow remembers Cézanne asking her to play the piano for him, during which time he usually dozed off. By then he was old and ill. Madame Gasquet, to spare the old man any embarrassment, would bang out the final chords *fortissimo* to wake him up.

Émile Zola joined the *collège* at the same time as Paul Cézanne, though he was a year younger. They were of entirely different backgrounds, their physiques and temperaments made them an odd couple, but the friendship was immediate and it developed rapidly. Just as Marie had been Paul's protector at his junior school, so this became his role when the girlish Émile was ostracized for seeming to be a milksop. He was small for his age, shortsighted, horribly shy and pale. He spoke with a foreign-sounding accent, and the speech impediment his father had tried to cure was still making him lisp. Despite his academic success after he first arrived he was turning into a compulsive daydreamer, as he had been at junior school, no doubt to compensate for the miserable reality of his isolation. Then, all at once, a big strong boy with a terrible temper, expressing himself with peasant directness, was there at his side. For the first time ever he had a friend. Cézanne told Gasquet how it had come about:

> At school Zola and I were considered phenomenal. I used to knock off a hundred Latin verses just like that, for two sous. I was a businessman all right when I was young! Zola didn't give a damn about anything. He dreamed. He was stubbornly unsociable—a melancholy young beggar. You know, the kind that kids detest. For no reason at all they ostracized him. And indeed that was the way our friendship started. The whole school, big boys and little, gave me a thrashing because I paid no attention to their blackballing. I defied them, I went and talked to him just the same. A fine fellow. The next day he brought me a big basket of apples. There you are—Cézanne's apples! They date back a long time.[3]

Zola's father, François—formerly Francesco—was an unstoppable romantic. His ancestors were from Venetia and Dalmatia. Although the surname means literally "clod of earth," none of his forebears seem to have been close to the soil. He was a subaltern in the Venetian army; then when Austria conquered Venice he left the army and embraced engineering. He was footloose, an adventurer, who seemed to live by a series of wild impulses. In his thirties he turned up in the newly created

Foreign Legion as an officer, but left hastily after becoming involved with the wife of a German legionnaire.

In 1833 he reverted to his calling of civil engineer. This was in Marseilles. He conceived one brilliant scheme after another but was dogged by bad luck or unfortunate timing. Balked in his ambition to construct a new harbor at Marseilles, he began to investigate the possibility of providing Aix, the ancient capital of Provence, with its first permanent water supply. The town's importance as a center of trade and industry called for something more reliable than its three fountains, two of which dried up during the height of the summer. Aix sweltered in the middle of a plain, close to the river Arc. Zola's plan involved the building of a series of dams in the nearby hills, extending their water to the town by a canal system. Adolphe Thiers, prime minister of an unstable government, was enthusiastic—after all he was born in Aix. But his power fluctuated with his political fortunes. And if the nation as a whole was slow to take up the challenges of the Industrial Revolution, Provence was deaf to them.

François Zola's efforts to raise financing took him to Paris. Five years later he was still struggling. One day he saw a young girl leaving church, pursued her, and married her. She was Greek, from Corfu. Émile, Paul's future friend, was born two years later, and the family returned to Aix. The Société du Canal Zola was still a viable company, and finally in 1846 construction began. Six months later its visionary engineer collapsed and died from pleurisy.

The death of the father had a disastrous effect on the fortunes of the family. The boy Émile grew into a man dedicated to recognition as a way of revenging himself on the authorities for his father's early death. He worked ceaselessly, joylessly, like a packhorse, more and more successfully and yet obsessed with the fear of failure. Whatever he produced, with immense labor, he immediately loathed. As Sandoz in *The Masterpiece* he cries out in a howl of despair, "When I bring forth I need forceps, and even the child always looks to me like a monster. Is it possible for anyone to be so devoid of doubt as to have absolute faith in himself?" He had no faith in himself, yet he kept going in a Sisyphus-like toil. And in order to produce what? "There's always something repulsive, in my opinion, about a book. I don't see how you can possibly like it once you've gone through the messy business of producing it. . . . From the moment I start a new novel, life's just one endless torture. Oh for another life!"

At the time of his father's funeral Émile was six, trailing along in bewilderment in the strange procession. He was a pampered, far from happy little boy. In a photograph taken about this time he was chubby in the face, solemn in a velvet suit. An attack of meningitis at the age of three had left him with one eye lifted a little above the other. The big house where they lived in the Impasse Sylvacanne was soon under threat. The canal company went into liquidation, then was refloated by one of the chief financiers as a new company, in effect a swindle cheating Madame Zola and the original shareholders. She now had to face outraged creditors who wanted the settlement of debts she had known nothing about. François Zola's grand scheme went ahead as the Canal d'Aix, and is still working today, the dam known as the Barrage Zola. One of Aix's main streets is now called the boulevard Zola.

Inevitably the Zolas were forced out of their fine house and moved to a poorer quarter of the town. Émile, just before his father died, was molested by a servant, an Algerian youth called Mustapha. So Zola too, like Cézanne, suffered all his life from the aftereffects of an attack, in his case an actual one.

Now the boy found himself, together with his mother's father and mother, barricaded against the unsavory neighbors and the dust, dirt, and clamor of the street by a mother determined to save her son from contamination by poverty. She kept him indoors as long as possible, until—since at seven he couldn't repeat the alphabet—she was forced to let him go to a small preparatory school, the Pension Notre-Dame. Bored there, he played truant and liked to wander aimlessly on the edge of the town. In his novel *Claude's Confession* he refers to his first days at his next school, and his misery at finding himself among boys "who were merciless, soulless, like all children. I must be a strange creature, capable only of loving and weeping, for I looked for affection, I suffered, from the very first steps I took. My years at school were years of tears. I had in me the pride of loving natures. I was not loved for I was not known, and I refused to let myself be known."

A small improvement in Madame Zola's finances, when she was compensated in part for her husband's work, meant that by further economies, which included moving to an even humbler house in the center of Aix, she was able to scrape together enough to send her son to the local high school. There he soon met Paul, and his life took a dramatic turn for the better. For Paul too there was liberation from his

contact with this strange little boy who was already scribbling away at a full-blown historical novel set in the time of the Crusades.

The two oddities were soon joined by a third, Baptistin Baille, two years younger than Paul but a classmate, and before long they christened themselves the "Three Inseparables." Baille provided the ballast for the trio. He was prosaic compared to Paul and Émile, who were both obvious outsiders. As a pupil he was a conscientious plodder, and this was typical of his easygoing, unimaginative nature. Nevertheless he fitted in well with the youthful enthusiasms of the other two, perhaps flattered to be included in their flights of fancy and their wild expeditions. Zola in 1860 magnanimously embraced him along with Paul, writing in a letter that "what we sought was wealth of heart and spirit, it was above all the future that our youth made us glimpse as so brilliant." Baille's future, however, had to do with science rather than art, and could hardly be described as brilliant. He became an engineer, married the daughter of his employer, and succeeded to the business in due course.

Zola was the one who inspired and led the others with his cloudy visions of them all as poets united by their vows of eternal friendship. They would be spiritual brothers for as long as they lived, he declared, and wrote and declaimed verse that enshrined their future. It was Zola who gave Paul the first intimations of a life different from the one Louis-Auguste expected him to live. The revolt he began to feel stirring in him was many years coming to fruition, and one can speculate as to whether it would have happened at all without Zola's fervent alliance.

While in the sixth form they developed a passion for long idyllic hikes, whenever they could escape from the school and from the town's "contemptible provincial stupor." They loaded everything, from trees and streams to solitude, with their voracious romanticism.

In *The Masterpiece* we can read of their exploits, Cézanne carrying a sketchbook, Émile's pocket stuffed with a fat volume of inflammatory verse. Sometimes Baille would be left behind—he lodged at the school and could only come with them during holidays. Besides, says Zola when he came to write his novel, "his were the leaden limbs and unwilling flesh of the diligent goody-goody." Émile and Paul were made of sterner stuff. Every Sunday at four in the morning one or the other would be up and ready, waking the other with pebbles thrown at the other's bedroom shutters. Sometimes it was full moonlight still, with everything silent and transparent, all the undergrowth phosphorescent:

In summer especially their dream was the Viorne, the mountain torrent that waters the low-lying meadows of Plassans. When they were about twelve they had a passion for playing about in the deeper portions of the stream; they swam like fish and would spend whole days, stark naked, lying on the burning sand, then diving back into the water, spending hours grubbing for water-plants or watching for eels. They practically lived in the river, and the combination of pure water and sunshine seemed to prolong their childhood, so that even when they were already young men they still sounded like a trio of laughing urchins as they ambled back into Plassans on a sultry July evening after a day on the river. . . .

In middle age Zola thought longingly, as he shouldered his interminable tasks and realized that "work has simply swamped my whole existence . . . like a germ planted in the skull," of how gloriously happy he had been in the open air of those drunkenly sensual days, among the dank grass and the sun-hot rocks and amid the blinding dazzle of open meadows, as the summer turned from red to blond, and then white as chalk. Thinking of those country walks brought tears to his eyes. On some days they headed for the Zola Dam, or tramped the road that ran east from Aix to Le Tholonet, a hamlet in the middle of nowhere. Over to the south spread the fields of baked red earth, while to the north they came on the spectacular gashes of Infernets Gorge, feeling heroic and indomitable there in the thorny scrub and aromatic herbs of the naked hills standing in a herd, as if about to move. Once in early spring they entered an oak forest. The night, completely soundless, was upon them suddenly. Trunks of trees where they entered the ground looked cruelly distorted. Fearfully they brushed against dim undergrowth, the branches glimmering high overhead like horns tangled together.

Mostly it was endless joy, a glorious school for the senses. From high in the hills they gasped over sudden vistas, the aerial view of red vineyards that left them speechless, the water meadows of the Arc with its green masses of supple foliage that they imagined purring like cats, the majestic blue peak of the Mont Sainte-Victoire. Paul was the one who was to benefit most from this intimate contact with the landscapes of his native countryside. The lost earth of these paradises burned in him for the rest of his days and fueled his art. He recalled again and again their times lying naked by the river with water running off their bellies, as he made obsessive studies later, studies and paintings, of groups of male and female bathers.

And it was all married to art, this Provence, indissolubly joined to the literature they were discovering:

They went along the white roads once more, roads covered with dust like a thick fall of snow and ringing with the tramp of their heavy boots. They cut across the fields again and roamed for miles where the soil was rusty-red with iron deposits, and there was not a cloud in the sky, not a shadow, and nothing but a few stunted olive trees and the sparse foliage of almonds. They recalled their home-comings, the delicious sense of weariness, their boasting about hav-ing walked even farther than last time, the thrill it gave them to feel they were carried over the ground by sheer momentum, their bod-ies spurred into action and their minds lulled into numbness by some dreadful troopers' song. . . .

They lived in a kind of fine, romantic frenzy of high-flown verses, barrack-room ribaldry and odes poured out into the shim-mering heat of the summer air. And when they found a brook and a half-dozen willows to cast a patch of grey on the blinding earth they would lose all sense of time, staying there till the stars were out, acting the plays they knew by heart, booming the heroes' parts, piping the parts of the queens and the ingenues. . . . That was how they had lived from the time when they were fourteen, burning with enthusiasm for art and literature, isolated in their remote province amid the dreary philistinism of a small town. Vic-tor Hugo's mighty settings where dream figures immeasurably larger than life stalked through an everlasting battle of antitheses had carried them away by their epic sweep and sent them gesticu-lating to watch the sun go down behind the ruins or to watch life go by in the false but superb lighting of a Romantic fifth act.

Then Musset had come and overwhelmed them with his pas-sion and his tears; they had felt their own hearts beat with his and a new, more human world had opened before them, conquering them through pity and the eternal cry of anguish they were to asso-ciate henceforth with every mortal thing. On the whole they were not overdiscriminating, but swallowed the good with the detest-able, with the healthy gluttony of youth. Such was their appetite for reading, so eager were they to admire, that they were often as thrilled by trash as by an acknowledged masterpiece.

It was that love for long country walks, that insatiable appetite for literature that had saved them from becoming as stolid as their

fellows. They never set foot in a café, they professed a strong dislike for streets, where, they pretended, they pined away like eagles in a cage, while their contemporaries were already wearing out their elbows on café tables, playing cards for drinks. Provincial life . . . the local paper read to the last advertisement, the everlasting game of dominoes, the same walk at the same time along the same avenue, the ultimate degradation of the brain ground down by its inescapable millstone—filled them with indignation, spurred them to protest, sent them clambering up the neighboring hills in search of solitude, declaiming verses in the pouring rain, deliberately refusing shelter in their hatred of cities.[4]

We have to remind ourselves of history: this is the mid-nineteenth century. While Cézanne and Zola were metamorphosing into joyful pagans, turning their backs in repudiation of the growth of cities, there was, unknown to them, a whole epoch of romantic extravagance finding expression through the rediscovery of folktales. Rousseau had sounded the call of a return to nature. The two schoolboys would have been astounded to know how modern they were, registering a consciousness of vague emotional dislocation that Hardy was to call "the ache of modernism."

In 1855 Walt Whitman surfaced with his extraordinary rhapsodies, raising palaces to nature and art and joining other great literary walkers—Rousseau, Wordsworth—with his traveling poems "Song of the Open Road" and "Crossing Brooklyn Ferry." Sandoz with his personal cries, half anguish, half ecstasy—"Let me lose myself in thee, good earth, as I feel thee now beneath my limbs, embracing me, filling me with thy warmth"—was in fact aligning himself with the confessional antibooks of intimate journals, those of Emerson, Amiel, Delacroix. Rousseau had withdrawn from the foppish sophistications of Parisian life and gone to live in the country. Wordsworth saw the poet as a priest of nature, Shelley had become a self-imposed outcast and wanderer. Rimbaud, the last word in renunciation, born in 1854, flashed into view and vanished like a comet. His god was Baudelaire, soon to have a profound effect on the young Cézanne. Amiel, the sick man of Europe, was writing his *Journal Intime* from 1847 until his death in 1881. Thoreau's *Walden* came out in 1854. Whitman, we must remember, like these two boys escaping into the wilds of Provence at every opportunity, wanted above all to *unhouse* himself.

Another spirit in revolt, Tolstoy, tried to get rid of his wealth and

live like a peasant. Van Gogh would soon be writing heartsore letters of adoration and despair, before boarding a train and making for a totally unknown south. Jack Lindsay points out that Amiel in his Journal, August 13, 1865, related hiking to the philosophical stance of Rousseau: "He it was who founded traveling on foot before Töpffer, reverie before René, literary botany before George Sand, the worship of nature before Bernard de St. Pierre. . . ."[5] Anthony Trollope as a young man belonged to a trio dubbed the Tramp Society, who slept rough and wandered through three counties.

Zola, the leader of the Provence three, not only was unaware of this nineteenth-century urge to "go native," he had no idea until he joined his mother in Paris at the age of eighteen that he had been born into a century of feverish unrest. Paris was being torn down and rebuilt to suit the ideas of Baron Haussmann, the master planner whose taste ran to ruler-straight boulevards with vistas, wide enough to accommodate a marching army. Houses in the poorer quarters were razed to the ground and entire families thrown homeless on the streets. Thousands of laborers toiled and died. Speculators were having a field day, the capital bubbling with greed and corruption. Soon Zola would be planning his own masterwork, a multivolume chronicle of Louis-Napoleon's Second Empire, more specifically of the Rougon-Macquarts, "a pack of ravening beasts unleashed and gorged." Progress was on the march.

The Russian poet Akhmatova spoke of noticing a vein of unquenched childhood in Pasternak, and the diffident, moody Cézanne had this too. (Zola's harking back nostalgically to his own golden youth, however, smacks of sentimentality in his straining attempts to blot out the wretchedness of his workaholic existence. Affecting to despise "the old canker of Romanticism" and exalt science, he couldn't help writing like a "poet," and a romantic poet at that.) "My own view," writes Peter Levi in his book on Pasternak, "has been for a long time that genius is only a mysterious survival of the powers of childhood, with adult powers that for some reason have not destroyed them."

In those early days of running free and bathing naked, Zola was fond of dreaming up radiant futures for himself, Cézanne, and Baille. Paul, even then, had his feet firmly on the ground. He would mutter gloomily, "It's indeed black, the sky of the future." As a teenager he seemed to have been afflicted with an aversion to money, possibly as a result of his unvoiced antagonism to his father. If he had cash on his

person he got rid of it as quickly as he could, before going to bed
When Zola asked him about this, he told his friend, "*Pardieu*, if I were
to die tonight, would you want my parents to inherit?"

By the time Zola came to write *The Masterpiece* he had lost his facile
optimism and was admitting grimly that "It'll take another generation,
probably two, before painters and writers work logically in the simplic-
ity of truth. Truth and nature are the only possible bases, the essential
controlling factors in art. Without them everything verges on mad-
ness." He went on (through his mouthpiece, Sandoz):

> We're living in a bad season, in a vitiated atmosphere, with the cen-
> tury coming to an end and everything in process of demolition;
> buildings torn down wholesale; every plot of land being dug and
> redug and every mortal thing stinking to death. How can anybody
> expect to be healthy? The nerves go to pieces, general neurosis sets
> in, and art begins to totter, faced with a free-for-all.... All our
> activity, our boastfulness about our knowledge, was bound to lead
> us back again to doubt.

While still at the Collège Bourbon he enrolled in the free drawing
school for evening tuition. Classes were held in the town museum,
under the direction of the museum's director, Joseph Gibert, a dull
academic artist who painted portraits of generals, ministers, and
prelates. Solari went too, with the aim of being a sculptor one day.
Paul's father, no doubt seeing the drawing as a mere pastime, didn't
oppose him. After all, Marie too was becoming a charming little water-
colorist.

Besides Solari, Paul made the acquaintance of another kindred
spirit, Numa Coste, son of a poor boot repairer. Coste wanted to paint,
and in the end did so. He stayed in touch with Paul and became an ally
when Cézanne reached Paris. Before that, however, he was trying to
educate himself without means. Eventually he became a lawyer's clerk.
Coste was four years younger than Paul. Also in the town was an artist
ten years older than he, Joseph Villevielle, making a modest success as
a conventional painter. He had once been a pupil of Ingres's friend,
Granet, a native of Aix, one of whose paintings, *The Prisoner of Chillon*,
was in the museum. We can be sure that Cézanne studied this work as
well as a number of paintings by baroque artists of France and Italy. He
seems to have paid particular attention to one painting, *The Card Play-
ers*, either by Louis Le Nain or of his school.

◈ It must have been a severe blow to him when Émile Zola sudden-ly left for Paris. The boy's education had used up whatever small settle-ment Madame Zola had extracted from the Canal Company, and now they were staring at another dire crisis, the first effect of which was to uproot them yet again: they moved to a miserable two-room cottage in the rue Mazarine. To compound the distress, his grandmother died. His moth-er went off to Paris in an attempt to enlist the help of her husband's for-mer backers, leaving Émile in the care of her old father. In February 1858 a letter came from her telling her son to sell their possessions and bring her father with him to join her. The sale of the furniture and bric-a-brac raised just enough for two third-class coach tickets. Émile had been in Paris only once before, when he had stayed with his Uncle Adolphe in one of the clamorous poor districts of the city. The vio-lence and stink of poverty had frightened him. He had been glad to return south again to the sun and purity of the Aix countryside.

His mother moved them on their arrival to a grimy hotel at 63 rue Monsieur-le-Prince. They were in the down-at-the-heels Latin Quar-ter. Madame Zola had managed to pull a few strings and obtain a place for Émile at the Lycée Saint-Louis on the boulevard Saint-Michel, a stone's throw from their hotel. Though he had carried off prizes in Aix, studying for the baccalaureate was altogether different. He found the lectures impossible to absorb.

From these unpromising surroundings and the grind of school-work he sought escape by reading Montaigne, Rabelais, and George Sand, and by writing copious letters to his friends Cézanne and Baille in faraway Aix. Soon he was receiving rambling, arch, playful, and bawdy letters from Paul, including verse. Trying to believe in himself as a poet, Émile replied in kind, but his evanescent lines had none of his friend's gusto. The truth was that a clearly feminine side to his nature came to the fore when he wrote emotionally. Paul, suffering from the pangs of unrequited love for a girl who didn't give him a sin-gle glance, was addressed by Zola in a poem, "To My Friend Paul," which insisted on the superiority of friendship between blood broth-ers. It reads awkwardly and must have made its recipient squirm:

> But if my feeble hands, sweet-smelling wreath,
> Have not for a loved one woven here your flowers,
> If I've not mingled my capricious verses
> To gain a passing smile from two bright eyes,

My humble bouquet, it's that I prefer
One heart before the dear heart of a blonde.
A noble and tender heart, on which today
I set you, a moment's solace for his tedium.
Go then and find my friend. His masculine chest
I rate above the breasts of a childish front.
  You will gleam better on his coat of black
  Than in the jewels of a charming corsage.[6]

Paul was approaching his final examinations at the Collège Bourbon with increasing dread, expressed in his first letters to Zola with elaborate jokiness, accompanied by ribald and lovesick verses. He seemed to find it easier to pour out his emotions by distancing himself from them in poetry which was rough but full of energy, a mixture of doggerel and symbolism. "My dear chap," he wrote, "I'm studying for matriculation. Ah, if I had matric, if you had matric, if Baille had matric, if we all had matric. Baille at least will have it, but I—sunk, submerged, done-for, petrified, extinguished, annihilated, that's what I shall be. My dear chap, it's 5th May today, and it's raining hard."

Already he (and Baille) were waiting impatiently for the summer, hoping that Zola could join them for their usual jaunts. He did come, and for a while it was like old times, the trio running for their beloved wilderness, their rivers, stones, trees, and fields pulsating with heat, "wrestling, throwing stones at pots, catching frogs in their hands." Paul had already confessed in letters his mournful dreams of "the woman I spoke to you about. I don't know who she is. I see her sometimes passing in the street when on my way to my monotonous college. I have reached the stage of heaving sighs, but sighs that do not externally betray themselves. They are mental sighs."[7]

All this was forgotten when the three were together and they passed into the land of the groves, disentangling themselves from maples, climbing and descending the wooded paths, entering the morning silence of the open moors. On October 1 Zola went back to Paris and his hated *lycée*. Baille passed his two matriculations on November 12 as expected and Paul got through his, graduating on the same day with the degree of bachelor of letters. He was nearly twenty and it was time to choose a career. He was still spending most of his leisure time at the drawing school in the museum, though the stodgy teaching left him convinced of the innate philistinism of academic institutions and professors which stayed with him for the rest of his life. But he carried home a

second prize for drawing in 1858, which he probably hoped would win over his father. Alas, Louis-Auguste had other ideas for his only son.

Boosting his spirits as usual with wordplay, enormous gobbets of verse, and bawdy jokes, Paul resumed his letter-writing to Paris with a supposed celebration of his exam triumph:

> Yes, friend, O yes, I feel enormous joy
> As I this title in my heart deploy.
> No more of Greek and Latin I'm the prey.
> O blessed day, O more than blessed day
> This pompous title came my honored way.
> For I'm a Bachelor, a great thing I say.
> The person made a Bachelor in my notion
> Has drunk of Latin and Greek a mighty potion.

Execrable stuff, if good-humored, but he could do better, proving as much by grandiloquent parodies in the grand manner on the subjects of Cicero and the death of Hannibal. He wasn't to know that Zola, undermined by his hopeless prospects, had fallen dangerously ill with encephalitis soon after returning to Paris. He lay delirious for several days and was feverish for weeks. Once again the female world of his mother and grandmother drew close, cosseting him from the ugly problems posed by reality outside the windows. He was absent from school for so long that he failed the baccalaureate examination. Made anxious by his mother's financial state, he bravely skipped a whole year and tried for the diploma. At the Sorbonne he dealt with the science papers brilliantly, then his nerves went to pieces the next day during his orals in language and literature. He was given a humiliating zero for literature.

In November he made a second attempt at the University of Marseilles, failing this time even more disastrously. He did so badly with the written work that he fled before reaching the orals. He wrote miserably to Paul, "I failed to complete my studies. I can't even speak good French. I'm a total ignoramus!"

They were living now in a freezing attic in the rue Saint-Jacques, struggling to survive the winter. There was nothing for it but to take a job, anything at all. Still clinging to his dreams of literary life, Émile had sought work with a printer but was turned down. Now an old friend of his father found him some clerical drudgery at the customs offices. He marched through the streets daily to earn sixty francs a month, wearing out his boots to get there.

His ambitious plans for a long poem he wanted to write called "Chain of Being" (derived from Chénier and Hugo) were now shelved, though not, in spite of Baille's disparaging remarks, abandoned. "I am destined to rot on the straw of an office chair," he wrote to Paul, writing again later to paint a picture of his soulless existence. "My new life is monotony itself. I go to the office at 9 a.m. and until 4 make records of customs declarations, copy correspondence, etc.—or rather I read the newspaper, yawn, pace up and down, etc., etc. All very sad. But the moment I leave I shake myself like a wet bird, light my pipe, breathe, live. I turn over in my mind long poems, long dramas, long novels. I wait for summer that I might find an outlet for my creative spirit. Good God! I want to publish a volume of poetry and dedicate it to you."[8]

The squalid attic where his mother and grandmother lived was too cramped to accommodate him too, so he lived in a small hotel which gobbled up a third of his salary. He could get by only with the help of meager sums from his mother, which he despised himself for accepting. He wrote despondently to Baille that though he lived in Paris he might as well be in the country, since he hardly ever went out. "I'm in a back room, can hardly hear the noises of the traffic, and if it weren't for the spire of Val-de-Grâce in the distance I could easily believe myself to be still in Aix." And it was bitterly ironic to him there at the Docks Napoléon, surrounded by clerks "who were mostly stupid," to receive letters from Aix asking about his love life in libertine Paris. "You ask me to tell you about my mistress; my loves are only dreams," he told Baille, who had gone off to study in Marseilles. When Émile and Paul had been members of the town band they had once serenaded a young girl under her window with their clarinet and cornet, until the parents could stand no more "horrible discord" and emptied the house's chamber pots over the boys' heads. The girl, whom they called l'Aerienne, he mentioned in his letters to Baille and sadly asked his friend to "give her a smile from me if you see her." What he wanted, he said, and urged on both Baille and Cézanne, wasn't someone real who was bound to disappoint, but an ideal love "whom I did not so much see as dream of." This pure noble love that could never be sullied by "the dungheap" was, he believed, the ideal solution for an artist. From the window of his room he exchanged smiles with a florist's assistant on her way to and from work. "Not knowing her," he explained, "I can endow her with any number of qualities, invent endless mad adventures, watch her and hear her talk through the prism of my imagination."[9]

Throughout his life Cézanne was a curious mixture of timidity and

ferocious tenacity. Always unable to confront and oppose his father directly, nevertheless he got his own way in the end. But it would take years of writhing under his father's tongue, years of vacillations, retreats, defeats. If he ever voiced out loud his desire to be a painter and to join Zola in Paris it was only to be jeered at for entertaining such nonsense. Louis-Auguste thought he was extremely tolerant in not insisting that Paul should succeed him in due course at the bank. If the career of financier wasn't to his taste, no matter. He could study law instead.

Just like Zola, Paul was supported by females. But there was nothing practical that either his mother or his sister Marie could do for him. The lively, perceptive side of his mother's nature would be enacted vicariously through her son, and Paul in time would become as devout, in his own way, as his pious sister. His feeling for his mother was unexpressed, subterranean. He noticed things about her that moved him, and she knew he did, knew he depended on her emotionally. Sometimes she would feel bound to intercede for him, for her baby. But the brutally indifferent father was deaf to the pleading of women. And he controlled the money. For the next two years Paul studied law, stifling his resentment, reading in letter after letter Zola's urgent questions: When was he joining him in Paris? When would he find the courage to face his father?

He plowed away drearily at the Faculté de Droit in Aix, passing his first examinations in November 1859 for his bachelor of laws degree. Incredibly, he still needed his father's permission to paint at the museum in his spare time. He swallowed the humiliation down, along with the sense of loss, bad enough after Zola's departure and now redoubled when Solari won the Prix Granet of twelve hundred francs and went off to Paris also.

On June 20, 1859, he wrote to his woebegone friend owning up to fresh torments. There was a girl, another one, he told Zola—he had seen her at a distance and she had overturned his heart. Reading between the lines it is clear that he believed himself to be in love for the first time. Far too timid to approach, desolate, his hopes soared and fell as he caught glimpses of this untouchable creature. Really he was in love with love. He didn't trust himself to describe the experience until it was over and he could construct a "story" out of the sheer absurdity of it all, when he thought his heart was breaking:

> I tried to deceive myself. . . . I felt a passionate love for a certain
> Justine who is really *very fine*; but as I have not the honor of being

greatly beautiful she has always turned her head the other way. When I cast my peepers in her direction she used to lower her eyes and blush. And I thought I detected that when we were in the same street she made as it were a half-turn and dodged away without looking backward. . . . I am not happy, and yet I run the risk of meeting her three or four times a day. Better still, dear chap, one fine day a young man came up, a student like myself, in a word it was Seymard whom you know. "My dear fellow," he said, taking my hand, then hanging on my arm and continuing to walk toward the rue d'Italie. "I'm going," he went on, "to show you a pretty little girl whom I love and who loves me."

I confess that at once a cloud seemed to pass before my eyes. I had as it were a presentiment that luck was against me, and I wasn't wrong, for midday struck just then and Justine came out of her dressmaking workshop. And by my faith, as soon as I could make her out, Seymard, giving the signal, said, "There she is." At this point I saw nothing more, my head was in a whirl, but Seymard dragging me along I brushed against the young girl's frock. . . .

He breaks off his letter here with dots, as if the experience is too traumatic to convey. Jack Lindsay reminds us of Cézanne's instruction to his housekeeper to avoid letting her skirts brush against him when serving his meals. Friends were warned in advance not to upset him with sudden physical contact.

Since then I've seen her almost daily, and often Seymard was trailing her. . . . Ah! what dreams I've reared, the maddest dreams at that, but you see how things go; I was telling myself, if she didn't detest me, we'd go to Paris together, there I'd make myself an artist, we'd be happy, I was dreaming of pictures, a studio on the 4th floor, you with me, how we'd have laughed then. I wasn't asking to be rich, you know what I'm like, with a few hundred francs I thought we'd live in contentment, but by my faith it was a great dream, all that; and now I who am so idle, I'm only satisfied when I'm drunk. I can hardly do anything more, I'm an inert body, good for nothing.

By my faith, old man, your cigars are excellent, I'm smoking one while I'm writing. They have the taste of caramel and barley-sugar. Ah, but look, look, there she is, how she glides and hovers, yes it's my young girl, how she laughs at me, she floats in the eddies of smoke, look, look, she goes up, sinks, frolics, spins round, laughs

at me. O Justine, tell me at least that you don't hate me. She laughs. Cruel girl, you enjoy making me suffer. Justine, listen. But she is fading out, she goes up, up, always up, then, see, at last she vanishes. The cigar falls from my mouth, and at that I go to sleep. I thought for a moment I was going crazy, but thanks to your cigar my mind is fortified, ten more days and I'll get her out of my mind, or else I'll only see her on the horizon of the past as a shadow I've dreamed of.

He seems determined by his playful tone and his mimicry of a tipsy state not to have his longings taken seriously, and ends with a warm fraternal embrace:

Ah, what ineffable pleasure it would give me to shake your hand. You see, your maman told me you'd be coming to Aix toward the end of July. You know, if I'd been a good jumper I'd have hit the ceiling, so high I jumped. Really for a moment I thought I was going mad, night was coming on and I thought I was going mad, but it was nothing you understand. Only I'd drunk too much so I saw before my eyes spirits hovering at the tip of my nose, dancing, laughing, springing wildly about. Goodbye, my dear chap, goodbye,

P. Cézanne[10]

On the reverse of the final sheet he sketched a big leafy tree on the bank of a river, the three Inseparables bathing and fooling in the water under its shade. The image would stay with him as a symbol of comradeship and be reproduced in dozens of drawings and paintings of bathers. In another letter he wrote, "Do you remember how that pine tree standing beside the Arc tossed its hirsute head over the abyss yawning at its feet—that pine whose foliage sheltered our bodies from the fierceness of the sun? Ah, may the gods preserve it from the dread strokes of the woodsman's axe!" And he himself, in this shared romantic boyhood, was described with humor and affection by Baille as "that poetic, fantastic, bacchic, erotic, antic, physical, geometrical friend of ours."

In these early letters Zola comes across as having almost a feminine role, concerned about both Cézanne and Baille like a mother, doing his best to humor and encourage them, acting as the peacemaker when there seemed friction between them. It seems clear that Émile and Paul badly needed each other. The frustrated law student in Aix who

was beginning to think he would never get clear of all that trapped him was endlessly stimulated—and terrified—by Zola's letters and example. Zola usually managed to sound bravely optimistic. "I have few illusions, Paul," he wrote. "I know I can only stammer. But I'll find a way." Another time he admitted that "Like a shipwrecked man clinging to a floating plank I've been clinging to you, dear old Paul. You have understood me, your nature has been sympathetic to mine. In you I have found a friend and give thanks to heaven."

Zola still thought he was destined to be a poet, and his hackneyed, banal verse was in imitation of bad models. Romanticism might have been at its last gasp, but Zola had a long way to go before replacing it. He tried to inspire himself with his own despair, with "the end of all things, one last, pure, melancholy song, soaring above the ruins of the world!" But nothing soared for him. His daydreams foundered in loneliness and the desolation of a huge modern city which had no time for him. He wailed in letters that the city crowds crushed him. "I do not see a single soul, only prisons of clay, and my soul is smitten with despair at its immense solitude and grows more and more somber. . . . Jostling among its fellows, but never knowing them save for the commonplace exchange of commonplace conversation: is that not how man's life is passed? . . . Man is alone on the earth, shapes pass before his eyes, but every day shows me the vast desert in which each one of us lives."[11]

◈ Meanwhile the domestic rebellion under Louis-Auguste's roof continued to smolder on. Zola, as if his very sanity depended on it, kept trying to extricate his friend from Aix by a mixture of entreaties and clarion calls for more courage, more persistence, more agitation. Well aware of Paul's timid character he exerted steady pressure on the emerging artist, at one point putting the fear of God into him by threatening to write to the father himself. He knew perfectly well that Louis-Auguste thought of him as a pernicious influence, but he was easily swayed by his own words and really imagined he could talk the banker round. Paul would drive him frantic by announcing a definite date for his departure and then in his next letter postponing the visit yet again. In the twelve months it took Zola to winkle out his friend it is possible that Louis-Auguste was swayed by a number of factors. One was his son's obvious unhappiness. Then there was the mother, pointing out meekly that things couldn't continue in this way and backing

Paul's talent out of love and anxiety. She had no understanding of art but simply wanted him to be happy. The shrewd banker, thinking his son would cave in, played for time. Either this ridiculous course proposed by his son would be abandoned or the sheer difficulty of living alone would force him back to his doting mother.

Sensing a breakthrough, Zola wrote in exasperation, "What shall I say to you to end this letter cheerfully? Shall I give you courage to advance to the assault of the rampart? Cursed rampart, cursed painting! One is yet to be tested by the cannon, the other is crushed by the paternal veto. 'Child, child,' says your father, 'think of the future. With genius one dies and with money one eats.' Alas, alas, my poor Cézanne, life is a ball which does not always roll where the hand would like to send it."

On October 24, 1859, he tried another tack, dangling the fleshly delights of the capital in front of Paul's eyes. "Chaillan [an art student] says that the models are approachable, though not of the freshest quality. One draws them by day and cuddles them by night—though the term cuddles is perhaps too mild. You pay them so much to pose by day and so much for the pose by night. The fig leaf is unknown in the studio. The models undress as they do at home, and the love of art checks what other emotions might be excited by their nakedness. Come and see."

This was rich—and a hint of the voyeurism to come—from someone who was still recommending platonic love and Michelet's books, such as *Love* and *Women*, with their uncompromising stand against promiscuity. One of Zola's poems had been published, a bloodless fairy story in a medieval setting, "La Fée amoureuse." It sank without a trace.

He told Paul again that what he valued most about him and Baille was their solidarity with him. "I tell myself that, whatever our situations may be, we'll hold fast to the same sentiments, and that consoles me. . . . I feel a certain pride in having understood you, in having appreciated your true value. Let's have done with the wicked and the jealous; as the majority of human beings are stupid, the scoffer won't be on our side, but what matter, if it gives you as much joy to clasp my hand as it does me to clasp yours."[12]

He was beginning to smell victory. Yet when, after a whole series of tactful letters aimed at diluting Paul's fears by subtle persuasion, it looked as if he had won, he was uncharacteristically a prey to doubts of his own. In a long letter on March 3, 1860, he worried over

uneasy forebodings about your visit, I mean as to the more or less imminent date of your arrival. To have you near, to chat together, as in the old days, pipe in mouth and glass in hand, seems to me something so wonderful, so incredible, that there are moments when I ask if I'm not fooling myself and if this fine dream is really coming true. One is so often cheated in one's hopes that the realization of one of them takes one by surprise, and one doesn't admit it as possible till the facts are certain.

Somehow, in all Paul's shilly-shallying and wobbly confidence, Gibert, the director of the Aix museum, had been dragged into the vexed question of Cézanne's intentions. Apparently Louis-Auguste had decided to consult Gibert. Asking for advice was yet another ploy for postponing his son's departure. And of course it worked: the man thought Paul should continue in Aix with his studies.

All this gives me the shivers. I tremble at receiving a letter in which with many lamentations you announce a change of date. I'm so used to thinking of the last week in March as the end of my boredom that it'd be very hard for me, after storing up only enough patience to last till then, to find myself alone when the time comes. Well, we must follow the great maxim: let the water flow and we'll see what of good or ill the course of events will bring us. If it's dangerous to hope for too much, nothing is so stupid as total despair. In the first case one risks only one's future happiness, while in the second one is sad without even a reason.

More and more convinced that his absent friend lacks character and may easily let things slide rather than exert himself and take a stand, floating weakly between painting and the law, Zola the indefatigable fixer knows too that when it comes to organizing himself in practical terms there is no one more hopeless. Telling Paul not to leave his letters lying around for his parents to read, he goes on to devise a precise routine for his day in Paris and a budget so that his francs will be enough to survive on. Paul has mentioned a sum of 125 francs, though with his father's unwillingness to support him he can't even be sure of that.

You ask me an odd question. Of course one can work here, as anywhere else, if one has the will. Paris offers, further, an advantage you can't find elsewhere: the museums in which you can study the old masters from 11 to 4. This is how you must divide your time. From 6 to 11 you go to a studio to paint from the live model; you

have lunch, then from 12 to 4 you copy, in the Louvre or the Luxembourg, whatever masterpiece you like. That will make up nine hours of work. I think that ought to be enough, and you can't but do well with such a routine. You see, we'll have the whole evening free and we can use it as we think fit, without interfering in the least with our studies. Then on Sundays we'll dodge off and travel a few leagues outside Paris. The places are delightful, and if your heart desires you can sketch on a piece of canvas the trees under which we eat our lunch.[13]

He sets out, at this early age, the religion of work which he will end up loathing so much, an activity which devours everything in sight and blots out food, fresh air, mother, wife. For the moment he can only think of it as the one way out; above all as a collaboration.

Daily I have charming dreams I want to realize when you're here: poetic work such as we love. I am lazy when it comes to crude work, work that keeps the body busy and stifles the intelligence. But art, which occupies the mind, enchants me; and it's often when I'm carelessly lying down that I work the hardest. Many people don't understand that, and I'm not the one to bother about making them understand. Besides, we're no longer kids, we must think of the future. Work, work: it's the only way to get ahead.

As for the money question, it's true that 125 francs a month won't leave much room for luxury. I'll reckon out for you what you should spend. A room at 20 francs a month; lunch at 18 sous and dinner at 22, which makes two francs a day, or 60 francs a month. Add 20 francs for your room, the total is 80 francs a month. Then you have the studio to pay for: the Atelier Suisse, one of the least expensive, charges, I think, 10 francs. Add 10 francs for canvas, brushes, colors; that makes 100. So you'll have 25 francs left for laundry, light, the thousand little needs that turn up, tobacco, amusements. You see you'll have enough to live on, and I assure you I'm not at all exaggerating; rather I'm underestimating.[14]

The twenty-year-old future novelist was showing remarkable maturity, together with a curiously maternal kind of love. One would have thought he had overlooked nothing, but with Zola there was always the moral to be drawn.

Incidentally, it'd be a valuable experience. You'd learn the value of money and how a chap with his wits about him can always extri-

cate himself from a predicament. I repeat, so as not to discourage you, you can manage. I advise you to show your father the above reckoning. Perhaps the hard fact of the figures will make him loosen his purse strings a little. On the other hand you could earn some cash yourself. Studies made in the studio, above all copies made in the Louvre, sell very well. And if you did only one a month, that would add very nicely to the budget for your amusements. It all depends on finding a dealer: simply a question of looking round. Come without fear. Once your bread and wine are assured, you can, without danger, devote yourself to the arts.

Here you have plenty of prose, plenty of material details. As they're for your sake and useful as well, I hope you'll forgive them. This devil of a body is sometimes a nuisance, one has to drag it everywhere, and everywhere it makes terrible demands. It's hungry, it's cold, and so on, and there's always the soul waiting to put its word in and forced in turn to keep silent and behave as if it didn't exist, so that the tyrant may be satisfied. . . .

Answer this at least before the 15th, to reassure me and tell me of any new developments cropping up. Anyhow, I expect you to write, just before you leave, the day and hour of your arrival. I'll go to the station to meet you and take you at once to lunch in my erudite company. I'll write again before that. Baille has written. If you see him before leaving, make him promise to join us in September. Greetings to you, my respects to your family, your friend,

Émile Zola.

Already dominant through his will and purpose, Zola was equally precocious in his early grasp of the bewildering characteristics of "our time"—the increasing power and influence of the sciences, the state of flux in religion and the arts. Already cosmopolitan in outlook, he went whirling back to Aix in the summer to inspire his friends and stiffen their resolve to break out. In *Claude's Confession* he would romanticize their friendship, their dreams of love and glory, and their vows of poverty, all in the names of Hugo and de Musset. In reality he had tasted real poverty and had come to detest it, while Paul would always dread the thought of one day having to earn his daily bread. Writing to Baille on June 2, 1860, we find a very different Zola, seeing the age for what it was and raising questions of direction he would be trying to answer for many years to come:

Our century is a century of transition; emerging from an abhorred past, we move toward an unknown future. . . . What characterizes our time is this impetuosity, this devouring activity in the sciences, activity in commerce, in the arts, everywhere railways, electricity applied to telegraphy, steam-driven ships, the aerostat rising up aloft. In the political domain it's much worse: the people are rising up, the empires tend to unity. In religion everything is unsettled: for the new world that is going to come up, a young and lively religion is needed. . . . [15]

He had been stung by the conservative-minded Baille, already aiming for a sensible career and suggesting that Zola do the same. He had even made remarks to the effect that Zola's grand ambitions were so much poetic gas. "You call them crazy," Zola shot back, "and claim that you won't be so foolish as to expire in some attic merely for applause, as poets do." This must have rankled, for he went back to the attack shortly afterward. "The word position occurs several times in your letters, and it makes me angry. . . . Those eight letters have the touch of the prosperous grocer about them. . . . Are you really sincere? Do you no longer dream of liberty? Are all your aspirations limited by material success?"

Baille, as it turned out, was a lost cause in this respect, but Zola never really gave up on anyone in those days. With astonishingly youthful perception he was able to put his finger on the pulse of things. Under the seeming order and prosperity of Louis-Napoleon's regime, with its wide boulevards laid out in straight lines by Haussmann to prevent the barricades of 1848 being thrown up again, he was aware of the repression, the political ferment and unrest giving the lie to the air of optimism and excitement. Power politics was bringing war to Europe: "In a series of lightning moves Austria attacked Sardinia, France attacked Austria, Prussia mobilized against France, which won Nice and Savoy; France and England declared war on China, Spain went to war against Morocco; Garibaldi marched into Naples, Victor Emmanuel invaded the Papal States. . . ."[16] In 1859 Marx's *Criticism of the Political Economy*, Darwin's *Origin of Species*, and Mill's *On Liberty* all saw the light. Cézanne would always be totally indifferent to politics and public affairs but Zola was forever seeking to establish just where he stood. He still hadn't abandoned his golden dream of a collaboration. "I dreamed the other day," he told Cézanne, "that I had written a beautiful book, a magnificent book, which you had illustrated with

your beautiful, magnificent drawings. Our names gleamed in golden letters, united on the title page, a brotherhood of genius inseparable in posterity. Sadly, it is still only a dream."

Now, as part of his rebuff to Baille and to show how realistic he really was, he tried to understand what the role of the poet should be in the midst of this distracting, rapidly changing society. If romanticism had had its day, what should replace it? The new trend was toward the Parnassian. Its cold detachment he found deeply unsatisfactory, as much a dead end as the traditions of the past had proved to be. His own solution was to transfer his energies from poetry to prose, even though he would always see his novels as poems in some sense.

Paul was even more in the dark. He had yet to discover Delacroix and Courbet. We can see his uncertainty in his copious verse, where he was having even less success than Zola in resolving the conflict between his adolescent dreams and reality, lost as he was "in dreamy hours, as in a mist, a drift of gracious forms." We can see it too in the panels he painted for the alcove of the salon of the Jas de Bouffan, a mansion at first rented and then bought for eighty thousand francs by his parvenu father. Once the residence of the governor of Provence, this large property with its high ceilings, its acres of grass and wheat, its stretches of water presided over by moss-covered lions, its windows in the eighteenth-century style, and its Genoese roofing, was badly in need of renovation. The banker who wanted to be a landowner knew a bargain when he saw one. Only a mile from Aix to the west, the name meant "Habitation of the Winds" in Provençal, presumably because even on the most torrid days of summer there was a breeze. Louis-Auguste would sit at the open windows inhaling the smell of cattle and corn, hearing the cool music of fountains and the rustle of branches, all congratulating him on the ownership of his domain.

Though he didn't entertain there, he needed to demonstrate his new status in the most concrete form. What better than a country house? The family used it on weekends and to escape the heavy heat of the town in summer. Paul soon came to love the place and grounds and overgrown gardens—which were never restored—and especially the avenues of chestnuts. In a year or two he had one of the upper rooms fitted with a north light for a studio. For some reason, perhaps out of embarrassment, he failed to mention it to the impoverished Zola, who would in any case have seen it as one more bond he was encouraging Paul to break.

The panels he painted on the theme of the seasons were in a formal

neoclassical style, betraying the hand of the amateur by the innocence of the draftsmanship, yet quite deliberately attempting an imitation of Renaissance painting. Their order was curious: *Spring, Summer, Winter*, followed by *Autumn*. For all their apparent naiveté, these big pictures with their ambitious scale sounded a sardonic note. As always with Cézanne there was nothing ignorant in the enterprise. The panel *Winter* is signed and dated Ingres, 1811—Ingres was an artist Cézanne always disliked intensely. Later he painted a portrait of his father and placed it in the middle, in a manner so powerfully lumpish as to seem a facetious flourish aimed at the romantic spirit of the larger panels. Self-mockery, too, can't be ruled out. Excessively suspicious, he suspected most of all his own motives. His friend, struggling to launch himself on an indifferent Paris against all the odds, had already struck the word "failure" from his vocabulary. Now he attacked Paul's wavering faith in his own powers.

> . . . You say that sometimes you lack the courage to write to me. Don't be an egotist. Your joys as well as your sorrows belong to me. Another phrase in your letter also left a depressing impression on me. It's this: "Painting that I love, even though I don't succeed, etc." You, never succeed! I think you're mistaken about yourself. But I've already told you: in the artist there are two men, the poet and the craftsman. One is born a poet, one becomes a craftsman. And you, who have the spark, who possess what one can never acquire, complain, when for success you only need to train your fingers, to become a craftsman.

For all his unswerving loyalty to Paul and his growing awareness of the stubborn law student's thorny character, Zola had no real understanding of the other's work, dismissing it sadly later as the effort of a flawed genius. In his morale-boosting letter of April 16 he delivers a warning lecture on the evils of commercial art. Anyone less commercially minded than Cézanne would be hard to imagine. More puzzling is Zola's advice to the effect that quick painting shouldn't be admired or emulated. The agonizing slowness of the mature Cézanne at work has made this comment something of a joke, but his apprentice work was probably executed at speed as he moved toward the violent expressionism of his earliest achieved painting, his emotions bulging forth in dark, contorted pictures of nudes, murders, abductions, and rapes. Blithely confident as ever, Zola went on:

Recently I warned you against realism. Today I want to point out another danger, commercialism. The realists do after all create art—in their own way—they work conscientiously. But the commercial artists, those who paint in the morning for their evening's bread, they grovel in the dust. . . . I'm afraid for your sake about this path you're taking, all the more because he whom you are perhaps trying to imitate has some fine qualities which he shamelessly exploits, but which all the same make his pictures seem better than they are. [This was perhaps Villevielle, the Aix painter who had been Granet's pupil.] His work is pretty, it's fresh, the brushwork good, but all that's just a trick of the trade, and you'd be wrong to halt at that point.

Art is more sublime than that. Art is not limited to the folds of a drapery, to the rosy tints of a virgin. Look at Rembrandt: with one ray of light all his figures, even the ugliest, become poetic. So I repeat, —— is a good instructor to teach you the trade, but I doubt if you could learn anything more from his pictures. Being rich, you no doubt expect to follow art and not business . . . so beware of an exaggerated admiration for your compatriot. Put your dreams, those lovely golden dreams, on to your canvas, and try to bring out the ideal love you have in you. Above all, and here is the abyss, don't admire a picture because it is painted quickly.[17]

In the contest going on to prize Paul away from his father's bourgeois world and from Aix, Villevielle—if it was he—must have reared up as yet another obstacle. And Zola was getting infuriatingly contradictory messages. "I have just received a letter from Baille," he wrote. "I don't understand it at all. Here's a phrase I read in this epistle: 'It is almost certain that Cézanne will go to Paris; what joy!' Has he just been dreaming, has he taken your desire for reality? I repeat, I don't understand. For three months I have been saying to myself, according to the letters I get: He's coming, he isn't coming. Try, for God's sake, not to imitate the weathercock."

Blunt words. In July he tries some brutal sarcasm. What he doesn't altogether realize, or at any rate accept, is that Paul is not only struggling timorously to win the assent of his father but to overcome his growing self-doubt. What if he's fooling himself and there's nothing inside him, what sort of comic figure will he cut in Paris with his provincial accent, and so on. Zola sets about shaming the fearful Paul.

Let me explain myself yet again frankly and clearly. . . . Is painting with you only a pastime, a mere theme for conversation, a pretext for slacking at the Law? If that's the case I can understand your behavior. You do well in not driving things to an extreme and bringing about more family ructions. But if painting is your vocation—and that's how I've always looked on it—if you believe yourself able to make good at it after working hard, then you become an enigma to me, a sphinx. . . . One thing or the other. You don't want to—and in that case you're gaining your end admirably—or you do want to, and then I don't understand what it's all about.

Sometimes your letters give me lots of hope, sometimes they take away even more. Of such is your last, in which you seem almost to bid farewell to your dreams, which you could so well change into reality. In this letter there's a phrase I've tried vainly to understand. "I am talking in order to say nothing, as my conduct contradicts my words."

I've built up hypotheses in order to explain the meaning of this statement. None of them satisfies me. What is your conduct then? Certainly that of a lazy man. But what is surprising in that? You are being forced to do work repugnant to you. You want to ask your father to let you come to Paris and become an artist. I see no contradiction between that and your actions. You neglect the Law, you attend the museum, painting is the one work you care about. There you have an admirable agreement between your desires and your actions.

Zola's remorseless logic brought him to the point of abuse. Anything to precipitate some decision, action. With a beloved dead father and a mother endlessly doting on him he could never really accept what he kept calling Paul's "position." The position was that Paul hung on in the hope that Louis-Auguste would eventually relent. This seemed to be happening: then his opposition stiffened, Paul's hopes evaporated, and—as Zola gradually realized—this dreadful war of attrition went on in almost total silence. The only talk was with Paul's mother and sister. A second sister, Rose, would have been only six. Zola's naiveté is touching when he urges his timid friend to bring things out into the open, for "discussion illuminates everything." In his July letter he keeps hammering away remorselessly with his admonitions and calls for courage:

Shall I tell you something?—above all don't get angry—you lack character. You have a horror of fatigue of any sort, in thought or deed. . . .

Another passage in your letter grieved me. You say you sometimes throw your brushes at the ceiling when the form doesn't follow your idea. Why this discouragement, this impatience? I might be able to comprehend them after years of study, after thousands of vain attempts. . . . But you who so far had only the desire to work, you who haven't yet taken up your task seriously and regularly, you have no right to rate yourself incapable. So take courage. All you have done so far is nothing. Courage, and remember that to reach your goal you'll need years of study and perseverance.[18]

He cites the example of the complacent Chaillan, who "finds all he does excellent. That's because he has nothing finer in his mind, no ideal he is striving to attain. And he'll never be great, because he thinks he is great already."

In this year of miserable indecision and hopelessness Cézanne seems to have given Baille the cold shoulder when his friend came over from Marseilles to see Paul at the Jas de Bouffan. We hear of this through Zola, who now takes up the role of peacemaker to each of his friends in turn. First of all he writes to Paul telling him to make allowances for Baille, who "is not like ourselves, his mind is not cast in the same mold." Eager to patch up the quarrel, loss of temper, or whatever it was that Paul had done to offend—and he's in no doubt who is at fault, knowing Cézanne as he does—he tries to make Baille see that "the poor chap doesn't always know what he is doing, as he admits willingly enough himself, and that when he hurts your feelings you mustn't blame his heart but the evil demon who clouds his thoughts." The tricky strategy seemed to work. Soon Paul was writing to him shamefacedly asking for Baille's address, apologizing for his character "being what it is."

More hopes were dashed when Paul's little sister fell ill, though Zola must have seen this as another excuse for postponing the decision to leave. If so, he kept the thought to himself. He can't have understood—or Paul never made clear—that the one thing that kept Paul in Aix was his father's disapproval, since that meant no allowance on which to live. The idea of living close to destitution like Zola filled him with absolute dread, even though frugality in itself was never a problem for him. But it was more than the fact of money: he looked healthy,

strong-blooded, and yet his dependence on his father prevented him from being a man: he felt condemned to live fretfully in the shadow of his father like a child. He sometimes wondered if he could ever escape his own fatal weakness and become strong at the center of himself, instead of nothing. Would it always be like this, where in all the serious matters of his life his father ruled over him? What was the point of ambition when something inside him refused to come to grips with life?

Turning away for a moment from the never-ending problem of Paul, Zola outlined to Baille his effort to find a new way for himself in literature. He still clung to poetry and the idea of himself as a poet, and couldn't yet see that the "new form" for him would be prose, the novel:

> I would rather not follow in anyone's footsteps. Not because I'm ambitious for the name of head-of-a-school—normally such a man is always systematic—but I'd like to find some unexplored pathway and get away from the crowd of scribblers of our time. . . . It's an evident thing, each society has its own particular poetry; well, our society is not that of 1830, so our society does not yet have its poetry and he who found it would be rightly famous. The aspirations toward the future, the breath of liberty that rises up on all sides, the religion that purifies itself: there indeed are powerful sources of inspiration. The problem comes down to that of finding a new form, of singing worthily the future peoples, of showing with grandeur humanity climbing the steps of the sanctuary. You cannot deny that there's something sublime to be found. What? I still don't know. I feel confusedly that a great figure is agitated in the shadows, but I can't grasp its features.[19]

The truth was that Baille, concentrating on a lucrative career, was drawing away from being part of the old threesome. It was too high-falutin and up in the air; he could see it leading nowhere. At the same time he was hurt to think he was being excluded. "When you realize I'm incapable of giving expression to art in painting or poetry, don't you feel I'm unworthy of you?" Zola, gentle and tactful when he wanted to be, turned the question round and asked, "When you see us, art-student and scribbler, incapable of gaining a position for ourselves in life, don't you think we're unworthy of you, poor Bohemians that we are?"

A few letters on, feeling that the reconciliation he had been trying to effect between Baille and Cézanne was still touch and go, he wrote

to Paul begging him to remember the vows they all three made, "glasses in hand, to walk all our lives along the same path, arm in arm." Ever the willing go-between, he did his best to restrain Paul from putting his foot in it once more. "If you have anything to reproach him with, tell me."

So far as Louis-Auguste was concerned, he had apparently known for some time that the old man assumed the right to open letters to any member of the family. With this in mind he began to slip into his endless advice words that he knew Paul was incapable of saying to his father, hoping they would catch Louis-Auguste's eye. "After the night comes the dawn, and when the dawn comes you can say: I've slept long enough, Father. I feel strong and courageous, have pity, do not cage me in an office, let me take wing, I am suffocating. Be kind, Father."

◆ All three were hoping for a reunion in Aix that summer. Zola had to back down, simply because he was too poor to afford the fare, and too discouraged himself to find the words of encouragement he had been dispatching to Aix so tirelessly until now. He must have been told about the Jas de Bouffan at last, writing morosely that he had been looking forward to seeing "the panels of Paul, the moustache of Baille," and now would not make it after all. "I am consumed by boredom." His long-lasting hypochondria was setting in, "my nerves are so shattered and fretted." He had left his clerical job at the docks, unable to stomach any more of it.

He lived now in abject poverty, sinking lower by the week—or rather, higher, as the cheapest rooms were attic rooms that boiled with heat in summer and froze in winter. He was living on pitiful handouts from his mother and selling what few articles he owned. Soon he was a regular caller at the local pawnbroker.

His malnutrition made him exist in a stupor from day to day, living on bread dipped in oil or watery soup, now and then a bit of penny pork. Perpetually hungry and listless, he stayed in bed for long periods to stay warm. He wandered along the Seine embankment staring at books which had lost their meaning. Examining himself morbidly he decided that "I believe in nothing, least of all myself. On some days I think I have no mind at all, when I wonder how I ever allowed myself to have ambitions." Trailing around lethargically he couldn't rouse himself to write to Paul. Instead he asked Baille to "tell dear old Cézanne that I'm sad and can't answer his last letter." The poet Paul Alexis, who also

came from Aix and followed the older man's career for years before meeting him as an ardent fan, said later that the winter of 1860–1861 was truly a period of total abandonment on the Paris streets for Zola, "without position, without resources, nothing to do, no future...."

Somehow, with the spring of 1861 in sight, the destitute poet's dreams and aspirations revived. The bitter winter had dealt his idealism a blow from which it never recovered, and no doubt this was all to the good. His vehicle for this period, *Claude's Confession*, has the autobiographical hero saying, "I fear greatly that our dreams are merely lies. I feel petty and puerile in the face of a reality of which I am dimly aware." He was growing up rapidly. To Paul he confided mysteriously that "I've gained a new outlook on love that will be of much help for the work I'm planning to write." On hearing that Paul was sketching out in the open, leaving Gibert's studio for "the frozen earth, taking no thought for the cold," Zola was impressed, as he always was by the evidence of real commitment. Then a letter from Baille disturbed him greatly. Either Baille had heard from Paul secondhand or had been told directly by Louis-Auguste that Zola was not to be trusted—a devious character out to feather his own nest at his well-off son's expense. This would certainly have made sense to the banker, who saw money behind most motives, unless of course he was being sly, taking the attitude in order to block Paul's departure once again. In fact Zola was the one who, years later, often helped his friend with small sums when Cézanne was hard-pressed. In a period when he was turning up at his mother's boardinghouse to share a frugal meal and enduring Madame Zola's silent stares of reproach, watching her toil away at poorly paid needlework, he didn't once ask Paul for a loan.

Now he was badly hurt by these accusations. He may have wondered too whether Baille had passed on the information because he was half in sympathy with the suspicious father, who after all had gained the kind of success he was beginning to want for himself. Zola replied with dignity that to be called an intriguer after the efforts he had made in the name of friendship and disinterest, was very hard to take.

It's heartbreaking.... The sad impression it made on me was somewhat lessened by the vague knowledge I already had of the suspicions floating round me. I felt myself an adversary, almost an enemy, of Paul's family. Our different ways of seeing, of understanding life, warned me secretly of the lack of sympathy that M. Cézanne must have felt for me. What shall I say? All you've told

me I already know, but didn't dare to admit to myself. Above all, I didn't believe they could accuse me of such infamy and see in my brotherly friendship only cold-blooded calculation.

I am frank, I must admit that such an accusation coming from such a source saddens rather than surprises me. I'm beginning to get so used to this mean and jealous world that an insult seems to me a normal thing, not worth feeling annoyed about, only more or less able to astonish me, according to who throws it in my face. Generally I'm my own judge . . . and I smile at the judgment of others. I have constructed a whole philosophy so as not to suffer a thousand vexations in dealing with other persons, I go on, free and proud, bothering little about the tumult, sometimes making use of it with an artist's eye for a study of the human heart. . . . But in the present case it's hard to follow the path I've marked out. As Paul's friend I'd like to be, if not loved by his family, at least respected. If somebody quite indifferent to me, whom I'd met casually and shouldn't see again, were to hear calumnies about me and believe them, I'd let him do so without even trying to alter his opinion. But this is not the same thing. Wanting at any cost to remain Paul's brother, I often find myself compelled to be in touch with his father. I am forced to appear before the eyes of a man who scorns me and whom I can only repay with scorn for scorn.

As this long letter of April 22, 1861, develops its themes of self-jus-tification and hurt pride, one sees finally what a zealous, transparently sincere and incorrigible character Zola is. Nothing is going to stop him: he even contemplates—Heaven forbid—trying to open Paul's father's eyes himself:

> . . . I don't want under any circumstances to cause trouble in that family. As long as M. Cézanne considers me a vile intriguer, and as long as he sees his son associate with me, he'll grow angry at his son. I don't want that to happen; I can't keep silent. If Paul isn't ready to open his father's eyes himself, I must try to do it. My superb dis-dain would be misplaced here. I mustn't let any doubts remain in the mind of my old friend's father. It would mean, I repeat, the end of our friendship or the end of all affection between father and son.
>
> There's another detail I think I can guess at which you're doubtless hiding through affection. You include us both in the Cézanne family's disapproval; and I don't know what it is that tells me I'm the more accused of us two, perhaps even the only

one. . . . There are a thousand details, a thousand arguments, that have led me to this belief. In the first place my poverty, then my almost declared profession to writing, my sojourn in Paris, etc. . . .

The question seems to me this. M. Cézanne has seen his plans thwarted by his son. The future banker has discovered that he's a painter. He feels the eagle's wings on his shoulders and wants to leave the nest. Astounded at this transformation and this desire for liberty, and quite unable to believe that he could prefer banking and the air of heaven to his dusty office, M. Cézanne has gone questing for an answer to the riddle. He doesn't want to admit it's happened because God willed it so, because God, having created him a banker, has created his son a painter.

Having probed the matter thoroughly, he decided at last I was responsible, that it was I who changed Paul into what he is at present, that it was I who robbed the bank of its dearest hope. No doubt evil associations were mentioned, and that's how Émile Zola, man of letters, turned into an intriguer, a false friend, and I don't know what else. It's just as sad as it's ridiculous. If done in good faith, it's stupid; if deliberate, it's the worst kind of wickedness.

Always prepared to self-dramatize at the drop of a hat, half flattered and half aghast at being seen as an evil influence, he says disingenuously at one point that anyone reading his letters could see that he "often pointed out the disadvantages of a visit to Paris"

and counseled him above all to conciliate his father. But there's no call for me to justify myself to you. . . . I can be accused of nothing worse than thoughtlessness. In the advice I gave Paul I always restrained myself. Knowing his character wouldn't accept any definite opinion, I spoke to him of art, of poetry, not so much from any set plan on account of my own nature.

I wanted to have him near me, but in suggesting this idea I never urged him to revolt. In a word, my letters have had nothing but friendship for motive, and for contents only such words as were dictated by nature. The effect of those words on Paul's career cannot be held against me as a crime. . . . I examine myself and find I'm guilty of nothing. My conduct has always been frank and blameless. I loved Paul like a brother, thinking always of his welfare, without egotism, without any selfish motive, reviving his courage when I saw it weaken, always speaking to him of the beau-

tiful, the true and the good, always seeking to raise his spirit and make him above all a man.

This farrago of indignation and fairness, pompous at times but understandably so in a young man of twenty, comes to a head at last when Zola reveals his alarming "plan":

It's true that I never spoke of money in my letters; that I didn't suggest such and such a deal by which one could make enormous sums. It's true my letters only spoke of friendship, of my dreams, and I don't know how many fine thoughts: coins without value in any business in the world. . . .

I'm joking and don't feel like it. Whatever comes of it, this is my plan. After consulting Paul I propose to see M. Cézanne in private and come to a frank understanding. Have no fear as to my moderation and the propriety of the words I'll utter. Here I can breathe out in irony my wounded self-esteem; but in the presence of our friend's father I'll be only as I ought to be, strictly logical and with a frankness based on facts. Indeed you yourself seem to advise such an interview. I may be wrong but certain vague phrases in your letter seem to urge me to bring these calumnies to an end by an explanation.

I say all this and I don't yet know what I'll do. I'm waiting for Cézanne and I want to see him before I decide on anything. His father will have to grant me his esteem sooner or later. If he doesn't know the facts of the past, the facts of the future will convince him. Perhaps I've dwelt on this matter too long. . . . I'm so anxious to demonstrate my lack of guilt and the ridiculous side of these accusations.

There was no way he could have known that he was wasting his time: the dependent son would only become independent after the death of his father. But now the emphasis had shifted: Zola felt compromised and it rankled. One could imagine him doubling and turning for several pages more if it hadn't been for an extraordinary twist of fate. He broke off a letter that had been rendered out of date at a single stroke, and added a final paragraph:

I've seen Paul!!! I've seen Paul, do you understand that? do you understand the melody in these three words? He came this morning, Sunday, and shouted at me several times up the stairs. I was half

asleep. I opened my door trembling with joy and we embraced furiously. Then he reassured me as to his father's antipathy toward me. He claimed that you had exaggerated a bit, doubtless because of your warm feelings. Finally he announced that his father had asked for me. I am to go and see him today or tomorrow. Then we went out together to lunch and smoke a quantity of pipes in a quantity of public gardens, and I left him. As long as his father is here, we'll be able to see each other only rarely, but in a month we expect to take lodgings together.[20]

# 4  SECRET AFFINITIES

It was sensational news, and puzzling for a number of reasons. Why hadn't Paul let his friend know, so that they could have met at the station as Zola wanted? The second part of the question is easy to answer: Paul had his father and sister with him. But why not write? Either he was vacillating to the very end, or his father's capitulation was so sudden that there was no time for a letter. And what about the old man's suspicions about Zola's ulterior motives? Here he was delivering his son to be fleeced, if that was what he seriously feared. Not only that, but he had taken the trouble to escort a young man who had never been further than a few miles from Aix. Paul must have been thrilled by the journey, with its twenty-hour ride by express even when they had got to Marseilles, gaping out of the window at the Rhône valley, the endlessly changing vistas of fields and vineyards, the strange paraffin-lit wayside stations.

Louis-Auguste and Marie stayed a few weeks with Paul at a small hotel in the rue Coquillière, near the Halles Centrales. The father had arranged for an allowance to be remitted to Paul through the firm of Le Hideux, Paris correspondents of the bank of Cézanne and Cabassol. The amount—250 francs a month according to Jack Lindsay, 150 in Gerstle Mack's biography, and 125 francs in Graham King's life of Zola—was raised quite soon to 300 francs, exceedingly generous by the banker's standards. Left to his own devices after his father and sister departed, Paul moved to a furnished room in the rue des Feuillantines

on the Left Bank, so as to be near Zola. (His letters to Baille after reaching Paris have not survived, so that Zola's is the only account we have of his first months in the capital.)

When he took in the squalid circumstances of the house where Zola lodged in the rue Soufflot near the Panthéon he must have been shocked, as he undoubtedly was by the down-at-the-heels state of his friend, with his threadbare coat and ancient overcoat. Whores lodged in the house and there were frequent police raids. But for the moment everything went well. The organizing side of Zola took over. In his element, he steered Cézanne in the direction of museums and exhibitions. He wanted him to see the fountain of Jean Goujon and the works of Scheffer, a feeble painter whom they both admired at that time. He planned jaunts on Sundays to the outer edges of the city and proudly took his friend along to enroll at the Atelier Suisse. One can picture him explaining confidently as they walked that it was only necessary to pay a fixed sum monthly for the costs of models and overheads. He had found out everything months before in anticipation of this moment. At the Suisse there was no instruction unless anyone asked for it. Everyone worked as they liked in pastel, watercolor, or oils, either working from the model or inventing freely. Discussions were encouraged, providing there was nothing stormy.

The founder, Père Suisse, was a former model. Famous artists who had used the place included Delacroix, Bonington, Courbet, and Isabey. Manet had worked there five years before, and only three months ago Paul would have seen Monet, now off doing military service in Algiers. "The house in which this Atelier Suisse was located," writes Dubuisson, "was at the corner of the boulevard du Palais and the quai des Orfèvres. It was demolished some years ago to make room for the new buildings of the Prefecture of Police. . . . The atelier, which was on the second floor, was reached by means of a very old wooden staircase, very dirty and of a rather dismal appearance, always spotted with bloodstains. That was because the first floor was occupied by the office of a dentist, whose sign was visible from a considerable distance along the quai: SABRA, dentiste du peuple."[1]

Coquoit in his life of Cézanne says there was a male model for three weeks in the month and a female for the fourth. The dentist's premises and the atelier were on the same stairway. Patients making for the place on the Île de Cité occasionally lost their way, and "a number

of them must have fled in panic, never to return, on seeing in the dentist's office—having opened the wrong door by mistake—nude models shamelessly sitting or standing about."[2]

Beginning timidly, Cézanne settled in and began to enjoy the atmosphere and his fixed routine. He sketched and painted there every morning and in the afternoon availed himself of his compatriot Villevielle's studio, or else made copies in the Louvre. Maybe to escape the miserable eating places used by Zola, whose bohemian sloppiness was hard to take, he visited Villevielle at his home and enjoyed the hospitality of his wife. He found it hard to adjust to the crowded narrow streets and the unfriendly stares he received, so unlike Aix where he was known to so many. The sense of alienation was forgotten while he was with Zola or Villevielle, but left to his own resources he would feel forlorn, hating "black muddy smoky Paris" and the unexciting country around it. Twenty-four years earlier Millet had been just as downcast, lost in a city-wilderness that took no account of him whatsoever. "The light of the streetlamps," he had written, "half quenched by the fog, the vast number of horses and carriages, jostling and crossing one another, the narrow streets, the smell and the atmosphere of Paris affected my head and my heart as if they would suffocate me. I was overtaken by a burst of sobs which I couldn't check. . . . I wished to be stronger than my feelings but they overcame me with their whole power. I only succeeded in keeping back my tears by throwing in my face handfuls of water scooped up from a street fountain." Awkward, countrified, made clumsy by a painful shyness, Cézanne was acutely lonely and homesick when the light faded. But dawn was no better. He found this period of aimless misery described later by Jules Vallès, a socialist author and journalist whose autobiographical novel *Jacques Vingtras* became a favorite book of Cézanne's. Vallès captured the provincial youth's pariah feeling in words which must have caught at Cézanne's heart:

What silence! Everything looks pallid under the sad glimmer of morning, and there is the solitude of villages in this sleeping Paris. It's as melancholy as abandonment. It's cold with dawn-cold and the last star blinks stupidly in the dull blue of the sky.

I'm scared like a Robinson disembarked on a deserted shore, in a country without trees and red fruit. The houses are tall, mournful, and like blind men with their closed shutters, their lowered curtains.

◈ Paris was in a turmoil of reconstruction, and France was gripped by a railway mania. The rue de Rennes and other main thoroughfares were half completed; the boulevard Saint-Michel (then called the boulevard de Sébastopol) had been dug out. It all seemed to add to Cézanne's feeling of confusion. He had been longing for years in Aix to confront the old masters in the Louvre, but now their sheer size overwhelmed him. They towered and crushed him with their unattainability, while mediocre academics such as Meissonier with their meticulous and lifeless productions were indistinguishable as far as he was concerned from real artists of the caliber of Courbet and Corot. Delacroix hadn't yet swung into view for him. As for Corot, there was a foretaste of him in the example of Granet, the poor bricklayer of Aix who had been discovered by Ingres. As an old man Cézanne spoke glowingly to Gasquet of Corot's portrait of Daumier, exclaiming, "Both their hearts are beating in it. . . ."

He badly wanted to paint, but how to set about it? Who to emulate, which of his contemporaries could help him find a method, an approach, so that he could harness the chaos of emotions surging within him so painfully? Anyone approaching him, as Zola was tempted to do, with concrete advice was seen as the same kind of threat to his identity from outside that his father had always been. The negative capability proposed by Keats that Cézanne would employ so triumphantly one day, sinking his identity in something larger than himself, was as far beyond him as the canvases in the Louvre. Yet even in these early years, when the clashing styles around him only served to increase his uncertainties, he seemed to know instinctively that Zola, when it came to art, was no critic. Certainly he was clever at latching on to trends, and would soon seize on Manet as "one of the masters of tomorrow." He was good too at stirring up controversy. The new young painters were admired by him not so much for their work as their revolt against the establishment. This readiness to take up the cudgels was in the future, but what Cézanne sensed already was a hunger for success which had nothing to do with his own problems.

A rift was soon opening up between them. For a fortnight or so after Cézanne's arrival, Zola had nothing to complain about. Writing to Baille at the beginning of May he said he was seeing his friend very often. Only Cézanne's work schedule kept them apart, which was as it should be. So far they hadn't been on any weekend excursions worth mentioning. The next day, Sunday, they had planned to go to Neuilly

and spend the day lazing on the banks of the Seine, bathing, drinking, smoking. Alas, the weather had collapsed, the temperature had sunk, the wind was howling. Maybe though they would do something together—"Paul is going to paint my portrait."

A few weeks later Cézanne wrote to a boyhood friend, Joseph Huot, who was to come to Paris three years later for the Beaux-Arts. It's clear from this letter that the exile was still bobbing around aimlessly on the sea of his impressions. He speaks wistfully of the "good wine of Provence," and goes on:

> You, know, the wine here is detestable. I don't want to write elegies in these few lines, but *I must confess* I don't feel very gay. I fritter away my little existence right and left. Suisse occupies me from 6 a.m. to 11. I eat at the rate of 15 sous per meal. It's not big, but what would you have? I still don't die of hunger.
>
> I thought that by leaving Aix I'd leave far behind me the boredom that pursued me. All I've done is to change place, and the boredom has followed me. I've left my parents, friends, some of my habits: that's all. And yet to think I wander round almost all the day. I've seen, it's naive to mention, the Louvre and the Luxembourg and Versailles. You know them, these boring things housed in these admirable monuments, it's upsetting, swankily impressive, shattering. Don't think I'm becoming Parisian.
>
> I've also been at the Salon. For a young heart, for a child born for art who says what he thinks, I believe that that is what is really best, because there all tastes, all styles meet and clash. I could launch into some fine descriptions and put you to sleep. Be grateful to me for sparing you.[3]

A week after this, Zola, aware that Cézanne had begun to withdraw from him—as he did too from Villevielle after a month or two—was bitterly reviewing the state of their relationship. Nothing was turning out as he had imagined, nothing was how it had been in those heady summers at Aix when they were eighteen and carefree, with only a golden Hugo-inspired future to contemplate. "I rarely see Cézanne." This was the harsh real world where everything conspired to part them. Instead of their seeing a great deal of each other they were separated by their different routines. Even at lunchtime they ate apart. At the end of the day Cézanne only wanted to have his supper and go to bed. Zola asks plaintively, "Is this what I'd hoped for?"

Out of touch with his friend's inner life now they were no longer

corresponding, he began to imagine him suddenly clearing out for good and heading back to Provence, his discontent was so palpable. Doubtless too he was exasperated by Cézanne's total lack of interest in his own insecurity, scraping by on handouts from his mother, whereas the banker's son didn't even know what deprivation was. All the same, the thought of Cézanne abandoning him threw Zola into a panic. In desperation, knowing how slowly Cézanne worked as a rule, he came up with the idea of the portrait. This at least was a kind of contact. "Sometimes at noon I go to his room, then he works at my portrait."

It succeeded after a fashion. Cézanne's little room became a place of reunion for Zola. "I read or we babble, both of us; then when we're deep immersed in work, we usually go and smoke a pipe in the Luxembourg."

Usually, as the portrait painting went on, there were no callers. If someone happened to call they would be ignored, Cézanne painting obsessively in a kind of dumb fury. Zola sitting there obediently like a sphinx. Any intruder would be intimidated, either sitting down a moment, afraid to move, or mumbling goodbye and slipping out of the door.

Always eager to dissect and analyze, Zola unburdened himself in a letter to Baille in a deliberate attempt to come to grips with Cézanne's baffling character. On June 10 he wrote:

> Paul is still the same excellent fantastic fellow I used to know at school. As proof of his having lost nothing of his eccentricity I have only to tell you that no sooner had he arrived here than he was talking of a return to Aix. To have fought for three years to make this trip and then to throw it away like a straw! Before such a character, such unforeseen and irrational veerings of conduct, I admit that I stay dumb and put away my logic.

But not for long. Zola was never the man to leave well alone. He was learning firsthand that intimacy with Cézanne could go only so far. Eventually he would give up on the impossible creature who seemed at times to be a mass of phobias, but he did tolerate his tantrums to an extraordinary degree. So did Philippe Solari, but that was meekness. Zola was a person who took pride in his ability to fathom the intricacies of the other's character. To have his forebearance and understanding thrown back in his face was hard to take. And there was Cézanne's maddening stubbornness. It made not the slightest difference that

Zola's advice was sensible, which it invariably was. The man's will fixed itself, obstinate as a mule:

> To convince Cézanne of anything is like wanting to persuade the towers of Notre Dame to dance a quadrille. He might say yes, but he wouldn't budge a fraction. And note that age has developed his obstinacy, without giving him rational bases on which to be obstinate. He is made in one piece, rigid and hard under the hand. Nothing bends him, nothing can draw concession out of him. He won't even discuss what he's thinking; he has a horror of argument. First, because talk is tiring, and also because he may have to change his mind if his adversary is proved right.

This was more astute than perhaps Zola himself realized. Arguments, in Cézanne's suspicious mind, meant opposition, condemnation. They meant that his friend had suddenly lost faith in him and become an enemy, just as the world would soon be the enemy. He was in the world but not of it. Arguments only reinforced his suspicion that he was isolated, secretly opposed. On the other hand, Zola's well-meaning concern and protectiveness made him feel he was back among the restrictions of his family, making demands he could never hope to meet. Zola's long letter pours out his disillusionment together with misgivings with which one can readily sympathize. After all, he does like the man: loves him even. What he has known with him in those naked hours and days on the banks of the Arc is something that happens rarely in a life, and perhaps only between ardent young men who find themselves in absolute accord, body and mind, a mystical bond sealing their friendship, as it seems forever. Put another way, in each approach to Cézanne he was addressing the imagined feminine part of himself, and because of this he couldn't bear to give up on him, to part from him. In a sense he was talking to a spiritual twin who for some inexplicable reason kept turning away. In his distress he failed to take account of such obvious factors as Cézanne's fear of a city that Zola had begun to make his own. Paris to Cézanne was just ugly, a dirty place with no mountains.

"So there he is," Zola tells Baille, needing urgently to share his new critical assessment of Cézanne with their mutual friend,

> thrown into life, bringing to it certain ideas, unwilling to change them except on his own judgment; at the same time remaining the best chap in the world, always saying what you say—the result of

his horror of arguments, but just as firmly thinking his own thoughts. While his lips say yes, most of the time his judgment says no. If by chance he advances a contrary opinion and you take this up, he flares out without wanting to examine the matter, shouts that you don't understand anything about it, and jumps on to something else. Go on then arguing—what am I saying? no use even in conversing with a chap of this temper, you don't gain an inch of ground, and all you get out of it is the fact of having observed a very odd character.

Upset he might be, but Zola wouldn't be Zola if he didn't have a plan. He outlined to Baille his decision to be flexible, to humor this exasperating man, accept his moods, and though this seems almost ludicrous in view of Zola's interfering temperament, he does appear to have stuck to it.

> I had hoped the years would modify him to some extent, but I find him just as I left him. So my plan of conduct is very simple. Never hinder his fantasy. At most to insinuate advice very indirectly. To leave entirely to his good nature the survival of our friendship; never to force his hand to clasp mine; in short, to efface myself completely, always welcoming him gaily, seeking him out without importuning him, and handing over to his good pleasure the decision of how much or how little intimacy he wants between us.
>
> Perhaps my language surprises you, but all the same it's logical. Paul is always for me a chap with a good heart, a friend who can understand and appreciate me. Only, as each of us has his own nature, the only sensible way is for me to conform to his moods, if I don't want to lose his friendship. Perhaps, to keep yours, I'd use reasoning; with him that would mean a total loss. Don't think there's any cloud between us. We are still very close, and all I've just said doesn't take into account the fortuitous circumstances that separate us more than I'd wish.[4]

None of these stresses and strains was doing him any good physically. He complained to Baille that he was unwell, "some physical ailment or other, of which no doctor can give me a satisfactory account. My digestive system is thoroughly upset. I am always feeling a heaviness in my stomach and bowels; sometimes I could eat a horse, at other times food fills me with loathing." He was existing on a miserable diet of "bread and coffee, or bread and a pennyworth of Italian cheese,"

and sometimes it was only bread. Or not even that. What churned him up too, of course, was Cézanne's attitude, or rather his indifference to the precarious financial state Zola was always in. He had no inkling of what it was like to live from hand to mouth: his only fear was that his father's allowance might suddenly dry up. Even then, his plight would in no way have been comparable to Zola's. He would simply have given up on Paris, packed his few belongings, and gone home. Without knowing Pissarro, Renoir, and Monet, he would have ended up a very different painter, probably a minor one.

Although Zola was now making a determined effort to analyze his friend's behavior and to learn from it, it was far too soon for him to plumb the depths of the problem. He came closer than anyone, but in the end had to admit defeat. For one thing, their backgrounds were so different. Instead of a threatening father he had a beloved lost father. For all his sympathy, as he balanced daily on the edge of starvation, he must have felt envy and resentment of Cézanne's middle-class security. His friend's already near-paranoid fear of physical and emotional contact and his wild determination to avoid entanglements were behind nearly all these weird withdrawals and hidings, but Cézanne was the last person to own up to his acute discomfort, let alone seek help or discuss it. He either retreated and disappeared or exploded in outbursts of nervous rage which afterward shamed him deeply. Better to be alone than risk such humiliations.

The only comment he made—it was hardly offered as an excuse—was the expression: *"On me mettrait le grappin dessus*—they might get their hooks into me."[5] These *grappins* came in many guises. The most obvious one was his father, who held the purse strings and never let his son forget it. Friends were *grappins* and, because of affection, as hard to deal with as the *grappin* of his mother, on whom he relied for so much moral support. Then there were fellow artists, out to put their hooks into him with theories and views that he thought might endanger his own lonely path, or put obstacles in his way. He was a highly intelligent man who knew perfectly well that these other opinions sometimes had merit, but how to explain, when he hated artistic chatter, that they were not for him?

Jack Lindsay is astute in pointing out that "His extreme difficulty in completing portraits came from his discomfort in being forced into familiar terms with another person as much as from his inability to realize his aesthetic intentions; indeed the two problems were indissolubly connected for him."[6]

Then there were women, inaccessible, complex, infinitely threatening for one so morbidly shy. He was quite chaste. The bawdy exchanges with Zola and Baille couldn't be applied to real living women. For someone so diffident, so fearful of ridicule, what defenses were there? If he had none at the social level, how could he ward off the visceral? Worse still, he was obsessed by women. He shrank from their approach, and in imagination he delivered himself over to a dream being, as he did in his verse, only to find himself clutching a skeleton. There was the idea of women, with which he often tormented himself, afterward feeling debauched and ashamed, and women alive in the flesh, before whom he was helplessly uneasy.

◆ He went off to stay briefly at Marcoussis on the Seine-et-Oise. On getting back he sought out Zola and was as affectionate as ever. It was as if the differences between them were nonexistent. Zola, his previous conclusions about the man thrown into disarray, wrote in August to Baille, feeling guilty at the thought that he might after all have judged wrongly or too hastily:

> I find nothing so repugnant as to pass a definite judgment on anyone. If I'm shown a work of art, a picture, a poem, I'll examine it with care and won't be afraid to express my opinion. If I err, my good faith excuses me. This picture, this poem, are things one shouldn't change one's mind about. They have but one quality. If good, they'll be good forever; if bad, eternally bad. If I'm told of a single act of a man, even, I'll judge unhesitatingly whether he did well or ill in that separate act of his life.
>
> But if I'm then asked the general question: What do I think of the man? I try to be politely evasive so as to avoid answering. And indeed what judgment can be passed on a human being who isn't brute matter like a picture, nor something abstract like an action? How can you come to a decision about the mixture of good and evil making up a life? What scales can you use to weigh exactly what you're to praise and what to condemn? And above all, how are you going to collect the totality of a man's actions? If you omit a single one, your judgment will be unjust. Finally, if a man isn't dead, what favorable or unfavorable judgment can you make about a life that may still produce evil or good?
>
> This is what I've been saying to myself, meditating over my last letter in which I spoke about Cézanne. I was trying to judge him,

and despite my good faith I repented having arrived at a conclusion which after all wasn't correct.

But what was correct? For all his edgy perceptiveness, Zola had yet to understand that his friend's inability to get on with people wasn't a mood but cripplingly permanent, and only fed the feeling of inferiority he suffered at gatherings. It was both a curse and a blessing. As a human being Cézanne was isolated cruelly by it. As a painter he gained immeasurably. His concentration was ferocious, hardly ever distracted. Stripped down to his own company, as friends learned to give him a wide berth or fall away, he became a force of art. Nothing mattered in the end but painting.

I'd like to give you still more details. Cézanne has many accesses of discouragement. Despite the somewhat affected scorn he expresses for glory, I see that he desires to succeed. When he does badly, he speaks of nothing less than returning to Aix and making himself a clerk in a commercial house. I then have to embark on vast discourses to prove to him the folly of such a return. He gladly agrees and sets himself again to work. However the idea gnaws at him. Twice already he has been on the point of going off. I fear from one instant to the other that he'll escape me. If you write him, try to speak of our forthcoming reunion, and in the most seductive colors. It's the only way to hold him.

The portrait of Zola had been getting nowhere. Cézanne struggled with it, stopped, then took it up again. Wanting, he said, to finish it, he asked for a final sitting. Zola went round to his place gladly. It wasn't so long since he'd heard Cézanne announce that he was packing his trunk and leaving the following day. That was how he had come to suggest the idea of a portrait, as they sat in a café together and he tried not to object to Cézanne's talk of leaving.

"But yesterday this cursed portrait, which I'd expected would keep him in Paris, came close to driving him away," Zola related. He turned up as asked for a final sitting, only to find a grim-faced Cézanne heaping things into his trunk, the drawers of the chest open, half emptied. "Well, tomorrow I'm off," he said calmly.

Zola asked about the portrait, then saw the ripped-up canvas in the corner of the room. "I've just torn it up," Cézanne said. "I wanted to retouch it this morning, and it got worse and worse, so I demolished it. Now I'm off."

I held myself back from any comment. We went out to lunch together and I didn't leave him till evening. During the day he came back to more sensible sentiments, and at last, when leaving, he promised to stay on. But it's only a bad bit of patching up. If he doesn't go this week, he'll go the next. You can expect to see him go off from one moment to the next. I even believe he'd be doing the right thing. Paul may have the genius of a great painter, but he'll never have the genius to become one. The least obstacle throws him into despair. I repeat, let him go off, if he wants to save himself from many vexations.[7]

At last Zola had had enough of coaxing and coddling Cézanne. In spite of his determination not to pass judgment, here is the harsh verdict he held to, with regret and sadness, all his life. When he came to write *The Masterpiece* he underlined the conclusion that Cézanne lacked the tenacity to be a great artist. "Though owning an excellent nature and full of natural gifts, he cannot accept a remonstrance however gentle it may be." This at any rate was true. But Lantier in Zola's novel had little of Cézanne's inner doggedness. Cézanne fell on his failures and hacked them to bits and then began again. His intransigence and perennial restlessness were to do with the indecision that often tormented him rather than instability.

If there were other portraits of Zola from this time, none have survived. All that exists is an unfinished oil sketch in profile. Hollow-eyed, wistful, it is as surprising in its delicacy of features as the portrait painted later by his friend Manet. From the same period is a Cézanne self-portrait worked up from a photograph. The eyes of the photograph gaze at us timidly from the diffident, moustached face. The head is strong, on a strong neck. Apart from the intensity of gaze, nothing prepares us for the changes made by the artist to convey his sense of his inner self. The lighting is sharpened, the face lengthened, the mouth touched with aggression. The whole picture breathes hostility, a young man at bay, desperate, balked. At the corners of the eyes are blood-red flecks. It could be the portrait of someone contemplating a murder. One draws back from the uncompromising effort being made to tell the truth. It is as if the painter is looking at someone else, another man, an animal cornered. It catapults us forward to the wild expressionism of a Münch, it has such astonishing modernity.

The letter to Baille ends with a postscript: "Paul will surely stay on

in Paris till September; but is that his final decision? Yet I have hopes that he won't change it."

If he told the truth, Zola was no longer sure he wanted his friend to stay. All in all the visit had been a big disappointment, so long awaited and in the end bitterly frustrating for both of them. Zola had always dreamed of an alliance of kindred spirits against the indifference of the contemporary world. If they couldn't conquer then at the very least they would be establishing a cell of good living, with perhaps Baille and Solari joining them in due course. That dream had gone smash on the rocks of grim reality, but Zola was nothing if not resilient. His effort to tear the rose-tinted spectacles from his eyes for good are recounted in *Claude's Confession*, an autobiographical novel of a young poet in Paris who tries to redeem a prostitute he takes into his room off the streets. Even before Cézanne's departure Zola was grinding away at an ambitious essay on the contemporary scene entitled "On Science and Civilization in their Relations with Poetry." Experiment was in the air, and the scientific method seemed enviably concrete and purposeful when Zola stepped back and contemplated his own floundering romanticism, although the butterfly of poetry would go on fluttering fancifully for some time to come. Nevertheless the painful transition from romantic to realist was under way. Poetry, it appeared to him, had no future. What he burned to have, what he believed would set free his creative energies and transform his life, was a success. One day he wrote triumphantly, "My mind is awake and functioning wonderfully well. I believe I am even growing through suffering. I see, I understand better. New senses, which I lacked for certain things, have been granted me." Or he would note, with scientific objectivity, "I feel a heaviness in my belly and in my bowels. My insides worry me, and so does the future."

It was no wonder. By the end of 1861 he was drifting further downward, pinched with cold, hungry as ever, plagued with obscure complaints, yet somehow still determined to cling to his hopes and dreams. He had moved into the worst kind of hotel, a vermin-infested boardinghouse in the rue Soufflot. It was only one step from the bottom; soon at this rate he would be joining the *clochards* sleeping rough under the bridges of the Seine. And even in these dire straits he was managing to work, that is when he could afford the price of a candle. A friend in Aix told him of a satirical review put out by students opposed to the empire. They were looking for a poet to enliven the pages of *Le Travail*. He sent in some verses, they were accepted, and Zola's spirits soared

again. Was he about to make a name for himself? Not yet; the police pounced and closed the journal down. Another iron in the fire was more practical. He had looked up an old friend of his father, Boudet, who had obliged with a reference so that he could apply for a job, no matter how menial, with one of the biggest publishers in Paris, Hachette. Meanwhile Boudet, taking pity on the starved-looking devil, paid him a franc or two to deliver New Year's cards around Paris. Really it was charity in disguise.

For all Zola's later shortcomings, there is no doubt that his influence on Cézanne in these early years was salutary. His great value was in bolstering up the other's wavering faith in himself. His enthusiasm was unflagging; he had astonishing powers of recuperation and what seemed like endless confidence. For all his occasional bombast and lapses of judgment he was unquestioningly loyal, ready at the drop of a hat to defend this most difficult of men.

Back in Aix that autumn, Cézanne was treated like a prodigal son. His mother and sister were overjoyed to see him, and no doubt relations with his father were never better, since the young man was willing to give up law and join the bank as a clerk. Louis-Auguste, so it must have appeared, would be able to hand over his business to his son in due course. Clearly the boy was discouraged with his painting. Obviously too he was glad to be back in his native town. He went around docilely and upset no one.

It was only temporary. Though he didn't know it, any more than did Zola, he had established a pattern that was to continue until a few years before his death. He itched to be in Paris when he was in Aix, and once there he soon wanted to be back on home ground again. The geographical and cultural distance between Aix and Paris was one factor which in the future set him apart from his contemporaries, reinforcing his solitariness, his stubborn conviction that he had to ignore everyone and be his own man, finding his inspiration in some curious pact with himself and his sensations.

All his letters to Zola from now onward, until 1877, are missing. The two comrades made contact less often but still regularly. We know he wrote to Zola in January 1862, for on January 20 came the reply, truncated, wary even, puzzled, but loyal as ever:

> It's a long time since I wrote you, I don't exactly know why. Paris did our friendship no good. Perhaps it needs the sunshine of

Provence in order to flourish vigorously. Doubtless it is only some unfortunate misunderstanding that has put a chill into our relations, some untimely incident or perhaps a sharp word to which too much importance has been attached. I don't know and I don't want to know—stirring up mud always soils the hands. Never mind, I still consider you my friend. I believe that you judge me incapable of a low action and that you think as much of me as ever. If it's otherwise, tell me frankly what you have against me.—But I don't want to write you a letter of explanation. I only want to reply to your letter as a friend, and chat with you a little, as if your trip to Paris had never taken place.[8]

He adds, curiously, "You advise me to work and do it so insistently that anyone might think work repels me."

It's hard to know what is being referred to here. And there is surprise in the proposal Cézanne evidently made to try again in Paris, after only three months in Aix. Though he was back in the counting-house he hadn't stopped painting in his spare time. The novelty of being home again had worn off. Banking was as hateful to him as the law. Rebellious once more, he relieved his boredom by doodling, scrawling verses and making sketches in the margins of ledgers. One couplet must have found its way home, or been composed there, for Marie quoted it in her letter of reminiscence to her nephew in 1911:

My banker father can't help shuddering to see
Born in his countinghouse a painter-to-be.

Baille had told Cézanne in February that their mutual friend had been promised a job in the packing department of the Librarie Hachette at a salary of one hundred francs a month. Baille had come to Paris to take up a place at the Polytechnic School, which meant that he and Zola were seeing each other on Sundays and Wednesdays. "If you come as you promise in March," wrote the ever-hopeful Zola to Cézanne, "if I have a job, if fortune smiles on us, then perhaps we'll be able to live a little in the present."

Evidently Cézanne's hopes had been rising. Once he regained belief in himself, anything was possible. He was sketching landscapes out of doors, and from Zola's reply we have news of his first definite proposal for an arrangement that he would hold to from now on. Paris was necessary for his studies, the Midi for his peace of mind. He felt strong enough to contemplate trying his luck in Paris again, though

cautiously holding back from naming an exact date. It would be a year before he made his next attempt. On September 29 Zola, who had at last learned not to lean on his friend, wrote with new restraint:

> As for the view of the dam, I much regret that the rain has kept you from carrying on with it. As soon as the sun comes out, take the path by the cliffs again and try to finish it as soon as possible.
>
> There's one hope that has doubtless helped to cure my blues, that of soon being able to clasp your hand. I know it's not quite settled yet, but you allow me to hope, that's something. I entirely approve of your idea of coming to work in Paris and then retiring to Provence. I believe it's a good way to escape academic influences and to develop some originality if one has it.

Amending his romanticism to the extent of relinquishing his original dream of a daily life shared down to the last detail, he proposed soberly, "We will plan our lives, spending two evenings a week together and working all the others. The hours we spend together will not be wasted. Nothing encourages me so much as chatting with a friend for a while. So I'll expect you."[9]

For Zola, laboring away in Hachette's packing room, knee-deep in commercial literature, things were at last beginning to look up. Simply to be working in a bookish atmosphere, even at such a menial level, was something. Now and then he caught glimpses of illustrious figures such as Taine, Sainte-Beuve, and Lamartine. Lesser authors shocked him with their petty complaints and their servility. The wage he earned was barely sufficient to live on, but he did buy a new black frockcoat and also leave his flea-ridden lodgings in the rue Soufflot for something a little cleaner and quieter in the impasse Royer-Collard.

His appearance was changing. Now that he was eating better he put on some weight, losing his boyish slenderness and becoming stocky. His face too was chubby, and he added to his new manliness by growing a beard and moustache. A month after writing to Cézanne he received the dreaded call-up number for military service: 495. Luckily for him, and unlike Baille and Numa Coste, his number wasn't called.

Never an author who wrote easily, he slogged away most evenings after his meal, often making little progress. Everything he produced struck him as labored and clumsy, chaotic, stunted. He shrank from showing his efforts to others, but one day copied out with great care his poetic trilogy, "The Comedy of Love," and left it on the desk of the firm's head and founder, Louis Hachette. That was on a Saturday

evening. The following Monday he was called to the old man's office. Hachette, a former teacher, gave the reticent author some sensible advice, telling him to turn his attention to prose. But the young man's zeal and initiative impressed him. Zola had broached the idea of a new magazine, to which Hachette listened with interest. He doubled Zola's salary to two hundred francs a month, later inviting him to contribute a short story to one of the firm's children's magazines.

"Sister of the Poor" was too realistic, not to say radical for Hachette, who, like every publisher, had to submit all proofs to the police censors. Napoleon III's regime was increasingly repressive and writers were always liable to be prosecuted. Flaubert was fined for *Madame Bovary*, Baudelaire for *Les Fleurs du mal*. Mediocrities like Feuillet and Paul de Kock were all the rage. It was the emperor's uncle who had once declared, "Four hostile newspapers are more to be feared than a thousand bayonets."

Cézanne in Aix was attending evening classes with his old friends Numa Coste, now a lawyer's clerk, and Solari. At home he continued the process of trying to soften up his father, no doubt aided and abetted by his mother and sister. Through all this prolonged struggle, which went on as long as his powerful father was alive, Cézanne was never able to confront the old man openly. He had come home with the burden of his unlived self shaming him, unable to escape the knowledge that he was living on his father. Yet away from home he was nothing. Polarized in his mother, he remained a boy.

The undercover contest had been simmering for years in verse fantasies, some of which he sent to Zola. One hellish scene has a family at a meal, being served up a severed human head by the father. It was at mealtimes, with the father presiding, that Cézanne saw himself as the odd man out of the family, when he felt under a cloud. Another poem, full of self-loathing, depicts the young hero disgracing himself in a drunken orgy. He spills the wine on the tablecloth and slides under the table, falling asleep and dreaming anxiously of his vengeful father arriving in a chariot drawn by four white horses. The father takes hold of his son and shakes him, leads him by the ear and upbraids him for the state of his clothes, stained with sauce, wine, and rum. The critic Meyer Schapiro, trenchant as always, wonders whether in Cézanne's "lifelong occupation with still life there is not perhaps an unconscious impulse to restore harmony to the family table, the scene and symbol of Cézanne's conflict with his father."[10]

He had now managed to have a studio installed on the top floor of

the Jas de Bouffan. If his father hoped that by allowing this concession to his son's mania he would see the temptation of Paris fade away, he was mistaken. And who knows, it may have been out of a desire to mollify his father that Paul painted his portrait, the one he placed in the salon between his neoclassical panels. Lindsay and others speak of the problem for biographers in dating the artist's pictures, but Cézanne scholars all date the first portrait of Louis-Auguste between 1860 and 1863, and probably 1862.

The style has a brutal power, the paint applied thickly and darkly in broad strokes. The figure is bunched on a chair and viewed sideways on, a newspaper up near the face, suggesting long sight. The father is wearing his peaked cap. He is all packed vigor and casual authority, and was presumably gratified by the likeness, otherwise he wouldn't have allowed it to be hung. What strikes home in this, one of the earliest of Cézanne's achieved paintings, is the solidity, not only the modeling but the design, soon to be the hallmark of the painter's originality. The red tiled floor running under the seated figure may have been borrowed from Titian and contrasts sharply with the rudeness of the overall conception.

What was the son thinking, how did he feel, setting his father down and going to work on a monumental picture that could only have emphasized for him the rocklike immovability of this gross man, for whom he experienced such a painful mixture of love and hate? Louis-Auguste must have sat, patiently or irritably, for hours. If he objected so much, why did he stay there? The vanity of an old man? The power he felt, the son attending him like a slave? Storm Jameson writes of Stendhal, another native of Provence and like Cézanne the son of a formidable father, that "there was a strong tradition in the family that they were remotely Italian in origin. He liked to believe it. . . . For his father he felt, already as a child, only dislike and an involuntary repugnance. Never, he wrote in his fifties, had chance brought together two more radically antipathetic human beings. The antipathy is real enough, but there was a deeply buried likeness. . . . It was from the father that he had his emotional vulnerability and the instinctive mistrust with which he hid it. A circumstance which ironically separated them. They never came within speaking distance of each other. . . . His father was without graces of mind or body. He was pock-marked and unattractive, avaricious, dour, strait-laced, interested only in making money."[11]

◈ About the beginning of November 1862 Cézanne boarded the train for his second trip to Paris. His father's permission was, as usual, conditional. Apparently he had bowed to the inevitable. His son would never make a businessman, let alone a lawyer. One can imagine him waiting sourly for the young fool to come back again in a few months with his tail between his legs.

Cézanne found a room in the Latin Quarter, in the rue de l'Est, near the still unfinished boulevard Saint-Michel. Now that he had a plan—really a retreat—in place at the back of his mind, he felt he wasn't aiming too high or expecting too much. He came this time prepared to adjust and compromise. The academics still intimidated him. The realist approach, losing social significance after the failed radicalism of 1848, was turning lyrical and would soon be overtaken by the Impressionists. Strangely, Courbet, the heroic individual—"I too am a government"—hadn't yet clicked with him. It was his discovery of Delacroix, sixty-three and near death, which first propelled him forward: essentially it was the revelation of color.

Soon after the arrival of Cézanne—and Baille too, close on his heels—Zola moved again, this time to an apartment large enough for himself and his mother. Another school friend, Marius Roux, joined the trio. For the moment Zola's happiness was complete. Each Thursday evening in the rue des Feuillantines apartment the four young men met for tea and to put their heads together earnestly, putting the world right. Painting was often the main subject for discussion. On other evenings Zola would march the willing if tongue-tied Cézanne to the studios of painters he knew personally: Degas, Monet, Manet, Fantin-Latour. Then there would be weekend jaunts on foot to Aulnay and the Vallée-aux-Loups. Cézanne liked nothing better than to sit by Chalot Pond with his sketchbook.

Much of the wild talk about mounting challenges to the academic artists who ruled the roost went over his head, though one can see him nodding noncommittally to indicate his interest, and for the sake of peace and quiet. True, he was sympathetic, but at the Suisse where he went daily to work as before, he stood shoulder to shoulder with academically minded men like Villevielle, Chautard, Chaillan, and Truphème. Truphème, who had won first prize at Aix in 1861, was now at the Beaux-Arts. Cézanne apparently applied to the Beaux-Arts, no doubt to please his father, and failed the entrance exam. For all his inner resistance, his father's presence lived with him powerfully. Once

away from him he was able to reject his authority, but he was never free of him. There was something pitifully weak and boyish in him that cringed and sought approval. It was a secret he carried around everywhere.

An examiner at the Beaux-Arts is supposed to have dismissed him with the remark "He paints riotously." The story may well be apocryphal. The emotional attack of his early painting, that he called *couillarde* (painting from one's balls) hadn't yet developed—unless we can count the portrait of his father. Certainly he hadn't yet begun to wield the palette knife.

As he looked around and tried to get his bearings he would have seen French art dominated by the followers of Ingres, who was very old but still alive and painting, and by David. Delacroix was recognized, and hung, but tolerated rather than celebrated. No one else of stature had taken up the romantic torch. Courbet the realist was the constantly attacked enemy of the academicians, whose official art took the form of vast gloomy panoramas varnished to imitate the old masters and framed in massive gilt. The Barbizon group of painters, headed by Corot, were beginning to change the approach to landscape. Writing to Numa Coste in Aix on January 5, 1863, Cézanne was clearly still marking time:

> This letter, sent to you, is meant for both you and M. Villevielle. To start with, I could have written to you a long time back, for it's already two months since I left Aix. Shall I tell you of the fine weather? No—only the sun, so far hidden by clouds, has just today put its head in at the garret window and, wanting to finish off gloriously this last day, is throwing a few rays on us as it departs. I trust this letter finds you in good health. Courage, and let's try to get together in the near future. As in the past (it's right for me to let you know what I'm doing) I go to the Suisse in the morning from 8 to 1 o'clock, and the evening from 7 to 10. I work calmly, I eat and sleep likewise. I go fairly often to see M. Chautard, who is kind enough to correct my studies. The day after Christmas I had supper at his place and tasted the old wine you sent them. . . . By the way, is the picture of which I saw you making the sketch, on its way? I spoke to M. Chautard on the subject, he praised the idea and said you ought to be able to make something of it.
>
> O Coste, Coste junior, are you still enraging the *révérendissime* Coste senior? Do you still paint? And the academic evenings at the

school, how are they going? Tell me who's the wretched person who takes up the X-like poses for you and holds himself by the belly? Have you still got the two louts of last year?

Lombard has been back in Paris nearly a month now. I learned, not without grief, that he attends the Signol studio. That worthy gentleman instructs after a certain pattern that leads to an exact copy of his own practice. It's very fine, but it isn't admirable. To think it was necessary for an intelligent young man to come to Paris in order to lose himself. . . .

. . . I hope this letter, which wasn't finished all in one, finds you all in the best of health, my regards to your parents, greetings to friends. I clasp your hand, your friend and brother in painting, Paul Cézanne. Go and see young Penot and remember me to him.[12]

Though not yet unhappy among budding academics at the Suisse, he was here taking sly digs at one of their idols, Signol. The turning point for him—and in a sense for Zola too—was the infamous Salon des Refusés (the Salon of the Rejected) in 1863, and the little group of young dissidents who later became the founders of the Impressionist movement. The oldest of these, and the painter who would be most crucial for Cézanne's development, was Camille Pissarro, born in 1830 on one of the Virgin Islands. He was Jewish, of Spanish descent. Like Cézanne, he had found himself in conflict with a father intent on forcing him into a business career. At twenty-two he broke free and went off with a Danish painter to Venezuela, then made his way to France. His tough character enabled him to survive without the benefit of an allowance. He existed on next to nothing but gradually began to sell pictures. At the time of Cézanne's first real contact with him he was living with his mother's maid, having a son by her in 1863 and a daughter two years later.

Pissarro had been painting out of doors in Antigue in the West Indies. Because of this habit and above all through his character, large-spirited and well-balanced, he exerted a wide influence. Impressionism in effect began with him. Unlike the other rebels he did manage to infiltrate the salons, though not in the crucial year 1863. His impetus, a continuation of the new direction in landscape painting begun by Corot and the Barbizon school, joined forces with the strides made by Courbet, a socialist like Pissarro who drew his inspiration from the common people, backed by the writings of Proudhon.

Unless Pissarro's memory was at fault, he first noticed Cézanne in

1861 at the Suisse and was struck by something unusual in his work. In 1895 he said, "Was I not right in 1861 when Oller and I went to see that odd Provençal Cézanne . . . making studies which were then derided by all the untalented in the school, among them the celebrated Jacquet, who declined ages ago into the pretty-pretty and whose works fetched their weight in gold?" More likely it was this Spaniard, Francisco Oller, who was instrumental in bringing the two men together. Oller lived at Saint-Germain, where Cézanne went on painting expeditions with him. In March 1865 we find Cézanne writing to Pissarro: "Forgive me for not having come to see you, but I am going to St. Germain this evening and will come back on Saturday with Oller to help him carry his pictures to the Salon, for he has done, he wrote me, a Biblical battle-scene I think, and the large picture you know about. The large one is very good, the other I have not yet seen. . . . I should like to know if you have done, in spite of the misfortunes you have suffered, your pictures for the Salon. If you should ever wish to see me, I am at Suisse's in the mornings and at home in the evenings, but fix an appointment at any place that is convenient for you and I shall be glad to meet you there when I return from Oller's. Saturday we are going to the Palais de l'Industrie to deliver our pictures (to the Salon), which will make the Institute howl with rage and despair. I hope that you have painted a fine landscape, I greet you cordially."[13]

❖ The rise of landscape painting in the nineteenth century in France, influenced by the English art of Constable and Turner, coincided with the Industrial Revolution, its triumph and its threat. It was Turner who had intensified the pitch of his color so that it approached the strength of daylight, and Constable who had understood that color varied according to the time of day. Thomas Hardy said of Turner that "What he paints chiefly is light modified by objects. He first recognizes the impossibility of really reproducing on canvas all that is in a landscape; then gives for that which cannot be reproduced a something else which shall have upon the spectator an approximate effect to that of the real. . . ."

Violent changes were transforming the Continent, old forms were in dissolution, and nature represented the one stability. Landscape acquired a new poignancy, nature came to symbolize the only permanence. If France remained a rural nation longer than the rest of the Continent, the urbanization and population explosion, bringing facto-

ries, the growth of the railways, gas, electricity, were still felt as traumas and bitterly opposed by nineteenth-century painters. "Everything I wanted to paint has been destroyed—trees cut down, no more water in the river, houses demolished," lamented Charles Daubigny in 1854. Trees were now sacred emblems, so that Theodore Rousseau could declare, "Trees are for me great history that will never change. If I could speak their language I would be using the tongue of all ages." At the turn of the century we find Cézanne railing against progress and "the invasion of bipeds who do not rest until they have transformed everything into hideous quays with gas lamps—and what is still worse—with electric light. What times we live in!"

The forays of the three Inseparables into the pagan wilderness of Provence during their youth were not merely the jaunts of three innocent savages but were permeated with a dissent flowing of its own accord from their joyful nature worship. Later, the solitariness of landscape painting, and Cézanne's heritage, his boyhood and youth in the heart of rural France, were two factors drawing him ever closer to his mature art, when the confrontation with landscape became one of the basic tenets of his life purpose. He wanted to withdraw as a person after each failed encounter and be alone with the shifting features of nature in a simple confrontation. But an abiding sense of history and a deep awareness of his cultural predecessors meant that he could never see himself as being educated by nature alone, or say with Monet that the only aim of the landscape painter was to register "your own naive impression of the scene before you." It was simply that it suited him in the beginning to align himself with his contemporaries to this extreme. In time he would react against what he felt to be an impoverishment.

His motives were always intensely personal. To master his painting was soon for him a matter of his own survival. What began as a vision of Arcadia, created and inhabited in his teens by comrades, turned into a lifelong search for what he was to call the Promised Land, a sustained, incessant effort to paint the earth's virginity which had nothing to do with Gauguin's South Seas escapism. Nature for him—and not only him—was no longer a field for study, it was a cause. Because nature had been, as it were, lost in the void created by the Cartesian division between man and his world, ending as material for the natural sciences, a terrible struggle took place in the nineteenth century in the hearts of artists who understood that man was now alienated from nature. Van Gogh literally presented himself as nature, a wild man of art, thrown down in the fields by the madness of his passion, driven

from his family as a force out of control, nature personified. Cézanne devoted himself to building bridges.

All this lay some way ahead. The drawings of the Cézanne of 1862 were in the main competent, meek, formularized. Though the academic style inhibited him, his submission to it was strange. He was not a natural rebel. He was in fact content to play safe, to conform, to have no personality. The series of studies from the male nude he did at this time could have been done by anyone.

Then came the astonishing debacle of 1863. The absurdly reactionary jury appointed to select the pictures for the official salon of that year had turned down anything which deviated even slightly from academic principles. Painters rejected included Fantin-Latour, Legros, Manet, Whistler, Jongkind, Vollon, Cazin, and Harpignies. Such a clamor of protest rose up that it reached the ears of the emperor, who was in any case aware of his country's growing political unrest. Napoleon III called in person to view the rejected canvases and a decree was issued. A separate exhibition, the Salon des Refusés, would open on May 15 in another part of the Palais de l'Industrie, built for the Universal Exhibition of 1855 and since demolished to make way for the avenue Alexandre III.

Some of the rejected refused to take part in a show labeled Rejected, seeing it as a stigma, but in the event over six hundred canvases by more than three hundred artists were hung, in addition to roomfuls of drawings, engravings, and sculpture. "The success was as great as the scandal," writes Joseph Pennell in his life of Whistler. The controversy had stirred up enormous interest; "the exhibition was the talk of the town, it was caricatured as the Exposition des Comiques and parodied as the Club des Refusés at the Varietés. Everyone rushed to the galleries."

The painting the mob rushed to see and ridicule before anything else was Manet's *Déjeuner sur l'herbe*, depicting men in contemporary dress lunching in the open air with a nude girl. Originally called *Le Bain (Bathing)*, the painting thumbed a nose at the conventions imposed by the French Academy's School of Fine Arts (the Beaux-Arts), which maintained that patches of light on a canvas should be separated by areas of dark, that each strong color should be connected by another through graduated semitones, and that shadows should be rendered always in browns, blacks, and greys.

Here, on the contrary, were areas of light next to each other, with the shadows of trees no longer in muddy brown or bituminous black

but glowing in clear blues and greens, the sunlight reflected as in life. As well as producing—according to the critics—a spectacle of shrieking vulgarity, the composition was condemned as disreputable. Onlookers dug each other in the ribs delightedly and asked what this naked lady, obviously a Parisian tart, was doing there on the grass with two young men in ordinary clothes who looked as if they had just strolled off the boulevard. When Manet objected that his idea came from Giorgione, based on an engraving by Raphael, the critics retorted that there was no comparison: the Old Master had idealized his nudes.

Twelve years later, when Zola came to describe the event in his novel *The Masterpiece*, he set about the task with gusto.

The Exhibition of the Rejected was well arranged. The officially accepted pictures were no better displayed. The doorways were hung with antique tapestries, there were red velvet cushions on the benches, and the skylights were shaded with canvas blinds. At first glance down the long series of rooms it looked the same as the official Salon, with the same gold frames, the same splashes of color. But what was not immediately apparent was the atmosphere of life and gaiety, the presence of brightness and youth. The crowd, already dense, was growing by the minute, for visitors were deserting the official Salon for this one, encouraged by curiosity and eager to pass judgment on the judges, convinced they were going to be vastly entertained. The rooms were already hot; a fine dust rose from the floor, and by four the place would be stifling.

It was the hostile reaction that aroused Zola's rebellious spirit, and it was Cézanne who had stimulated his appreciation of Manet. Though he was one with Zola in applauding the "kick in the arse that Manet gave to the Institute," as he put it later, what really excited him were the simple directness of the painting, the daring oppositions of light to dark, and the artist's fresh, unprejudiced eyes.

Summing up the effect of the massed dissidents, Zola wrote that superficially it was a muddled heap impossible to decipher,

but there was truth and sincerity about the landscapes and sufficient points of technical interest in most of the portraits to give it a healthy atmosphere of youthful passion and vigor. There may have been fewer frankly bad paintings in the official Salon, but the general level of interest and attainment was certainly lower. Here was a scent of battle in the air, a spirited battle fought with zest at the crack of dawn, when the bugles sound and you face the foe con-

vinced you will defeat him before nightfall. The warlike atmosphere put new life into Claude and roused him to such anger that he listened to the swelling laughter of the crowd with a look on his face as defiant as if he were listening to the whistle of bullets.

In Zola's novel the surging crowd have come for one reason only, to hurl abuse and mock Manet's *Lunch on the Grass*:

. . . As the visitors entered the door he could see their jaws gape, their eyes contract, their faces expand. Opposite, several young men collapsed into contortions as though someone was tickling them. One woman fell onto a bench, her knees clamped together, choking and trying to get her breath back. Rumors of this excruciatingly comic picture had been spreading everywhere, and new visitors kept jostling into the room with shouts of "Where is it?" "Over there!" "Good Lord, what a joke!" Witty remarks flew about at the expense of the painting, for it was the subject that amused and baffled them—it was so insane, so ludicrous, it made them sick with laughing. "Look, the lady is too hot, and the gentleman too cold, because he's put on his coat." "No—she's blue, so he must have just pulled her out of the pond!"[14]

We can take it for granted that the defiance was Zola's, the bugles sounding in his own excited heart, agitating his fertile receptive mind. Cézanne was simply moved to realize he was not alone, he was among fellow spirits. The brilliant colors of the Manet—which now hardly strike us as bright at all—stirred and delighted him. Shortly after this liberating moment he began to associate more willingly, if shyly, with the young painters around him.

One of these was Antoine Guillemet, a little younger than Cézanne. According to Vollard it was Oller who introduced them to each other. Guillemet was a pupil of Corot and intended to concentrate on landscapes and seascapes, though he was such a wag it was difficult to know when he was serious. Cézanne enjoyed his mocking nature and the Rabelaisian taste in jokes of this well-to-do young man, who pocketed every month a hefty allowance from his father, owner of a wholesale wine-merchant's business at Bercy. He affected low-bred manners, which may have amused the self-conscious young countryman, only too aware of his thick Provençal accent.

Georges Rivière speaks sympathetically of Guillemet playing "a very active part in the events that marked the beginning of Cézanne's

career," and he "remained the young painter's favorite companion during his hours of relaxation."[15] It was probably Zola's suspicious mind, or perhaps his jealousy, which led him to model the opportunist and fop Fagerolles on Guillemet in *The Masterpiece*. We read of Fagerolles allowing himself to be influenced by the older man's thickly painted work, "of bits of nature thrown on to the canvas, palpitating with life" and then poking fun elsewhere at "the adepts of the open-air school, whom he accused of impasting with a kitchen ladle." Fagerolles is "a pale, thin young man, whose pert, girlish face remained perfectly grave," though "There was but the slightest yellow twinkle of spitefulness in the depths of his grey eyes." Handsome and cunning, he hung back from sending in to the Salon, calling it "a foul bazaar, where all the bad painting made even the good turn musty." In his "inmost heart," however, he dreamed of honors. And Guillemet himself, for all his mediocrity as a painter, was rewarded finally with medals, ribbons of the Legion of Honor and other distinctions, a tribute to his ability to gauge the public taste.

By the time *The Masterpiece* appeared, Zola had come to the conclusion that his old friend Cézanne was an artistic failure. His central character, the failed genius Claude Lantier, said to be based on his revised view of Cézanne, and to some extent on Manet, was also portraying a side of his own personality. Zola had by then turned into a professional nine-to-five slave to literature, while deep within him lay buried the romantic seeker after an ideal, which Lantier represented.

Literary romantics like Zola held that the genius was fated to be a martyr, misunderstood in his own time and driven into the wilderness. Utopians in nineteenth-century France arose as a reaction to the destructive criticism of the *philosophes* of the Enlightenment, and the idea of genius entered politics through them. So in effect did the intellectual. Genius maintained its uniqueness as a quality that could not be acquired: one was born or cursed with it. Only from posterity was the worth of the genius acknowledged. Before that he was doomed to be met by ridicule, persecution, and bafflement. According to the doctors there was only a fine line between genius and madness. Dr. Moreau de Tours declared that genius was a sickness. "The constitution of many men of genius," he wrote, "is really the same as that of idiots." Zola's wretched painter illustrates this doctrine of the genius to the letter. His hero suffers from start to finish, descends into madness, and finally hangs himself before his aborted masterpiece.

We can catch glimpses of a coarsened Cézanne in Zola's depiction

of a minor character, Chaîne, who gave only a muttered growl when someone bade him good morning, keeping his head down. He has a heavy, deliberate manner, and "his only noticeable feature was his forehead, displaying all the bumps of obstinacy; for his nose was so small as to be lost between his red cheeks, while a stiff beard hid his powerful jaws." This "rustic genius" from Provence who had "successively failed at everything, his studies and competitions . . . nevertheless had started for Paris after worrying his father, a wretched peasant, into premature payment of his inheritance." The wretched peasant hardly fits Cézanne's father, though he was certainly a social outcast, as Zola knew perfectly well.

◈ Another painter who studied at the Suisse alongside Cézanne was Armand Guillaumin. A little younger than the southerner, he was a Parisian by birth, growing up in the provinces of Moulins-sur-Allier. He arrived in Paris at the age of sixteen to serve an apprenticeship in his uncle's linen shop. Like Cézanne he was hopeless at business. He struck out as a painter, but with no financial support from his family had to earn a living on the side. It wasn't until he was fifty that a legacy freed him from the Bureau of Roads and Bridges and enabled him to paint full time. Until then he had supported a wife and children and gone on painting whenever he could, on the quays of Paris or in the city suburbs. Cézanne would often accompany him.

On Sundays sometimes Cézanne would go off with Zola, taking an early train as far as Fontenay and then walking through the fields to the woods of Verrières. If they caught the first available Sunday train, wrote Zola later, they would be past the fortifications by early morning. "Paul carried a complete artist's outfit. I had only a book in my pocket." Skirting the broad expanses of strawberry fields they reached Aulnay and the Loups valley. One morning,

> wandering in the forest, we encountered a pond, far from any path.
> It was a pond filled with rushes and slimy water that we called the
> Green Pond, not knowing its real name. . . . The Green Pond
> finally became the goal of all our walks; we felt for it the affection
> of a poet and a painter. We loved it dearly and spent our Sundays
> on the thin grass around it. Paul had begun a sketch, the water in
> the foreground with big floating reeds, with the trees receding like
> theatre wings, drawing their branch-curtains as in a chapel, with

blue holes that disappeared in an eddy when the wind blew. The sun's thin rays crossed the shadows like balls of gold and threw on the lawns shining quoits, the round discs of which traveled slowly. I stayed there for hours without boredom, exchanging an occasional word with my companion, sometimes closing my eyelids and dreaming in the vague rosy light that bathed me. We camped there, we lunched, we dined, and only the twilight chased us away.[16]

Villevielle was still happy to welcome Cézanne to his studio and in his home, and the difficult friend was glad to sample, even if vicariously, the domestic delights of the household. He liked Villevielle's charming wife, a girl who was so "rosy, plump, and merry," who made no demands, allowing him to relax and feel content. Happiness was like a strange element to him. Bathing in it briefly he dreamed of it for himself and remembered it tenderly long after he had ceased to have access to it. Villevielle was too academic for him and they saw little of each other after that first encounter in Paris. It took the death of Cézanne's mother forty years later to reunite them, when he asked Villevielle to make him a drawing of her on her deathbed.

The only letter by Cézanne in 1864 to survive was written to Numa Coste on February 27. The poor devil had drawn a conscription number and was passed for military service. Cézanne had been able to buy a substitute to take his place, but poor Coste had no resources. Troubled by his old friend's predicament, Cézanne put forward an idea which he had cooked up with Baille. "If by any chance you wanted to forestall the draft and could come to Paris to enter the military service here, he (Baille I mean) could recommend you to the lieutenant of your corps, as he tells me he knows a number of officers who graduated from the same school as himself." If he did this, Cézanne went on, he would have more opportunities for painting, even though in the army, whether on leave or during spells of light duty. Coste took this advice, and the string-pulling by Baille seemed to work. As for himself, Cézanne went on,

> my hair and beard are longer than my talent. Still, no discouragement for painting, one can do one's little bit, even though one is a soldier. I have seen some of them here who attend the anatomy lectures at the School of Bozards [Beaux-Arts], which as you probably know has been mightily changed and which has been separated from the Institute. . . . I haven't touched my [illegible] after Delacroix for the last two months.

I shall however retouch it before leaving for Aix, which I don't think will be before the month of July, unless my father sends for me sooner. In two months, that is to say in May, there will be an exhibition of paintings like that of last year. If you were here we could visit it together.[17]

The painting of Delacroix that he had been copying could have been the *Boat of Dante*. It is a rare example of a copy that follows the original closely. The belief in some quarters that his painting in these early years was incompetent is put to flight by the skill of this faithful copy.

As for the beard, it lasted only a month or two. Zola wrote in a gossipy vein to Valabrègue in April that "Cézanne has cut his beard and sacrificed the tufts on the altar of victorious Venus." Either a girl had told him to shave or it was a despairing attempt to attract one by altering his appearance. The truth was that he was losing his hair. By the 1870s he was quite bald. He was also looking more bohemian, wearing a red waistcoat and lying on park benches to sleep with his shoes under his head. On visits home, no doubt, he dressed more appropriately.

He was back in Aix in July, accompanied by Baille. If there were still occasional clashes with his father we hear no mention of them. Louis-Auguste's capitulation was never total. But at least Cézanne was free to disappear into his upstairs studio in the Jas de Bouffan. On the top floor he worked undisturbed, and he let no one in, not even to clean or tidy up the mess of easels, paints, brushes, and the objects collected for future still lifes. As well as here he painted on the walls of the salon below, and went tramping into the grounds and through the countryside around Aix. Sometimes he ventured as far as l'Estaque near Marseilles. His mother rented a fisherman's cottage there, on the place de l'Église. The vivid contrasts of red-tiled roofs and factory chimneys against the flat expanse of wide blue sea and the far hills gave him plenty of motifs. Usually he was calmer in the Midi, less subject to sudden attacks of self-doubt.

Antony Valabrègue must have been in contact with him this summer, from the letter Zola had written on July 6: "Has Baille made a furious swipe at you with his good Toledo blade, and has Paul dressed the wound with his benevolent lint of indifference?" Valabrègue reported what must have seemed to Zola a startling change of character in his noncommittal friend. "The dumb fellow has found his tongue and used it to talk radical politics. He produces theories and develops doctrines. Worst crime of all, he even allows you to discuss politics with him (the-

oretically of course), and says the most terrible things about the Tyrant."
In Paris, infested with police informers, it was wise to keep quiet on the
subject of Napoleon III.

The police were ubiquitous, as Frederic Grunfeld makes clear in
his life of Rodin. As well as spying on political agitators and infiltrating
their circles they had dozens of lesser functions. They fixed the price of
bread. They certified weights and measures in shops and markets, tast-
ed wine, maintained a register of prostitutes, kept a list of every for-
eigner in Paris, and provided an inspectorate of schools, hospitals, and
hotels. Their powers extended to the cleaning and lighting of the
streets, the licensing of hackney drivers, and the unloading of boats on
the Seine. By these various means they kept a grip on every aspect of
Parisian life, and especially the teeming slum districts. For those with-
out resources Paris could be merciless, far more brutal, comments
Grunfeld, than anything described by Balzac, whose tragedies took lit-
tle account of the new proletariat.

It is possible that on this visit home Cézanne added to the painted
panels in the salon the nude torso of a man posed against a heavily dark
background, the figure seen from behind and executed "in a coarse
manner." According to Coquoit, it caused Louis-Auguste to protest,
"See here, Paul, you have sisters—how could you paint it?" To which
the son is supposed to have answered, "Well, haven't my sisters got
bottoms like you and me?"

Although he was no longer being badgered to give up painting and
return to the bank, his behavior was often seen as odd. He felt obliged
to give explanations for his movements, and each time he left for Paris
he was made to feel unreasonable. There was either a scene or a disap-
proving silence. His mother, sympathetic as ever, was nevertheless baf-
fled by his restlessness. Why, after only a few months, did he have to
rush back to Paris? The extent to which he was constantly torn finds
expression in a letter to his family quoted by Vollard:

> It is only that when I'm at Aix I am not free; that whenever I want to
> return to Paris there is a struggle to be gone through, and although
> your opposition is not very tyrannical I am greatly upset by the
> resistance I feel on your part. I could wish with all my heart that my
> liberty of action were not interfered with, and then I could hasten
> my return to you with all the more joy, for I should very much like
> to work in the Midi, where the views offer so many opportunities,
> and I could make the studies I should like to undertake.[18]

Needless to say he could never have unburdened himself face to face, but had to wait until he was at a safe distance, emboldened by Zola's moral support.

Valabrègue was an Aixois Jew—another was Abram. Both men appear in two early pictures, *The Conversation*, where they are in the rear of a painting of Cézanne's sisters, Marie and Rose, and *The Promenaders*. Valabrègue was a poet and critic, drawn into Zola's orbit and away from Cézanne, who painted all three portraits of him. The first is an early example of the palette-knife technique he was soon to use constantly. This painting was a combination of palette-knife and forceful brushwork. The figure rises blackly, the hands worked up "almost to orange" as Rilke wrote, clenched with the stubborn determination of the artist himself, the whole a foretaste of the monumental portraits soon to come.

❖ In this year Zola, stimulated by the events of 1862–1863—the persecution of Flaubert, the Salon des Refusés, the experimentation of Edmond and Jules Goncourt—was reading voraciously, producing literary theories of his own and finding he had a flair for publicity. Soon he would be given the job of publicity chief at Hachette's, an astonishingly fast promotion. Then he would be in a position to plunge into the world of journalism. Undeterred by the rejection of his children's story ("You are a rebel!" he was told) he had been approaching publishers with a collection of fantasies entitled *Stories from Ninon*. He finally interested Hetzel and Lacroix, a small firm in Montmartre. Late in 1864 he was overjoyed to find himself a published author at last. The contract did nothing to enrich him, but what did that matter? He had a voice, his name could unlock a few doors. Newspapers and journals were suddenly interested in him. Writing excitedly to young Valabrègue in Aix he expressed amazement that he had emerged from the abyss without serious damage. "I am on the threshold, the battle is wide open, yet I may still very well break my neck!" The letter ended, "Get ready to write an article about me." Art, he declared at this time—and Cézanne must have heard the famous remark in discussion—was "a corner of nature seen through a temperament."

It was to this same young poet that Zola confided his thesis of "screens of genius" in a letter of August 18, 1864, which Cézanne was presumably shown. In any case he had no doubt heard versions of it already. As Zola saw it, "Every artwork is a window opening out onto

creation. Stretched taut in the window frame is a sort of transparent screen, through which one can see objects that appear more or less distorted because they undergo more or less palpable alterations in their lines and colors."

It was a theory of creative activity, and Zola went on to identify three screens: the classical, the romantic, and the realist. The latter category was the one which most vitally concerned him, since this was the path he saw as the most appropriate for his own future work. He regarded realism as simply the accurate representation of real life, freed from the distortions of both classic and romantic literature. He was anticipating the Goncourts, who prefaced their new novel *Germinie Lacerteux* with a statement amounting to a credo embodying the first principles of naturalism. Zola couldn't have agreed more when he read that the contemporary novel must be true to life, based on science, not abstract philosophizing, and observe society with a detachment that included the recognition of the working classes.

The laying down of his screen theory began with characteristic thoroughness:

> The classical screen is a beautiful screen of very pure talc, of fine dense grain and a milky white. On it the shapes of things are clearly drawn with simple black strokes. The colors of things are veiled by passing through the veiled limpidity; often they are wholly extinguished by the passage. The lines undergo a perceptible distortion, all tend to become curved or straight lines, to flatten out, to stretch in length, with much extended undulations. In this cold and scarcely permeable crystal, Creation loses all its hardness, all its life and glowing force; only its shadows are retained and they appear in relief on the smooth surface. In a word, the classical filter is a magnifying glass which promotes lines and makes it difficult for colors to pass through.

When he comes to the second category it is intriguing to see him edging toward a definition of impressionism, an art as yet unborn.

> The romantic screen is a sheet of unsilvered mirrorglass, pure, yet a little dull in certain areas and tinted with the seven colors of the rainbow. It not only lets colors through but gives them extra strength; often it transforms and mixes them. Outlines too undergo alterations; the straight lines bend to breaking point, the circles turn into triangles. Nature shown to us through this screen is rest-

less and exciting. Shapes are strongly marked, by means of great patches of shadow and light. The illusion of naturalness is strong here, more seductive; there is no peace but life itself, a more intense life than ours; no pure development of lines but instead the whole passion of movement and the whole sparkling luster of imaginary suns. In brief the romantic screen is a prism with immense refraction, which bends every ray of light and splits it up into a dazzling spectrum of sunlight.

Only a few years before this, Walt Whitman in America was issuing a stern injunction to himself in a notebook: "Rules for Composition—A perfectly transparent, plate-glassy style, artless, with no ornaments, or attempts at ornaments . . . the most translucid clearness without variation." Zola, elaborating zestfully, was moving toward a very similar conclusion. Coming to realism he described the realistic screen as a simple windowpane, "very thin, very clear,"

which is aimed to be so wholly transparent that things seem to pass right through, are thus present with complete realism. So there is no alteration here in lines and colors but an exact, free, and artless reproduction. The realistic screen denies its own existence. But that is too conceited. Whatever is said, it exists and so cannot boast of giving us Creation in the radiant beauty of truth. However pure and thin, even if it's only windowglass, it still has its own color and a certain thickness; it tints things, it reflects their shapes like every other screen. For the rest I willingly admit the pictures it gives are more real; it attains a high degree of exact reproduction. It's certainly hard to describe a screen of which the main quality is a near nonexistence. I think however that I judge it fairly in saying that a fine grey dust lessens its limpidity. Everything that penetrates this material loses its splendor, or, rather, is slightly dimmed. On the other hand lines grow more voluptuous, to some degree exaggerated in breadth. Life is unfolded with greater opulence, a material life, slightly ponderous. To sum up, the realistic screen, the latest to appear in contemporary art, is a smooth windowglass, very transparent without being limpid, which gives pictures as true as any screen ever can.[19]

Here was the proof, if any were needed, of Zola's increasing involvement in the visual arts. Through his friendship with Cézanne, who was getting to know more young painters, he soon had access to the studios

of such men as Pissarro, Monet, Degas, and Fantin-Latour. He was better acquainted with painters at this time than he was with writers.

It seems that Guillemet took Cézanne to Frédéric Bazille, a talented artist from Montpellier whose career ended tragically when he was cut down in the war of 1870. He was tall, blond, with a long moustache, born of a wealthy family of winegrowers. Originally he intended to study medicine, then when he came to Paris he had a change of heart and joined the Atelier Gleyre. The Salon of the Rejected had affected him like a bombshell. Bazille in turn presented Cézanne to painters he worked with at Gleyre's—Monet, Renoir, and Sisley. The Englishman Alfred Sisley was exactly Cézanne's age, born in 1839.

In a year or two it was Bazille again who was instrumental in taking Cézanne—and Pissarro—to meet Renoir, saying, "I'm bringing two capital recruits." Renoir would be one of the few friends with whom Cézanne never quarreled. Reading the account of him by his son Jean Renoir it is easy to see why. Renoir was the son of a poor tailor and began earning his living as an assistant to a porcelain painter. At first he only painted the borders around plates, but he was so proficient that he was soon decorating the centers with shepherdesses, imperial eagles, or historical portraits. Thrifty by nature, he saved enough to attend art classes for a year. In old age he told his son, "I would walk on the soft earth along the side of the street to avoid wearing out the soles of my shoes on the hard pavement."

His son describes him as having had an almost physical aversion to doing anything he didn't like. "He was like a human sponge, absorbing everything that had to do with life. . . . Of his own unbelievable unselfishness he had no conception." Old Gleyre asked him once if he painted simply for pleasure. "Of course," Renoir said, "and if it wasn't pleasure, I assure you I wouldn't do it."[20]

There would be gatherings of young painters at Fantin-Latour's studio in the house on the rue des Beaux-Arts where Renoir and Bazille actually lived. In *Renoir, My Father* is the charming story, which may or may not be true, of Cézanne's first "sale." The painter was on his way back from the Gare Saint-Lazare where he had been working. He trudged along with his landscape under his arm. A young man in the street asked to see the picture. "Cézanne put it down against the wall of a house, making sure it was well in the shade so as to avoid any reflections of light. The stranger expressed delight, enthusing especially over the green of the trees. He said he could almost smell the freshness. "If you like my trees, have them," Cézanne said.

The stranger, a penniless musician named Cabaner who played the piano in cafés, said that alas he was broke. Cézanne insisted on his taking the canvas anyway, and was still pleased with himself when he arrived at Renoir's studio to say what had happened. One wants it to be true: lightheartedness is hardly a quality one associates with Cézanne.

Other glimpses of the morose young provincial, always ambivalent about the aims of his fellow innovators and deeply suspicious of social gatherings, come to us via Renoir, who recognized Cézanne at once, and without resentment, as a lone wolf. "He looked like a porcupine." His movements seemed strangely impeded, his voice slow and careful. He often looked aimless and excluded, as if not knowing what to do with himself, with a curious look of silence about him as he sat down in a corner or with his back to a wall. His real nature was courteous and gentle, but out of wariness he exaggerated his polite manners. Now and then his frayed nerves would snap and he'd shout "eunuch" or "blockhead," his two favorite insults. Word had got around that he was thrown completely off balance by women models, explaining it in terms of his need to be on the defensive constantly, so that the motif vanished.

Renoir was quick to appreciate the genuineness of Cézanne, just as he disliked those artists who affected thick accents and wore heavy corduroys to convey their solidarity with "the people." He wanted Cézanne to hang on to his rough exterior, for "he is a real person at least, and his manners express all the finesse of the people of the Midi." There was in fact nothing of the inarticulate "surly bear" about the hidden Cézanne. He had no use for Paris wit but was more scholarly than Zola, with a deep knowledge and love of classical literature. Again it was Renoir who spoke of Cézanne revealing to him the precision of Mediterranean thought.

The furiously active journalist and careerist in Zola was now out in the open. With his financial situation still far from secure, he was determined to say goodbye to poverty forever and make a name and money for himself. He made no bones about his intentions. "One is to make myself well known, the second is to increase my revenue. May Heaven help me!" But he found in himself a knack for self-advertisement which he never lost. His past poverty always haunted him. "It has been said of his fictional characters," writes one of his biographers, "that an accurate accounting can be made of every sou that passes

through their pockets." Every week he churned out contributions for the *Petit Journal* at twenty francs an article, and he could now earn fifty or sixty francs from longer pieces for the *Salut Public* of Lyons: in other words he could equal the salary he received from Hachette's.

Cézanne's favorite modern poet was Baudelaire, who, in *Flowers of Evil*, declared, "The man who does not accept the conditions of ordinary life sells his soul," meaning by this that romantic ivory towers were to be despised. Artists had to face the truth, unsavory or not, and create from the materials of common existence. Zola was primed and ready to accept the challenge. As controversy broke over the Goncourts' novel *Germinie Lacerteux* he rushed to defend it in an article which gained nearly as much notice as the book. Secretly he wished *he* was the author of it. The theme, a pretty servant girl degraded and cast aside, was hackneyed enough. What was original was the treatment, the uncompromisingly realistic observations along the way. It was just the kind of book he longed to write himself. Yet when he got into his stride as a novelist he created endless types rather than persons, manifestations of hereditary and social causes rather than men and women struggling and failing and refusing to act out the natural law of their own being. And inside each book was a romantic poet fighting to get out.

He was now about to publish *Claude's Confession*, which set out to kill the ideal in his autobiographical hero and himself, and now struck him as hopelessly flawed, full of the decadent romanticism he saw as played out.

The circumstances of his life changed dramatically when he fell in love in the spring of 1865 with Alexandrine Gabrielle Meley, a seamstress. She was a year older than Zola, born illegitimately to teenage parents. Rumor had it that Cézanne had brought her in touch with Zola, but unless she had also worked part-time as a model it hardly seems likely. Her father was a letterpress printer at one time, and this may have been how Zola met her. The copy of *Claude's Confession* which he inscribed and gave to her is dated Christmas Eve, 1865. By then they were already living together, along with Zola's mother, on the rue de Vaugirard. Alexandrine was tall, dark, pale, with intense black eyes. A tale ran that Zola was neurotically obsessed by the thought that Alexandrine's previous lover might one day turn up to usurp him. He was always fearful of love affairs. Like his friend Cézanne he distrusted women, preferring to idealize them as a way of rendering them powerless. Failing that, the safe option for the artist

was marriage, he believed. The essential condition for sustained work, as he made clear through his mouthpiece Sandoz in *The Masterpiece*, was for the artist to have a sensible, good housekeeper behind him. This in effect he now had. Beyond it, however, lurked the terrifying image of the demonic woman who grinds down the artist's heart and eats out his brain, the fate of his doomed hero Claude Lantier.

Madame Zola, at first a little hostile, quickly took to Alexandrine, seeing in her someone as devoted to her only son as she was. The two women were soon friends and allies, organizing and conducting the Thursday evenings together. Presumably Cézanne still came. Alexandrine, ambitious for her Émile, would have wondered what he saw in this old school friend who sat moodily in a chair looking curiously monolithic and disreputable, impossibly farouche. Obviously he was going nowhere. And there was no reaching him, he was so remote-seeming.

Zola suddenly discovered, ready-made, the philosophy he needed for his Rougon-Macquart novels. He was powerfully stimulated. For a man who always needed to know the answers in advance, what could be better than the determinist philosophy expounded by Hippolyte Taine in his *History of English Literature*? It was an encounter that rescued Zola from doubt, since he could now shape his future novels on the theory that all actions—and moral questions too—were predetermined, subject to heredity and environment. Scientific determinism swept God and the concept of free will to one side, and how attractive this was. He had long ago rejected Christian dogma but had found nothing to take its place. Now he could begin to construct his master plan for a documentary fiction of enormous scope, a study of a family and an empire.

Meanwhile he was frantically busy promoting his book *Claude's Confession*, for all his private misgivings about it. Using the expertise gained in the publicity department at Hachette's he flooded critics and associates with letters drawing attention to the book. It didn't matter to him if the book was attacked—in fact he rather hoped it would be. The note enclosed with the review copy to *Le Figaro* expressed just such a hope: "I would even prefer to see it abused than merely have pleasantries written about it." The pit out of which he had climbed so recently still yawned at his feet and he was out to sell the small edition of fifteen hundred copies if he possibly could. One critic's condemnation of the novel's "hideous realism" elated him, leading him to hope for a full-scale attack, but he was disappointed. He redoubled his sales efforts, falling foul of his employers by sending out a new Hachette

publication together with his own. This came to light when a reviewer assumed that *Confession* had been published by Hachette.

A review copy went to an old school friend of both his and Cézanne's, Marius Roux, soon to be a journalist in Paris, for him to publicize it in Aix. Magnanimously, Zola asked a favor, which was that Baille and Cézanne be mentioned in the notice. He may have had it in the back of his mind that his success, such as it was, would be taken note of by Louis-Auguste. At any rate Roux did as he was asked, and handsomely. "We are a group of Aixois," began his reference to Cézanne, "all of us schoolmates and

all of us linked in good and genuine friendship. We do not know what the future has in store for us, but meanwhile we work and struggle. . . . If we are all linked in friendship's bonds, we're not always united in our conception of the beautiful, the true, and the good. In such a matter, some of us vote for Plato, others for Aristotle; some admire Raphael, others Courbet. M. Zola, who prefers the *Spinning-Girl* by Millet to the *Virgin of the Choir* by Raphael, dedicates his book to two devotees of his school.

M. Cézanne is one of the good students which our Aix school has contributed to Paris. He has left us with the memory of an intrepid worker and a conscientious student. There he will establish himself, thanks to his perseverance, as an excellent artist. Though a great admirer of the Riberas and the Zurburáns, our artist is original and gives his work a character of his own. One thing is sure: his work will never be mediocre. Mediocrity is the worst thing in the arts. Better be a mason if that is your profession; but if you are a painter, be a complete one or perish in the attempt.

M. Cézanne will not perish. He has taken from the Aix school principles that are too good; he has found here examples which are too excellent, he has too much courage, too much perseverance in work to fail in reaching his objective. If he were not afraid of indiscretion I'd give you my opinion of some of his canvases. But his modesty forbids him to believe that what he produces is adequate, and I do not wish to hurt his feelings as an artist. I am waiting till he shows his work in broad daylight. That day I won't be the only one to speak. He belongs to a school which has the privilege of provoking criticism.[21]

Another copy of Zola's novel had gone to Marguery, also an old classmate. In *L'Echo des Bouches-du-Rhône* he followed suit, writing of

Cézanne and Baille that "They are making names for themselves respectively in the arts and sciences."

In the autumn of 1865 Cézanne was back in Aix, and able to scribble on the bottom of his friend Marion's letter to a German musician, Heinrich Morstatt, a reference to "the noble accents of Richard Wagner." Morstatt, working in Marseilles for a musical instrument firm, was a lodger with Marion at the Pension Arnoux. Marion was inviting the German to spend Christmas at Aix and play some Wagner for them.

Cézanne's interest in Wagner is hardly surprising; French late romanticism and Wagner were intimately related, as Nietzsche points out in *Beyond Good and Evil*: "As a musician Wagner belongs among painters, as a poet among musicians . . . one and all fanatics for *expression* at any cost—I call particular attention to Delacroix, Wagner's closest relation—one and all great discoverers in the realm of the sublime. . . ."

The censoriousness of the Salon of 1863 had given way by 1865 to a more tolerant view, the jury allowing works by Pissarro and Oller, and most remarkably Manet's *Olympia*. But really little had changed. The trite conventions of the Salon still held sway. Cézanne, rejected in 1863 together with most of his friends, and again the next year, wrote in March 1865 to Pissarro that he intended to submit pictures deliberately chosen for their capacity to make "the Institute blush with rage and despair." Cézanne's later alignment with Courbet, praised by Baudelaire as "a murderous iconoclast," and his submission of paintings of grotesque expressiveness, cannot disguise the fact, says Gotz Adriani, "that right into his old age . . . he sought the approval of just those Salon painters who operated successfully within these conventions."[22] To be accepted by the Salon was the equivalent of receiving the approval of his father. The triumph of the one and the love of the other were both to be denied him. If he was not a natural rebel, like Courbet, neither did he have the poise of the upper-class Manet, supported vigorously by Zola for "shattering the dreadful mediocrities that surround him." Zola was often naive and insensitive artistically, with little real insight into Manet's achievement. It was Cézanne's insistence on Manet's importance that led to the writer embracing in print the artist's "simple, honest talent" which "takes hold of nature directly . . . without concealing anything of the artist's own character."

In contributions to the Parisian daily *L'Événment* launching his first onslaught on the hated Salon, Zola wrote in savage terms between April 27 and May 20, 1865, to condemn the "little tricks of the hand," "theatrical effects," and "perfumed dreams" thought by the jurors to be worthy of inclusion. It was these jurors, he alleged, who were responsible for the "long bloodless halls" in which "are spread out every sort of mediocrity, every sort of stolen celebrity."[23]

What Cézanne liked about Manet's *Olympia*, which the critics and the *grande bourgeoise* found so scandalous—his *Lunch on the Grass* had already been condemned by the emperor as obscene—was its outright provocativeness. About Manet himself he was always ambivalent. His way of painting in clear flat colors didn't appeal to him. He admired the man's courage in "coming right out with it," and in old age he told Vollard, "Yes, but he lacked harmony, and temperament as well." It was the fellow's attack on hypocrisy that he liked so much. He reminded Vollard of Daumier's words: "I don't entirely love Manet's painting, but I find in it this enormous quality: it brings us back to the figures of playing cards." Another reason for not following Manet was the limit it would have placed on his increasingly urgent need to find a channel for his emotions. Manet's was cool, contained, elegant painting.

The attraction for Cézanne of the theme of *Olympia*, a modern woman stripped and observed with detachment, shouldn't be overlooked either. Manet had made a copy of Titian's *Venus of Urbino* and then "translated it" to form the basis of his *Olympia*. There the similarity ends. Nor has the painting anything in common with the odalisques of Ingres and Delacroix. We are looking at a young whore, scarcely more than a child, with her immature body and impertinent gaze, laid on a rumpled bed for our inspection. A black servant woman attends her. She is staring out at her customer, coldly indifferent. The viewer is implicated not only as a voyeur but as a participant. At the foot of the bed is a black cat, waving its sinuous tail.

When Cézanne came to paint his parody of this picture, and later his succession of bathers, the female bodies he favored were large, billowy: after all he was a lover of Veronese and Rubens. This skinny creature of Manet's has more than a touch of perversity about her. Manet the man of the world would have been familiar with Goncourt's entry in his Journal dated April 11, 1864, which speaks of "meager women, emaciated, flat, bony, thin enough to hold in your hand, with hardly a body at all," as well as the passage in *Manette* describing how the artist "followed these unexpected apparitions, these charmingly

irregular and radiant faces," finding these undernourished girls "pale with lack of sleep and as if vaguely tormented with a nostalgia of idleness and luxury." Later, Cézanne's *Modern Olympia*, a mocking comment on the Manet, includes the black cat and the black servant but has left the bleak realism of the whore's boudoir for a cloudy dream world of his own invention. In the foreground he has inserted himself, his hat behind him on the divan, a strange blatant figure like a judge, seated with his back to us. There is an air of perplexity about the whole scene.

He was still not so far away from the nineteen-year-old in Provence who was afraid his "smitten sighs" might "betray themselves outwardly." Contemplating a yearned-for loved one in his verses, "vaporous elegies" eddied and swirled. In some ways so different from each other, both Zola and Cézanne went in fear of the opposite sex. One twisted and turned in a net of words, the other fought to get some measure of control over his betraying imagery. Cézanne seemed to feel himself the most despicable, cursed with this inability to approach women physically. Zola was quick to notice the other's shame. Making notes for his novel *The Masterpiece* he wrote directly of his boyhood friend: "He mistrusted women. . . . He never brought women to his room; he always treated them like a youth who ignored them in an agony of shyness, hidden under a brutal boastfulness. . . . 'I don't need women,' he said, 'it would be too much of a nuisance. I don't even know what their use is; I've always been afraid to find out.'"

Zola, in his rebuttal to the critics attacking Manet, remarked that the naked *Olympia* had "made the grave mistake of looking like many other women." The contemporaneity of the nude was the shocking thing—she is undressed rather than nude—and the figure bears out Baudelaire's comment on the indecency of thin nudes. Letters of protest poured in to the editor's office, accusing Zola of atheism and "spiritual shamelessness."

# 5 PURSUED BY FURIES

Long before he came to write his revealing preparatory notes for *The Masterpiece* Zola was beginning to regard his Provençal friend with those mixed feelings, of disappointment and exasperation, which would lead eventually to their estrangement. Others may have seen the Cézanne of the 1860s as a scowling, dumb, uncouth barbarian, but Zola knew better. He had been acquainted for years with Cézanne's fine mind, but began to wonder if his problems and frustrations were in some way bound up with wild intellectual activity, which undermined his power to create. He was still holding this view of his friend when he got down to the planning of his painter novel, describing it in advance as "a poignant study of the artistic temperament in a contemporary context." The reader would be confronted by "the terrible drama of a mind devouring itself." But all this lies nearly two decades ahead.

Many commentators have speculated on the violence bulging through much of Cézanne's early work. It makes no sense to see it merely as a symptom of his hatred for academic art, when side by side with his contempt for the bigots on the juries of the Salon lay a longing to creep into its "beatific womb." He thrashed around in a desolate isolation, his genuine respect for tradition at odds with the avant-garde claiming him as one of their own. Solitary by nature, a prey to hallucinatory fantasies that could have been due to that "wild mental activity" Zola knew only too well, suffering from its nervous consequences him-

self, he strove to reconcile his sensations, some of them loathsome, within a context of family and his "secret affinities" with the opposite sex. In front of a canvas, suffering agonies of doubt, he would be racked with his old restlessness and balked desire. Often these slashed-down battles ended in fury, with a fist through the canvas.

Violence as a result of frustration and impotence is easy to understand, and has become a cliché of art: the wild man running amok. John Berger believes it to be something else: "It is violence done to the idea that a painting might be desirable. The tragedy is the tragedy of easel painting, which cannot escape the triviality of becoming a desirable possession. Hence his early brutality and ugliness."[1] The blackness in these works is not so much funereal as defiant, as well as signaling a recognition of his fate. The nineteenth-century artist, Berger comments, "is now alone, surrounded by nature, from which his own experience separates him."

Ugliness there certainly was in these early paintings, and a disturbing tension. One feels assaulted by an unhappy man determined to project his pain onto you. In appearance he was looking deliberately *outré*, slouching along the pavements in a shapeless felt hat, wearing an enormous rain-streaked overcoat that had once been chestnut brown. He was round-shouldered, looked older than his years, and seemed agitated when cornered, sometimes "with a shiver of nervous disquiet that must have become habitual," standing there reluctantly in his big laced boots, his trousers at half-mast, evidently longing to be somewhere else. To be a mere brute, to be free of this stigma of self-consciousness, would have been a merciful release. He often wanted to give way, degrade himself, but his ferocious reserve held him fixed and helpless. What passed for humor in his conversation was often scatological. Asked once by Manet what he was going to send in to the Salon, he said—no doubt because it was Manet—"a pot of shit."

It would have been too much to expect Zola, whose taste in art was limited, to appreciate the originality of Cézanne. Who expects one's friend and protector at school to be possessed of genius? His character Claude Lantier was an amalgam of Cézanne, Manet, and also Monet—as the Christian name suggests. There was too an aspect of Zola himself, for the novel was meant to chronicle the bitter defeats, the endless battle to achieve truth, "the blood and tears involved in giving one's flesh, the struggle with the angel." Above all it depicted the tearing process of giving birth, which never ended. Parturition figures in many of the titles he jotted down for the novel: *Living Flesh, Creating, Cre-*

*ation, Our Flesh, The Anguish of Bearing, The Bloody Couches, This Is My Flesh, The Blood of My Work*, and so on. A more accurate translation of *L'Oeuvre* would be *The Artwork*.

Lantier first crops up as an art student in Zola's novel *The Belly of Paris*. In the family tree of the Rougon-Macquart, published with the preface to *A Love Episode*, he describes Lantier as "a mixture, a fusion," inheriting his mother's characteristics, physical and mental, and illustrating with his personality "an inherited neurosis turning into genius."

Sightings of Cézanne as he must have appeared in his late twenties can be found in Zola's careful notes for *The Masterpiece*, which describes him as "thin, with knotty articulations, a strong bearded face. Nose lost in the bristly hair of the lips, eyes narrow and clear. In the depth of his eyes a great tenderness. His voice was strong." Another note outlines his "long form, accentuated brow, Arab visage." "Very important" he comments beside the observation of his ill-disguised timidity in the presence of women.

Joachim Gasquet, the young poet who befriended Cézanne in his old age and tended to romanticize, wrote, "Those who saw him at the time have depicted him to me as terrible, full of hallucinations, almost bestial in a sort of suffering divinity. He was in despair at ever being able to satisfy himself. He changed his model weekly."[2]

Coquoit's account is along the same lines. Cézanne, unnerved by a model getting undressed in front of him, would abruptly change his mind and panic, once pushing the woman out half naked on to the stairs. Going back to his easel he subjugated her "on the bed of his pictures." In the mornings he was cheerful, in the evenings desperate, liable then to call painting "a dog's trade." Disgusted, he would exclaim, "When I paint I feel as if I'm tickling myself." Despairing of his lack of progress he lamented aloud, "I've never finished anything, never, never." Coquoit speaks of him sinking down into the mud of his self-loathing "with the cold rage of a tender and exquisite spirit that doubts itself and dreams of sullying itself."[3]

He and Zola were drawing apart inevitably, though for many years to come they stayed on excellent, even affectionate terms. Temperamentally, for all the idyllic memories of their youth, kept alive by Zola in numerous books, they contrasted sharply with each other. With Zola finding his feet as a polemical journalist and soon seeing himself as the pitiless dissector of the industrial and capitalist age, and Cézanne fleeing regularly to the volatile south in reaction from the urban scene, their daily lives could hardly have been more disparate.

Friction between Zola and his employers over his self-absorption in pursuing his literary ambitions had led to the author of two published books taking a courageous gamble. Louis Hachette had died and the executives who took over didn't share the old man's sympathy for Zola. On the contrary, he was told pointedly by one director, "You know, your salary here is two hundred francs a month. For someone of your talent it's ridiculous." The times were uncertain, but Zola took the hint, sending in his resignation to coincide with the end of 1865. Fame was the spur, not only for himself but to avenge the defeat his father had suffered at the hands of the bureaucrats. One day, he vowed to himself, letters would come for him addressed to Émile Zola, France.

Once clear of his six weeks' grace at Hachette's he hurried to establish himself as a polemical journalist. The Second Empire was a time of boom. Paris, though still only half the size of London, was expanding rapidly and already had become the largest city on the Continent. "New boulevards continued to slice through the patchwork of the old quarters. Like the spokes of a gigantic wheel twelve wide avenues radiated from the Opera House, already rising grandly from its imperial foundations. And beneath this steaming compost, snaking sinuously under the railway networks, canals, and the ninety miles of new roadworks chaotic with cabs, hansoms, ornate victorias, and lumbering delivery vans ran a vast complex of sewers: great tunnels, arches, and dripping caverns that would become one of the unseen marvels of European civilization."[4]

Migrants from the provinces had helped to swell the population and workmen of all kinds were still arriving in their hundreds, emptying their pockets in the packed, gas-lit cafés and spending recklessly on any entertainment. J. K. Huysmans wrote lyrically of the smells of Paris, some as "equivocal as a cry in a dark street." If you passed near groups of people in certain working-class districts of the city you held your breath. "Negligence, and the weariness of arms that have toiled at back-breaking tasks, account for the sharp, goat-like odor that comes from their sleeves." The blood pumping through all this ferment was money, and the bonanza attracted carpetbaggers and adventurers from the length and breadth of France. Newspapers had begun to cash in and expand, inspired by the rewards of big circulations in this era of endless opportunity.

A newly launched cheap daily was *L'Événement*, owned by the publisher of *Le Figaro*, Henri de Villemessant. As a free-lance contributor Zola had one foot firmly planted in the door. Now he wrote proposing

that he should write a gossipy column about books and authors, similar in fact to the popular feature the paper ran about the theatre world. Villemessant, shrewd and energetic and on the lookout for novelties to titillate the appetites of the salon crowd, said yes. Zola was engaged on a salary of five hundred francs a month. This was generous, compensating for the lack of security involved in working for a man like Villemessant, who believed in paying by results and telling his readers so. Introducing his new column he announced blatantly that his new "performer" would aim to

> spy on a new book, even before it is published if possible; to give a brief and impartial judgment; to know everything about the world of books . . . this is the role of M. Émile Zola. If my performer succeeds, well and good. If he fails, nothing is simpler—I drop him from my vaudeville act.

And he was known to do just that. Journalists who fell from favor were not even granted an interview with the editor—they were simply presented with a walking stick.

As Zola thrust himself into the limelight at every opportunity, eager to become the kind of campaigning journalist who is known everywhere, Cézanne grew increasingly introverted. The friend of his youth, so passionate in his letters and during those halcyon days roaming the countryside around Aix, feeding on Musset and helping to create their Virgilian idyll, had begun to strike his mentor as anything but romantic. Unlike Zola, he seemed incapable of compelling others to take him seriously. He could neither go his own way nor submit to the way of others. Somehow his life lacked force and balance when he was out of Provence. A sense of history, of the past, had always affected him powerfully, whereas in the present he was ineffectual, nowhere. He gave the impression, more and more, of wanting to ignore the modern world. To fight his way in the world, when the world wasn't worth it, made little sense to him. If Zola hadn't seen him with his own eyes slaving over canvases, he would have taken him for an idler. He had no desire, and no need, for the prizes Zola fought tooth and nail to win. But the love of the two men was genuine, and it endured. The ambitious novelist was always glad to see Cézanne, whether he was sunk in a black mood or not, at the Thursday evenings in his apartment, presided over by his ailing mother and Alexandrine, or later at his country house at Médan.

◆   Not only Cézanne but his art was turning in on itself. His grow-ing taciturnity, his alternating bouts of humility and arrogance, were bound up with blocked sexuality and thwarted love. He suffered the torments of an unrequited love for no one in particular: for all women. "A self-induced passion," writes Storm Jameson of Stendhal, "can be as violent and absorbing as any other kind of love."[5] Zola had Cézanne very much in mind when he wrote of his youthful hero in *The Master-piece* that "chaste as he was, he had a passion for the physical beauty of women, an insane love of nudity desired but never possessed, an impossibility of satisfying himself, of creating as much of this flesh as he dreamed to hold in his frantic arms. The women he hustled out of his studio he adored in his pictures. He caressed them, outraged them even, and shed tears of despair over his failures to make them suffi-ciently beautiful, sufficiently alive."

No wonder he seems misogynistic, prisoner of a sexuality that only burned him, chained him where he stood. It is possible that he knew Victorie, the model for Manet's *Olympia*, at any rate by sight. After the picture went eventually to the Luxembourg, and Cézanne, Vollard, and Guillemet stood looking at it, Cézanne is supposed to have said, "That would please me well enough—to pose nudes on the Arc's banks! Only understand, women are cows, calculating, and they'd put the *grappin* into me."

There seems little doubt that the studio Zola described in his painter novel was one of several he knew from his visits to Cézanne. Neurotical-ly tidy himself, judging by descriptions of his study, he must have been appalled by such disorder and neglect, seeing last winter's ashes

> still heaped up in front of the stove. Apart from the bed, the little washstand, and the divan, the only other pieces of furniture in the place were a dilapidated oak wardrobe and a huge deal table lit-tered with brushes, tubes of paint, unwashed crockery, and a spirit stove on which stood a saucepan still spattered with vermicelli. Chairs stood about with holes in their seats, surrounded by rickety easels. Near the divan, on the floor, in a corner which was probably swept out less than once a month, was the candle he had used last night, and the only thing in the room that looked neat and cheerful was the cuckoo clock, a large one of its kind with a resounding tick, ornamented with bright red flowers.

Then there were the paintings, shrieking and raw, which the hero's timorous mistress confronts as if forced to look at her tormented lover's exposed nerves, "the unframed sketches hanging on the walls, covering them from ceiling to floor, where others lay heaped up in a disorderly landslide of canvas. She had never seen painting like it, so rugged, so harsh, so violent in its coloring; it shocked her like a burst of foul language bawled out from the steps of a gin-shop."[6]

Before this, when he had invited Christine in for the first time, taking pity on her, only to be dumbstruck and helpless, floundering before her innocence, "He was raging. Furious with himself and with everyone else he vented his anger by kicking the furniture about and shouting. He was right never to bring any women back home. He knew he was. All the bitches were good for were to make a monkey out of a man! That one who'd just gone, now, how could he be sure she hadn't been fooling him right and left, in spite of her innocent face?"

Each faltering step forward Cézanne took would find him flung back before long in a full-scale retreat. The contradictory violence, that his intelligence told him was futile, helped to shape the psychological truthfulness of his disturbingly crude and intense early work, the ungainly nudes of bacchanals and bathing scenes and orgiastic festivities, the scenes of abduction, rape, and murder soon to come. Outwardly cynical, he was arrested within himself, at the mercy of a chaos that beat in his blood like a mad sea, powerful and conflicting. His soul had darkened and was inflamed, pungent. Outside himself he saw the world as a cynical parade while his inner world was all distortion, hellish.

It took Zola only a month to get himself appointed art critic on *L'Événement*. With his memory of the exciting controversy surrounding the Salon of the Rejected still clear in his mind he put to Villemessant the idea of a series of articles on the 1866 Salon. His instincts told him there would be trouble, and in the hope of fanning what flames there might be he helped Cézanne to compose—or perhaps wrote himself, for the painter to sign—a letter of protest to the superintendent of the Beaux-Arts, Comte de Nieuwerkerke, after two canvases of Cézanne's, *An Afternoon in Naples, or The Wine-Grog* and *Woman with Flea*, were rejected.

The likelihood is that the whole idea was a calculation, with Zola as the linchpin in an attempt to goad the authorities into staging another Salon of the Rejected. Cézanne had submitted two violent and grotesque pictures as a deliberate ploy, it seems. Marion wrote to his friend Morstatt in March, "I've just had a letter from my

Paris friends. Cézanne hopes to be rejected at the exhibition and the painters of his acquaintance are preparing an ovation in his honor." He broke off his letter and then continued with more news he had just received. The whole realist school had been refused, Cézanne, Guillemet,

> and the others. . . . In reality we win and this mass rejection, this vast exile is in itself a victory. All we have to do is plan a show of our own and put up a deadly competition with those bleary-eyed idiots. We are in a fighting period: youth against old age . . . the present, laden with promise of the future, against the past, *that black pirate*. Talk of posterity. Well, we are posterity. And we're told it's posterity that judges. . . .[7]

The jury had two members sympathetic to the dissidents, Corot and Daubigny. Renoir was hovering outside when they emerged. Bashfully pretending to be a friend of Renoir he was told by Dubigny that his friend shouldn't be disheartened, there were fine qualities in his picture. "We recalled the picture ten times without managing to get it accepted, but what would you have? We were six for against all the others. . . . He should make a petition and ask for an Exhibition of the Rejected."

Meanwhile Cézanne wrote his protest and had no reply. His second letter has been lost, but Vollard quotes it as follows:

> I need not repeat here the arguments which I thought it necessary to put before you. I shall content myself with saying once more that I cannot accept the illegitimate judgment of colleagues to whom I have not myself given the authority to appraise me.
>
> I write to you then to stress my demand. I wish to appeal to the public and to have my pictures exhibited in spite of the jury. My desire does not seem to me extravagant; and if you ask any of the painters who find themselves in my position they will reply that they disown the jury and that they wish to take part in one way or another in an exhibition which should be open as a matter of course to every serious worker.
>
> Therefore let the Salon des Refusés be reestablished. Should I find myself alone in my demand I sincerely desire that the public at least should know that I no longer wish to have anything more to do with these gentlemen of the jury than they seem to wish to have to do with me.

I hope, Monsieur, that you will not choose to remain silent. It seems to me that any polite letter deserves an answer.[8]

The answer, if it came, would have reiterated the curt note written on the margin: "What he asks is impossible. We have come to realize how inconsistent with the dignity of art the Exhibition of Refusés was, and it will not be reestablished."

Why, in spite of the indignant tone of his protest, he should have kept on trying to get work accepted by the Salon, which he called in private the "Salon des Bozards" and the "Salon de Bouguereau," is puzzling. But apart from his deep respect for tradition, a token of official acceptance and success would have dispelled to some extent his ever-present uncertainty and self-doubt at this time. There are stories of his arriving at the last possible moment with pictures in a handcart, aided and abetted by his friends, who saw themselves as part of a demonstration he was mounting. He was that paradox, the hater of a new acquisitive and uncultivated middle class who found that his rebellion against arbitrary authority clashed with his distaste for anarchy.

Of the two paintings he sent in this year, one has since disappeared. Both were on the theme of drunkenness. Zola had Cézanne's current work in mind when he wrote of a fictional artist whose garish daubs "were painted with real energy, thick and solid in appearance, each passage standing out in magnificent splotches. . . . Certainly these studies were clumsy, but they had a strangeness, a character so powerful that they announced an artistic sense of the most developed kind. One would have spoken of lived painting. Never had he seen sketches so full of high promise."[9]

In fact they appealed to him for more subjective reasons. The shady milieu they depicted—the world of brothels and sensuality, procuresses and drink—was one he would soon make his own. *Therese Raquin*, completed the following year, tells of the murder of a husband by an adulterous couple—condemned in *Le Figaro* as "a pool of blood and dirt." In *Claude's Confession* the virginal hero from the country takes in a prostitute whose name, Bertha, was an alias for Laurence, the girl Zola had taken in off the street and tried to rehabilitate. This highly romanticized autobiography had a gushing dedication to Cézanne and Baille which evoked yet again the golden days of their youth:

Brothers, can you remember the days when life was a dream for me? We were friends, we dreamed of love and fame. . . . But Provence is no more, my fears and joy, my dreams and hopes. What has taken its

place? Paris, the dirt, the room, Laurence, the shame of my tenderness for this woman. . . . I live in ecstasy, screaming with pain, stammering with rapture, in heaven and in the sewer, more devastated after each new advance, more radiant after each new reverse.

Cézanne's study, rejected by the Salon, had a facetious title, *An Afternoon in Naples, or The Wine-Grog*, which had been supplied by his gleeful friend Guillemet. Why not, if the intention was to be turned down anyway? The picture comes to us with a curious tag attached. The model of the male in this painting, says Vollard, was an old night-soil man whose wife kept a little creamery where she served a tasty beef soup much appreciated by her hungry young artist-clients. Cézanne, having gained the confidence of the old man, asked him to pose. How can I, the old fellow said, I work at night and in the day I go to bed. "All right, I'll paint you in bed."

The old man obligingly got into bed and lay there in his nightcap, covered in bedclothes. Eventually, encouraged to pose naked, as there was no one else around, he threw back the sheets. His wife, perhaps unaware, became a model too, handing her naked husband a bowl of wine.

This odd picture, together with the version done a year later in pen, watercolor, and gouache, were both inspired—if that is the word for something so clearly meant to outrage—by Manet's *Olympia*. The classical pose devalued by Manet with his bleakly arranged provincial beauty was now degraded further in the eyes of the jury by introducing a lover to share the female nude's divan. In the second version the male is older and wears the night-soil man's red stocking cap, and nonchalantly smokes a pipe. *Afternoon in Naples* shows a man, young and black-haired, sprawling on his stomach, while against his brown form leans the pale reclining figure of a professionally seductive woman, hair long down her back. A black servant attends them, as in the Manet, though in the variant, called *The Rum Punch*, she appears as a homely woman dressed in green. At the left, by the female posed this time in the foreground with her right arm weirdly extended, is the black cat of the Manet. Delicacy and finish are thrown overboard in this slap in the eye at public taste; but what intrigues, in the delightfully free, rough handling, is something we would never have expected from such a desperately ingrown artist, a ribald and scabrous humor that makes us almost able to hear Cézanne's laughter as he kicks off all restraint and lets go completely.

Why a black cat? There it is again in the deep shadows of his *Modern Olympia*. All art is symbolic, whether conscious or unconscious. If an outrage against philistine respectability was intended, then the iconography of mid-nineteenth-century aestheticism had a ready-made image, the age-old black cat with tail erect, the embodiment of sensuality and the devil. Baudelaire, admired by Cézanne—his *Painter of Modern Life* appeared in 1863—had compared the cat to the libidinous woman in his poem "Le chat." Champfleury had written a cultural history of the cat, illustrated by Manet. Edgar Allan Poe's "The Black Cat" was well known in Parisian circles.

In 1867 the ritual rejection of Cézanne's work continued. Arnold Mortier somehow got wind of this news and was able to provide some entertainment for the readers of *L'Europe*, extracts from which were reprinted in *Le Figaro*. "I have heard," he wrote, "of two rejected paintings done by Monsieur Sésame [sic],

> the same man who, in 1863, caused general mirth in the Salon des Refusés by a canvas depicting two pig's feet in the form of a cross. This time Monsieur Sésame has sent to the exhibition two compositions that, though less queer, are nonetheless just as worthy of exclusion from the Salon. These compositions are entitled *The Rum Punch*. One of them depicts a man to whom a very well-dressed woman has just brought a rum punch. The other portrays a nude woman and a man dressed up as a lazzarone: in this one the punch is spilt.

Here was a chance for Zola to make what was to be his only public defense of his "childhood friend." As with his defense of Manet and the others, whose work he didn't properly understand or, if he told the truth, particularly care for, he acted from a duty he felt toward anyone persecuted and abused. On April 12, 1867, he wrote spiritedly to *Le Figaro* concerning

> one of my childhood friends, a young painter whose strong and individual talent I respect extremely. You reprinted a clipping dealing with a Monsieur Sésame who was supposed to have exhibited in 1863 "two pig's trotters in the form of a cross" and who, this year, had another canvas rejected entitled *The Rum Punch*. I must say I had some difficulty recognizing under a mask stuck to his face one

of my former schoolmates Paul Cézanne, who has not the slightest pig's foot in his artistic equipment, at least not so far. I make this reservation because I do not see why one should not paint pig's feet just the same as one paints melons and carrots. Monsieur Cézanne, in excellent and numerous company, has indeed had two canvases rejected this year: *The Rum Punch* and *Drunkenness*. Monsieur Arnold Mortier has seen fit to be amused by these pictures and to describe them with flights of the imagination that do him great credit. . . . But I have never been able to understand this particular kind of criticism, which consists of ridiculing and condemning what one has not even seen.

Just before this had come his Salon reviews in *L'Événement* for which Villemessant had given him the go-ahead. The publisher's "star reporter" set about giving his boss the scandal he assumed he wanted. Villemessant was an ex-actor and ex-singer, eager to find new gimmicks and well aware of the revolution under way in the newspaper world. *Le Petit Journal*, the first of the cheap new journals, had a circulation approaching 200,000, enormous for the time. Advanced machinery and rotary steam presses had speeded up output. Digging around in the dirt of ordinary life was a great excitement for Zola, who felt he was having a hand in forming this chaotic new society. His style as a journalist was lively, colorful, and courageous. Seething with energy, he longed for a noble cause to champion, and found one soon enough in the Impressionists.

He began first with a defense of Manet. His mission as an art critic, he declared, was to "search for men in the company of eunuchs." His strategy was that of the *provocateur*, and the target for his destructive passion those who "amputate art and present to the crowd only a mutilated corpse," in other words the Salon. Its jury was united by indifference . . . "artists of a past age who deny new ideas and artists of the present who grip their modest success between their teeth and growl like dogs, threatening anyone who comes near." Inspired by his own derision, he concluded, "Art has had its face washed, its hair carefully combed. The fashionable ladies who visit the Salon will find everything as neat and clear as a mirror. They could do their hair in the canvases. . . ."

As a measure of the jury's stupidity he cited the case of an artist known to them as a student of Courbet, and therefore suspect, who sent in a picture under his own name and one under an alias. They turned down the first and accepted the second. Announcing his credo,

"A work of art is a personality, an individuality, a corner of creation seen through a temperament," Zola went on defiantly, "M. Manet's place is marked in the Louvre like that of Courbet." Members of the jury let out howls of rage, some even wanting to fight a duel with the critic. Undeterred, Zola pressed on. He wrote his articles under the name of Claude, the alias used for his autobiographical hero of *Confession* and for the Cézanne figure in *The Belly of Paris* and *The Masterpiece*. He was still thinking and worrying about his old comrade, and this use of "Claude," together with the affectionate dedication be wrote in the form of a preface to these articles when they were published as a pamphlet, was further evidence of the solidarity he still felt existed between them. He saw the pamphlet *Mon Salon* as a joint work. Clearly he saw them as standing shoulder to shoulder in their fundamental position, friendly and harmonious as they had always been. And it was true that Cézanne had taught Zola much about Manet, pointing out deeper layers of meaning in *Olympia*, for instance, than Zola had ever suspected. What Zola in his articles was seeking to establish was that Manet and his friends belonged to that group of "analytical painters" who were satisfied with what he called

the great realities of nature. Yes, I consider myself the defender of reality. I avow calmly that I am going to admire M. Manet. I declare that I take little account of the rice-powder of M. Cabanel, and that I prefer the harsh and healthy smells of true nature. Besides, each of my judgments will duly come true. I content myself with stating here, and nobody will dare to contradict me, that the movement described under the name of Realism will not be represented in the Salon. . . .

What I ask of the artist is not to give me tender visions or terrifying nightmares. It is to deliver himself up heart and flesh. It's to make a lofty affirmation of a powerful and particular spirit, a nature that can seize nature liberally in its hand and set it standing upright before us, such as it is. In a word, I have the profoundest disdain for small clevernesses, for interested flatteries, for what study has been able to learn and a tenacious labor has made familiar, for all the historical *coups de théâtre* of that gentleman and for all the perfumed reveries of that other. But I have the profoundest admiration for individual works, for those that come from the stroke of a vigorous and unique hand. . . .

I am not for any school, because I am for human truth, which

excludes all coterie and all system. The word *art* displeases me. It holds I-don't-know-what ideas of necessary arrangements, of absolute ideals. . . . I, I want artists to make life, I want them to be alive, to create anew, outside everything else, according to their own eyes and temperament. What I seek before everything else in a picture is a man and not a picture. I consider there are two elements in a work: the real element, which is nature, and individual elements, which are the man. [10]

Apparently the notes for these articles were provided by Guillemet, and Cézanne too was consulted. In his demolition work Zola went straight for the idols of the Academy—Cabanel, Fleury, Olivier Merson, Debufe, Signol, and others. He was looking beyond the old rebels, Courbet, Millet, who he said were already out of date. Another article acclaimed Monet. By this time subscriptions were being canceled in thousands. Alarmed, Villemessant commissioned a second series of articles by Théodore Pelloquet to put the case for the maligned academics. This didn't stop the rot, and Zola's contributions were abruptly terminated.

The seven articles he had managed to push through, and afterward collected in a pamphlet, were later included in a volume of occasional essays entitled *My Hates*, which he dedicated to Cézanne in a preface overflowing with nostalgic love. He begins disingenuously, "You cannot believe how I have suffered during this quarrel I have just had with the crowd, with unknown people. I feel myself so little understood, I divine such hatred around me that often discouragement has made me drop the pen." More truthfully he confided to his friend:

Today I can give myself the close pleasure of one of those causeries we have had for ten whole years. It is for you alone I write these few pages. I know you will read them with your heart and that tomorrow you will love me more affectionately. . . .

For ten years now we have talked of the arts and literature. We have often lived together—do you remember?—and often the day has surprised us, still discussing, digging into the past, questioning the present, trying to find the truth and create an infallible and complete creed. We have turned up some terrifying heaps of ideas, we have examined and rejected all the systems, and after such a rough labor we have told one another that outside potent and individual life there was only lie and folly.

Zola was increasingly lost and baffled before Cézanne's paintings, but he had insights into the man's heart which he found hard to forget. John Rewald's famous biography was called *Cézanne et Zola* when it appeared more than fifty years ago, and the relationship between the two men was central, the thread binding together the narrative of the painter's development. Zola's preface to *My Hates* with its telltale phrases of regret ("Do you remember?") grow ever more plangent and mournful as it unwinds. "Happy those with memories. I see you in my life like the pale young man of whom Musset speaks. You are all my youth. I find you mingled with each of my joys, in each of my sufferings. Our spirits, in their fraternity, have developed side by side. Today, in the day of our first appearance, we have faith in ourselves because we have penetrated our hearts and bodies. . . ."[11]

It isn't easy to keep track of Cézanne's movements during these formative years, as he flitted back and forth between Paris and Aix like someone pursued by furies. No artist has had more addresses, and no place he settled in was satisfactory for long. It has been said of Baudelaire that he was a man of his time whose time was modern, "our uneasy familiar." In his prose poem "Any Where Out of This World!" he speaks of his preoccupation with the fugitive, the contingent: "One would prefer to suffer by the stove. Another believes he would recover if he sat by the window. . . . I think I would be happy in that place I happen not to be, and this question of moving house is the subject of a perpetual dialogue I have with my soul." The correspondences between his and Cézanne's disquiet are many, and it is no surprise to discover *Les Fleurs du mal* among the painter's sacred books. Acute restlessness could be seen as a curse, a modern malady, or as an urge to live, an instinct for renewal. Movement could be the solution to more than we think. "Why can't one sit still?" asked Lawrence, drawn by the Mediterranean, by Etna, by Sardinia. For him the very essence of man's nature lies in movement.

When Cézanne disappeared, it wasn't always to Aix. Even when he was based in Paris he often made trips to the suburbs or farther out into the countryside, staying away for days or weeks if he found himself in a congenial location. In the spring of 1865 he had taken lodgings on the right bank near the Bastille, in a house that was two hundred years old, the Hôtel de Charny, which looked elegant but was cheap enough for

clerks and people of modest means like himself to live there. Baude-laire had stayed there once. The painter's reason for landing there, however, was probably his friend Oller, whose address in the 1865 Salon catalog is the same as Cézanne's, 22 rue Beautrellis. In the future Cézanne would move to the other side of the river, which he preferred.

Early in the summer of 1866 Zola had told Numa Coste in a letter that he was off to spend some time in the country. Cézanne was joining him, also Baille, in a grand reunion. Zola's future wife Alexandrine—Cézanne always called her Gabrielle—would be there too, for this was really a sort of honeymoon for the couple. They were off to Ben-necourt, and not only the old trio but Solari, Valabrègue, and Marius Roux as well. But before this began, Cézanne was elsewhere, and defi-nitely not in Aix, for he was running short of money and complaining of the food. He mentions names with which Zola must have been familiar, though they mean nothing to us. In a puzzling letter of June 30 he thanks Zola for sending him sixty francs, "since I'm more unhap-py than ever when I haven't a sou."

So nothing amusing happens of which you don't speak at length in your last letter. Impossible to get rid of the *patron*. I don't know for sure which day I leave, but it'll be Monday or Tuesday. I've done little work, Gloton's birthday was last Sunday, and the *patron*'s brother-in-law came, then a pack of idiots. Dumot will leave with me.

The picture doesn't go too badly, but the day takes a long time to pass. I must buy a box of watercolors so I can work when I can't get on with my picture. I'm going to change all the figures in it. I've already given Delphin a different pose [drawing of a man dig-ging]. . . . I'm going to alter the other two as well. I've added a bit of still life at the side of the stool, a basket with some blue linen and green and black bottles. If I could work longer at it, it'd go fairly quickly, but with hardly two hours a day it dries too quickly, it's infuriating. Decidedly these people should pose for you in the stu-dio. I've begun in the open air a portrait of father Roussel the elder which is coming on not too badly, but I need to work more on it, especially on background and clothes. . . .

I fished yesterday with Delphin and yesterday evening with my hands in the holes. I caught at least more than a score yesterday in a single hole. I took six, one after the other, and once I caught three at the same time, one in the right, two in the left—they were rather

fine. It's easier all that than painting, but it doesn't get a man far. My dear friend, see you soon. My regards to Gabrielle as well as to yourself, Paul Cézanne.[12]

By July he had joined the others for a summer holiday, swimming, fishing, walking, and canoeing. It was like the old days. Well, they did their best to recapture those pagan days of pure sensation. But they were in their mid-twenties, and with Alexandrine keeping a watchful eye on her Émile it could hardly have been the same. Nevertheless it gave Zola the material for the honeymoon of Claude and Christine, the one idyllic episode in his grim novel *The Masterpiece*.

Bennecourt was a little village beyond Mantes. From the Saint-Lazare station one caught the Havre train, getting off two hours later at Bonnières. Bennecourt was on the opposite bank of the Seine, reached by an old ferry boat that went creaking and grating across on its chain. Fields and wooded hills were all around, the river half-choked with islets sprouting reeds, the yellow houses of the village straggling delightfully along the river bank. Zola had been there before and knew there was an artists' inn "with its little grocery business attached, its large common room smelling of soapsuds, and its spacious yard full of manure, on which the ducks disported themselves." After a meal of omelettes, sausage, bread, and wine, the company lay on bales of straw out in the yard, smoking and talking. On July 26 Zola was reporting to Coste:

> Three days ago I was still at Bennecourt with Cézanne and Valabrègue. They are both staying on and won't be back till the start of next month. The place, as I've told you, is a regular colony. . . . Baille left for Aix last Saturday—he'll return the 2nd or 3rd of October. He has finished a book on physics for Hachette, about which I think I wrote to you. It will appear before the year's end. . . . Cézanne is working. He grows more and more firmly set in the original course into which his nature forces him. I have great hopes for him. At the same time we expect he'll be rejected for the next ten years. At present he's trying to paint huge canvases of 4 or 5 meters. . . .[13]

Zola was as usual too optimistic. Most of his painter friends had to wait a good deal longer than ten years, and Cézanne's wait was longest of all. Forty years later he was still waiting.

"He's going soon to Aix," Zola added, "perhaps in August." And so

he did. Marion, now teaching geology at the University of Marseilles, kept him company, as did a law student, Paul Alexis, son of a rich solicitor, an amateur poet and soon to be the first of Zola's disciples. For the moment he hero-worshiped from a distance, following every detail of the older man's career.

◈  Evidently Marion felt, as he strolled with Cézanne along the Cours, that he was walking with someone who had become a local celebrity, people staring at Cézanne with "his scarce and immensely long hair" and his "revolutionary beard." They were even wished good morning. Soon to join them was Valabrègue, and then the joke-cracking Guillemet, who had taken a liking to the place earlier in the year and now brought his wife Alphonsine.

This was the year when Cézanne took to the palette knife with a vengeance, for twelve months or more using nothing else, apart from rags, his fingers, a spatula. He admired Courbet now and was perhaps following his example, but he took the knifing to its extreme. These paintings with their insistence on pigment now look to us astonishingly modern, anticipating the late Van Gogh, and beyond him the Fauves and Expressionists, painters like Soutine and Münch. The palette knife is like the tool of a tradesman or sculptor, able to plaster, trowel, gouge, and scrape. The physicality of the paint is wrestled with directly. One result of this combat was an attempt to paint Valabrègue and Marion out of doors. Marion did paint as a hobby, which is perhaps why he is dressed for this picture as an artist wearing a wide-brimmed Barbizon hat and a painter's smock, and carrying a sketching easel. The sketch, plastered with heavyweight, crusty paint, is alive with the excitement of a new freedom, which was filling Cézanne with uncharacteristic confidence. He told Zola that nothing done in the studio would ever equal what was done outdoors, and spoke of Guillemet's approval for his sketch "which makes everything else collapse and appear bad."

His triumph was short-lived. The large canvas he built up from the sketch was a failure. As for his model, Valabrègue commented sardonically, "Paul is a horrible painter as regards the poses he gives people in the midst of his riot of color. Every time he paints one of his friends he seems to avenge himself for some hidden injury."

Vollard, not too reliable a source, tells of an intervention made by Guillemet this summer, either asking Louis-Auguste to allow his son

to come back to Paris with him, or pleading with him to raise Paul's rather stingy allowance. It seems extraordinary that he was still unable to stand up for himself. The truth was that at the center of him he was afraid, not only of his father but of life itself.

There were painting expeditions in the hills near the dam with Guillemet, with Marion tagging along. Cézanne records these events in a letter of October 19 to Zola. It had been raining on and off in "a pertinacious way."

> Guillemet spent some days with me, and yesterday, Tuesday, went to a small lodging, not bad, at 50 francs a month, linen included. Despite driving rain the countryside is superb and we've made a few sketches. When the weather clears he'll get down seriously to work. As for me, I'm overwhelmed with idleness. For 4 or 5 days I've done nothing. I've just completed a little picture which I think is my best yet. It represents my sister Rose reading to her doll. It's only one meter. If you like I'll give it to you. . . .
>
> Guillemet's apartment consists of a kitchen on the ground floor, with salon opening on to a garden which surrounds the country house. He has taken two rooms on the first floor with a small wash room. He has only the right wing of the house. It's at the start of the route d'Italie, just opposite the little house where you've lived and where a pine tree grows, you must recall it. It's next door to Mère Constalin, who keeps an inn. . . .

Then comes his manifesto of faith in *plein-airisme*, premature as it turned out. Again he is ahead of his time. "In representing out-of-door scenes, the contrast of the figures with the groundsite is astounding, and the landscape is magnificent. I see some superb things, and I must make up my mind only to do things in the open."

> I've already mentioned a canvas I mean to try. It'll show Marion and Valabrègue setting out for the motif (I mean the land-scape). . . . I think indeed that all the pictures of the old masters respecting things out of doors haven't been done with a sure touch, for they don't seem to me to have the true and above all original aspect provided by nature.
>
> Père Gibert of the Museum invited me to visit the newly acquired Musée Bourguignon, and I went with Baille, Marion, Val-abrègue. I thought everything was bad. It was very consoling. I'm

rather bored, only work occupies me a bit. I'm less dull with some-one else. I only see Valabrègue, Marion, and now Guillemet.[14]

Here is the first evidence of that nagging conscience of his, more and more at work as he grew older. What he calls here the "true aspect" would force him to leave an empty space if there was some-thing he didn't know. A dab of color would go down, or be withheld, for that perfect balance he strove for in his last years, which had to do with finding the exact equivalent of the object. Rilke went to view some late Cézannes in Paris in 1907 with the painter Mathilde Voll-moeller, who said of one picture that the artist must have "sat there in front of it like a dog, just looking, without any nervousness, without any ulterior motive."

Although he had been with Zola and the others at Bennecourt in July discussing everything under the sun as they always did, he speaks in this sudden revelation of the importance of open-air painting as if it was a discovery he made in Aix. His increasing contacts with Pissarro must have helped in this direction. In his letter he asked to be remem-bered to

> Gabrielle, also to Solari and to Baille, who must be in Paris with his *frater.* I suppose now the nuisances of the argument with Villemes-sant are over and you'll be feeling better and I hope your work isn't getting you down. . . . If you see Pissarro, tell him lots of things from me. But I repeat, I have an attack of apathy for no reason. As you know, I don't know what's the cause. It comes back every evening when the sun sets and there's rain. It makes me gloomy. I think that one of these days I'll send you a sausage, only my moth-er must go and buy it, otherwise I'd be cozened. That'd be very annoying.
>
> Just imagine, I hardly read now. I don't know if you'll be of my opinion, and I won't change for that, but I begin to discover that art for art's sake is a hell of a humbug: this between ourselves . . . I've had the letter in my pocket and I feel the need to send it on to you. Goodbye, my dear chap.[15]

A few days later, spurred on no doubt by the greetings he had passed on through Zola, he wrote to Pissarro himself. Clearly he was now on fairly intimate terms with the older man—whom he had begun to regard almost as a father—since his letter opens with a furious attack on his own family, not just Louis-Auguste but all of them.

Whenever his rage reaches such a pitch that it overwhelms him he lets fly with scatological abuse, hurling excrement at the object of his disgust. What had happened to bring about this convulsion, recoiling violently on himself, as he did now if he was in danger of being physically touched? What had broken his shell? He gives us no clue. "My dear friend," he exploded, "here I am in my family, with the dirtiest beings in the world, those who compose my family, a supreme lot of shitters. But no more of that." Calming down abruptly, he went on:

> Daily I see Guillemet and his wife, who are fairly well lodged, Cours St. Anne 43. He hasn't started yet on big pictures; he has preluded by some small canvases that are very good. You're perfectly right to speak of grey, for grey alone reigns in nature, but it's a terrifying hard job to catch it. The landscape here is very beautiful, much character, and Guillemet made a study of it yesterday and today in grey weather which was most beautiful. His studies seem to me to stand out much more than those he brought back from Yport last year. I am much struck with them. Anyhow you'll judge better when you see them. I add nothing more except that he's soon to start a big picture, as soon as possible, the moment the weather recovers.
>
> I've just posted a letter for Zola.
>
> I keep on working a bit, but paints are rare here and very expensive, misery, misery! Let's hope and pray that there'll be sales. We'll sacrifice a golden calf for that. You aren't sending anything to Marseilles, ah well, neither am I. I don't want to send again, all the more because I lack frames and that means expense it'd be better to consecrate to painting. I'm saying this for myself, and then shit for the Jury.
>
> The sun will I think give us some fine days still. I'm very sorry that Oller, so Guillemet tells me, can't return to Paris, as he might be fed up with Porto Rico, and then too, with no colors available, it must be very difficult to paint. And he told me that it'd be a good thing to take a job on a merchant ship coming straight to France. If you write to us again any time, please tell me how to write to him, I mean the address to put on the letter and the correct way of stamping so as to avoid unnecessary charges for him.[16]

Guillemet wrote an affectionate postscript on the bottom of this, beginning "Dear Pissarro, I was going to write to you when yours arrived. . . . Cézanne has done some very beautiful paintings. He is

*123*

working in light tones again and I'm sure you'll be pleased with the two or three canvases he'll bring." Pissarro was spending more time now out at Pontoise—where Cézanne would join him before too long, with wholly beneficial results—though it seems his wife had been pining for Paris, to where they had just returned. "The babies are well, I take it," Guillemet went on, "and if you should get too bored give us your news."

Then on November 2 he wrote at some length to Zola with vivid impressions of Cézanne at this time. He liked Provence, which was still a novelty to him, and especially Aix,

> this Athens of the Midi, and I assure you the time hasn't dragged. Fine weather, lovely country, people with whom to talk painting and build up theories that are knocked down next day, have all helped to make my stay here pleasant. In his two letters Paul told you more about me than himself, and I'll do the same thing, that is the opposite, and tell you a lot about the master.
>
> His physiology has rather improved, his hair is long, his frame exhales health, and his very appearance causes a sensation on the Cours. So reassure yourself on that score. His spirits, though always in ebullition, leave him moments of calm; and painting, encouraged by serious commissions, promises to reward his efforts. In a word, "the sky of the future seems at moments less black." On his return to Paris you'll see some pictures you'll like a lot, among others a *Tannhäuser Overture* that could be dedicated to Robert, for there's a successful piano in it. Then a portrait of his father in a big armchair, which looks very good. The painting is light in color and the whole looks very fine. The father would suggest a pope on his throne if it wasn't that he's reading the *Siècle*. In a word, it goes well, and from now on we'll see some very fine things, be sure.

Marion's impression of the respect being accorded to Cézanne, now defiantly bohemian in appearance, as he accompanied him through the town, is contradicted by Guillemet, who nevertheless feels there is a core of support for him, and that a vacancy at the museum might mean a directorship for him.

> The Aixois keep jangling his nerves. They ask to come and see his painting, so as to abuse it afterward. "*I shit on you,*" he says to them, and those who lack temperament flee in horror. Despite, or perhaps through this, there is a turn to him, and the time is near I

think when the museum's direction will be offered to him. I strongly hope for that, since either I know him very little or we'll be able to see there some pretty successful landscapes done with the knife, which have no other chance of getting into any other museum anywhere. . . .

The cholera, as you know, has left the Midi, but we still have Valabrègue, who, with astonishing fecundity, daily brings to light one or more corpses (in verse, it goes without saying). He'll show you quite a fine collection on his return to Paris. The verses you're familiar with as *The Two Corpses* are now entitled *The Eleven Corpses*. . . . A very nice chap, giving the impression of having swallowed a lightning conductor, making it difficult for him to walk. As for young Marion whom you know by reputation, he cherishes the hope of being called to a chair of geology. He excavates hard and tries to prove to us that God never existed and belief in him is a put-up job. In which we take little interest, as it's nothing to do with painting.[17]

Marion enthused over the homage to Wagner, proclaiming it "as much of the future as is Wagner's music." The composer's attraction for artists is made clear more than once in Nietzsche's *Beyond Good and Evil*, as in this invocation of *Die Meistersinger*: "What forces and juices, what seasons and zones are not mixed together here! . . . It flows broad and full . . . already the old stream of well-being broadens and widens again, the stream of happiness old and new, *very* much including the happiness of the artist in himself, which he has no desire to conceal, his happy, astonished knowledge of the masterliness of the means he is here employing, newly acquired, untried artistic means. . . ."

The portrait of Louis-Auguste is so august a presence that one can readily appreciate Guillemet's witty observation that it suggested a pope on his throne. Enthroned by his son, with unqualified admiration and respect, is what this old man is—as if the painter is saying: I am my father's son after all, and there's an end to it. With a touch of devilment he has retitled his newspaper *L'Événement*, one he would never have read. He subscribed to *Siècle*, a far more conservative paper, and clearly when Guillemet first saw the portrait the alteration hadn't been made.

The painting shows the figure sitting monumentally, perfectly at ease with ankles crossed, in a flowered armchair. The banner heading of the newspaper, folded back, is boldly stenciled and an integral part

of the design. Behind, on the wall, hangs a still life done in the new palette-knife style, as if announcing a new departure. The luscious pigment, handled with such force and freedom, is absolutely *Fauve*, the sugar pot, fat pears, and blue cup wildly singing together, more extreme than anything he—or anyone else—had done before.

Another still life, dated this same vital year, is preoccupied with black and demonstrates what he has learned from Manet. The black is treated as a color in its own right, not as the opposite of the white draped cloth and the two white eggs, so alive as if caught in the act of rolling further toward the old gold of two onions. Both the eggs and onions are on a smoothly black table and rest against the flank of a long golden crusty loaf. There is a thick wine glass, and a black knife set on a slant. Far to the left, looming mysteriously out of the black, stands a bluish tin milk container. Courbet's influence is also here, as well as the Spanish artists he so admired. And what he most admired in the Spanish and Italian masters was their gusto. Hazlitt's short essay "On Gusto" speaks of "gusto in the coloring of Titian. Not only do his heads seem to think—his bodies seem to feel." Yet what appears in early Cézanne as total realism is in fact subjective, a statement only he could have made. For many years to come his apparent realism would be misunderstood.

The laborious thin handling taught at the Aix museum school by Gibert had been finally repudiated. Encouraged by Manet's directness Cézanne had gone further, to the extent of putting paint to canvas so that the physical gestures were left raw and exposed, with no attempt at conventional finish. The little group around him in Aix at this time were infected by this temporary triumph over his difficulties. Marion commented to Zola that "Paul has been an epidemic germ at Aix. Now all the painters, even the glassmakers, have begun to impaste."

A self-portrait—which, as we shall see, accompanied each new phase—done entirely with the knife fills the canvas with a smoldering romantic image, the eyes deep-set and ferociously intent on his new creative path, canceling out the angst-ridden picture worked up five years before from his own photograph. At the bottom his signature has the same stenciled lettering as that seen on the top of his father's newspaper.

◈ While still at Aix he embarked on a series of monolithic heads of his uncle Dominique, who sat patiently each day while Guillemet came

and went and "made appalling jokes at his expense." "Every after-noon," said an amazed Valabrègue, "another portrait appears." And these half-day paintings of such skill and brio are indeed astonishing, a tribute to his newly gained assurance. Keeping up the impetus and the furious pace he turned out profiles, full-face, and three-quarter por-traits, fitting out his uncle with a cap, a turban, and most dramatically a Dominican robe, turning him into a monk, arms folded implacably.

In an insightful commentary Meyer Schapiro draws attention to the play on his uncle's name. Cézanne as a youth was addicted to puns. The idea of dressing the compliant, black-bearded, strongly built countryman in the white Dominican robe would have appealed to him. And there were many resonances. Not long before, the order had been revived by an ardent preacher, Lacordaire, who excited France's youth by attempting to swing the Catholic church in the direction of republi-canism. Later he opposed the regime of Louis Napoleon. Romantic painters and poets were inspired by Lacordaire, who founded a society for the revival of religious art.

Schapiro points to the grand simplicity of design in one of these portraits. The broad shoulders and head fill the canvas, in fact over-flowing it at the sides. Everywhere we are impressed with duality, "the sensual and the meditative, the expansive and self-constraining."[18] There is the renunciation of the crossed arms on the chest, below the cross hanging from the neck, contradicted by the strong sensuality of the fleshy hands and face with their ruddy earth tones. A piercing cold bluish white gleams in the neckpiece. The palette knife lifts the pig-ment in thick relief, as if the earth has a voice and is protesting. The taut structure dominates, the hanging cross uniting the head to the hands, the tip of the hood rising sensitively, pointed like the hands and reminiscent of the Gothic soaring of spires. The solitude the painter relishes and the flesh he feels he must master are projected onto the sitter and resolved, at the moment of gestation, by art.

In December he was still in the south. Zola had begun to miss his solid presence, his near-silent integrity. His position at L'Événement was far from secure. He felt he was slipping downhill. He had the idea of a serial story for the paper and it failed to reach its final chapter. He could see himself having to look elsewhere for an income. He fell out with the publisher and left, just as L'Événement merged with its sister paper, Le Figaro.

This hadn't yet happened, but Zola had a nose for such things, writing on December 10 to Valabrègue, "Tell Paul to come back as

soon as possible. He'll inject a little courage into my life. I wait for him as for a savior. If he isn't to arrive in a few days, beg him to write. Above all, let him bring all his studies and prove to me I should work." Casting around for an approach that dealt with the life being lived on all sides, "not dolls stuffed with sawdust but beings of flesh and bone, whose blood and tears really flow," he turned to the police pages of newspapers and tried to breathe life into them, using a melodramatic style that would one day be his hallmark.

The pictures of Cézanne's uncle kept coming. One shows him bareheaded, a man of the people, head only, troweled powerfully out of darkness with a black-outlined profile. These portraits teetering on the edge of naiveté were in fact modeled precisely and at speed. He dressed his uncle in lawyer's robes, cravat, and headgear, and for another had him gesturing, one hand held up as if pleading a case, perhaps suggested by Daumier. In all these versions the uncle stares out skeptically at nothing, at a wall, at his intense nephew. One is tempted to see them as exercises in what Keats called "humility and the capability of submission." Black is dominant in the Spanish manner, the mood somber. The raw exuberance and force comes over through the visceral handling, which he later called *couillarde*, liking the coarse word. He painted bread and a leg of lamb in the same unremitting style, the joint of meat modeled like sculpture, the green board it rests on steeped in the savage butchery that was the painting's subject.

He tried the same crude vigor on small landscapes, and while with Zola and the others in July he had done a view of Bonnières, across the river from Bennecourt, spreading the color from the knife in buttery lozenges, combined with short strokes of the brush. All are stamped with the same aggressive originality. When Cézanne came to submit these or other examples they would be greeted with horror, seen as repulsive, the work of a madman. Nothing could have been more slanderous than this accusation that he was a man out of control. A deep instinct had always told him that "Art lives from constraints and dies of freedom," as Da Vinci puts it.

Early in 1867 Cézanne and Guillemet went back to Paris. Valabrègue stayed behind and was able to tell Zola about the excitement caused by a Cézanne sent to a Marseilles dealer. The picture went in the shop window. "There has been a great deal of fuss; crowds gathered in the street outside. They were astounded. People wanted to know who Paul was. From that point of view there has undoubtedly been a certain excitement and success due to curiosity. However I

think that if the picture had been exhibited any longer, in the end the window would have been broken and the canvas destroyed."

It would seem that Cézanne, though never by nature a bohemian, had no choice in these years but to be one. The artistic camp was split as never before, on one side antirespectable, antiaristocratic, antibourgeois, and on the other the artist as successful businessman, breaking completely with the old image of the romantic genius. The money-making academic world had no time for Balzac's concept of genius as a prophet crying in the wilderness, doomed to be misunderstood, his lot suffering and martyrdom, his worth acknowledged only by posterity. During the Empire the status of the academician reached new heights. Dissidents like Manet and Degas, gentlemen by birth, found themselves with a foot in each camp. They saw no reason to give up their position in society. Jack Lindsay recounts the story of Monet, nearly broke, dressing up in his best clothes and marching in to see an official about his intention to paint a picture of Gare Saint-Lazare. He introduced himself as "the painter Claude Monet." The superintendent, judging by appearances, assumed his visitor must be a Salon exhibitor. "The trains were all halted, the platforms cleared, the engines packed with coal to produce as much smoke as the painter wanted. Afterward he was bowed out by uniformed officials."[19]

Manet, with his pedigree, was pandered to in the same fashion, getting soldiers sent along as models for his painting of the execution of Maximilian. Zola, commenting scornfully on the attitudes and assumptions of the smug men of the Beaux-Arts, spoke of their certainty that "the State owes them everything, the lessons to teach them, the Salons to display their works, the medals to reward them."

Cézanne must have been familiar with romantic versions of the artist as bottom dog by authors such as Murger with his *Vie de Bohème*. The dissidents' identification with the cause of the democrats and their hatred of privilege had to be externalized and projected onto a monster, something they could unite against. The Goncourts, always with their finger on the current mood, brought out their novel *Manette Saloman* in 1867 with its picture of studio life, its mess, confusion, everyone talking at once, agreed on only one thing:

Each threw in his anecdote, his word, his touch; and each new recital was saluted by hurrahs, derisions, groans, enraged laughs, a savagery of joy that had an effect of wanting to eat up the Bourgeoisie. One would have thought one heard all art's instinctive

hates, all the scorns, all the rancors, all the revolts of the studio-people's blood and race, all its deep-seated and national antipathies rising up in a furious hue and cry against this comic monster, the bourgeois, fallen into the Ditch of the artists who'd destroy its ridiculous representatives. And always came back the refrain: No, no, they are too stupid, the bourgeois!

◆  Like it or not, Cézanne for all his deep sense of history and tradition and his awareness of his cultural heritage, found himself part of the avant-garde, though always uneasily. Around this time he met Manet—his friend Guillemet was probably the go-between. Manet paid him a return visit, or rather he inspected some still lifes while at Guillemet's studio and pronounced them "boldly handled." Cézanne was present, struggling to disguise his pleasure. To be acknowledged in this way by the undisputed leader of the younger painters was surely progress. Valabrègue, also there, saw the two men as kindred spirits with "parallel temperaments." He was far from the mark; the two were in reality poles apart. Cézanne had a sincere admiration for the other man, particularly his stand against the Academy, but couldn't warm to him as a person. What had this elegant Parisian with his polished conversation and quick wit, his top hat and gloves, to do with him and his world? He held court in places like the Café Tortoni, surrounded by a group of attentive disciples.

The favorite rendezvous, the rebel artists' unofficial club, was the Café Guerbois on the avenue de Clichy. Zola went there, although his writer friends were now beginning to outnumber the painters. Manet and his retinue occupied a couple of reserved tables on the left of the entrance. A young art critic, Theodore Duret, frequented the Café Guerbois and describes these meetings as a witness. Fantin-Latour, who held to his own methods of painting, was often seen there. Guillemet the landscape painter of the naturalist school, the engravers Desboutin and Belot, Duranty

> the novelist and critic of the realist school, Astruc, sculptor and poet, Émile Zola, Degas, Stevens, and Cladel the novelist appeared there frequently. . . . These, together with the painters directly allied with Manet, formed the nucleus of the group. . . . Manet was the dominant figure among them; with his animation and wit, the authority of his artistic judgment, he set the tone of the discussions.

His position as a persecuted artist, abused by the champions of official art, made him the leader of the men assembled there. . . .[20]

Monet saw these gatherings as useful for keeping them all on their toes and unified as a group. The collective will was strengthened, their thoughts clarified. Someone would bring into the discussion the ideas of the socialist Proudhon, inspirer of Courbet, or the case of Millet who had declared, "I will never have the art of the Parisian drawing rooms forced upon me. A peasant I was born, a peasant I will die."

Socialist talk inevitably threw up the name of the utopian Charles Fourier (1772–1837), whose influence on all thinking of a libertarian cast was considerable. Fourier, a Lyons businessman, devised a utopia expressly for the small man, the petty bourgeois. Seeing apples being sold in Paris at a hundred times the price they fetched in the place where they were grown, "I began to suspect that there must be something radically wrong in the industrial mechanism." In his book *The Passions of the Human Soul* he split humanity into *phalanstères* (phalanxes), each of about eighteen hundred members. Each phalanx was devised to encourage work for passion rather than profit. Fourier's theory was built around three abstract principles, Nature, God, and Justice. Nature was passive, received through the five senses. God was active and made possible the "group" feelings. Justice was a welding or reconciling element which gave rise to the "distributive passions." Martin Seymour-Smith in his book on Thomas Hardy tells us that Hardy was "fascinated by Fourier's broadly Rousseauist notion that the passions essential to humanity had been repressed by civilization. When they were released, civilization and the greed attendant upon it would be replaced by harmony—in itself the crowning passion which synthesizes the rest—and self-realization."

His ideas amounted to a sweeping indictment of the whole social order, which had to be transformed. Work, at present crushing and inefficient, had to be made a joy, and the "parasites of commerce" destroyed. It was not a question of improving man but liberating him. Once this was achieved, the rest would follow as the day follows night.

Cézanne dropped in occasionally and sat at one of the coffee-stained tables, after first making a performance of opening his jacket and hitching up his trousers. He would shake hands all round with a show of affability and extravagant courtesy. These preambles were all

symptoms of his acute discomfort. Monet, full of self-assurance himself, took pleasure in what he took to be the other's arrogance, whereas Cézanne, still as gauche in sophisticated circles as when he was an adolescent, took the smiles and chatter and fine clothes as somehow intended to ridicule him. He would sit in a corner and do his best to ignore everyone. Once he said to Manet, grinning painfully, "I won't offer you my hand, M. Manet, I haven't washed for a week." If he heard something especially maddening and falsely clever he was liable to shout out something abusive and then depart abruptly. "*L'esprit m'emmerde*" (wit shits on me), he would mutter over his shoulder.

His cloacal humor and abuse and his recoiling from physical touch now and then produced the comic element we see appearing incongruously in Cézanne's early paintings. We can't laugh heartily: there is too much rage, painful struggle, and oppressive sensuality coming through. The tension and hurt disturb us. It is too close to the bone, too near the adolescent fantasies that have contorted us all at one time or another. Inhibitions, neuroses, violence, fantasy: we feel uncomfortable, intruders on a private world where furious games of revulsion-attraction are being played out with morbid, sometimes murderous intent.

What exactly is going on? Zola, timid in his youth to the same extent as Cézanne when it came to the physical self, felt compelled to make the sexual female wicked, attracted and repelled simultaneously by the nakedness of women and driven in his work to dwell on obscenity and excrement. Sex in his books is invariably destructive, desolate, promiscuous. Worst of all, it threatens the toil that produces literature. How inevitable it was then that he should come to loathe his own productions.

D. H. Lawrence in his *Introduction to These Paintings*, in part an extended essay on Cézanne, advances the argument that a fear of the instincts and a horror of the living body took a grip on the northern consciousness at the end of the sixteenth century. With characteristic vehemence he goes on to argue that this strange horror and terror of the physical came, "I believe, from the great shock of syphilis and the realization of the consequences of that disease."[21] This terror-horror lodged deeply in the human imagination led to the rise of Puritanism and, says Lawrence, to the crippling of the consciousness of northern man. Whether we accept this or not, there is no denying that in the case of Cézanne it makes sense to see him a prisoner of sex, caught by an overmastering dread and horror of the body—the desired female body being the greatest dread—and wanting, beginning with bread, an

onion, a can of milk, to climb out of morbidity and miasma and regain his own flesh. Then the intuitions, the earth, apples, would be added on to him. Are we touching here on the prime torture of his life? "I am so feeble in life," he said repeatedly. Was this what he meant?

His absurd behavior at times, like his social phobia, come to take on a kind of bitter logic. Sex after all had become a dirty business, the physical was a horror—why not throw excrement at it? As for the encroachment of others, maybe if he sounded disgusting and looked unsavory, people would give him a wide berth, let him be. It was a solution of a kind.

As we shall see, in his oscillations he dreamed of returning to that Arcadia of his youth where all was virginal and unsullied. That was where he had, briefly and wonderfully, lived in the body like a happy savage, running around naked, in real natural innocence, on the river banks with Baille and Zola. He wanted to return not out of nostalgia but in order to begin truly. So he conceived a terrible desire to paint naked figures, male and female bathers. No one else wanted them but he kept on.

Immediately he came up against the cliché: the classical, the romantic, the optical. A cliché is something tired, worn out, a memory cut off from its root, at worst a habit. He waged war on the cliché from the outset, the moment he recognized it for what it was. Those who maintained that he couldn't draw have only to look at the careful academic studies from the nude and from casts at Aix and in the Louvre. The slur is fatuous. He could turn out the cliché with the best of them. They are sensitive, competent drawings done in obedience to a formula. And here Lawrence is unerring. "But when his drawing was conventionally all right, to Cézanne himself it was mockingly all wrong, it was cliché. . . . He wanted true-to-life representation. Only he wanted it *more* true to life. And once you have got photography, it is a very, very difficult thing to get representation *more* true to life: which it has to be."[22]

Nineteenth-century artists suffered abominably from this dilemma, often without knowing why. Cézanne always knew. What made him smash up canvases again and again was his refusal to admit that his deadly enemy had triumphed over him, as it so often did. He began again, facing the problem. How to paint from an awareness of all round, not just of the front, as the camera does. How to express a world of withheld knowledge, of sensations, intuitions.

Given the impossibility of working from the female model,

Cézanne's longing to paint female figures would seem to have been doomed to failure. In the opinion of many it was. He should have stuck to landscape, they say, to still life, where he was a master. But the desire never left him: on the contrary it intensified. He worked up his figures from sketchbooks filled in the Drawing School at Aix, from life classes at the Suisse, from his copies of classical sculpture in the Louvre. He copied reproductions from an album called *Le Nu au Laouve*. He used photographs. He made copies from Delacroix, Rubens, and the sculptors Puget and Michelangelo. He wanted a baroque style that would stand comparison with the old masters, something grand and voluptuous like Tintoretto. In his long fight to square this ambition with his instinct to paint out, obliterate what had gone before, so that his realization of what was true and whole in his Mediterranean consciousness could come through, he produced the most ungainly, rudimentary nudes of his time, or of any time. Often their faces were blank or masked, as if to refuse them all personality. In an exhibition in Paris in 1978 of the late work, many people were oppressed by his towering emblematic bathers. How did one relate to such abstraction? They were confronted by what they saw as magnificent or clumsy failures, which nevertheless cast a spell on them.

# 6 THE WOMAN UNDERNEATH

We are moving toward a group of paintings that Cézanne must have seen as a new phase, allegorical pictures that critics have usually skirted around uneasily, seeing them as necessary if unfortunate aberrations to be got off his chest before his mature work began. Zola was searching at this time for a philosophy of the novel that would give him a framework for future novels. The two men were still closely linked, and Cézanne's efforts to get beyond the neurotic obsessions of his adolescence may have compelled him to assault his fears and horrors head-on in the guise of narrative or philosophical painting.

Zola was still struggling with a financial crisis that was at least partly of his own making. Under a cloud since the Salon scandal, forced to sign articles now with a pseudonym, he clashed with Villemessant and resigned.

Since he had taken the job with *L'Événement* his standard of living had been transformed. He had moved to the affluent Right Bank at Batignolles, leasing a house near the avenue Clichy which had delightfully rural views, gardens, vineyards, and smallholdings to the northwest and the outlines of Montmartre windmills on his skyline to the right. Deprived of his regular salary of five hundred francs a month he was immediately up against it, smelling again the poverty he thought he had left behind for good.

Things became so desperate that the Zolas' furniture was seized by

creditors. He went around drumming up literary hackwork from publishers. Then he managed to obtain a commission for a lurid serial, organized around material from the files of the Aix and Marseilles law courts, which ran for nine months in a small Marseilles newspaper, *Le Messager de Provence*. This series of stories went under the title *Mysteries of Marseilles*. It bored him to write it, and he dismissed it as he did so as a potboiler, but the enterprise alerted him to the benefits of newspaper serialization. Immediately he was in touch with a much larger public than he could ever hope to reach from novels alone. In the future all his fiction would appear first in serial form. Toiling away at his dreary crime stories in the mornings gave him time to start work on a tale that really interested him, *Therese Raquin*, during the rest of the day.

Valabrègue took his friend to task for writing trash, and Zola answered bluntly that he was in need of money. "I know what I'm doing." It had begun to dawn on him that a documentary work-method of this kind was congenial to him. And he was good at it, accumulating huge quantities of facts and breathing life into them.

His old school friend Marius Roux talked him into a collaboration, adapting a summary of the *Mysteries* for the stage. Probably it was this which started him dreaming again about a group, with himself as leader, united in a common purpose. He wrote to Valabrègue on February 10, "I won't hide that I'd have preferred to see you in the midst of us, struggling like us, daily renewing your endeavors, striking out to right, striking out to left, marching always ahead." He wrote again shortly afterward to report on Cézanne's progress. "Paul works very hard, he has already completed several canvases and dreams of immense pictures. I greet you in his name."[1]

Then we learn, from a letter of April 4, that Cézanne has been rejected by the Salon yet again, and so has Guillemet. "The Jury, irritated by *My Salon*, has thrown out everyone who follows the new road." Cézanne's mother had come to Paris on a visit, so she would have witnessed this latest failure. Her presence may well have been a factor contributing to his decision to give up and return home with her in the middle of June. The solitude of the country was a balm he could never resist for long.

Meanwhile, Zola's spirited reply to the jeering critic in *Le Figaro* at the expense of Cézanne's *The Wine Grog* brought an appreciative note of thanks from Valabrègue. "Paul is a child and ignorant of life," he wrote, "and you are his guardian and guide. You watch over him. He walks beside you and is always sure of being defended. An alliance

between you to defend him has been signed, an alliance which will even be an offensive one if necessary. You are his thinking soul. His destiny is to paint pictures, yours to organize his life."

Their roles were now reversed. The rough, studious schoolboy with a vile temper and peasant energy who had been the protector of the puny mother's boy was now someone to be watched over, a liability, bogged down with problems, frightened of life and unable to cope with it. To Valabrègue he was obviously an overgrown child, often distracted and beside himself. Zola, despite his incessant self-promotion, was not yet the success he craved to be, but was certain the prize would soon be within his grasp. His pathological fear of failure made it hard for him not to want to distance himself from a friend who seemed to be his own worst enemy.

When Marius Roux went to Marseilles in August to arrange a production of their play with the local theatre, Gymnase, Zola, who had lost touch with Cézanne, asked Roux to look him up. Roux went, and found himself face to face with a "veritable Sphinx." In the first few days of his stay

> I went to see him. I saw him at his house and we talked quite a long time. A short time ago we went together in the country and slept there one night; we had a lot of time to chat. Well, all I can tell you is that he's in good health. Not however that I've forgotten our conversations. I'll report them verbally to you and you'll translate them. As for me, I'm not capable of that. You understand what I mean. I haven't had a deep enough intimacy with Paul to catch the exact significance of his words. Still (I can hazard a guess) I believe he has retained a holy enthusiasm for painting. He is not yet beaten, but without having the same enthusiasm for Aix as for painting I believe that henceforth he'll prefer the life he leads here to that he leads in Paris. He is vanquished by this dull existence and he has a devoted respect for the paternal vermicelli. Does he deceive himself, and does he believe himself beaten by existence instead of by Nieuwerkerke? That is what I can't tell you and what you must decide for yourself when I describe our conversations at greater length.[2]

We hear from Marion around this time that the palette-knife paintings with their slabby solidity have been superseded by work using long strokes of the brush, choppy in the trees and ground and curling rhythmically around the limbs of figures. "Paul is here," he wrote to Morstatt, "painting, more Paul than ever but imbued this year with a

firm resolve to succeed as quickly as possible. Lately he has painted some really beautiful portraits, no longer with the knife but just as vigorous and much more skillful and pleasing in technique."

Zola came down to endure the first night of his play based on *Mysteries*. Cézanne was there on September 6 with Marion. The audience showed what they thought of the performance with a barrage of boos and catcalls at the final curtain. Zola agreed with them. His low opinion of his tale was confirmed. He went back to Paris on September 11 and Cézanne was with him. Instead of staying at the rue Beautrellis Cézanne kept on the move, lodging first at the rue de Chevreuse, the rue de Vaugirard, settling at last at rue Notre-Dame-des-Champs. Roux, writing again, exclaims in astonishment at Cézanne's watercolors, which "produce a strange effect of which I did not think watercolors capable."

Changing his technique for something altogether more fluid, Cézanne sought models for the expression of his dark moods in the baroque paintings of the old Italians and Spaniards, taking over their dramatic uses of light and dense shadow. Delacroix was another source, with his scenes of massacres and grief, but his figures had little connection with contemporary life. Cézanne wanted to dramatize the macabre conflicts within himself, and—perhaps instinctively, as a means of hanging on to his sanity—he now began to free his unconscious in a series of alarming pictures. He succeeded, despite grotesque effects and strange distortions, in marrying figure influences as diverse as Tintoretto and Daumier, in images that seemed on fire with a half-buried incandescence.

More than one commentator lately has seen remarkable parallels in the artistic productions of Zola and Cézanne during this year, 1868. What Zola called their "secret affinities" reveal themselves in both literature and painting that at times border on the psychotic. Cézanne produces a sequence of scenes of violation, murder, entombments, and stranglings. The attacker is always male, the victim a tangle-haired female. There is an atmosphere of vengeance, as if this victim, sometimes a seductress but more often drugged by terror, is getting what she deserves. There is usually an accomplice in attendance, either male or female, passively watching the crime.

*Therese Raquin* appeared first as a serial in October 1867 entitled *Un Mariage d'amour*. It was inspired by a crime Zola had seen reported

in a newspaper. Into it he poured himself, a timid puritanical man morbidly obsessed by death, sin, decay, drawn to sex and disgusted by it, emphasizing on every page the brutality and squalor from which in reality his soul shrank. Two guilty lovers murder the woman's ineffectual husband and come to loathe and destroy each other. Cézanne's imagery at times mimics Zola's, as in his *Preparation for the Funeral*. The bald, bearded figure bending over the corpse, watched by a woman, is recognizable as the artist. In *Therese Raquin* the murderer Laurent is more than coincidentally like Cézanne. They are both from Provence, both are painters, both are hog-tied by stingy fathers who object to their careers. After the murder, Laurent is driven by a compulsion to find his victim's corpse and becomes almost an inhabitant of the morgue, feverishly examining one body after another.

In both *Therese Raquin* and the novel of the following year, *Madeleine Ferat*, there is a puny, unattractive, and effeminate man who is fatherless, like Zola, in awe of a stronger, more virile friend. Laurent and Therese sweep aside the pallid, mother-dominated Camille. Presenting his novel in a preface as a deliberately concocted piece of scientific objectivity instead of the imaginative fiction full of black macabre poetry that it is, he introduces for the first time his new theory of "naturalism": "I hope that by now it is becoming clear that my object has been first and foremost a scientific one. When my two characters, Therese and Laurent, were created, I set myself certain problems and solved them for the interest of the thing. I tried to explain the mysterious attraction that can spring up between two different temperaments, and I demonstrated the deep-seated disturbances of a sanguine nature brought into contact with a nervous one."

Early in the story the Cézanne-like figure of Laurent is described as being "of genuine peasant stock, a little ponderous and stooping, with slow precise movements, calm and stubborn-looking. You could sense the hard, well-developed muscles beneath his clothes, the whole organism built of solid, firm flesh."

This calm-seeming temperament begins to crack and disintegrate after the crime, when

> a strange process took place in him. The nervous side developed and took precedence over the sanguine, and this single fact modified his whole nature. He lost his calm ponderousness and ceased living in a state of somnolence. He reached a stage in which nerves and blood were nicely balanced, and this was a stage of deep enjoy-

ment and perfection of life. But then the nerves became predominant, and he fell into the agonies that torture those whose minds and bodies are disturbed.

That was how Laurent had come to tremble at the sight of a dark corner, like a cowardly child. This haggard, shuddering creature, the new individual who had just emerged from the lumping oafish peasant, was now going through the fears and anxieties of nervous temperaments. All these circumstances . . . had combined . . . intensifying his senses by sudden, repeated shocks to the nerves. Insomnia had followed inevitably, and with it hallucinations.

Again we see how well Zola knew his friend, how close was his observation, how he understood him as an artist—as he understood himself—even if his paintings frequently left him high and dry.

We visit the artist's studio, which could well have been one of Cézanne's. It was a sort of attic,

fifteen to eighteen feet square, with a steeply sloping ceiling in which was a big window that shed a glaring white light on the floor and dirty grey walls. No sound from the street came up as high as this, and the silent room, with its crude lighting from the sky above, seemed like a hole or vault hollowed out of grey clay. Laurent furnished this hole after a fashion with two chairs with broken seats, a table he propped against the wall to prevent its falling down, an old kitchen cupboard, his paint box and old easel. The one luxury was a large divan that he had picked up for thirty francs in a secondhand shop.

There are passages that reveal, as well as his knowledge of his friend's fluctuating moods and fits of despair, his bafflement before work whose power he could sense, and by a man who was surely going nowhere. A friend, met in the street and invited up, climbs reluctantly up the five flights of stairs to see Laurent's work, "which would certainly make him sick. All he wanted was to satisfy his curiosity. But when he was up there and had glanced at the canvases on the walls his amazement redoubled. There were five studies, two female heads and three male ones, painted with real energy; the work was rich and solid, and each stood out in magnificent relief from its pale grey background."

The visitor can't believe that his friend is really the painter. "Why shouldn't I be?" Laurent asks.

He did not dare to say: "Because those canvases are the work of an artist and you were never anything but a hopeless bungler." He stood looking at them for a long time in silence. . . .

Standing there, he tries to analyze the change in his friend's character. What had brought it about? How could the sluggish, apathetic creature have so transformed himself?

On considering Laurent he thought that his voice was gentler and his every movement had a sort of refinement. He could not guess what a shattering upheaval had changed this particular man by developing in him a feminine nervous system with sensitive and delicate reactions. . . . It is difficult for analysis to plumb such depths. Laurent had perhaps become an artist in the same way as he had become a coward, as the result of the breakdown that had thrown his mind and body out of gear. Formerly he had been overcome by the sheer weight of his sanguine nature, blinded by the dense fog of his bodily health; but now, thinner, pulsatingly alive, he had the restless animation and keen, acute sensations of nervous temperaments. In the life of terror he was living, his moral disease or neurosis which had disturbed his whole being had developed in him a strangely lucid artistic sense. . . . Just as his bodily movements had taken on a sudden elegance, so his paintings were beautiful through having all at once become personal and alive.[3]

Cézanne would certainly have read his friend's novel and discussed with him the idea that a "naturalist" novelist is a scientist, no different from a vivisectionist or anyone experimenting on organic matter, since characters were only animals motivated by natural processes. Clearly he hadn't minded it; he probably saw the brutish Laurent as only superficially resembling himself. Hadn't they talked anyway about the appropriation of life for art, grist for the mill? Laurent after all was a drifter, a cynical opportunist, in contemporary terms a dropout. A railway clerk, he had tried the legal profession (like Cézanne) and turned to art as an easy option, only taking it up seriously toward the end of the novel as a means of escape from the horror of his crime.

Something in Cézanne's complex personality remained untouched throughout his life, staying innocent, even childlike, never maturing to the extent of making relationships with others relaxed and normal. Outside his family—whom he would sometimes in fantasy have liked to murder, and would soon do so in paint—he had only drawn close to

one person and that was Zola. In some uncanny fashion the two men were like twins in their imaginings. For years Zola had been aware of his comrade's devouring self-pity, apathy, and fear, so like his own, and had sought to stiffen his resolve, transfer some of his own pride, refusing to let him wallow in a picture of himself as craven, "feeble in life." Baudelaire's mordant portrayal of himself in 1851 as someone "lost in this ugly world, elbowed by the masses . . . like a weary man whose eye, cast backward into the depths of the years, sees nothing but disappointment and bitterness, and in front of him a storm which holds nothing new, neither learning nor pain," gives us a picture of Cézanne's inner state. Zola was a tougher character, able to feed on his own weaknesses and, to some extent, exploit them. If he did in fact deliberately cut himself clear at some point of the apparent wreckage of his friend's career, as some have alleged, calling him in 1896 *"un grand peintre avorté,"* it has to be remembered that he also said, "I had grown up virtually in the same cradle as Paul Cézanne; one is only now beginning to discover the touches of genius in this abortive great artist."

One is tempted to wonder whether the example of Zola, plunging with both hands into the dark recesses of his own night, compelled and mortified by the demons he dredged up, served to propel Cézanne toward the oppressive symbolism and autobiographical violence of the next three or four years. The period of savagery, orgy, temptation, murder, rape, and self-mythologizing was soon well under way, with, alongside it, the internal romance which accompanied everything he did. This painter claimed by the realists was in point of fact a repressed romantic who dreamed of being a classical artist.

The bizarre *Abduction* was actually painted in Zola's house. The classical trimmings are firmly in place in this scene of violation. The bronze giant carrying off the fainting woman wears a garland. One of the two warm-bodied nymphs on the distant river bank dangles a girdle belonging to the victim which, says Mary Lewis, identifies her as Persephone abducted by Pluto to his nether kingdom.

The dense trees crowd in darkly, blocking any escape. The man, grotesquely muscled and huge, has knotted, congested limbs. The woman collapsed in his arms is corpse-white, drained of blood, and is one of the first of Cézanne's curiously masculine females, with broad shoulders and as tall as the man. Though not yet introducing himself, Cézanne localizes the landscape by having the mountain Sainte-Victoire clearly visible in the distance as it is on the plain outside Aix. A river which could be the Arc flows down from the base of the moun-

*142*

tain and cuts the lower part of the picture in half. The wind-torn gloomy forest brings to mind Cézanne's adolescent poem "A Terrible History," where "trees thrusting their branches toward the sky spontaneously bent their audacious heads." The poem's dreamer encounters a woman, which proves rapturous and then horrific: "Oh, upon my soul I never saw such a beauty . . . encouraged, I kissed her palpitating bosom. At that instant the chill of death seized me, and the woman in my arms who had been so pink and rosy suddenly disappeared and turned into a pale cadaver. . . ."[4]

Cézanne is positioned in the middle of a page of sketches which is undated, dressed in a dark frockcoat and light breeches, balding with long hair. He stands like a dandified ringmaster: all he needs is a whip. Around him are vignettes of groups and couples all engaged in violent acts. Again one is reminded of Baudelaire, whose personae included "the top-hatted dandy and the tormented soul, the voluptuary and the obsessive perfectionist, the petulant child and the worshiper of child-like naiveté. . . ." On the sheet of sketches one finds the abducted woman, bodies are being carried, wild gestures and upraised fists denote assaults and stranglings. Soon we will have pictures that include obvious self-portraits. The close association with Zola would have brought him a copy of the novelist's *Madeleine Ferat*, and very probably he read *The Temptation of Saint Anthony* by Flaubert, a writer he greatly admired. In each book the author is unmistakably present.

So in a sense the dream of collaboration which Zola had always nourished was being enacted. Zola once wrote to tell Cézanne of his dream: a beautiful book he had written was illustrated by his friend's engravings. "Both our names were shining there together in gold letters on the first page, and in this bond of genius, inseparable, passed into posterity."

Mary Louise Krumrine has noticed that in these first examples of Cézanne's allegorical phase the form of the woman is often indistinct, half hidden by the man's body as in the *Abduction*, or by shapeless clothing or flowing hair. The fate of the woman, however, is always brutally apparent.[5]

The wall of blackly rotting vegetation in the *Abduction*—sometimes called *The Rape*—and the mountain sealing off the couple, the river of dissolution at their feet, tells us that they are *both* trapped. So indeed was Cézanne, by the neuroses bred in his adolescence, bubbling up vilely in him as corpses, putrefaction, ogres, specters, which he tried to pin down in thick paint, spawning misshapen creatures that clung to

*143*

him in his struggle to break out into maturity. The abductor was him, but so was the victim. His psychology tended as much to self-immolation as it did to transgression. The big, bloodless, swooning woman could be seen as a manifestation of his wretched helplessness before the host of phantoms lying in wait, always ready to swarm out from that gloomy wood and ambush him.

The rapist is fueled by self-loathing—which Cézanne had in abundance—but what feeds him above all is his hatred of women. There is little point in raping an unconscious woman: her terror needs to be seen. It is possible of course that in this picture the rape had already happened. The woman being carried off could almost be someone rescued, taken to a place of safety, except for the man's backward-straining torso, the woods and mountain and black river enclosing them like a tomb. The woman is the corpse of beauty. In Cézanne's eyes, in his wretched state, beauty makes no sense. His nightmares have killed it.

◆ A curious rumor began to circulate after Zola's next novel, *Madeleine Ferat*, was published, and what this tells us is how closely the two men were still bound together in the eyes of colleagues and friends. It shows us too how deeply implicated the writer was in his fiction, just as the painter was in his art, fighting tooth and nail to retrieve something lost in the fields and woods of his native Provence. When the extent to which Zola's new novel was based on personal anxieties becomes clear, it is no surprise to find so many autobiographical parallels.

A tendency to plagiarism led Zola more than once to borrow the ideas of others, and in this instance he found a theory in Michelet's *L'Amour* which blended well with a treatise on heredity by a Dr. Prosper Lucas. Why he found such a dubious theory so irresistible is puzzling, until we read of his obsession concerning Alexandrine at the start of their affair. An irrational fear whispered in his ear that if her former lover, a medical student, were to return, she would go back to him. The theory Zola had accepted unconditionally as scientific maintained that a woman stayed tied to her first lover organically and inescapably, regardless of any new relationship. (The idea was taken up as a theme and explored with great subtlety by D. H. Lawrence in his story "Samson and Delilah," in which a man who has deserted his wife fifteen years earlier turns up out of the blue in Cornwall to claim her.)

Nothing of this sort happened to Zola, but he was haunted by the

fear that it might. The pernicious theory he had swallowed so readily also suggested that a child by a subsequent partner would resemble the lover who had first possessed the woman. This black magic too was accepted wholesale, and may possibly have led to Zola and Alexandrine remaining childless.

The similarities with real life mount up as the novel unwinds. The former lover in the book, Jacques, is a medical student. Guillaume, the spooked hero, was teased and bullied at school—like his creator. He is an only son, fleeing from life into dreams, who loses his visionary adored father at an early age—again like Zola. It transpires, in another twist of the knife, that Jacques was an old school friend and like a brother to Guillaume. Madeleine Ferat is in fact Alexandrine idealized. The persistent tale that it was Cézanne who had introduced Alexandrine to Zola in the first place now took on a new slant: the triangular relationship worked out in a melodrama riddled with preposterous coincidences was, so the rumor ran, built on the trio of Zola, Alexandrine, and Cézanne. It demonstrates, if nothing else, how little was really known of Cézanne by anyone except Zola. He was no more capable at this stage of being a lover than of being the abductor in his painting. Neurotically paralyzed by the thought of any interaction with the world outside himself, he had to convert activity into theatre and project tableaux in paint that were sheer rampages in the unconscious, planting them with mementos from his own life and internal "crimes." Solitude had become a way of life.

*Abduction* is linked by scholars with a picture painted from life, *The Negro Scipio*. One can see why. The latter canvas may have come before or after the big painting. The model was a favorite with students at the Academy Suisse, where Cézanne went to paint and draw from 1862. Apart from the figure itself, seated on a stool, naked to the waist, and presenting an enormously long muscled back, one hand tensely gripping the stool and the other arm cradling the head, critics point to the free curling brush strokes, even more passionately handled than in the big composition. The body itself, elongated and huge, immediately suggests the dark aggressor of *Abduction*. Again, both pictures have been linked with a decoration, *Christ in Limbo with the Magdalen*, which adorned the salon wall of the Jas de Bouffan, before being removed and sliced in half after Cézanne's death. The *Magdalen* is now in the Musée d'Orsay, Paris, and discussion still goes on regarding this dismembered painting. The drawing of the hands recalls the same detail in *Abduction*; the loops of drapery in the former look similar to the looped folds of

Scipio's blue trousers. Suspended over the Magdalen's grieving head in the darkness are three large stylized tears representing Pentecostal flames (now discovered in pious French poetry by Mary Tompkins Lewis). Cézanne borrowed freely here and for his *Abduction* from sixteenth-century conventions. He had begun in earnest to make use of sacred art for his own purposes. Pictures by Ribera which had appeared in the Louvre had their influence on the grim cartoonlike *Preparation for the Funeral*. Lawrence Gowing is reminded by the bearded, wrinkled bald head bending over the corpse of the series of bald heads in Caravaggio's *Death of the Virgin*.

It is also one of the first instances of Cézanne inserting himself, in this case center stage. The head's peculiar resistance to foreshortening appears again in *The Murder*, this time on the shoulders of a woman holding down the victim for stabbing. This terrifying expressionist picture, dragged sideways in all its parts by the violence howling through it, has the ferocity and horror of one of Goya's war atrocities. There is much distortion, as if the artist himself was convulsed, near to hysteria. One recalls the murder in *Therese Raquin*, the victim a "poor creature, with his twisted body and looking so skinny," Therese not participating but just as much an accomplice as the woman in the picture.

It was in the late 1860s that he met Père Tanguy, the Paris color merchant. Julien Tanguy came of a family of small weavers: he was born in Brittany in 1825. When they met, Tanguy was middle-aged, a committed socialist, the type of incorruptible working-class man Van Gogh loved to paint. Vincent, meeting Tanguy as an old fellow twinkling with innocence, enshrined him in a famous portrait. Tanguy began adult life as a plasterer, sold sausages in his wife's butcher's shop, and then became a railway worker. Moving to Paris he learned to grind colors and then sold colors himself, while his wife supported them as a concierge in Montmartre. He despised money and was always ready to give credit. Naturally the painters liked him, but he was easy to befriend. If a painter was hard up he would take a canvas as payment. Eventually he accumulated some fine Cézannes.

The Salon jury of 1868 surprised the rebels by letting in works by Manet, Monet, Pissarro, Bazille, Renoir, Sisley, and Solari. Manet showed a portrait of Zola. Of these stalwarts, Cézanne was the only one rejected. The Comte de Nieuwerkerke expressed his contempt for what he regarded as a "Salon of Upstarts," and sympathetic critics

were surprised to find that "The doors have been opened to nearly everyone who presented himself."

Only Marion gives us any idea in this year of what Cézanne was thinking and feeling. He wrote loyally that Cézanne was stronger than Courbet and Manet, adding naively, "I think the moment of his success isn't distant. It's merely a question of producing."

Though he was soon to take a more pessimistic view of Cézanne's future, his faith in his friend's powers remained unwavering. Writing somberly to Zola about the chances for "realist" painting, he confided gloomily that in his opinion Cézanne was becoming a marked man, since

> his name is already too well known; too many revolutionary ideas in art are connected with it. The painters on the jury will not weaken for an instant. And I admire the persistence and nerve with which Paul writes to me, "Well, they'll be blasted to eternity with even greater persistence." All that considered, he ought to think about finding another and greater means of getting publicity. He has now reached an astonishing perfection of technique. All his exaggerated fierceness has been modulated, and I think it's time that circumstances offer him the means and opportunity to produce a great deal.[6]

Another time he reported, this time to Morstatt, "Cézanne is working with all his might to control his temperament, to impose rules of a cool temperament on it. If he succeeds, my dear chap, we'll soon have powerful works of great achievement to admire."

Marion goes on to describe with some excitement a landscape which would include portraits of friends. "One of us, in the middle of the landscape, will be speaking, while the others listen." When it was done Cézanne intended "to make a gift of the canvas, nicely framed, if it's welcome, to the Marseilles Museum, which will be thus compelled to display realist painting and our glory." If this picture was ever completed, it hasn't seen the light. He may have put his fist through it, seized by one of his uncontrollable rages. It was a time of impetuous outpouring, which was the only way he could express a terrible need he now had to fling open a door in himself and be exposed, stripped and surrendered for all to see. Sometimes the guilt churning in him came out as erotic indulgence, sometimes in picturesque effects that made him lash out in disgust. He seized on caricature and overdid it, producing grotesque bodies, ugly profiles. *Christ in Limbo* was a blasphemous

exercise in autobiography. His work stained and blackened him, plunged him into depression.

Marion was an appalled witness. "What a generation of sufferers, my poor old friend Zola, the pair of us, and so many others. There are sufferers among us who're just as unhappy with fewer troubles: Cézanne with his secure livelihood and his black despairs of morale and temperament. One must resign oneself to all that."

Proust, in *Against Sainte-Beuve*, wrote that "We are dumbfounded when meeting socially with a great man whom we know only through his works." How did one find the source of great art in someone who seemed often on the verge of lunacy? Proust puts forward the notion of two selves, the one that produces the art and another, obscuring self, "which may be very inferior to the outward self of many other men."

As well as inner turmoil, Cézanne was suppressing money worries. His father, preoccupied with the widespread recession that would hasten the end of the Empire, obstinately refused to make any addition to his son's allowance. He had always kept him short as a matter of principle. Sometimes he even hinted darkly that he wouldn't be able to afford it much longer. None of these tidings and vague, only half-serious threats improved his son's temper. Marion would hear him express blistering contempt for the circle around Gibert, director of the museum. Cézanne was never able to abide bad painters, calling them "goitrous."

On the other hand the tenderness called up in him by thoughts of friends and acquaintances in Aix is moving to read. Exiled in Paris once more he wrote to Justin Gabet, a cabinetmaker who lived and worked near the Cézannes in the rue de Boulegon, asking to be remembered to everyone.

> Well, I've been rejected in the past, but I'm none the worse for it. Unnecessary to add that I paint all the time and for the moment am well. . . . Please give my regards to Mme. Gabet and kiss little Tintin for me. Greetings also to your father and father-in-law. And don't forget our friend the street lamp extinguisher Gautier, and Antoine Roche. My dear friend, I embrace you with all my heart, and good courage, all yours, your old friend P.C.

This was in a year or two. Still in Aix in July 1868, he wrote to Coste, now doing his military service outside Paris, telling him about his days, his uncertainties and vacillations, and showing a sociable side to his nature which surprises, and an engaging warmth, always imped-

ed by the painful shyness which never left him. There is a reference to Rochefort, an uncompromising republican whose paper *La Lanterne* had recently been banned. If not an ardent republican himself, Cézanne was certainly hostile to the Empire.

From Aix, the nomadic painter whose deepest desire was to be an anchorite tries to rake up something about Coste's "far-off homeland" in reply to his friend's letter of a few days before. Here he was "in the green," in the country,

> and I've cast myself loose a few times. One evening, then another, I ventured on your father, whom I didn't find in, but one of these days, at full noon I think, I'll catch him at home.
>
> As for Alexis, he was kind enough to come and see me, learning from the great Valabrègue of my return from Paris. He has even lent me a little 1840 revue by Balzac. He asked me if you went on with your painting etc.—you know, everything one says when chatting. He has promised to come back and see me; I haven't seen him for more than a month. On my part, and especially after getting your letter, I've been turning my steps in the evening in the direction of the Cours, which is somewhat contrary to my solitary habits. Impossible to meet him. However, urged by a great desire to fulfil my duty I'll try a descent on his house. But on that day I'll first change my shoes and shirt.[7]

His lonely isolation comes over strongly and sadly when he tells Coste of "a great gulf [that] seems to yawn about someone who's been away from home for some time. . . ."

> I don't know if I'm living or only remembering, but everything makes me think. I wandered off alone as far as the Dam and St. Antonin. I slept there on a straw pallet among the miller's family, good wine, good hospitality. I recalled our attempts at climbing there. Shall we ever make them again? *Bizarrerie* of life, what a diversion, and how difficult it would be right now for the three of us and the dog, at the moment I mention, to be together in the place where we were only a few years ago.
>
> I have no distraction outside the family and a few copies of the *Siècle* where I gather anodyne news. Being alone, I venture with difficulty into the café. But behind it all I'm still hoping. . . .
>
> P.S. I left the letter unfinished when at midday Dethès and Alexis tumbled in to see me. You can imagine we talked of literature

and took refreshment, for it was very hot that day. Alexis was good enough to read me a piece of poetry that I found truly very fine, then he recited from memory some strophes of another entitled "Symphony in A Minor." I thought these verses more unusual, more original, and complimented him. I also read him part of your letter; he said he'd write to you. Meanwhile I send you his love, also my family's: I read them your letter, for which I heartily thank you, it's like dewdrops in burning sunshine. . . . I vigorously clasp your hands, with all my heart, Paul Cézanne.[8]

We see here his great respect for poets, and the swerve of his thoughts and feelings, evoked by his pilgrimage to the dam, back to the carefree past and lost comradeship. "Shall we ever make them again?" Driven out by loneliness from the family home, he knows that nothing he might encounter in the streets of Aix is likely to help. Contact with others seemed to intensify his plight, which shamed him, it was so pitiful. A constant fear of life crippled, disabled him. "I venture with difficulty into the café."

Desperation can become a way of life. Willing himself to live took energy. He never seems to have been suicidal but willed himself desperately to go on, somehow finding the courage to overcome dire feelings of unreality and vacancy, when he felt orphaned, the last man on earth. To be essentially passive meant that one was receptive as a flower, a great gain for his art but a state liable to render him ineffectual and purposeless in everyday life. Keats understood the condition perfectly well. Writing to his friend Richard Woodhouse in October 1818 he expressed the belief that the "poetical character . . . has no self—it is everything and nothing—it has no character. . . . A Poet is the most unpoetical of anything in existence, because he has no identity—he is continually filling some other Body." And he went on to confess that "When I am in a room with People . . . the identity of every one in the room begins to press upon me so that I am in a very little time annihilated."

Perhaps Cézanne was saved, finally, by his grasping peasant forebears, rooted in the earth. Strangest of all, it could well be that he was saved by his intractable father, who accustomed him to failure and gave him a contempt for recognition. How could he ever please his father? And if he couldn't, what did success matter?

Within him always were those youthful halcyon days, lodged in his breast like a secret sun, an earth memory of ancient sunlight, whereas for Zola, as celebrity overtook him, they steadily faded. When Cézanne at last inherited his father's money he became an upstart bourgeois like his father, ready to spit in anyone's eye, important or not. His coarse sense of fun saved him from paranoia. Zola ending as a bourgeois was a quite detestable sight, his taste atrocious, his wife ruling him as his mother had, through bourgeois devotion, order, and efficiency. He succumbed in a way that timid Cézanne, always in fear and trembling before his father, never did. Lawrence, alert and canny as Cézanne himself, writes in his essay on painting that "a bourgeois in Provence is much more real and human than a bourgeois in Normandy."

He was plunging headlong into the creation of fantasies, yet could still turn aside and paint from life. He did more work while at Aix on the *Overture to Tannhäuser*, his elder sister Marie posing for him at the Jas de Bouffan piano. The painting went back to 1866, evidence of the doggedness with which he hung on to certain projects. Louis-Auguste occupied the armchair, then was painted out and replaced by his friend Marion. Finally the armchair was left empty. A woman on a settle, sewing or knitting, could have been the artist's mother. The drawing is naive and childlike, the style, in Gowing's words, "Manet gone barbaric." The fat bold arabesques patterning the wallpaper create fauvism forty years before its time.

Wagner's overture, first played in Paris in 1860 and hailed by Baudelaire as voluptuous and orgiastic, sounded hosannas for both Zola and Cézanne, eager as they were to abandon moderation and embrace excess, to exploit the raw material of life for art. Cézanne would have already seen the large oil in the 1864 Salon by Fantin-Latour entitled *Tannhäuser: Venusberg*. Now Cézanne was ready to stage his own dramas of transfixed conflict and dreamlike repose, using voluptuous nudes in dark pastoral settings, opposing the senses and the spirit, pain and pleasure.

Two more paintings from life came first. Paul Alexis, Zola's only dedicated fan at this time, is shown reading to the master in a crudely naive oil sketch, with the heavily swagged curtain to the left—owing something to Dutch genre painting—giving the scene the look of a lit stage. (One realizes that virtually all Cézanne's work issues from the dramatist in him: even his still lifes were composed dramatically.) He followed up this sketch a year or two later with a remarkably accomplished, utterly modern version of the same subject which he left

unfinished, presumably seeing it as a failure. The Prussian blue tones and dense Manet blacks give it a morose intensity. Alexis has papers in his hand and is drawn up in a chair in profile. Zola, gazing gloomily out of the picture, faces us like a pasha with his legs folded up on a divan. Painted by Cézanne in his friend's house, it was found unacceptable, perhaps by Zola but more likely by his wife, and consigned to the attic.

The faithful Alexis is portrayed far from attractively in Zola's *The Masterpiece* as the character Jory. The son of a rich lawyer in Plassans (Aix), whom he had driven half crazy by his dissolute behavior, he had

> crowned everything by running away with a music-hall singer under the pretext of going to Paris to follow the literary profession. . . . His first writings in his native town had been some Parnassian sonnets celebrating the copious charms of a handsome pork-butcheress. In Paris—where he had fallen in with the whole band of Plassans—he had taken to art criticism, and, for a livelihood, he wrote articles for twenty francs apiece in a small, slashing paper called "The Drummer" . . . he displayed a hereditary tightness of fist which most amused his friends. He managed to lead a profligate life without money and without incurring debts; and with the skill he thus displayed was allied constant duplicity, a habit of incessantly lying, which he had contracted in the devout sphere of his family, where his anxiety to hide his vices had made him lie about everything at all hours. . . .

Altogether more admirable by all accounts was the cruelly deformed and stunted Achille Emperaire, eighteen years older than Cézanne. Born in Aix in 1829, he remained obstinately dedicated to art all his life. He was always poor, often in desperate straits. The two men first became acquainted when Achille left for Paris in 1861 and joined the Academy Suisse. Two superb preliminary heads in charcoal led to the big oil, over six by four feet, a full-length portrait showing the sad little dwarf defiantly enthroned in a flowered armchair, his shrunken stick legs not reaching the floor. Instead his feet are propped on a footwarmer. He wears a blue bathrobe. His overlarge head, mane of hair, and goatee, together with his bony clawlike hands, are painted thickly in broad vigorous strokes. Above his head, "like an ironic proclamation," Cézanne stenciled the name in large capitals: Achille Emperaire. One could accuse the painter of brutal caricature, before taking in the

wistful eyes, the delicate rendering of the skin, and the fact that the diminutive body and cavalier's head convey deep sympathy for the man's pariah life, painted by an artist who often felt himself to be one. The armchair is the one in which he painted his father.

They must have looked a strange couple as they visited the galleries in Paris together. They shared enthusiasms for Rubens and the Venetians, only falling out over Delacroix, for Cézanne as for Baudelaire "one of the rare elect . . . the model of the painter-poet," an artist whose color "thinks for itself independent of the objects it clothes."

The young Gasquet, who knew both Aixois in their old age, remembered poor Achille's nerves of steel, "the iron pride in a deformed body, a flame of genius on a warped hearth, a mixture of Don Quixote and Prometheus." As usual Gasquet is enraptured by his own language, but his words are the only ones we have. He describes Achille doing exercises in his miserable lodgings for an hour every day in a feverish desire to grow taller and to keep on living. In a cheap eating house on the passage Agard in Aix he had left paintings of an Amazon in the style of Monticelli and two still lifes, one a haunting picture of game by the side of a bowl of blood, "which Cézanne liked so much that he sometimes ate the horrible stew of the restaurant in which they were hung in order to be able to look at them in peace. He wanted to buy them, but had not the courage, he told me, when the restaurant failed and the property was sold."

Once when Achille was destitute, Cézanne wrote an appeal for help to Zola, by then in a position of some influence. It was at a time when he had quarreled with his father and was without funds himself. "His family is in a most distressing position, three children, winter, no money etc.," he wrote of Achille to Zola. "You can imagine what it is like. Consequently I beg you . . . to see if there is nothing to be obtained for him within a short time. . . . See if you could find for him, or help him to get some kind of job, on the docks for example."[9]

According to an unconfirmed story Cézanne did once—perhaps through Zola—wangle for Achille the offer of a position as inspector of sewers in Paris, which the fiercely proud little man turned down as beneath his dignity.

Cézanne told Gasquet on one occasion that there was something of Frenhofer, the artist-hero in Balzac's *Unknown Masterpiece*, in Achille Emperaire. He certainly found a likeness to himself in Balzac's character. The novel appeared in 1831 and haunted him for years. Émile Bernard reports a startling reaction when, toward the end of

Cézanne's life, he spoke about Balzac's legendary painter. Cézanne got up from the table without uttering a word, tapping his chest and his head repeatedly with his index finger. There were tears in his eyes.

Why was he so moved, and why did he identify himself with Frenhofer so emphatically? When he came to paint his *Modern Olympia*, seemingly a crude parody of Manet's picture, he created a scene replete with details from Frenhofer's own painting: "One sees a woman lying under curtains, on a couch of velvet. Near her a three-footed stool of gold exudes perfume. You are tempted to pull the tassels on the cords which draw back the draperies, and it seems that you can see the breast of Catherine Lescault, a beautiful courtesan called La Belle Noiseuse, move as she breathes."

Reading Cézanne's statements on art and its aims one is struck by the way in which Frenhofer's ideas resemble his own. Balzac's artist is an agitated, tormented creature, never sure of his achievement. After struggling for ten years he is convinced that his painting is a triumph. He shows the painting to two younger painters and they see nothing of the sort, only "colors placed together in chaotic confusion, held together by a mass of strange lines and forming an impenetrable wall of paint." They go on searching for meaning in all this confusion. One artist spots "a piece of foot emerging from this chaos of colors, shades, undifferentiated hues, a kind of mist without shape," and exclaims, "There's a woman underneath!"[10]

The "woman underneath" would be a source of anguish for most of Cézanne's working life. Did he want to get beyond Frenhofer's obsession with ideal beauty, tear off the veils and reach the "eternal feminine" underneath? The female in his *Modern Olympia* bears no resemblance to Manet's pert, immature prostitute. There are pages of studies of a penitent Magdalen. Charles Blanc describes a Magdalen by Correggio as passing from sorrow to seduction in her pose. "There is more elegance than sadness, more voluptuousness than remorse in this beautiful body lying amorously on the grass."

Not that Cézanne's drowsy Olympia could be seen as beautiful. To our modern eyes she seems a sardonic jest. In *Claude's Confession* the Zola-like narrator looks at the sleeping prostitute Laurence: "The girl was still asleep and now fully revealed in the light. I thought I had been mistaken when I declared she was ugly and began to contemplate her. A gentler sleep had put a vague smile on her face; her features were relaxed, and past suffering had given her ugliness a look of both bitter

and sweet beauty. Her soul overcame her body and found its true expression in her face."

Woman is more deeply enmeshed in cliché than anything else because of centuries-old dread. The instincts inside a man can be ignored, in a woman they are there for all to see, until clothed in the ideal, until dressed in cliché. "Clichés are the leprosy of art," said Cézanne in his old age, and went on to say that by painting goddesses you cease to paint women.

Frenhofer was a man who had not managed to make clear his vision, who was deluded—a fate especially poignant to Cézanne, who was never quite convinced that he had beaten the cliché and broken through, as he touched the canvas intuitively, with the very touch of life itself. And because to him art was a religion, nothing else would do.

Balzac describes Frenhofer as a man "passionately devoted to art, who sees higher and further than other painters. He has thought profoundly about color, about the absolute truth of line, but as a result of his researches he has begun to doubt even the object of his researches." He concludes that nature is a series of interlacing curves; drawing does not exist, since line is the means by which man renders the effect of light on objects; "but there is no line in nature where everything is full. It is in modeling that one draws—that is, detaches things from their environment. The distribution of light alone gives bodies their appearance." The only way, rather than drawing a single line, was to attack an object at the center, dealing with highly lit features first, then the darker parts. "Is this not what the sun, the divine painter of the universe, does?"[11]

Cézanne's opinions, recorded in old age by his contemporaries, contain many echoes of Frenhofer's thought:

Line and relief do not exist. Drawing is a relation of contrasts, or simply the relation of two tones, black and white.

Pure drawing is an abstraction. Drawing and color are not distinct, everything in nature is colored.

There is no such thing as line or modeling; there are only contrasts. These are not contrasts of light and dark, but the contrasts given by the sensations of color. Modeling is the outcome of the exact relationship of tones.

Everything in nature is modeled on the sphere, the cone, and the cylinder.

Drawing and color are not separate at all; in so far as you paint, you draw. When the color achieves richness, the form attains its fullness also.

It is all summed up in this: to possess sensations and to read nature.

Painting from nature is not copying the object, it is realizing one's sensations.[12]

Jack Lindsay notes astutely that although the climax of Balzac's tale—the cruel defeat and the collapse into chaos—were not the crucial things for Cézanne, he was acutely aware of the dangers threatening the artist in a society as disruptive and anarchic as his. Modern life with its pressures, its uglinesses, its innate disorder and loss of belief, as if everyone was stricken with an inner disease, led inevitably to self-dissolution, to a rendering meaningless of artistic form, unless the artist slowly and doggedly fought back, substituting another way. This was the moral of Balzac's story.

Cézanne spoke repeatedly of "realizing one's sensations." The terms *realize* and *realization* were of prime importance to him, encapsulating everything he was striving to create out of himself, new and different. They implied a reaching out for objective substance by subjective means, rather than by projecting oneself into it subjectively, which was Van Gogh's way. Lawrence uses the same term, in his reflections on Cézanne and elsewhere. "His consciousness wanted a new realization," was how he put it. A nineteenth-century critic, Castagnary, wrote in his *Philosophie du Salon de 1857*, "A realized work is, on the basis of the idea contained in it and its outward form, not a copy and also not a partial imitation of nature, but an extraordinarily subjective production, the outcome and the expression of a purely personal conception."

# 7 PRISONER OF SOLITUDE

The monumental portrait of Achille Emperaire was submitted to the 1870 Salon jury, together with a nude, since lost. The intention must have been to shock and scandalize, but this time Cézanne exposed himself to ridicule, falling into the trap of being "interviewed" by the Paris weekly *Album Stock*. (Previously he had deliberately invited ridicule but on his own terms, trundling his submissions through the gates in a wheelbarrow, dressed in workman's overalls, on his head an old peasant hat. He could have been mistaken for a hawker.)

The journal quickly produced a cartoon of him waving the two rejected pictures. Underneath was printed a paragraph of comment, which included Cézanne's rancorous answer to the tongue-in-cheek reporter:

> The artists and critics who happened to be at the Palais de l'Indus-trie on March 20th, the last day for the submission of paintings, will remember the ovation given to two works of a new kind. . . . Courbet, Manet, Monet, and all of you who paint with a brush, a broom, or any other instrument, you are outdistanced! I have the honor to introduce you to your master: M. Cézannes [sic]. . . . Cézanne hails from Aix-en-Provence. He is a realist painter and what is more, a convinced one. Listen to him rather, telling me with a pronounced Provençal accent, "Yes, my dear Sir, I paint as I

see, as I feel—and I have very strong sensations. The others, too, feel and see as I do, but they don't dare . . . they produce Salon pictures . . . I do dare, Sir, I do dare . . . I have the courage of my opinions—and he laughs best who laughs last!"[1]

The legend ACHILLE EMPERAIRE PEINTRE, stenciled with packer's stencils across the top of the portrait in yellow ochre—anticipating the avant-garde of the next century—was no doubt suggested by the inscription on Tintoretto's self-portrait in the Louvre. The missing reclining nude, caricatured in *Album Stock* by a hideous bony figure, once belonged to Gauguin, who took it to Denmark with him. In 1884 it found its way to Tanguy's shop, along with the portrait. Émile Bernard and Maurice Dennis both saw it there. The awkwardly protruding hip and elbow and the distortion produced by the twist at the hip found favor later with artists such as Matisse.

After this mauling by the press, Cézanne retreated once again inside himself. He wrote to Coste confessing that he needed to write himself a list of things to do and people he ought to see, otherwise he was liable to forget. "Your letter has given me a great deal of pleasure, it rouses one from the torpor into which one ends by falling. . . . You can see clearly how much the willpower of our boyhood comrades is beginning to weaken, but what can you expect, things are like that. It appears that one doesn't remain full of energy for ever, one would say in Latin *Semper Virens*. . . ."

In May 1870 the critic Theodore Duret, who wrote for the anti-Bonapartist *Tribune*, had become curious about Cézanne and was trying to track him down. Failing, he appealed to Zola. "I've heard talk of a painter named, I think, Cézanne or something like that, who'd be at Aix and whose pictures have been rejected by the jury. I seem to recall that sometime you spoke to me of an Aixois painter who's totally eccentric. Wouldn't he be the rejected one of this year? If so, please if you will give me his address and a word of introduction so that I can go and make acquaintance with the painter and his painting." Protective as ever, Zola replied, "I can't give you the address of the painter you mention. He keeps himself too shut away; he's going through a phase of gropings; and in my opinion he's right in not wanting anyone to penetrate his studio. Wait till he himself turns up."[2]

Duret was wrong; Cézanne was still in Paris, though about to leave. The day after Zola's letter he appeared as a witness at Zola's marriage

to Alexandrine, in the company of three other Aixois: Solari, Roux, and Alexis.

The letter tells us that what we assume, but are no longer sure about, is still true. As the two men moved apart into their very different spheres, the secret bond attaching them to each other held. They had aspirations in common as well as anxieties about sex and memories of themselves as boon companions in their youth. Often out of touch, they held each other in esteem, spoke loyally of one another to others, and watched each other's progress—or, in Cézanne's case, frustrations. Zola continued sending affectionately inscribed copies of his books to his old friend as they appeared. Cézanne, whose taste in literature was basically classic, would be touched by Zola's gesture and do his best to respond intelligently. His remarks may have sounded lame but they were genuinely meant.

The previous year, with Zola now launched on his huge Rougon-Macquart cycle and researching his novel *The Conquest of Plassans*, Cézanne had written to Marie for information about the dress of peasant women which he could pass on to the novelist.

The subtitle of Zola's cycle, which would run to twenty novels, was "The Natural and Social History of a Family under the Second Empire." The inspiration came from Balzac and his *La Comédie humaine*, a design as gargantuan as his own. As early as 1866 he had delivered a lecture in Aix which had ended in a paean of praise for Balzac, his literary hero. He acknowledged his borrowing but maintained that his objective was different. Indeed it was. Balzac, spinning out his two thousand characters, was undisciplined, a romantic of prodigious energy who had only the vaguest notion of where he was heading. He was political, philosophical, moral, whereas Zola was determined to be primarily scientific, a vivisector of a family in southern France during the Second Empire. His boundaries were strictly limited, his details researched and organized with meticulous care. The Goncourt brothers, staggered by his plans, revised their opinion of him. The shallow-seeming, inhibited young man they had thought they knew now entered their famous diary as someone complex, "a rebellious victim of some malady of the heart . . . a disturbed, profound, reserved, and complicated man. . . ."

Science in this decade was making enormous strides, its importance for human enlightenment looming ever larger in Zola's mind. Each day, it seemed, ushered in another marvel: Pasteur's germ theory, Lis-

ter's antiseptic surgery, dynamite, the transatlantic cable, celluloid, margarine. The Suez Canal was about to open.

The Catholic church he saw as shamelessly implicated in the unjust society which lay before his eyes. He was captivated by the opportunities opened up for the naturalistic novelist by the new science of genetics. The stock-in-trade of fiction, fate and coincidence, was now played out. "Increasingly," writes his biographer Graham King, "he found himself in the medical, physiological, and neurology departments of the Bibliothèque Impériale in Paris, though not so much in search of a philosophy as a formula, a catalyst, to unite all the elements of the grand scheme that was so vividly in his mind."[3]

He chose the Second Empire for the setting of his chronicle of a family because he knew it firsthand. Also, he had deep-seated personal motives. Immediately before the coup d'état of 1851 his father had been exploited and disgraced by the same society of opportunists that now had Napoleon III at its head. The corruption, patronage, and greed that flourished then was now more materialistic and merciless than ever. Great fissures had begun to open up in its rotten fabric. He had grown up among its predators, fighting to survive like most of its citizens in the filthy depths of the glittering pie Paris had become. The regime cried out for surgery—or a bomb.

It was ironic that the anticlerical theme of *The Conquest of Plassans*, with its local middle-class family, the Mourets, vaguely based on the Cézannes (Mouret was a hatter), should have been helped along, even in this very minor way, by Cézanne's deeply religious sister. On April 5, 1869, Marie had replied dutifully to her brother with the details Zola wanted for his notes. Peasant women

> when working in the fields have a skirt, usually blue, darker when the stuff is cotton and then called *cotonnade*, paler when the stuff is *en fil* and the peasants then call it a *cotillon* made on a *toile*. For corsage they have a *cosaque* . . . to which is added a flap, straight at the lower end and of equal length all round the belt, and the *basque* is called *lou pendis* or the parasol. When heat obliges them to remove this corsage, only the braces are seen—they're made with cotton attachments a little longer than a finger-breadth. They are sewn on to the *jupon*; behind they start off both from the same point in the middle of the waist, passing over the shoulders and in front remaining a little apart from each side of the waist and not joining up as at the back. When they take off the *casque* their corsage is then visible,

usually blue or white; they are *en bras chemise*, sleeves drawn up and folded to the elbow, a colored *fichu* round the neck with the ends stuck in front of the corset. For headdress, a felt hat of blue wool with big brim: that is the old way, nowadays one rather sees straw hats. I've forced myself to be as clear and lucid as possible. . . .

*Adieu*, I'm off to eat my soup that's getting cold. I embrace you for us all, your sister Marie.[4]

The hot Parisian summer of 1869 was just beginning when Zola went to lay his grand plan (originally of ten novels) before Lacroix, his publisher. Full of confidence he said he could produce them at the rate of two a year, asked for a contract for five years and a guaranteed five hundred francs a month, and got both. The contented novelist moved his then mistress and his mother to a six-room house on the rue Condamine in upper Montmartre. It sounded grand but wasn't. There was a little pavilion in the garden where he thought he might work. The dining room was so narrow, says Alexis, his self-appointed Boswell, "that when he later bought a piano he had to have a niche hollowed in the wall to take it." The garden, with its poky pavilion, had one big tree and a number of smaller ones. On fine summer evenings the family dined out on the narrow terrace. If friends called later, the women left them to their interminable talk. This was where Alexis sat, together with Roux, the writer Duranty, Beliard, and Coste, and "felt the great *Rougon-Macquart* work germinating from the very ground beneath him."

The primal cycle of germination, growth, decay, death, and rebirth is the overriding theme of the chronicle, applied to humans instead of plants. Zola, who had to plan every step in advance and make his intentions absolutely clear, announces this theme in the opening pages of the first Rougon-Macquart novel, *The Fortune of the Rougons*:

> The earth, which had been glutted with corpses for more than a century, literally perspired with death; and it had been necessary to open a new burial ground at the other end of the town. The old cemetery, long abandoned, had been gradually purified by the dark, thick-set vegetation which used to sprout over it every spring. This rich soil, in which the gravediggers could no longer delve without turning up some human remains, possessed a most formidable fertility . . . the place presented the appearance of a deep somber green sea studded with large blossoms of singular brilliancy. Under

*161*

the shade of the close-set stalks the very sap seemed, as it were, to boil and ooze out from the damp soil . . . so that eventually the only odor one could detect, in passing by this accumulation of putrefaction, was that arising from the strong smell of the wild gillyflowers. It was merely a question of a few summers.

◈  No one knows exactly when Cézanne met the woman who would one day become his wife. Marie-Hortense Fiquet came from the Jura. Her parents brought her to Paris when she was a child. When the two met, her mother had been dead for some time.

How they came to meet is another mystery. As a young girl Hortense earned her own living by sewing handmade books. The possibility that she may have posed part time as a model could be true, or else a legend dreamed up to explain their encounter, since the sphere of art was Cézanne's whole world. She was a lively young woman, ten years younger than Cézanne, who in 1869 looked much older than his thirty years. By all accounts she was vivacious, talked freely and aimlessly, had no serious interests, and gobbled up one romantic novel after another.

What did she look like? The impressions given by the numerous portraits—a dozen at least, apart from sketches and studies—indicate a big girl, her face a delicate oval in the first pictures, heavier and with a squarer jaw in the succeeding ones. The serenity of her portraits was probably boredom. As Cézanne grew older his painting slowed down, until he was subjecting his sitters to hours of agonizing stillness, sometimes prolonged for weeks or even months. Hortense hated posing, hated to keep quiet, submitting as a duty by an act of will. This resolution and the silent resentment it produced enter the paintings as a grave frozen quality.

Jack Lindsay suggests it was her lightheartedness that overcame the painter's defenses. His morbid timidity before women and his phobia concerning touch were formidable obstacles. Perhaps the combination of her ignorance of his true nature and his desperate need to abandon himself at last won the day. His fears would never disappear but at least there was a gain in self-confidence now and a new stability to his life. One can't imagine a lyrical romance, and the relationship was at best a compromise, at worst a charade. But this was in future decades, after he became a father. She was certainly shrewd enough not to cling, and seemed totally indifferent to his work. Any love he may have had for her he gradually transferred to his son.

162

At its lowest ebb the marriage degenerated into farce, with Cézanne saying contemptuously, "My wife likes nothing but Switzerland and lemonade"—to the amusement of his friends. The sardonic streak came from his father, who spoke of Paul being devoured by painting and his sister by the Jesuits. In the same vein his son remarked after Louis-Auguste's death, "He was a genius; he left me an income of twenty thousand francs." And after he had died, Hortense said bleakly that in all the years she had known him her husband was lost, in a muddle, unable to properly finish his pictures. "Renoir and Monet, they knew their craft as painters."

But he was now, in 1869, in physical relation with a woman for the first time in his life. How did this affect his work? The frenzied "black pictures," as critics have called them, the violent assaults, rapes, stabbings, naked dead bodies being washed, fell away and thunderous dreamy pictures took their place, apparently tranquil but full of disquiet, the figures kept apart from one another by a disturbing tension. In the midst of these casual scenes, picnics, pastorals, there is often a figure in contemporary dress who is the "odd man out," someone who could easily be Cézanne himself. Mary Louise Krumrine has this to say: "The embodiments of fear (fear of women, fear of temptation, and fear of rejection) appear as he begins his relationship with Hortense Fiquet. They seem to foretell the distant partnership that their marriage inevitably became."[5]

If Hortense was the active partner from the beginning, initiating the courtship and keeping it alive with her warmth and naturalness, it seems likely that her undemanding nature would have had few expectations of anything deep or profound developing between them. She seems realistic and ordinary, prepared to accept her shy prickly artist on his terms. The dull and unexciting duality of the relationship, thinks Lindsay, was what enabled Cézanne to sustain it for as long as he did. What Hortense wouldn't have known was the extent to which Cézanne was prepared to hide her away from his family, or at any rate from his father, for fear of retaliation in the form of a suspension of his allowance.

For an amazing length of time he kept Hortense's and then his son's existence a secret from his father. And yet ménages such as his were a commonplace of the *vie de bohème*, "and most such couples led lives of irreproachable domesticity." The young women partners of the artists were usually as respectable as housewives, remarked Somerset Maugham later in the century, "notwithstanding a difficult position,

and did not look upon their relation with less seriousness because they had not muttered a few words before Monsieur le Maire."

◆ The sudden collapse of the Empire and the outbreak of the Franco-Prussian War in July 1870 would have been enough for Cézanne to start packing in Paris, at 53 rue Notre-Dame-des-Champs, that is if he and Hortense were still there. Back in the south he deposited Hortense in lodgings at l'Estaque, then went off unconcernedly to paint in his studio at the Jas. In this way he covered his tracks, probably confiding his new status as a common-law husband to his mother and sister and swearing them to secrecy. As for the war, he considered it nothing to do with him. Provence was another world: the whole commotion was unreal. He proceeded to ignore it for as long as possible.

The conflict had been bubbling away in the background of everyone's lives for a decade, with the French involved in diplomatic skirmishes and defeats. On the international front France had lost ground steadily, culminating in Maximilian's defeat in Mexico and the end of Napoleon III's hopes for a sphere of influence in the Americas. Prussia was on the march, crushing Austria in a matter of weeks in 1866. Attempts to secure an alliance with Austria and Italy had foundered and France was exposed to the east. Otto von Bismarck, spoiling for war, seized his chance when the Prussian Prince Leopold, eager to succeed Isabella on the throne of Spain, inflamed France into a demand for his withdrawal.

By the end of the summer the ill-prepared soldiers of Napoleon were routed. Every other day the frightened citizenry read in their newspapers of more defeats. MacMahon's troops were outmaneuvered at the Battle of Worth and then again at Sedan. Napoleon, suffering from gallstones, was captured and the Empress Eugenie fled to England.

Shortly after war was declared Zola had got himself into trouble by publishing in *La Cloche* an antiwar article, "Vive la France," making clear his disgust with the Empire. The rapid advance of the Prussians and the proclamation of the Republic a month later rescued him. He became a refugee from Paris, taking his wife and mother to join Cézanne at l'Estaque. Baille and Valabrègue headed in the same direction, or rather to Aix, enthusiastically determined to support the Republic and defend their hometown against the Prussians. Another friend, Roux, wasn't impressed. "I'm bored stiff here," he wrote. "I

watch the revolution pass by. In the gang are our admirable friends Baille and Valabrègue. They give me a tremendous laugh. Can you see these slackers from Paris, who come here to stick their noses into the local government and vote resistance? Let's march like one man, say the proclamations. March! They're a fine pair."[6]

In actual fact the two enthusiasts threw themselves into the fray with genuine zeal. They were sworn on to committees, as was Louis-Auguste, who in his seventy-second year became a councilor with responsibility for finance. His wife was also engaged in public works. The reconstituted municipality appointed Paul on November 18 to a committee for the drawing school, but he usually managed to be absent when the meetings were held.

Zola had meant to go back to Paris more or less at once. Then he heard that the siege of the city had begun. The Third Republic, founded by Jules Simon, Jules Favre, and the working-class Gambetta, began its rocky seventy-year span. The country now swung behind the new Republic as it would never have done under Napoleon III. Magically, Gambetta escaped from Paris in a hot-air balloon to direct the war from the provinces.

Zola, feeling useless in the national turmoil, the pen struck from his hand by the war, tried to create some sort of role for himself by going to Marseilles, the intention being to start a daily paper, *La Marseilles*, with Roux and a local publisher. Valabrègue came over to help, but the paper failed almost at once, hit by shortages of labor and finance.

It would have been remarkable if Cézanne, always prone to anxiety, hadn't been badly shaken by these chaotic events. The mobilization intensified, and he was young enough to fight. Louis-Auguste had retired from banking long ago and Cézanne must have felt that the crumbling of the Empire might lead to a situation in which his very way of life was under threat. Yet all he would say years later was, "During the war I did a lot of work on the motif at l'Estaque. . . . I divided my time between the countryside and the studio."[7]

A few days before the outbreak of war Zola had been asking Guillemet about Cézanne's progress or lack of it. "It's time for him to create according to his conceptions and I'm anxious to see him occupy the position he ought to have. What a strange thing is painting. It's not enough to be intelligent to do it well. Still, in time he'll get there, I'm sure." But in fact he was far from sure, as Guillemet's reply makes clear. "What you tell me about Paul makes me very sad: the good fellow must suffer like a damned soul because of all the attempts at painting

into which he throws himself headlong and which only rarely succeed, alas! Where there is good material one can't despair. Myself, I always expect him to produce beautiful things which will give pleasure to us, his friends who love him and which will confound the skeptics and denigrators."[8]

From this it would appear that nothing had basically changed. Hortense had initiated him into the mysteries of the female sex, but what did that mean? His obduracy held firm, he was sustained and stabilized to some extent by his friends, all of them men. Did he now have a woman behind him, someone who knew him more intimately than anyone outside his family? There was still the never-healing wound of his isolation, for which he secretly blamed himself. There was his old dreadful enemy, self-pity, which threatened his whole being with unreality. Self-pity was a prison. You saw yourself and everything you touched as pathetic, to be wept over. The strength he thought he had, a deep reservoir to be drawn on, would drain away in the face of this worthlessness. Only painting helped, that dogged edging toward what was virginal and untouched in the unbounded spaces deep inside himself.

Only his few intimates knew how he slaved at painting. In the eyes of others he was idle, ineffectual. Baudelaire, who prided himself on his indolence, believed that art was a handicap that enfeebled the artist in his dealings with everyday life.

The complicated sadness locked in him, subtly present in his art up to now, suggests that the man Hortense embraced in the conjugal bed was very probably a virgin. No one had any reason to suppose otherwise. Sensuality had lived in him as something sinister, involving violence, breeding terrible secrets. Sex was like a black sickness, a thing of fear and servitude. Now this girl, who refused to see him as depraved but touchingly foolish, suffering only from a lack of experience, had embraced him without conditions. His precious and valuable touchstone of virginity was no more, broken into like his freedom. Suddenly and catastrophically he was the slave of another person, someone who had access to his secret dark corners. Thankfully it wasn't so: he realized soon enough that she saw only what she wanted to see. But she had stolen a part of his being: she assumed, as if by right, the existence of a bond between them. In the many portraits of her we see her looking blankly, stolidly back at him, her head inclined whimsically, in her eyes the flat curiosity of a superior being.

After the failure of the Marseilles newspaper, Zola cast around despondently for some way to earn sufficient money for the support of his wife and mother. His friends were beyond reach. Renoir, Manet, and Degas had joined the army. Monet and Daubigny were in England. So was Pissarro, who had found himself in the path of the victorious Prussians. His house was turned into a slaughterhouse and he lost all his paintings. Two of them came to light years afterward, covered in animal blood. His other canvases had been made into butchers' aprons. "I imagined," wrote Zola when it was all over, "that the world was coming to an end, and that no more books would ever be written."

He left his wife and mother at 15 rue Haxo in Marseilles and went to Bordeaux, from where the Government of National Defense operated. From his description later of the provisional government, it was a shambles. Nevertheless he managed to attach himself as secretary to a minister he had known on *La Tribune* at a salary of five hundred francs a month. His hopes rose. On December 22 he wrote to Roux, "If we are clever about it, we'll make a triumphant return." As usual he was wildly optimistic, and for once out of touch.

These were alarming days for Cézanne, who had received his call-up papers. He promptly vanished. His mother was left to face the police who called at the Jas to pick him up. "He left two or three days ago," she told them innocently. "When I hear where he is I'll let you know."

Maxime Conil, later to join the family as Rose's husband, said that when the police came they searched the house. Cézanne was still there, but the building was large and rambling and he knew where to hide safely. That night he packed a few belongings and went tramping over the hills to l'Estaque, a distance of fifteen miles. Presumably he was making for the woman who waited for him, in the little house belonging to his mother.

Informers had put the police on the trail of Zola too, not knowing that he was by now in Bordeaux. Roux's father overheard in a café the news that four guards and a corporal had been detailed to hunt down any dodgers. There seems to have been some confusion as to Zola's status: a man responsible for the support of two women wouldn't normally be called up. Young Roux wrote to Zola, passing on the results of his father's eavesdropping, including the "vexatious bit"

that Paul C. is being actively searched for and I'm much afraid that he won't escape from the searches if, as his mother has said, it's true

*167*

that he'll stay all the while at l'Estaque. Paul, who in the early stages didn't foresee what could happen, has shown himself a lot at Aix. He went there often enough and stayed there one, two, even three more days. It's said also that he was getting properly drunk together with gentlemen of his acquaintance. He must have, it's certain, made known the place of his residence, since the gentlemen in question (who in short must be jealous of him for living without having to do a stroke of work for his livelihood) have lost no time in denouncing him and giving all the necessary information for getting him found.

These same gentlemen (here is the astonishing bit of news) to whom Paul remarked that he was staying at l'Estaque with you— not knowing that you have been able to quit this hole—ignorant whether you precisely are bachelor or married man—have denounced you at the same time as a defaulter. . . .

I told my father to lend a deaf ear and not get mixed up in any conversation of this sort whatsoever; I myself would make it my business. And next morning I ran to the Marie. There I had free scope and had the list of defaulters shown to me. Your name wasn't there. . . .'[9]

As Cézanne lived peacefully and not in hiding at l'Estaque throughout the war, painting openly in the vicinity, it seems strange on the face of it that no attempt was made to find him. But the local authorities were simply going through the motions. There weren't enough rifles, ammunition, and uniforms to equip the troops already available. Hunting down defaulters was hardly worth the effort. In Provence, hundreds of miles from the action, apathy reigned. People of the northern and eastern provinces were living in daily fear of occupation, but the Midi was too remote for strenuous recruiting. Who was likely to invade their part of the world?

On January 29, 1871, the war was over. Besieged Paris caved in and the government signed an armistice. The slaughter had been awful. A series of national humiliations followed. As well as paying Prussia an indemnity of five billion francs the French were forced to surrender Alsace and Lorraine. In a final insult Prussian troops marched in a triumphal parade through the streets of Paris. This was perhaps the catalyst precipitating into being the establishment of the Paris Commune two months later. "It was as though we were waking from a night-

mare," Zola wrote, ". . . as though, through a long cold winter we had crouched in a muddy ditch, waiting to die."

In the four-month-long siege of the city the departure of politicians and prominent citizens had left a power vacuum. Revolutionaries were busy at work fermenting hatred of the authorities, accusing them of being responsible for France's degradation. A scratch election in February with a limited franchise brought a shock victory for the two royalist parties. When the National Assembly, instead of returning to Paris, moved from Bordeaux to Versailles, resurrecting the fear of a restored monarchy, the Communards made their sink-or-swim move, proclaimed Paris a commune on March 28, 1871, scrapped the guillotine and conscription, and declared war on the Catholics.

Paris was now a revolutionary state. The hope was that other cities of sympathetic workers would follow suit, but few did. Communications were near to breakdown and the provinces had no clear picture of what was happening. Lyons and Marseilles did establish communes. At Marseilles the National Guard joined the populace, occupying the prefecture. Then the regular troops struck back, shelling the prefecture and recapturing the city in a bloody assault. In the brutal repression that followed five hundred were arrested. Cézanne, close at hand, identified with the Communards while keeping his head well down.

Not long before this, Zola and his dependents had returned to Paris. He was worried about his little house. It had been taken over as a shelter for refugees, but Paul Alexis had managed to transfer Zola's belongings to an upstairs room and keep the refugees confined to the ground floor.

The disoriented novelist had heard from Manet, in active service as an officer on the general staff, the news of poor Bazille, killed in action the November before. In the Batignolles Quarter he sat in a daze, "as if I'd just woken up from a bad dream. My little garden-house is the same as ever, my garden is untouched, not a stick of furniture, not a plant has been damaged, and I could almost believe the two sieges were bad jokes invented to scare the children."

But the bad dream wasn't yet over. Zola, unable to settle to his huge work, traveled by train to Versailles to report the activities of the New Assembly. It was a dangerous time to commute. He was arrested twice, once by the Communards and again by government forces. Adept as ever at pulling strings, he was released by the intervention of the son of a politician. "My only consolation," he wrote, "is that there is no third

government to arrest me tomorrow." He seemed to have a charmed life, wandering through the barricaded streets and peering at everything through his spectacles like Pierre in *War and Peace*, naively concerned, trying to work out what was going on. Eventually the shells whistling overhead convinced him that he should evacuate his wife and mother until it was all over. He took them to Bonnières.

Adolphe Thiers, profoundly hostile to every form of socialism, now set about crushing the Communards with the same efficiency he had employed to establish the monarchy in 1830, and to bring Louis Napoleon to power in 1848. He had nothing but contempt for the *viel multitude* and he knew how the bourgeoisie feared this new enemy. Karl Marx commented later that the Third Republic had inherited from the Empire "not only ruins but also its dread of the working class."

The carnage launched on May 22 was ghastly. "Below Montmartre anglers sat unconcernedly on the banks of the Seine. The restaurants and cafés were crowded with patrons, joking with groups of Communard guardsmen in their ill-fitting uniforms about the distant explosions. Above Montmartre, fashionable ladies in carriages watched the halfhearted bombardment through opera glasses."[10]

It was the lull before the storm. The bloody reprisals when they began lasted a week. Army regulars advanced in waves and penetrated the city. Innocent bystanders were cut down by the crossfire from both sides. Hostages were rounded up in batches, roped to the railings of the Bourse, and mowed down. Twenty-five thousand died manning the barricades, thirteen thousand were locked away in prison, seventy thousand deported and exiled. The center of the city burned, dozens of fires raging unchecked. Executions went on for days in the Père Lachais cemetery. Two decades later Zola recreated this hell in the final volume of his Rougon-Macquart chronicle. For once he had no need of notes.

Soon after the Commune had been bloodily suppressed Zola heard from Alexis who had news of a sort concerning Cézanne. "I have had a long talk with M. Giraud [the owner of the house leased by Madame Cézanne at l'Estaque]. The two birds have flown . . . a month ago. The nest is empty and locked. They've left for Lyons, M. Giraud told me. Wait till Paris stops smoking. I'm surprised that for a month we haven't seen him in Paris."

Zola, aware more than most of the twists and turns of his friend's secretive nature, suspected otherwise. On June 30 he wrote worriedly to Alexis that in his opinion

what you say of Cézanne's flight to Lyons is an old wives' tale. Our friend has simply wanted to put the *sieur* Giraud off the track. He is hidden in Marseilles or in the hollow of some valley. And it's up to me to find him again as soon as possible, for I'm worried. Imagine. I wrote to him the day after you went. My letter, addressed to l'Estaque, must have been lost—not a great loss; but I fear that through an unforeseen set of circumstances it may have gone on to Aix, where it will fall into his father's hands. It contains certain details compromising for the son. You follow my reasoning, eh? I'd like to find Paul so as to make him reclaim this letter. So, I count on you for the following commission. Go to the Jas de Bouffan where you'll have the air of seeking news of Cézanne. Arrange things so you have the chance of speaking a moment with the mother in particular. Ask her for the precise address of her son for me.[11]

It says much for Zola's loyalty that he could bother about such matters at a time when he had lived through such horrors and now sat, as he believed for some weeks, among the ruins of his grand plan. The entire project, a contemporary study of life under the Second Empire, was now in shreds. It was too late to back down from something he had already announced publicly. What was he faced with—a series of dusty historical novels? He had intended a merciless indictment of a corrupt regime, only to see it reduced to rubble in a matter of months. Then, as he soon realized, little had really changed. The right-wing Republican government, he soon saw, would do nothing to halt the excesses of the last two decades. "Even his half-written novel *The Kill* and the events it described would not be out of place. Although the story was woven around the creation of Haussmann's Paris and the scandalous speculation which ravished the city in the 1850s, a brief visit to the Bourse convinced Zola that the speculators, eager to share in the economic boom that was following on the heels of the disastrous war, were just as rapacious and insatiable as they had been during the Second Empire."[12] Zola had recognized some time ago the inevitability of war and the collapse of the empire, but thought it would happen after 1880. There would be chronological oddities now in his literary enterprise, but also gains in freedom. And his final volume, *The Debacle*, would describe an actual cataclysmic event, comparable, according to Henry James, to Tolstoy in its masterly reporting of military action, instead of the mythical war Zola had intended.

*171*

It was while Cézanne was tucked away in l'Estaque with his mistress, supposedly in hiding but hardly acting the part, that he turned away from the oppressively emotional scenes he had perhaps begun there, the gloomy pastorals taut with naked effigies of passion, the idylls and picnics and temptations, and painted half a dozen landscapes. A year before he had done a somber watercolor, *Factorie à l'Estaque*, showing the belching chimneys of an industrial scene, destined to be mounted later in the lid of Madame Zola's workbox. At l'Estaque he repeated the strange experiment with an oil of a sprawling industrial installation with tall smoking chimneys against the backdrop of Mont Sainte-Victoire. John Rewald, one of the best writers on Cézanne, who knew the country between Gardanne and Aix, says that no such factory exists or ever has. It looks as if both this and the watercolor were invented. Cézanne may have wanted to create a Provence which Zola, living nearby for a while with his evacuated family, would have found as relevant as the urbanized countryside surrounding Paris that he was embracing with such enthusiasm in his novels. The forceful style was, in this sense, Zola-like. The sweeping streaking technique, the soiled colors, the embrace of industry, all speak of a creed of realism the two held in common.

He was coming to the end of his spontaneous *couillarde* style, casting about for a broad treatment which would give him more time to organize his compositions, yet with as much power as the boiling-over palette-knife paintings with their furious frustrations. In *The Masterpiece* we have the artist Claude experimenting with various methods, the secrecy and details clearly borrowed from Cézanne: carefully hidden methods using

> amber solution, liquid coal, and other types of resin which dried quickly and kept the paint from cracking. And so he found himself engaged in a terrible struggle against flat and streaky effects, since his absorbed canvases soaked up the modicum of oil there was in the paint. Brushes were another of his problems; he insisted on having them made to order and preferred oven-dried horsehair to sable. Perhaps the most important thing was the palette knife. Like Courbet he used it for his groundwork and had quite a collection of long flexible knives, broad stubby ones, and in particular a specially made triangular one like that used by glaziers and just like the knife used by Delacroix. To employ a scraper or a razor he considered

discreditable, though on the other hand he indulged in all sorts of mysterious practices when it came to applying the colors. He concocted his own recipes and changed them at least once a month.

In a painting from this early period that has become justly famous, *The Black Clock*, we can see the transference to the harsh clarity and monumental simplicity which announces the "genius of the future" called for by Zola—who failed to recognize its manifestation under his own nose. It is one of the first of his still lifes in which we recognize the artist as the most original painter of the nineteenth century. Though a small picture, its grandeur places still life painting in an entirely new light. It was probably painted in Paris just before the war and the uprising. The clock belonged to Zola and the picture may be saying something about the painter's esteem for his friend's growing reputation.

Much has been made of the fact that the clock has no hands. This, says Gowing, is to misconceive the breadth and comprehensiveness of the style. The scale is too massive to allow of small hands among forms which include the slabby hanging folds of a white tablecloth—reminiscent of the rock outcrops of his native region—and the huge seashell with red gaping mouth, that has caused the wall behind it to protest in a downpour of thunderous blue. Manet is a powerful influence in the picture's conception, but beyond that is something almost monstrous, a half-violent, ungainly personality not yet able to rest content within the contemplation invited by the subject. Yet Cézanne, writes Meyer Schapiro, is in fact "the more gravely contemplative mind." The painter is suggesting here what he was to prove triumphantly later, that the still life could contain everything and be a complete world, combining nature and man. The young Cézanne is discovering his powers as a dramatist, arranging his structures masterfully in space, using the lurid gash of a mouth to express a loaded and ominous sensuality.

The baroque exuberance of the weird shell is carried over into a landscape that was definitely painted during the winter of 1870–1871 when he was evading military service. It is easy to read into *L'Estaque, Melting Snow* the frightening world on the slide beyond his hiding place, the greyish slopes threatening to overwhelm and crush the spectator. The canvas has the melancholy and brooding of a man uncertain and fearful of the future and what it holds for him. Everything slides downhill sickeningly. The pines look as unstable as the slipping wetness that provides no foothold. "Color and brushwork sustain the hurricane violence of the scene," comments Schapiro. "A blackish tint

permeates the landscape, and even the snow, which in places is a pure unmixed tone, seems a partner of black. Painted in stark contrasts with an overwhelming, almost monotonous fury—less to capture the essence of the changing scene than to express a gloomy, desperate mood—the picture has some subtle tones: the varying whites of the snow and the many greys, including the warm tones of the middle ground set between red roofs."

He was shaping a landscape by passion, just as Van Gogh would do a decade or so later. This wouldn't continue: Cézanne's was to be a supremely internalized art, as opposed to the externalizing of Van Gogh, who projected his intense feelings onto the trees and hills and people he painted. Cézanne, in common with Baudelaire, would in time seek to fall into a state of reverie and become possessed by inanimate nature, letting go of the ego and allowing objects to speak through him. Only a vocation of silence and a gradual renunciation of human values would make this possible. He was to make a most unlikely saint, a role frequently abhorrent to him, forced on him by the unremitting pressure of art. Baudelaire in his consideration of Delacroix in the "Salon de 1846" had written that "For a man like this, endowed with such courage and passion, the most interesting struggles are those which he has to maintain against himself."

Zola, at l'Estaque at the same time as Cézanne and always sensitive to landscape, has vividly described the panorama in which he found himself, the arms of rock stretching out

> on either side of the gulf, while the islands, extending in width, seem to bar the horizon and the sea is only a huge basin, a lake of brilliant blue when the weather is fine. At the foot of the mountains the houses of Marseilles are visible on different levels of the low hills; when the air is clear one can see, from l'Estaque, the grey Joliette breakwater and the thin masts of the vessels in the port. Behind may be seen, high on a hill, surrounded by trees, the white chapel of Notre-Dame de la Garge. The coastline becomes rounded near Marseilles and is scooped out in wide indentations before reaching l'Estaque; it is bordered by factories that at times let out high plumes of smoke. When the sun falls level to the horizon, the sea, almost black, seems to sleep between the two promontories of rocks whose whiteness is relieved by yellow and brown. The pines dot the red earth with green. It is a vast panorama, a corner of the Orient rising up in the blinding vibration of the day.

When he turns to the terrain of the interior, Zola describes for us in his admirable documentary style the subject matter of so many of Cézanne's paintings of his middle and late years. Far from being merely an outlet to the sea, the village, its back against the mountains, is traversed

> by roads that disappear in the midst of a chaos of jagged rocks. Nothing equals the wild majesty of these gorges hollowed out between the hills, narrow paths twisting at the bottom of an abyss, arid slopes covered with pines and with walls the color of rust and blood. Sometimes the defiles widen, a thin field of olive trees occupies the hollow of a valley, a hidden house shows its painted façade with closed shutters. Then again, paths full of brambles, impenetrable thickets, piles of stones, dried-up streams, all the surprises of a walk in the desert. High up, above the black border of the pines, is placed the endless band of the blue silk of the sky.
>
> And there is the narrow coast between the rocks and the sea, the red earth where the tileworks, the district's big industry, have excavated large holes to extract clay. . . . One would think one were walking on roads made of plaster, for one sinks in ankle-deep; and, at the slightest gust of wind, great clouds of dust powder the hedges. . . . When this dried-out country gets thoroughly wet it takes on colors . . . of great violence; the red earth bleeds, the pines have an emerald reflection, the rocks are bright with the whiteness of fresh laundry.[13]

One picture which has puzzled many writers, but that Cézanne valued sufficiently for it to be included in his first one-man show organized by Vollard in 1895, is *The Feast, or The Orgy*. Some date it before 1870, others a little later, as the color is too light for his earlier phases. To be sure it is a far cry from the Cézanne who would one day long to paint nature with new sensations, as if no one had painted it before. "I want to paint the earth's virginity," he declared once. But *The Feast* with its affinities with the great Venetians makes us wary of dismissing the work as an aberration, a vain desire to paint in the grand manner, though all his life his genuine honesty was tangled with what Roger Fry called his "willed ambition." And possibly if he had possessed the gift of virtuosity the willed ambition would have won out. He was no Picasso: in the end he could only be himself.

Veronese, Titian, Caravaggio, Rubens—these, together with the great Spaniards, remained his heroes throughout his life. He never stopped making studies after Rubens. Delacroix was always a touch-stone: Baudelaire's 1863 tribute to Delacroix moved him deeply. Two years before his death he spoke of the Venetians and Spaniards as "the true colorists."

This "fanciful reverie" called *The Feast* with its brilliant color has been linked by Mary Tompkins Lewis to a novel Cézanne would certainly have read avidly, Flaubert's *Temptation of Saint Anthony*. The temptation theme, the essence of which is loneliness, would occupy him obsessively for the next two or three years. His instinct for self-dramatization would have produced an immediate response to Flaubert's "In *Saint Anthony* I was myself the saint." Always close to Zola in his love-fears, he had found in Flaubert—as he had found earlier in Baudelaire—a writer who shared his preoccupation with "the apparitions he himself used to see, which bewitched him and brought him to despair."[14]

The picture is pure theatre. Framed by columns to the left and a streaming canopy high above, the stagelike setting and dream atmo-sphere, as if the whole scene is afloat in space, is contradicted by the extraordinary perspective, the banquet table narrowing like a road into the distance. Scholars draw attention to such influences and borrow-ings as Couture's *Romans of the Decadence* (1847), exhibited at the world's fair—Cézanne kept a photograph in his studio—and Veronese's *Wedding Feast at Cana*. Both paintings are presented in shal-low horizontal fashion, whereas the coloring and composition of Cézanne's picture may have derived to some extent from Delacroix's *Heliodorus Driven from the Temple*. Here too the columns are vast, the draperies gorgeous and flowing like water.

In *The Feast* the stage setting half dwarfs the players. Curiously, some of the properties, the vases, plates, and baskets, nearly equal the size of the figures. Making a first appearance are the forerunners of Cézanne's strangely awkward nudes. Ambiguity appears too in the reclining voluptuous nude in the foreground, seen from the rear, with blond hair and masculine-looking arms and shoulders. The pose is the one taken up by *L'Hermaphrodite endormi*, the antique marble in the Louvre well known to Cézanne.

The theme of orgies was all the rage in nineteenth-century France. Revived from Renaissance bacchanals, it cropped up repeatedly in nov-els and on the stage. Offenbach's *Orphée aux enfers* was a great success

in the theatre in 1858. There would be endless variations after this. Debauchery had been one of the subjects of Cézanne's adolescent verse, as well as of the watercolor *The Rum Punch* and his paintings and drawings called *Afternoon in Naples*. But this was the first time he had attempted, by means of a colorful crowd dwarfed under monumental architecture, to equal such radiant masterpieces as Veronese's *Wedding Feast*. A study for *The Feast, or The Orgy*, only discovered by John Rewald in 1978, clearly establishes the link with Veronese, even though the final oil evolved rather differently.

Flaubert's description of the banquet of Nebuchadnezzar, with its array of luxury and wealth, shows how close was the literary source for Cézanne's picture:

> Then appears, beneath a black sky, a vast hall, lit with golden candelabra. Plinths of porphyry, supporting columns that are half lost in the shadow, so high are they, form long lines, one following the other, outside the tables that lengthen out even to the horizon where appear, in a luminous mist, enormous architectural structures, pyramids, cupolae, stairways, flights of steps. Among the silver-footed bronze beds and the huge pitchers from which trickle black wine, choirs of musicians crowned with violets pluck at great harps singing in vibrant voices.
>
> Slaves run about with dishes, women pass round the tables and pour out for the guests to drink, the baskets creak with the weight of the loaves. . . . Now and again a spark flies from off the great torches, and crosses the night like a shooting star.[15]

If this were not conclusive enough, the line in the text, "The king eats from sacred vessels, then breaks them," is reproduced on the canvas in the form of broken and scattered crockery. "Above the vapor," writes Mary Lewis, "Cézanne superimposes a small flight of steps, a literal detail from Flaubert and, without benefit of the literary source, the most inexplicable element of the painting."[16] The theme of temptation is emphasized by the addition of "a sinister undulating serpent in the lower right-hand corner. The serpent serves as a telling footnote and ominous mirror to the curves of the tempting female forms above." The sprawling naked bodies presenting a tableau of gluttony and abandonment are like a vision of a forbidden dream come true. But these bodies have a sensuality that doesn't let them rest. They writhe.

What we know already about Cézanne's shrinking before female nudity prompts us to ask—in the light of this picture and the ones con-

temporary with it, his own *Temptation of Saint Anthony*, the *Pastoral* and *The Picnic*—whether anything has altered since his relationship with Hortense. Did she reconcile him to his own physicality, banish the mad horror, give his wavering confidence a boost and enable him to strike out more boldly, or has the challenge of woman, experienced now at close quarters, driven him back further on himself and intensified the conflict between fear and desire? These enigmatic "conversation pieces" with their thunderous atmosphere contain secrets, if we can only unlock them.

Mary Louise Krumrine has attempted, with much rigor and subtlety, to do just that in her book *Paul Cézanne: The Bathers*, which served as the catalog for a major exhibition held at the Kunstmuseum, Basel, in 1989. The young Cézanne, seemingly about to step forward in all his complexity and reveal himself, in the end eludes her and us. The language of symbols is always more profound than we think.

The Temptation motif would appear from now on in many guises. Here was a direct approach, sanctioned by the popularity of the theme at the time. Religious art was now being revived; the Lives of the Saints were widely read. The theme is prominent in Baudelaire's *Flowers of Evil*. Delaroche, Corot, and Millet had painted Temptations—Millet's *Temptation of Saint Jerome* presents the city of Paris as an evil seductress. In the 1869 Salon alone there were three Temptation paintings. The story of the Egyptian hermit was again fashionable, as were Egyptian settings since the invasion of Egypt by Napoleon.

Cézanne's need at this time to insert himself in his fantasies, no matter how disturbing—the bald figure bending over the corpse in the *Autopsy* could be clearly identified, as could the accomplice in *The Murder*—compels him, suggests Mary Krumrine persuasively, to be both bald saint and observer, actor and spectator. His *Temptation of Saint Anthony* is crammed with darkness, the scene taut with menace. In this dark celebration of an ordeal the participants have somehow become *stuck*, cut off from each other, trapped by hideous thoughts and dreams. The life of the flesh triumphs over the lonely dedication of the artist torn from his path, whose monkish self, not even in eye contact with the naked temptress confronting him with raised arms, peers around her to the hermaphroditic figure in the opposite corner. "Cézanne seems to have separated two facets of one character—the feeling of fear and the feeling of boredom when confronted by a woman—and portrayed them in two different figures."[17]

It is when we come to look more closely at this seated nude, fattish

and unattractive, underneath her a licking orange fire, that the plot really thickens. Of the four nudes—three of them curiously masculine in aspect—this one, propping her head with her left hand, the right hand bunched in her lap, is the most peculiar. The figure has heavy breasts but is so sexually ambiguous that it repels and confuses us. What is the figure's role, sunk there in a corner in an attitude of complete indifference, secreted in thought? This male with a rounded belly and breasts, posed under a cloud of melancholy, owes much to the seated artist in Delacroix's *Michelangelo in his Studio*. The painting was first shown in 1864, and Cézanne owned a lithograph.

The flames of fire in alchemy represent the wedding of the male and female substance. Under the androgynous figure in the corner burns orange fire. But what is this figure doing here, apparently redundant and bearing a distinct resemblance to a head-and-shoulders portrait of Zola done much earlier by Cézanne?

The brothers Goncourt saw the twenty-eight-year-old Zola as "a young man with the delicacy and molding of fine porcelain in his features. . . . His character was like those of the heroes of his own novels, whom he made from two opposing types, blending male and female; and as far as his own morals are concerned, they show a resemblance with his spiritual creations who are made up of ambiguous contrasts."[18]

In this picture and ones on the same theme associated with it Cézanne was fashioning a sexual idiom that had a flagrant intent, something he would turn from in disgust later as "imaginative." These direct allegories dispensed with models, with their libidinous associations, and drew, from his own interior maze, images more blazingly damning than anyone posing naked in front of him might have provided. We have to remember too how enmeshed were the characters of Cézanne and Zola. Schapiro goes so far as to hint that Cézanne may have merged their two identities in this androgynous image, just as Zola created characters containing strands of both himself and Cézanne, and points to the conflated name Sandoz in *The Masterpiece*. Zola seems to be underlining the implications of their closeness when he has Madeleine Férat in his novel of that name contemplate the "double love" of Jacques and Guillaume: "These two men loved each other with a fraternal friendship. She saw a sort of incest in her double love. . . . She could possibly savor a monstrous pleasure in the embraces of these lovers whom she could confuse."[19]

If Cézanne, as his images of women seem to tell us, found a frightening masculinity alive in them—as, judging by his novels, did Zola—

something "hardly disguised by the voluptuous exterior of a courtesan or femme fatale," then we are bound to wonder whether he found Hortense Fiquet similarly intimidating. Are we witnessing in these strange pictures the conflict that his new life with Hortense had brought him? She was a brunette, tall, with large black eyes and a sallow complexion. Several portraits of her show her posed demurely, her head tilted to the right and her hair pulled back revealing her ears. The nude in the painting, standing facing the spectator, is not only the one figure approaching elegance, but is dark-eyed, dark-haired, and her hair is pulled behind her ears, her head tilted demurely to the right. She holds apart blue drapery and is thus a temptress, the cloth as it reaches the ground writhing in frenzied coils like a snake. Zola's Madeleine is seen by her servant Genevieve as devilish: "This creature came from Satan, heaven had put her on earth for the damnation of men. She watched Madeleine twist and become disheveled, as she might have looked at the trunk of a snake writhing in the dust."

There are many parallels in the painting with Zola's Madeleine: in fact there is a trait belonging to her in each of the nudes: the blue drapery, the red hair of the saint's tormentor, the fat buttocks of the kneeling blond, the fire. We are told that her blue peignoir

> was still opening, revealing breasts that her chemise scarcely concealed . . . she seemed to ignore her nudity and was unsensitive to the burning caresses of the fire on her skin.
>
> Guillaume contemplated her. . . . He was absorbed by the sight of this half-naked creature whose solid and fat shapes aroused in him only a painful anxiety; he felt no desire for her, he saw her as a courtesan with the hard, coarse face of a satiated woman. . . . All her features, mute and rigid, took on an air of cruelty. Her red hair, still damp from the rain, fell in heavy masses over her cheeks and her chin, framing her face with rigid lines. . . . When he lowered his glance to her breasts and bare legs he felt afraid as he saw the yellow flames dancing. . . .

The blond nude, her hair snaking down her back, who squats on her haunches and leans into the picture, shows us her moon-white buttocks and heavy masculine torso. She could well be a version of Renée in Zola's *La Curée*, suggests Krumrine—the novel began serialization in 1871. This ferocious Sphinx-woman reduces the manhood of her lover-stepson Maxime to a cipher, even altering his sex, so that he is nothing, a sterile shape beneath her. "He saw Renée kneeling, bent

over, with her eyes staring, a savage posture that frightened him. Her hair loosened, her shoulders bare, she leaned on her fists, her back stretched out like a huge cat with luminescent eyes. . . . Renée took the role of the man, the passionate and active will. Maxime surrendered. This neutral person, blond and pretty, his virility affected since childhood, became a big girl with the strange hairless limbs of a woman."[20]

The saint's temptress, confronting the frightened man and causing him to lean away as if from a blow, as she twists violently and raises and bends one arm over her head, the mane of brown hair falling clear of her strongly muscled back, could have come from reliefs of furies or engravings of caryatids Cézanne may have seen. At any rate we will encounter the highly dramatic pose many times in future bather paintings of his middle and late periods.

◈ Four or five years later he painted further variations on the Temptation motif, using for inspiration the Queen of Sheba episode in Flaubert's 1874 *Temptation of Saint Anthony*. A rather grotesque masculinized female is replaced in another treatment by a temptress—other nudes have been cleared away—in center stage, holding white drapery over her head and behind her legs, her hip thrust forward toward the saint. Behind her lurks a horned demon, over him a flying bat, around her feet a group of putti dancing attendance. The shadowy devil with a cloak just visible in red threatens the kneeling, cowering saint. His bald head gleams. The hazy dark features of the devil, hair receding, jawline shadowed by a beard, could be another self-portrait, as indeed could be the saint. If so, Cézanne has split himself in two for some intricate working-out we can only guess at. In the painting the two figures seem bound together, somehow struggling with each other. The undraped woman who sways forward seductively has been left stranded, a spectator, poised for the outcome of this bitter strife.

Temptation as a theme is another way of saying Choice. Before looking at two narrative paintings that appear to be pursuing the same motif, oppressive and troubled fantasies difficult to decipher, we can perhaps go some way toward unlocking them by considering first an allegory on the theme of the Judgment of Paris which came much earlier and cropped up again in the following decade. Paris, son of King Priam of Troy, was a shepherd tending his father's flocks on the slopes of Mount Ida. Hera, Athene, and Aphrodite all claimed the prize of beauty on Olympus, a golden apple inscribed "For the fairest." To set-

tle the dispute Zeus ordered them to submit the argument to the judgment of a mortal. Paris was acutely embarrassed but had to obey Hermes, who had conducted the three goddesses to him. One by one they appeared and tried to influence his choice. Hera promised to make him lord over all Asia if he awarded the grand prize to her. Athene's promise was that she would ensure his victory in battle. Aphrodite, goddess of love, always persuasive in matters of seduction, promised Paris the most beautiful of mortal women, Helen. So the coveted apple went to Aphrodite. Hera and Athene, their pride wounded, took their revenge in due course, destroying Paris's country and his people and having him fall to the weapons of the Greeks. In Cézanne's painting the two vanquished goddesses still hold out their arms to the chaste, awkward young shepherd.

The myth of Paris had a double meaning for the virginal lad up from the provinces, faced with accessible models in Paris, the city of endless temptation. Offenbach made Paris the city a temptress in his *La Belle Hélène*. Art loomed in the young painter's mental self as the ultimate seducer, forcing him to choose between creation and woman. This was a dilemma that Zola understood only too well and felt impelled to dramatize in his novels. When he came to write *The Masterpiece* he imagined a painting by the artist-hero that was meant to symbolize Paris, showing "a boat filling the whole center of the composition and occupied by three women." Here was the myth, with Claude-Cézanne the painter substituting the city for the shepherd of the same name, who stands back with his brush as if defending himself and his miserable timidity from something he both damns and idolizes. "One of them, wearing a bathing costume, was rowing, another was sitting on the edge with her legs in the water and her bathing dress slipped halfway off one shoulder. The third was standing at the prow, completely naked, her nudity so radiant that it dazzled like the sun."

The artist's friend, Sandoz, concerned with the lapse of realism in a picture ostensibly set on the Seine in Paris, wanted to know how a woman naked in a boat in the middle of the city could be justified. Claude refused to back down and gave a number of unsatisfactory

and violent reasons for his choice, since he didn't want to admit the real reason for it. It was an idea that he had, but an idea that he would have been unable to express clearly, the old streak of romanticism in him that made him think of his nude figure as the incarna-

tion of Paris, the city of passion seen as the resplendent beauty of a naked woman. Into it he poured all his own great passion, his love of beautiful bodies and thighs and fruitful bosoms, the kind of bodies he was burning to create in boundless profusion so that they might bring forth all the numberless offspring of his prolific art.

The mental love-hate enslaving him, confused with the city and with art, that monstrous devourer—always Zola's nightmare rather than Cézanne's—falls away in *The Picnic* and *Pastoral*, leaving the one problem crying out for resolution that would never be solved, his vacillating response to women. We can at least say with certainty that the entry of Hortense into his life had steadied him, when we contemplate *The Picnic*, for instance. Let us suppose that in the beginning she was patient. She may even have taken him in hand to the extent of reconciling him to his fate, consoling him like a fractious child, giving him a sense of his own worth, making him feel at moments almost lordly, as full of power as his father. Maybe. But in *The Picnic* and *Pastoral* there are too many dark questions, too much obscurity and built-in difficulty and doubt for us to feel that Hortense was now established in a vital part of his life.

In *The Picnic* the myth activating Cézanne appears to be that of Adam and Eve rather than Paris. The apple, emblem of love, is not so much being offered as shown by the woman at center stage, bending from the waist and elongated rather in the El Greco manner. Schapiro sees the rounded orange-colored fruit as an orange, but the symbolism is clear. A tablecloth spread on the grass at her feet has two more apples or oranges. By the woman's bending attitude one is made to feel that a sacrament or ritual is being enacted before a man seated on the ground with his back to us, his head in profile and his pointing finger leveled at another man seated directly opposite. The bald pointing man, his head bulky and high-domed, is clearly recognizable as the prematurely bald Cézanne.

Who though is the man in the distance smoking a clay pipe, arms folded, his expression Sphinx-like? He wears a white shirt and is outlined against the sky, at the edge of a mass of dark woods. And who is the pale feminine creature sitting across from Cézanne, again in a white shirt, his chin propped on his hand in the classical pose of melancholy?

Mary Krumrine has some intriguing answers. The picture has obvious antecedents, most immediately in Manet's *Lunch on the Grass*, and is close in composition to Giorgione's *Concert champêtre*, which has four

protagonists, two nudes and two clothed men. In *The Picnic* the two women are in simple long dresses. On the far left are a man and woman, he in top hat and formal attire and she with hair neatly drawn back, carrying a parasol. They are moving off with their backs to us, entering the shadows and concluding a part of the narrative that Krumrine calls the "secondary action."[21]

Let us go back to the main scene. The effete young man opposite the Cézanne-figure, the odd man out in this grouping of two couples, can be regarded as Cézanne's alter ego or double. The sad, faintly smiling countenance and the pallor—he is fair-skinned, with yellow hair falling over his forehead—mark him out as "this pale young man of whom Musset speaks," which was how Zola, in his commemorative essay on the poet, described his youthful friend Cézanne. The ardent young Inseparables, Zola, Cézanne, and Baille, were deeply moved and affected by Musset's poetry. His work was forever associated for them with "the awakening of our hearts."

Zola's reference to the pale young man comes from Musset's "La Nuit de Décembre," the ubiquitous "poor child, stranger, visitor, orphan, angel or demon, this somber friend who resembles me like a brother." As the poem laments:

Who are you in this life
whom I always see in my path?
I cannot believe that, in your melancholy,
you could be my evil destiny.
Your sweet smile is too patient,
your tears are too pitiful. . . .

Who are you then? You are not my good angel;
you never come to warn me.
You see my pains (this is strange!)
and you watch me suffer.
For twenty years you walk in my path,
and I would not even know your name . . .
You smile at me without sharing my joy,
you pity me without consoling me.

Mary Krumrine, studying *The Picnic* and other pictures relating to it with great care, wonders if in fact Cézanne has painted his own "spiritual mirror image" here. To reinforce this insight she quotes from Edmond Duranty's short story "La Double vue de Louis Séguin."

The manuscript, recently come to light, deals with a group of artists who gather in the "Café Barbois," a fictional substitution for the Café Guerbois, where Manet and his entourage met and Cézanne occasionally put in an appearance. There is a telling manuscript slip—the central figure is referred to as "Paul" instead of "Louis" Séguin—and a similarity in the two surnames which makes it reasonably certain that the protagonist is based on Cézanne. So what does this tell us about the painting? The story is a study of the double, and in particular the dual nature of the artist. Séguin stares at himself in the mirror and exclaims that "this abominable person can have nothing in common with me," and the narrator comments:

> But wasn't his malady original and subtle? For having wanted so intensely to know himself, Paul Séguin ended up by hallucinating. He doubled himself, saw himself, both physically and morally, and this person whom everyone admired so much became odious to him. . . . I wondered, when we left him, if each of us, seeing ourselves like him as a repetition of our own selves and as another person, would have this same aversion.[22]

Another enigma is the pipe-smoking man standing stoically in the distance on the right, observing the game of the three fruits but taking no part. Cézanne and Zola (especially Zola) were very fond of pipe smoking. The man with the pipe could well be a surrogate for Zola, as has been suggested by more than one writer. Why, though, would he have placed his closest friend at a distance? Was he commenting on Zola's gradual separation from him, and his growing importance in the Paris literary world?

"La Nuit de Décembre" ends with a declaration by Musset's pale young man: he tells us who he really is:

> Friend, our father is yours.
> I am neither guardian angel
> Nor the bad destiny of men.

> I am neither God nor demon,
> And you called me by my name
> When you named me your brother;
> Wherever you go, I will always be there,
> Until the end of your days,
> When I will sit on your tomb.

Heaven has entrusted me with your heart.
When you will grieve
Come to me without worry,
I will follow in your path;
But I will not touch your hand,
Friend; I am Solitude.[23]

And as time went on, this man his associates would call "terrible" became steadily more cantankerous, impossible to live with or even befriend. "'I am solitude." Zola, looking on from afar, could be contemplating Cézanne's lonely fate. But in the prison of his solitude he was free, as nowhere else, to be himself, to contemplate, to pursue his solitary goal. What others would see as confinement he experienced as the only freedom. Hermann Hesse in his short novel *Rosshalde* says of his painter-hero Veraguth that "What remained to him was his art, of which he had never felt as sure as he did now. There remained the consolation of the outsider, to whom it is not given to seize the cup of life and drain it." The consolation of his "unsuccessful life" was the "cold delight of art . . . the strange, cool and yet irresistible passion to see. . . ."

What of the woman leaning over the end of the tablecloth laid on the grass? She is in a curious crouching position, her thighs open inside her mauve dress, her buttocks on the ground as though in labor. Her features, and her position next to Cézanne on the right, tell us that she is his pious older sister Marie. She has her left hand to her lips, suppressing a warning or simply shocked by the game on the cloth she is watching so intently. The "game" is this: Cézanne is being tempted by the tall, bending Eve-figure, against whom his sister warns him by her presence. But to no avail. The woman triumphs, the man acquiesces. In the secondary action to the left—traditionally the left and right of a classical painting indicate the profane and sacred attributes— the restrained couple are leaving the stage, entering the dark wood, outwardly respectable but no longer in Adam's unsullied garden. All through the main action the artist has been pointing at his double, who cannot help but only smile. His "sacred" sister can only warn. The limb of a tree to the left is dying, the one to the right putting forth leaves. The top hat and the parasol, on the grass behind Cézanne, reappear as the accoutrements of the departing couple. A bottle lying on top of a snake thin as a black lace has its neck pointing ominously at the couple. The yellowish dog with its muzzle raised sits to Cézanne's

left. Whatever it is meant to represent, it has been steered around by the temptress and her partner.

These dramatizations of emotional states, frustrations and fears, embedded in foreboding, walled in by dense blacks and black-based greens, show arenas packed with physical presence, with bodies, clothed and naked, that are not allowed to touch. In the midst of them sits Cézanne, telling us through his stranded figures that he is chained down by his obsessions, his ineptness, his adoration and animosity, unable to reach anyone, prisoner of a solitude that would mercifully bear fruit.

The *Pastoral* or *Idyll* contains another group of bodies treated as frozen statuary. His most romantic picture, heavily Wagnerian and brooding, it mixes clothed men and voluptuous nudes in the same pastoral tradition stretching from Giorgione to Manet. There the resemblance ends. Alienation hangs in the air. At the edge of the painting to the left a naked woman lifts her arms in frank invitation—her pose comes from Rubens's *Apothéose de Henry IV* in the Louvre. Once again the figures, six of them—three nudes and three men in modern dress— are each trapped in their own worlds, unable to make contact. But to say "unable" implies a desire to be otherwise. Incapable would be a better word. There is a langorous nude who reclines in the foreground, blue drapery under her, exposing her back and buttocks to us. Opposite her is Cézanne, his gaze fixed on her in brooding meditation or desire. He seems to be copying the woman's pose. His legs are drawn up as he lies on the grass with his head propped on his hand. There is no mistaking the self-portrait. Or that the male and female are mirror images. Is the woman then another manifestation of his double? And is he ignoring the provocative nude to the right with her raised arms by propping his head in this way?

Mary Krumrine tells us ingeniously that the alter ego he faces is the hermaphrodite, identified by her similarity to the *L'Hermaphrodite endormi* in the Louvre. But there is another baffling male figure sitting passively with his back to us, close to the "double" in this interior drama where there is again no touching, interacting, or even overlapping. Each figure is encapsulated in its own mental consciousness. Over to the right, the most isolated male sits in a boat under a huge lifeless sail at the water's edge. Not only is his back turned to us, it is turned to exclude all the others. This aloof figure smoking a pipe may well be another allusion to Zola. As for the time, it is neither night nor day. This is not the real world: the lowering blues and greens are the

colors of a tomb-world. These figures are all specters in a poem of death. The women may look voluptuous, but reach out your hand and it will go right through them. We aren't living in the flesh. This is entombment—background music by Wagner. Cézanne is showing us his terrible predicament.

# 8 A SECOND FATHER

Cézanne went back to Paris in late 1871 accompanied by a pregnant Hortense. He moved into rooms at 5 rue de Chevreuse because the good-natured Solari was in the building. It must have been too noisy, and Solari kept well out of the way when his friend left abruptly, irritable and touchy. He had found a little flat more to his liking at 45 rue de Jussieu. It was on the second floor, with a view overlooking the wine market. Solari, who hadn't been given a new address, wrote on December 14 to Zola, "Greetings to Paul Cézanne, who has vanished. I heard the furniture rolling on the staircase, but I didn't show myself for fear of troubling the removalists."

The painters Cézanne had known before the war scattered them were returning, either to Paris or nearby. Manet was still installed in Paris, but Cézanne's relationship with him was never more than formal. His intimates—in so far as he had any—were Solari, Valabrègue, and Roux. Monet had come back from England and was at Argenteuil. Sisley was at Voisins, Pissarro at Pontoise. Bazille was dead.

No one went to the Café Guerbois any more. Any reunions happened at the Nouvelle Athènes. Initial optimism about the new regime and the outlook for art under the Republic soon faded when it became clear that France was ruled by a government as fiercely reactionary as the one it had displaced. The regime was Republican in name only. The new moral order was pasteboard. Behind the religious proces-

sions, pilgrimages, and consecrations the old system of money and exploitation still held sway.

It is true that the revolution had broken the mold so far as the Catholic grip on education was concerned. Yet until the fall of the Second Empire, religion and the priesthood still dominated free public education. If you were a priest with no teaching qualifications whatsoever you could run a school. Intellectuals and writers called this "the cretinization of Europe." The wave of religious zeal after the war filled Zola with contempt and influenced his next two Rougon-Macquart novels. Cézanne, however, remained as indifferent as ever to the religious and political background of his time. He submitted nothing to the 1872 Salon, either because the academics were seen to be as firmly in control as ever, or for personal reasons. Being a common-law husband and now a father provided him with problems enough.

Zola was coming up against the same censorship restrictions as before the war. His novel *The Quarry* had to cease serialization in *Le Cloche* after a warning of prosecution. Courbet, more of a bogeyman than ever after his emergence as president of the Federation of Artists under the Commune, was once again the excuse for the Salon juries to clamp down harshly on anything "advanced."

Cézanne's only child was born on January 4, 1872, in Paris. The baby, named Paul after his father, was registered at the *maire* of the fifth *arrondissement*, just as the illegitimate Cézanne had been recorded by Louis-Auguste. The painter-father was thirty-three.

The cramped flat, now with a crying baby installed, was if anything noisier than the lodging he had vacated. The barrels being rolled around on the market cobbles raised a horrible clatter. To add to the confusion, Achille Emperaire arrived on February 18 from Aix. He must have been in touch with Cézanne to have this address, and presumably Cézanne had told him he was welcome to stay. Emperaire had come primed to overcome the fortress of Paris single-handed, and spent hours chatting about this and that. With Cézanne growing nervier and more antisocial by the day, the arrangement was a disaster from the start, though Cézanne had endless sympathy for the plucky dwarf with his vast improbable ambitions, who did in the end stop talking long enough to notice how impossible it all was. "I'm leaving Cézanne's flat," he wrote. "I must. The way things are, I can't evade the other's fate. I've found him forsaken by everyone. He no longer has a single intelligent or affectionate friend. Zola, Solari, all the rest never see him now." His friend struck him as "the most extraordinary crea-

ture imaginable . . . a real monster if ever there was one."[1] Hardly friendly words; and yet they did remain friends. Destitute all his life, with never a scrap of success, Emperaire's iron will kept his body and hopes alive until 1898. Two years before we find Cézanne referring to him in a letter as "a brave friend . . . alas, he hasn't arrived anywhere, but that doesn't stop him being a devil of a lot better as a painter than all those messers with medals and decorations who make one sick."

Emperaire's appraisal is startling: were things already as bad as that? Probably not: Jack Lindsay suggests that Cézanne had withdrawn this time out of embarrassment, unwilling to let his friends and acquaintances see him as a family man. But the process of alienation was undoubtedly well under way, and only an extension of something that had come to be accepted long ago back home in Aix. For him it even carried with it certain privileges. After all, to be the misunderstood, difficult, problematic member of the family was also to be singled out, special, a kind of sacred cow. Cézanne's cumulative reputation over the years as someone to be left alone, who was disabled, out of touch, belonging to art and nothing else, would at some point be taken over by him as the only possible way of life. What others had named him, he became. He seems to have decided, either in mortification or despair or pride, to embrace what art had made him.

Zola would hardly have been seeking him out, that much is certain: he was thirty-two and grinding away compulsively at his daily stint for eight hours a day every day. The daily articles he churned out for a living robbed him of the time he wanted to devote to his huge chronicle. He hoarded time like a miser. Even lying in bed his brain kept toiling, so that at the start of each working day he felt a wreck. As Graham King puts it, "At this point Zola's life began to be ruled completely by a new calendar: the *Rougon-Macquart*. The sands of his days were the words he wrote; the hours his pages, regular and unceasing. For more than twenty years he was to be a captive among the cogs of a chronometer of his own making."[2]

Yet he was still attached to Aix: the evidence is there in novels yet to come. *The Abbé Mouret's Sin*, published in 1875, is Zola's retelling of the Garden of Eden story, more a poetic essay than a novel. Like so many of his books it has outbursts of lyrical prose with an undertow of black bitterness. The novel's paradise is Le Paradou, an abandoned garden fenced in by nettles and hedges and a high stone wall. The original of this was the Domaine de Gallice, a luxuriant old garden near Aix where Cézanne and Zola played and pretended to be lost in

their boyhood. All that is good in nature is personified by a sixteen-year-old girl, Albine. At the heart of Le Paradou is a tree that comes straight from the Garden of Eden, a tree of immense height

> with a trunk breathing like a thorax, and branches wide-stretched like protecting arms. In appearance it was sound, robust, powerful, fertile. It was the doyen of the garden, the father of the forest, the pride of all the herbage, the friend of the sun which every day rose and set in a flood of light cast over its summit. From its green vaulting all the delight of creation descended, the scent of flowers, the song of birds, the raindrops of light, dawn's fresh awakenings, the drowsy warmth of twilights. Its sap was of such energy that it oozed and trickled down the bark, bathing it in a drenching of fecundity, making it the very virility of the soil. From it derived all the magic of this glade. The other trees, round it, formed an impenetrable wall which isolated it deep in a tabernacle of silent half light. There was but one continuous mass of verdure, without a chink of heaven or glimpse of horizon, solely this rotunda, every inch of which was draped with the loving silk of the leaves, the floor below covered with the satin velvet of the mosses. Entering it was like plunging into the crystal water of a spring, a world of greenish clarity. . . .[3]

Cézanne, in a quandary now that his retreat to Provence was cut off—he was trying to keep his father in ignorance of his new domestic circumstances—wanted to leave the noise and crowds of the city behind and find some equivalent rural haven. His thoughts turned to Pissarro, painting away steadily at Pontoise. What if he were to take Hortense and the baby and join him there? Suddenly the prospect was irresistible. After all, Pissarro was a family man too—no fear of ridicule there.

To Cézanne, this man in his early forties, looking much older and venerable, was an exception among painters, a noble tree in the midst of his life whom he called later "the Good God." He was moved once to sign himself "a pupil of Pissarro." Gasquet records Cézanne as saying toward the end of his life, "We perhaps all come out of Pissarro. In 1865 he had already eliminated black, bitumen, raw Sienna, and the ochres. It's a fact." To another witness, Émile Bernard, he intimated that it was through Pissarro that he began to find himself in his forties. Thirty years after he apprenticed himself to Pissarro he called him "the

humble and colossal Pissarro." There is a photo of the two men, taken when they worked together in the early 1870s, in which we see Cézanne seated on a bench, his head bowed, before the man only nine years older than his pupil, who stands with his head similarly bowed before him. It speaks more eloquently than any words of spiritual kinship.

Cézanne had found a second father. Pissarro understood at once the emotional immaturity of his pupil and was wise enough to take account of it. He was hospitable and patient, a Jewish outsider who empathized at once with the outsider in Cézanne and had the tact to steer his friend's personality into quiet waters. Cézanne's quirks and thorny temper didn't provoke him. He kept them both clear of discussions that may have been potentially explosive. His wife, taking her cue from her husband, showed the taciturn man from Aix the same sensitive consideration, refusing to be offended by his surly manners. Pissarro, judging from his letters and the testimony of others, was a socialist who believed that socialism meant generosity. Actions flowed from him in accord with his convictions. He would extend a helping hand to anyone who asked, and favored mutual-aid communes for painters.

Another misfit who found a surrogate father in him, though much later, was Van Gogh. By this time Pissarro had a venerable white beard flowing down to his chest. A lover of Millet, like Van Gogh, he was the only painter of peasants in the Impressionist movement still to come. And maybe another reason for Cézanne finding him so congenial was his history. He too had abandoned a business career and defied his father. But as well as that, he felt no necessity to be on his guard. What a relief that must have been. No one in this peaceful, unpretentious household showed any sign of wanting to get their hooks into him.

Pissarro, whom Schapiro calls "perhaps the most idyllic of the Impressionists," was a disciple of Corot. The glamour and delight of that grand leap into the open air, into light that was Impressionism, the rococo scenes of picnics and boating parties and holiday crowds in the parks and along the river were not really for him, though he tried his hand at them more than once. Basically his concerns were more serious. His way was more ruminative, patient, slow. Cézanne was to benefit from him enormously. Above all, what he gained from Pissarro was a new stability.

He stayed first at the Hôtel du Grand Cerf, near the old bridge of Saint Ouen-l'Aumône. Pissarro was close at hand in the Hermitage Quarter. Now began a fruitful calm period of two or three years, when he adopted a clear palette, abandoning tonal construction and his bitu-

minous palette. Pissarro advised him to "use only the three primaries and their derivatives." He listened humbly to the older man, even copying one of his paintings. This was the turning point, when he left behind the introspective narratives and the raw ferocity and violence before that. Romantic, chaotic force gave way to painting that was a form of meditation. Cézanne, the most widely read of modern painters, would have been familiar with Schopenhauer's definition of artistic procedure as "the contemplation of the world independently of the principle of reason." One can readily see him embracing the idea of nature as a safe womb in Schopenhauer's *The World as Will and Idea*, in particular the description of a nature that never lies but is always straightforward and open. "Consider the insect on your path: a slight unconscious turning of your step is decisive as to its life or death. Look at the wood-snail, without any means of flight, of defense, of deception, of concealment, already a prey for all . . . the bird that does not know of the falcon which soars above it, the sheep which the wolf eyes and examines from the thicket. . . . Since now nature exposes its organisms, constructed with such inimitable skill, not only to the predatory instincts of the stronger, but also to the blindest chance . . . it declares that the annihilation of these individuals is indifferent to it. . . . It says this very distinctly and does not lie. . . . If now the all-mother sends forth her children without protection to a thousand threatening dangers this can only be because she knows that, if they fall, they fall back into her womb where they are safe. . . ."

It would be some time, though, before he could abandon the palette knife completely. Pigment still went on thickly, leaving bumps and ridges, while alongside him Pissarro was in the process of developing his technique of small juxtaposed patches. A peasant who had been watching both men at work out of doors said, "Monsieur Pissarro, when he painted, dabbed, and Monsieur Cézanne smeared." The most revolutionary thing was the startling brightness of Cézanne's palette. Before, he had been ruled by black and white dominants. Monet remembered seeing Cézanne put a black hat and a white handkerchief next to the model to judge values when working at the Academy Suisse. Black was now discarded: but unlike the Impressionists of the 1870s he resisted the temptation to dissolve everything in light. He was after something else. He hung on to local color while they intoxicated themselves with atmospheric greys. He became conscious of the canvas. He devoted himself to nature. He was the humblest of them all, the most severe, the most grave. Guided by Pissarro, who had

worked out of doors for years, he did the same. Around Aix he had often made landscape sketches from nature, using them as studies back in the studio. Now he began to complete the entire canvas in the open air. And for the first time he was painting more landscapes than anything else. He had joined the ranks of the *plein air* artists, though Impressionism as a movement had not yet been born. He was still liable to burst out in a kind of slapdash ferocity, but he was slowing down, cultivating a "handwriting" that would be uniquely his own, seeking to be true to something he called "sensation" as he accustomed himself to the soft wet greens and hazy blues of the Île-de-France.

His accommodation at Pontoise was temporary, unsuitable for the long stay he had now decided on. An introduction to Dr. Paul Ferdinand Gachet—probably made by Pissarro—who had a house at Auvers-sur-Oise, not far from Pontoise, made him want to live at Auvers himself. In the autumn he moved to a small rented house close to the Gachets. By a great stroke of luck he had found another person very to his liking, absolutely trustworthy and sympathetic, if somewhat odd. Also there were other artists in the neighborhood, coming and going. Guillaumin was there quite often, as well as Cordey and Vignon. It was pleasant to see them. All in all, his two years at Auvers would be one of the happiest times of his life. At least twenty-five pictures see the light during this period, and he was destroying fewer than before.

The Gachets lived in a large detached house with a terraced garden that was a landmark in the countryside around. Born in Lille, Gachet was of Flemish origin. When Van Gogh encountered him, shortly before his suicide, he was able to talk to Vincent in his own language. At the time of Cézanne's meeting with him his wife was still alive, though suffering from the consumption that killed her a few years later. Gachet was an amateur painter of no particular talent, but he was mad about art and artists. In Paris, where he practiced homeopathic as well as conventional medicine, he sat in art cafés and did his best to ingratiate himself with professional artists. In this way he got to know Manet, Monet, Renoir, Degas, and Pissarro. He admired Courbet ardently, was a socialist who tried like Pissarro to act out his convictions, and his defense of the young insurgent painters of his day would be unleashed on anyone with patience to listen to him.

Apart from the three days a week he spent at his surgery he painted little pictures at home, conversed with artists in Auvers whenever pos-

sible, and called on the occasional patient. If they were poor he treated them anyway, keeping his kindness to himself. Warmhearted and eccentric, he took in every stray animal that crossed his path. His house was full of lost cats and dogs. By the time Van Gogh came to be administered by him, the strange doctor had long ago lost his wife and was more eccentric than ever. In the house were eight cats and eight dogs, and in the gardens wandered chickens, peacocks, ducks, pigeons, and even sheep. He took out a goat called Henrietta for walks on a lead. He signed his paintings with a pseudonym, Paul van Rysell. In fact it was Pissarro, solicitous as ever, who had come up with the idea of a refuge for Vincent at Auvers under the supervision of Gachet when Theo was looking desperately for somewhere for his brother, still incarcerated in the asylum in Saint Remy but eager for release. Pissarro would have taken in the afflicted Dutchman himself but his wife objected, fearing for her children.

Vincent's portrait of Gachet is an extraordinary work; on his face and through his drooping posture he had sought to depict "the heartbroken expression of our time." The loss of his wife had left Gachet bereft, and fifteen years later, according to Vincent, he still grieved. In the house, canvases, framed and unframed, were everywhere: flower pieces by Cézanne, Pissarro landscapes, Renoir nudes—in fact most of the Impressionists were represented.

Gachet had been involved in the Franco-Prussian War and sometimes wore a blue army surgeon's overcoat. In summer he had on a white cap, in winter a fur one. If the weather was hot he carried a white sunshade. He dyed his hair bright yellow and was nicknamed Dr. Saffron by the locals. What upset Vincent particularly was the weird contrast between his blazing collection of Impressionists and his houseful of black antiques. "Black, black, black," he wrote nervously to his brother Theo. For all that, he felt close to him, and so did Cézanne. He was a freethinker, a utopian, an exponent of the simple life. He soon purchased a couple of Cézanne's canvases for modest sums, and has been named as possibly his first buyer. Because of his example a local collector, Rouleau, a teacher, bought one or two works, and a grocer in Pontoise by the name of Rondès took a canvas as payment of a bill.

Contented, collaborative—the words seem incredible applied to such an anomaly as Cézanne, a man whom even Emperaire had so recently found impossible. A self-portrait of this period shows a man aware at last of new possibilities, awake from a long nightmare, his beard so thick it has swallowed his mouth, his hair behind his head

grown so long it is curling back on itself. It was painted just before his removal to Pontoise. He had just written that he found himself in a mess, so had gone from the apartment overlooking the market to paint in the studio of his old friend Guillaumin. Behind him in the composition he structured there hangs Guillaumin's painting of the Seine, with Notre Dame in the distance. The *couillarde* fury of the portrait, hardly ever to be seen again, could have been rage at finding himself no longer a free agent but a parent with responsibilities.

◆ There was no turbulence apparent to Pissarro, judging by the letter he wrote in September 1872 to Guillemet: "Our friend Cézanne raises our expectations, and I have seen and have at home a painting of remarkable vigor and power. If, as I hope, he stays some time in Auvers where he is going to live, he will astonish a lot of artists who were too hasty in condemning him."[4] Photographs and drawings of the time reveal him as defiantly carefree, marching round in a broad-brimmed hat or in thick boots, a wagoner's cloak and an old cap, his beard ragged as a tramp's. Slovenly he certainly looked, but one is not prepared for the bright outgoing gleam in the eye, the head held pugnaciously. To astonish us further are untypical drawings by Cézanne such as *Family in a Garden*, presumably the Gachets, since in a top corner of the sheet is a sketch of the doctor himself. One bearded patriarchal figure could be Pissarro.

A note written on December 11 and presumably left for Pissarro makes clear the pleasant informality of his relations with the family, and how relaxed he now felt with the world in general. Not for the first time he had missed the train back to Auvers. One of the children adds a charming postscript with spelling that is all his own:

> I take up Lucien's pen, at an hour when the railway should be transporting me to my penates. It's to tell you in a roundabout way that I missed the train. Useless to add that I'm your guest till tomorrow Wednesday. Well then, Mme. Pissarro asks you to bring back from Paris some flour for little Georges, also Lucien's chemises from his aunt Felice's. Good evening, Paul Cézanne.

> —My dear papa, Mamman wants you to know the door is broken so come quick because robbers could come, I prey you if you like please bring me a paint box, Minette preys you bring a bathing suit. I is not written well as I were not inclined, Lucien Pissarro 1872.[5]

Auvers was much smaller than Pontoise, a real village of thatched and tiled cottages. Daubigny lived there, almost the only ally of the young painters inside the bastion of the Salon—he was the jury member Renoir had approached for news of his work, too shy to reveal his identity. Daubigny, with Corot, was admired for his fresh colors. He had been saying to Pissarro and others, "We never paint light enough." And not far from Auvers, in Valmondois, lived the half-blind Daumier.

One of Gachet's enthusiasms was a printing press in one of his outhouses. There is a drawing by Pissarro showing Gachet helping Cézanne to make an etching. The head of a girl etched by Cézanne may have been Hortense. But he didn't take to the medium. He drew a *Hamlet* scene after Delacroix but failed to etch it.

His contact with Pissarro didn't result in a wholesale conversion to an impressionism that was still feeling its way. He was too wary a character; and Pissarro himself was slowly and carefully experimenting. But it helped to free him from dark moods, and it began to liberate him in favor of something steadier. His savage impulsive drives died down, to be replaced by flickers of sensation before landscapes he had not until now allowed himself to see in their own right. He was aware of joy, both his own and the joy waiting potentially in nature like a buried treasure. It was as if, all this time, he had been painting the *wrong* picture. His profound respect for nature, to which he would henceforth devote himself as to a god, stirred in him like a new revelation. As his palette lightened, so did he. From this time come his first flower pieces. He would continue to swerve aside for a few years yet into romantic flurries, furious attacks. In this century Roger Fry named him as the first wild man of modern art. His naive, stark directness combined, even in the early days, with a baroque flourish, an extravagance which never altogether left him. But he was moving slowly and steadily away now from the thunderous gloom of tragic conflicts. He would never forget his debt to Delacroix, but the Baudelairean "Delacroix, lake of blood haunted by evil angels / Shadowed by a wood where evergreen fir-trees rise" was being left behind for what the critic Geffroy was to call, in his attempt to define Impressionism, an "exaltation" of the senses. And he was profoundly affected by Chardin, by his elevation of brown crockery to the realm of poetry, above all by a world brought to rest in an immense meditative calm, where an onion could be a memorial to patience and truth.

It is important to bear in mind always that Cézanne came from the

south, and that his ancestry was Italian. The Mediterranean gave birth to classicism, and Cézanne is a supremely classical artist. It was his belief that "the way to Nature lies through the Louvre, and the way to the Louvre through Nature."

But now something was happening that was entirely new in the history of painting. The spirit of out-of-doors was being put on canvas for the very first time. The hard and clear light of the Mediterranean, which had educated Cézanne's eye differently from his fellow Impressionists, intensifying colors and opening up distances, had always made him look for weight, for solidity. The dissolution of things in atmosphere and sunlight was joyous, an escape from form, a tremendous thrill. The discovery of light! Cézanne responded, but only so far. ("The truth is concrete," Hegel said.) His Mediterranean eye made him want to keep faith with the object, to submit to it, while his fellows were rapturously intent on escaping the drab tyranny of it. They had opened up a hole in the cosmos and could now leap out. Infinity beckoned. Cézanne's stubborn need to make the earth solid led him to declare much later, "Impressionism, it's no longer necessary, it's nonsense." Yet his esteem for Pissarro remained constant. In l'Estaque in 1876, away from the veils of mist over water, the atmospheric greys of Monet, Sisley, and Renoir, he wrote to tell his old mentor that the effect of light was to flatten the landscape "like a playing card." And he insisted later that "All painting lies in this dilemma, whether to give way to the atmosphere or resist it. To give way to it is to deny local values; to resist it is to give local values their full force and variety. Titian and all the Venetians worked with local values; this is what makes all true colorists."[6]

He painted views of Auvers, including one that went some way toward the new evolving credo, sacrificing some of his characteristic solidity in favor of a charm of light and color. The ease exuded by this panorama of cottages, trees, and fields is a remarkable departure. The eye is freed to enjoy an open, dispersed world of twinkling elements, over it the broad sweep of the sky. The thickly painted spotted colors create a kaleidoscopic chaos in the foreground, with clarity infiltrating in the far distance.

There is a series of views of the road through Auvers leading to Gachet's house. *The House of Dr. Gachet* presents us with a simplified, stark version of comparable works by Pissarro. The bare trees and the dull greys and browns indicate winter, probably that of 1872–1873. A single tree growing against the Gachet residence centers the composi-

tion, and the converging diagonals of the road and a low boundary wall balance the taut structure.

Schapiro calls *The Suicide's House*, painted in the same winter, the masterpiece of Cézanne's first probationary year as an Impressionist. Suddenly the color springs to life, luminous and vibrant. He hasn't given up his liking for thick pigment but the touch is lighter and smaller, the constructions built up with more gravity than in the pictures of his Impressionist colleagues—with the exception of Pissarro. He seems intent, by means of his thick granular patching, to imitate the actual texture of the plastered rendering, the rocky outcrops, the grass surfaces. The canvas bristles with this rough treatment yet retains a delicacy which is hard to explain when confronted by such a powerful image. What Schapiro calls "the mild, shapeless, open spaces of Impressionist art" are nowhere to be found here. The space is claustrophobic, crowded with shapes that cram up against three of the four edges of the canvas. We have again, as in those wartime landscapes of l'Estaque for instance, his liking for sharp declivities and obstructed passages in nature, hard to negotiate, as if making barriers to exclude the viewer or construct a retreat for himself. The critic Robert Hughes sees Courbet's limestone crags and ledges of the valleys of his native land reappearing in the work of the young Cézanne, who loved Courbet's physicality, his power to stress the very *weight* of the world.

*The Suicide's House* focuses closely on a bend in a road, packed with buildings and trees and rocks, the ground falling away immediately before us, lifting again to a high horizon and the clear blue of a strip of sky. What has happened in this house may have influenced his introspective nature: there is no way of knowing. Appearing for the first time is his taste for subtle correspondences, the dark line curving over the door that is echoed by the rock shape on the right; the sloping rise of the road filling the foreground, the door and windows of the main house on the same diagonal axis that encourages the actual verticals of the walls to tilt.

As we have seen he was reluctant to give up his lumpy way with paint, which was not to do with rudeness but on the contrary a sign of his stubborn desire to reach real objective substance. Again, he had taken in his Courbet, "along with the pasty, almost mortared paint that evokes surfaces." But he had done with emotional ejaculations and would be searching for many years for a means of using pure color to organize forms, letting them grow from the sense of color itself. This idea of using color and a certain distortion to create a kind of mosaic,

*200*

"a fluidity of masses proceeding from a tessellation of hues," was for the time being beyond him. "When the color has attained richness," he would eventually say to Émile Bernard, "the form has reached plenitude."

After 1880 he was moving toward a process involving the creation of volumes without illusionism. How was the natural scene to be adapted to the two-dimensional surface of a canvas? He gradually evolved a method that was all restraint, all concentration, transforming the Impressionist technique of broken brushwork into something more of a discipline, so that each painting was woven like a fabric out of marks, the surface held intact like a fine mesh. Dramatic incidents, changing eye levels, tiltings, flattened ovals, and ignored perspective all contributed to a harmony of subjective sensations. Canvases were covered with a pattern of small, elongated parallel brush strokes, the transparent luminous color laid on as thinly as watercolor. At first the strokes ran in the same direction, from upper right to lower left. Then came a more flexible approach using small patches, the uniformity of strokes in parallel being confined to each of the patches or areas. Other areas would have strokes slanting in different directions. It was a system that forced him to concentrate and paint with painstaking slowness, holding back each stroke of the brush until it was exactly right in relation to the whole. Driving him was the necessity for laboriously fashioning tools which had not been used before, that he insisted on originating himself. In all this he was more and more at the service of nature, an obsession that would soon absorb him totally. It was not so much knowing nature as participating in nature's nonhuman consciousness of itself, so that he was expressing the raw truth of the object as if speaking out of it, rather than through his meddling self.

It was an excruciating method. The whole of the canvas had to be taken into account before he would register one extra stroke. "I advance all of my canvas at one time," was how he put it, as he advanced toward his goal of stillness, from which everything rhetorical had been banished. Ordinary substance had to be restored in its true clarity. As Lawrence saw, Cézanne longed so much to be grand and voluptuous in the late Renaissance baroque manner, yet the nature in front of him, to which his own nature was so religiously faithful, wouldn't let him. Peculiar things happened to his forms when he tried to ignore what he knew intuitively he must do. Hence the critics who said his eye was defective, that he couldn't draw. These "failures" were what made him original. He drew "badly" so as not to repeat the facile clichés of others.

He would have liked to have accomplished his paintings at a blow. Naturally. But the *couillarde* style of painting at a blow was no longer valid, since its source was anger and frustration. He would have loved to paint sweepingly like Manet, bringing out the form with masterly sweeps of the brush. But he had the temperament to achieve more, much more. During these apprentice days at Auvers he occasionally ended in rages, going on too far, not knowing when to stop and not yet capable of going further. Gachet, watching, would cry out in agitation, "Come on, Cézanne, leave this picture, it's just right, don't touch it any more."[7]

He was very taken by Monet, who knew much privation in his early days. "Renoir brings us bread from his own home or we should die of hunger," he wrote once to Bazille. "For a week now we have been without bread, without fuel to cook by and without light." Cézanne had a great regard for him but was never seduced. Toward the end he told Vollard, "Monet is only an eye. But good God, what an eye!" And of course Monet had discovered the wonderful knack of dissolution by the simple means of drawing the world of matter into the delicious embrace of light. Once he started he couldn't stop. Haystacks, cathedrals, water-lily ponds were all transfigured, and in the process they virtually disappeared. One was left with bliss, disembodied. For Cézanne, struggling to resurrect something that had existed once, in the beginning, but was now no more than a concept—a tree, an apple—there had to be a revolution. Hence his remark to Zola that an apple or a carrot painted truthfully could conquer Paris. And so it did. Art swung around Cézanne's apple as around a fulcrum, into the twentieth century. Only Cézanne was on a different road, his back to us, heading for the promised land.

◆ For most if not all of the time he spent at Auvers he was out of contact with Zola—a foretaste of things to come. Nevertheless, newly published books kept coming, and as a deeply courteous man we can assume that he acknowledged them all with his customary note of thanks and some squeezed-out words of appreciation. Zola, preoccupied with his vast chronicle and with publisher problems, still had Cézanne in his thoughts. Notes for *The Fortune of the Rougons*, the first of the series, speak of "Return to brutalization. Influence of the feverish milieux of place and milieux of society determining the person's class (worker, artist, bourgeois—I and my uncles, Paul and his father)."

It was while Cézanne, guided wisely by Pissarro, was absorbed in his new approach to landscape in the open air that Zola foundered and nearly went under. His publisher, Lacroix, caved in under financial pressure and declared himself bankrupt. This was disastrous for Zola, who had been signing promissory notes amounting to thousands of francs against unearned royalties. These notes were now seized by creditors and Zola was plunged into debt. With a wife and mother to support and a modest home and only his newspaper articles as income, he was in despair. He trailed desperately from one publisher to another and at last persuaded Georges Charpentier to take him on.

Charpentier was young, intelligent, and adventurous. The business he had taken over from his father, a backlist of romantic authors, bored him. Eager to chance his arm, he took a gamble on the novelist, who was still an unknown quantity so far as the public was concerned. The deal was clinched after Theophile Gautier, a friend of his father, advised taking Zola on. The contract provided Zola with five hundred francs a month in advance of royalties from books still to be written. For Zola, saddled with debts of his father's that he was obliged to pay off, and eighty francs a month rent for his house, it was a struggle to keep his head above water. But he worked on harder than ever, his circumstances ever more domestic, including a pet dog and a hutch of rabbits.

Looking at the artistic progress of Zola and Cézanne and bearing in mind their love for each other and the dreams and fantasies engendered by the landscape of Provence in both men simultaneously, it is possible to see correspondences even at this stage. Cézanne, with his impressive *The Suicide's House*—it is now in the Louvre, which he would have found unbelievable—had broken into utterance in an entirely new way, as if he had all at once been given back the world and everything in it. At the same time, *The Belly of Paris*, Zola's first novel for Charpentier, took Les Halles—the outdoor market of Paris—for its subject, which grew in the novelist's mind as an epic metaphor for everything the city meant to him. It was also an homage to the physical world, an attempt to create "an immense still life," as its creator said. If Cézanne was now discovering how to make things real, so in this book was Zola—though of course as always his pen ran away with him. In one virtuoso passage he composes a mouth-watering song of the cheeses:

Under the display counter of red marble veined with grey, baskets of eggs suggested the whiteness of chalk, and in their crates on

wicker trays bung-shaped cheeses from Neuchâtel were placed end to end, and *gournays*, laid flat like medallions, brought expanses of more somber color, stained with their greenish tints. But for the most part the cheeses stood in piles on the table. There, next to the one-pound packs of butter, a gigantic *cantal* was spread on leaves of white beet, as though split by the blows of a hatchet; then followed a Cheshire cheese the color of gold, *gruyère* like a wheel fallen from some barbaric chariot; some Dutch cheese . . . with that hardness of an empty skull which has earned them the nickname of "dead-head." A *parmesan* added its aromatic sting to the thick, dull smell of cooked pastry. Three *bries*, on round boards, had the melancholy look of extinguished moons: two, extremely dry, were at the full; the third was in its second quarter, running, creeping out in a white cream which spread into a lake, making havoc of the thin boards which had been put there in a vain attempt to hold it in check. Some *port-saluts*, shaped like the ancient discus, showed the names of their makers inscribed round the perimeter. A *romantour*, dressed in its silver paper, made one think of a bar of nougat, a sugared cheese which had strayed into this realm of bitter fermentations. The *roqueforts*, too, under their crystal bells, were of princely aspect with their fat, marbled faces veined in blue and yellow. . . .[8]

Cézanne, as if to confuse everyone, all at once turned from nature to have another shot at the Olympia theme. Was his *A Modern Olympia* a joke at his own expense, or a parody of Manet's insolent prostitute? Roughly painted, far removed in color from his charged narratives hung with Wagnerian gloom, it has the look of something knocked off at a single sitting. The naked woman floating up in the center of the picture, flooded in brilliant light, has a Negress in attendance behind her who is pulling aside the figure's gauzy draperies. The crudity of the handling is perhaps another sardonic comment on Manet's elegance. The nude, huddled strangely in midair is one of his ugliest females, "ungainly, almost apelike." Below her on a divan is a self-portrait of the artist dressed incongruously as an upper-class roué, carrying a cane, his tall hat beside him as he sits like a pasha contemplating the woman's nakedness. What could be more unlikely? As Richard Verdi comments, "Only Rembrandt insinuated himself more often into his own imaginary compositions, as if to lend them a stamp of authenticity."[9]

Evidently Cézanne had been talking about Manet to Dr. Gachet,

remarking that the *Olympia* was something he could do, and Gachet challenged him to "Do it, then." Pissarro, startled by this weird apparition on a cloud of greenish vapor, wrote to the dealer Duret, who had been expressing a wish to see something by Cézanne, "If it's five-footed sheep you're after, Cézanne will be able to satisfy you: he has some very strange studies, seen in a unique way." Early in 1873 Pissarro sold some paintings, one at 950 francs. Heartened, he wrote to Duret of his ambition to hold a group show: "We begin to make our breach. We are strongly opposed by certain masters, but there's no need to wait on these divergent viewpoints when one arrives as intruder to plant one's little flag. . . ."[10]

While Cézanne worked in the open at Auvers he was noticed by curious passersby, among them Daubigny, who was impressed in spite of himself. "I've just seen on the banks of the Oise an extraordinary piece of work. It's by a young and unknown man, a certain Cézanne."

Advances in the analysis of light and color, the invention and development of the camera, and the impact of Turner were all influencing the more adventurous painters by the mid-nineteenth century. There was naturally fierce opposition to photography by such men as Delacroix, who was cited in a book of 1865 as saying that "even the most stubborn realist will improve the rigid perspectives produced by the camera, which by reason of its correctness actually falsifies the appearance of things." Photographs were first called "sun-pictures." The view was born, according to camera enthusiasts, from sun and light. Baudelaire expressed his contempt for the new craze and at the way "the whole foul lot rushed at it like one Narcissus, to look at their trivial likenesses."

Pissarro, open to all change, was stimulated by the camera's revelation of distances. He was familiar also with the chemist E. Chevreul's book *Principles of Harmony and Contrast of Colors* which had appeared in 1839. Chevreul's book investigated the influence of colors close to one another, discovering that any color was seen to be surrounded by a faint aureole of its complementary color. Working with Pissarro meant becoming aware of these factors, allied as they were in him to a sturdy common sense. At the start of his and Cézanne's working relationship the similarities in the two men's work were evident to many. As Pissarro was to put it, "In Pontoise he was influenced by me and I by him." Always modest and fair, he commented sagely that to assume that artists were the sole inventors of their styles was simply foolishness. Resembling someone else had nothing to do with a lack of originality.

It was Pissarro more than any other who enabled Cézanne to raise the pitch of his scale of colors without losing the sheer solidity of the object. Lucien Pissarro considered that "exploration of the values of closely adjacent colors" was "the outstanding characteristic of my father's art."

Writing long before Cézanne and Pissarro became properly acquainted, the painter L. Le Bail summarized Pissarro's standpoint and the methods he urged on others. As well as a fine painter he was a remarkable teacher. Mary Cassatt remarked that "he could have taught stones to draw correctly." Le Bail remembered Pissarro's advice as follows:

Seek out for yourself a type of nature which suits your temperament. One should observe forms and colors in a motif rather than drawing. It's not necessary to accentuate the forms. They can be realized without that. Accurate drawing is dry and destroys the impression of the whole, it annihilates all sensation. Do not make the bounding line of things too definite: the brush stroke, the right shade of color, and the right degree of brightness should create the drawing. With a mass the main difficulty is not to give it an accurate outline, but to paint what is to be found within it. Paint the essential character of things, try to express it with any sort of means you like, and don't worry about technique.

When painting, look for a clear object, see what lies to right and left of it, and work at all sections simultaneously. Don't work bit by bit but rather paint everything at once, applying paint all over, with brush strokes of the right color and brightness, and observe in each case which colors are near the object. Use small brush strokes and try to set down your observations directly. The eye should not be fixed on one point but should note everything, and in so doing observe the reflections which colors throw on their surroundings. Work at the same time on sky, water, twigs, and ground, bring on everything evenly and go on tackling everything without stopping again and again, till you've got what you want. Cover the canvas at one sitting and work at this till you can find nothing more to add. Observe accurately the aerial perspective, from foreground to horizon, the reflection of sky and foliage. Don't be afraid of applying paint, make your work gradually more perfect.

Don't proceed according to rules and principles, but paint what you see and feel. Paint strongly and unhesitatingly. For it's best not

**206**

to lose the first impression. . . . One must have only one master: nature. One must always ask her counsel.[11]

For all the absorption in landscape that Pissarro had inspired in him, Cézanne hadn't lost his desire to paint portraits. Two outstanding ones come from either side of his Auvers period, though as always it is hard to date most of Cézanne's work with any accuracy. All we know of *The Man with a Straw Hat* is the man's name, Boyer, and the fact that he was an Aixois. He could well have been an old school friend. Everything about him in this head—altogether more dominating than in other depictions of him—speaks of the provinces. Did he possess this packed energy, or was it the power of the forms that create such an impression? The strong profile of the three-quarter face is given extra force by the projecting outlines of the hat, jacket, and densely black bushy sideburns. Schapiro sees the man as a Balzacian character—or rather, he has been made into one by the painter's imagination. He has the almost dismissive look of the kind of self-made man that Cézanne's father was, one eye staring out with shrewd appraisal, the other in shadow, hinting at anger or uncertainty. It is a picture of pride and purpose, though Schapiro suggests that the aspect of somber will may well be Cézanne's own. There is reason for considering every portrait as in some sense a self-portrait. The blacks and greys and the mastery of tones, equal to anything by Manet, place the picture in that phase when the Parisian exerted a powerful influence.

The year after Auvers, so far as one can tell, comes the first of several portraits of Choquet, one of the first to collect Cézannes. Victor Choquet was a lowly civil servant working in customs administration who loved art, and from the start was an admirer of the Impressionists. He had little means, but real taste, and bought whatever works he could afford. He stinted himself with food and clothes in order to buy rare porcelain, antiques, and paintings. He was middle-aged, tall, with a long gentle face, his head elongated by Cézanne in the El Greco manner, as if he wanted to turn his new friend into someone drawn upward by a religious yearning. Again Cézanne is commenting on himself in this act of homage.

The head is almost in profile, topped by a bushy mane of silvery hair, and is altogether more luminous than the Boyer, showing signs of Cézanne's prolonged encounter with Pissarro. Not that his mentor would have produced anything like this. The agitated, dancing touches enlivening the ascetic face, with red around the nose and cheeks, the

brush active everywhere, all its movements visible and spontaneous, help to model the features subtly and yet leave a feeling of great strength. The subject has been made heroic by the painter's idealism and his desire to pay homage to a selfless character. There is distortion in the way the head is angled, the sides foreshortened, so that the portrait is nowhere at rest, played over by the painter's urge to get round the back of the form, to convey in each daub and facet the unarguably physical, even if it should end in exaggeration. The large nobility and powerful use of space in the finished work should have silenced the most dissenting critic, but of course it didn't. When it was shown in 1877 it was dismissed as resembling a notorious murderer in tones of chocolate.

◈  We have no news of Hortense while she was at Auvers with her new partner. The friction and irascibility that drove Achille Emperaire away from the apartment overlooking the Halle aux Vins may have been caused indirectly by the difficulty Hortense had in fitting easily into the tight circle of Cézanne's friends from Aix. Or the difficulty Cézanne had in adjusting to her inclusion. The atmosphere undoubtedly improved when he took his little family to Pontoise and then to Auvers.

A group photograph of a painting expedition shows the jackbooted Pissarro holding a staff, his luxuriant white beard square and wiry, under his broad-brimmed hat his eyes gleaming out like an Old Testament prophet. Beside him Cézanne leans back against the stone wall of a field in his shirtsleeves and waistcoat, arms folded nonchalantly like a roadmender at lunch.

In 1874 Pissarro painted the portrait of his friend that Lucien his eldest son, then eleven years old, later remembered:

> Cézanne's portrait . . . resembles him. He wore a cap, his long black hair was beginning to recede from a high forehead, he had large black eyes that rolled in their orbits when he was excited. He walked with a stick, steel-pointed at the ferrule, which frightened the peasants. . . . They discussed theories endlessly; I remember some words that I overheard: "The form is of no importance. It is the harmony."

One day some collectors turned up to have dinner with Pissarro, whose hopes were high. His wife, wearing her best silk dress, put a

The rapidly balding Cézanne, looking years older than his thirty-two years, was about to become a father. His only child was born in Paris in 1872. *(Hulton Deutsch Collection)*

Cézanne, seen here with Pissarro around 1872, had found a second father. He was once moved to sign himself "a pupil of Pissarro." *(Roger-Viollet)*

A photograph of Cézanne about 1875 shows him on the road to Auvers, making real progress at last under the influence of the "good God" Pissarro. This was perhaps the happiest time of his life. *(Réunion des Musées Nationaux)*

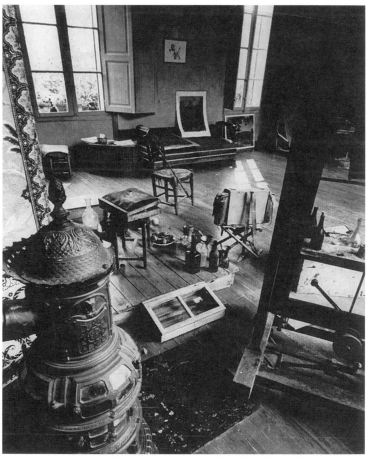

Feeling the need for a place of his own, Cézanne had bought a plot of land just north of Aix and commissioned an architect to design and build the kind of studio he wanted. In old age he walked uphill to it in early morning to escape the heat. He never lived there. *(AKG London)*

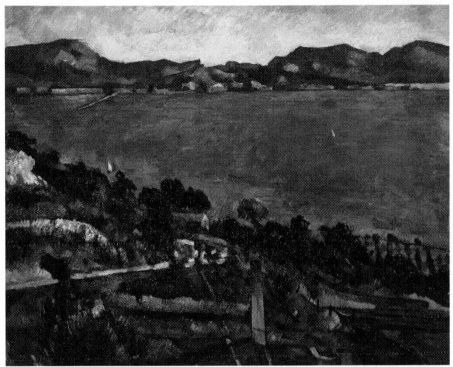

*L'Estaque* (1878–1879). The landscape at l'Estaque was one of the artist's favored locations. His mother rented a fisherman's cottage there. The contrasts of red-tiled roofs and factory chimneys against the sea and hills gave him plenty of motifs. *(AKG London)*

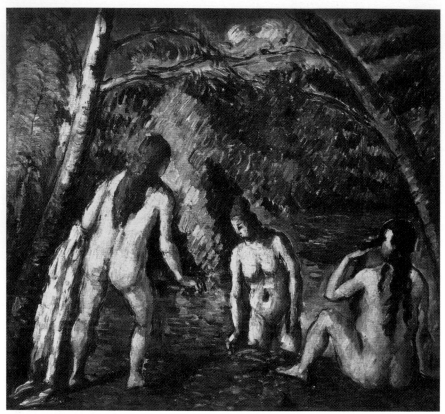

*Three Bathers* (1879–1882). There are at least three versions of *Three Bathers*. The little canvas of 1879 was seen at the end of the century by the impecunious Matisse, who felt impelled to buy it, declaring toward the end of his life that he had drawn from it "my faith and perseverance." *(AKG London)*

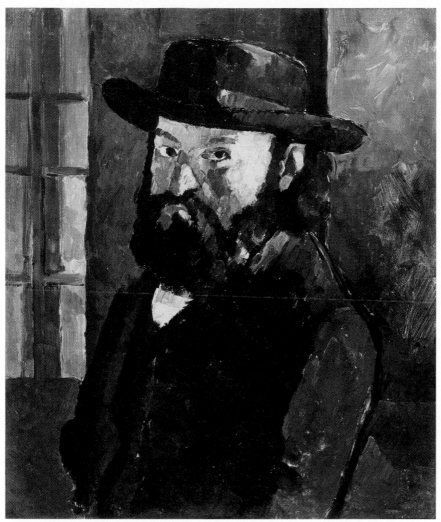

*Self-Portrait* (1880). Altogether there are more than thirty self-portraits. The poet Rilke compared the expression of one with the objectivity of a dog, catching sight of itself in a mirror and thinking: there's another dog. This one in 1880 shows him as at once exposed and implacable. *(AKG London)*

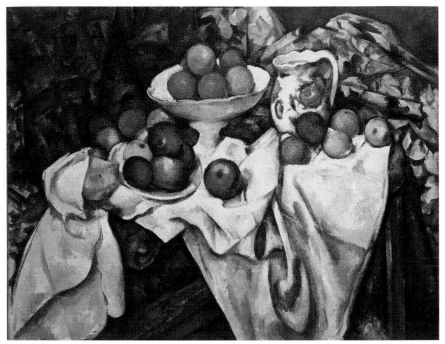

*Pommes et oranges* (1895–1900). The still lifes of the 1890s announce a master, able to create grandeur from the humblest of objects. Here in all its glory is the revolutionary apple with which he hoped to astound Paris. *(AKG London)*

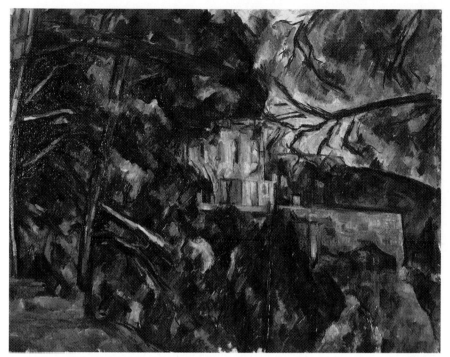

*Le Château Noir* (1900–1904). Cézanne painted the Château Noir many times. East of Aix in the direction of Mont Sainte-Victoire, the place was empty at the turn of the century when he became fascinated with it. The owner refused to sell, so Cézanne rented a room in the abandoned buildings. A majestic view opens up from its vantage point. *(AKG London)*

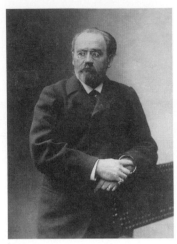

Zola in 1896 had been estranged from Cézanne for ten years following the publication of his novel *The Masterpiece*. The two friends never met again. *(AKG London)*

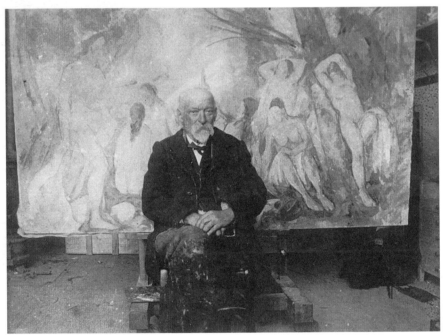

Plagued by ill health, his strength failing, Cézanne sits for this photograph in 1904, behind him his *Grand baigneusses*, the canvas that had been hauled up through a special slit in the studio wall. The painting was still unfinished at his death. *(Réunion des Musées Nationaux)*

delicious meal on the table. They were sitting to eat when Cézanne came in, shabby as usual. He was asked to join them, and did so. Madame Pissarro's carefully cultivated table manners for the benefit of her guests amused Cézanne, who started scratching himself with vigor. "Don't take any notice, Madame," he said, "it's only a flea."[12]

It was in the same year as Pissarro's portrait, 1874, that the dissident painters decided to get together and mount a radical show of their own. They had kept faith with one another long enough and a feeling of optimism spurred them into action. It was now or never, they felt. The economic situation was hardly encouraging, but when was it ever? There had been a false boom immediately after the war, followed by a recession.

Among the dealers, only Durand-Ruel was interested, though not to the extent of putting up money. No, they had to finance themselves somehow, by pooling their resources and accepting the help of a few sympathizers and collectors. To bring off the enterprise the true Impressionists were willing to join forces with artists less radical than themselves, that is if these more respectable artists could tolerate them. The hope was that the inclusion of some fairly well-known painters, less alarming than themselves but liberal, would help pull in the public. It was a compromise born of necessity.

Until 1870 most of the painters now under a cloud had managed to get taken by the official salons. Impressionism hadn't arrived and their pictures were low key, and in any case they practically disappeared, swamped by the huge bulk of academic painting. Often too they were hung high up, out of harm's way. Pissarro had been represented by a landscape as far back as 1859. Manet had two portraits taken in 1861. After the hard line of 1863, the boomerang of the Salon of the Rejected reverberated through the juries in the following years, resulting in a more relaxed policy. But memories were short; reaction set in again after 1867. Yet in 1869, Manet, Morisot, Pissarro, and Sisley all got in. By the end of the decade only Cézanne and Guillaumin of the *plein-air* painters had failed to gain admission. For the first time these two had the chance to place their work before the public.

Manet, when approached by the organizers, didn't want to know. His years of struggle to be accepted were coming to an end. The Salon was admitting him regularly, in spite of earlier scandals caused by his *Lunch on the Grass* and *Olympia*. Official recognition was in the offing and he wasn't prepared to jeopardize it. He no longer classed himself as an outsider. The Impressionists were deprived of their star by this

defection. They went ahead all the same, hoping to gain public consideration by being associated with the more palatable names of Degas, Boudin, Cals, Levert, De Nittis, Braquemond, and Rouart. Ottin was the only sculptor. Pissarro overruled those who saw Cézanne as a liability. Guillemet drew back at the last moment—he had enjoyed a modest success in the 1872 Salon.

The Société Anonyme Cooperative des Artistes, Peintres, Sculpteurs, Graveurs opened its exhibition on April 15, 1874. As Nadar the photographer had vacated a suite of offices at 35 boulevard des Capucines, they had moved in. Degas thought the show should be called *La Capucine*, but Renoir objected. Twenty-nine artists took part, exhibiting a total of 169 works. The association of the first Impressionists with this Nadar, the first man to use artificial light in photography, is significant, in view of the effect the camera was having on artists—on even Turner in his last years. Corot's art had already registered the influence of photography, and many Impressionists were to use photographs as aids, including Cézanne in his old age.

The show opened for a month, "from 10 to 6, and from 8 to 10 in the evenings," said the catalog. The thoroughfare, one of the busiest in Paris, funneled in a huge number of visitors. The entry fee of one franc didn't deter them. The crowds had scented fun or outrage. Cézanne had contributed his "horror," the *Modern Olympia* (sometimes called *The Pasha*), with its huge burst of flowers and monstrous enthroned nude, and two other offerings. One was *The Suicide's House*, and the second a view of Auvers which may have been his most entrancing work while with Pissarro, a hillside of houses and trees delicately patched to evoke the joyous flow of sunlight, across the foreground the blurred rails of a fence. Pinks, whites, blues, yellows, and greens dance over the scene.

His *Modern Olympia*, composed as if to deliberately provoke, with its brutal draftsmanship and brazen parody, was a gift to the sensation seekers. Manet must have felt justified in not taking part, and he was having reservations about several of his fellow rebels. Renoir, for instance, he dubbed "a good man gone astray." As for Cézanne, he had been at pains to distance himself from the southerner's coarse eruptions for years.

Degas, ever the pessimist, had been dubious about the show's reception from the outset. His worst fears were soon realized as the howls rose up. These deluded artists couldn't even see straight; their

minds squinted. They were perverse, seeing "hairdresser's blue in all nature."

Zola attended but mysteriously stayed silent afterward, neither reviewing the show nor attempting to foster understanding of it. His shaky financial position may have made him wary of turning the public against him. Over a decade later, in *The Masterpiece*, he reveals his disgust and contempt for a crowd "that had come for entertainment, was becoming excited by degrees, exploded apropos of nothing and was enlivened as much by beautiful things as by execrable ones. . . ." He noted "the round and stupid mouth of the ignorant who criticize painting, expressing the total sum of asininity, of absurd commentary, of bad and stupid ridicule, that an original work can evoke from bourgeois imbecility."

Cézanne, not surprisingly, came in for the roughest handling. Jean Proucaire of *Le Rappel*, asked, "Shall we speak of M. Cézanne, who, by the way, has his own legend? Of all known juries, none ever imagined, even in a dream, the possibility of accepting any work by this painter, who used to present himself at the Salon carrying his canvases on his back like Jesus his cross." The image conjures up a masochistic Van Gogh rather than the more complex Cézanne, who was equally maligned but given to sardonic gestures. And with an egotism that seems at times like megalomania, all the more astonishing in a man so racked, so often overcome by doubts. Like Courbet before him he saw himself as "the only painter alive," as he confessed once in a burst of arrogance to Gasquet.

The same critic went on, "A too exclusive love of yellow has up to now compromised the future of M. Cézanne." The reference was presumably to *The Suicide's House*, purchased after the show closed by a wealthy financier, Count Doria, to everyone's astonishment. Thus Pissarro's faith in his "student" was vindicated. Writing with more buoyancy than realism he told Duret, "Our show goes well. . . . Criticism overwhelms us and accuses us of not studying. I'm off back to my studies; that's worth more than reading the critics."

Not all the criticism was hostile. The writer Armand Silvestre, for instance, spoke well of Monet, Pissarro, and Sisley. "Sisley is one of those who are making progress—perhaps he sees nature with too narrow a vision. . . . *Les Chàtaigniers à Osny* by Pissarro is rather crude in color, but the richly painted portions indicate the good intentions beneath a still uncultivated surface."

In *L'Artiste*, Marc de Montifaud (the pseudonym of a woman) found the *Modern Olympia* almost too laughable for words:

> On Sunday the public found material for laughter in the fantastic figure who exhibits herself, surrounded by a sickly sky, to an opium smoker. This apparition in pink naked flesh thrust forward by a sort of demon into the smoky heavens, a corner of artificial paradise in which this nightmare appears like a voluptuous vision, was too much for the most courageous spectators, it must be admitted, and M. Cézanne can only be a bit of a madman, afflicted while painting with *delirium tremens*. . . . In truth it is only one of the weird shapes generated by hashish, borrowed from a swarm of absurd dreams. . . . No audacity can surprise us. But when it comes to landscapes, M. Cézanne will allow us to pass in silence over his Maison du Pendu and his Étude a Auvers; we confess they are more than we can swallow.[13]

The fleshy visions of a drug addict sunk in an artificial paradise connected Cézanne, accidentally or not, with Baudelaire. It was a pointed reminder of the dangerous territory he had inhabited for so long, turning on the poles of self-loathing and fear and soon to be discarded for good. Castagnary in *Le Siècle* drew attention to this overmastering subjectivity. "Cézanne," he wrote, "offers a cautionary example of the fate awaiting those who do not ponder and learn, but merely exaggerate the external impressions. After an idealistic beginning they will lapse into an unbridled romanticism, in which nature is only the pretext for daydreams; and the power of imagination will no longer be able to express anything other than personal subjective fantasies with no relation to general truths, since they are removed from all controls or comparisons with reality."[14]

Here for once was a contemporary critic coming near to the mark. L. Leroy in *Charivari* was simply intent on some labored fun. His notice was headed "The Show of the Impressionists" and relates a visit to the exhibition with a fictional landscapist, Joseph Vincent:

> Gently, with my most naive air, I led him before the *Plowed Field* of M. Pissarro. At the sight of this formidable landscape the *bonhomme* thought the glass of his spectacles was smudged. He carefully wiped them, then put them back on his nose. "By Michalon," he cried, "what on earth is that?" "As you see, a white frost on deeply cut furrows." "What, is that furrows, is that frost? But they're palette-

knife scratches made regularly on a dirty canvas." "Perhaps, but the impression is there." "Ah well, it's a funny thing, that impression."[15]

The tediously literal eye of this Vincent is outraged by Monet's *Boulevard des Capucines* with its walkers indicated by "black squiggles." "Then that's what I look like when I walk on the boulevard?" The *Modern Olympia* finally unhinges him and he staggers away, mumbling "Ho, so I'm a walking impression! Ho, ho ho!"

At least after this show the noncomformist painters were presented with a group name at last. They had been called the *plein air* school or the *intransigents*. Neither took the popular fancy. Now their generally accepted designation would be "impressionists." One of Monet's canvases at the exhibition was entitled *Impression—Soleil Levant*. But the term "impression" had been in use long before that. Gautier had once said of Daubigny that it was a shame he "contents himself with an *impression* and so much neglects details." Redon had said of the same artist that he was "the painter of a moment, of an impression." He had even been called once "the leader of the impressionist school." As far back as 1863, Castagnary wrote of Jongkind that "everything lies in the impression." After 1870 outdoor painting with its light tones and brilliant colors, its luminous shadows and original technique had panicked the Salon juries into further reaction to prevent the spread of these heresies. The impact of the camera, together with scientific developments in light and optics and the work of industrial chemists like Chevreul in the field of color harmonies were all helping the new movement to come into its own. Impressionism had arrived. [16]

◈ Cézanne returned to Paris as the Capucines show was being set up, occupying an apartment in a two-storied house at 120 rue de Vaugirard with his family. Cast down by the abusive notices of his work he neglected going over to Pontoise to say goodbye to Pissarro as he had intended and beat a retreat to Aix, leaving Hortense and his little son behind. He had been away from home for so long—nearly three years, unbelievable though that sounds—that it must have made him fearful for his allowance. So far as we know there was no trouble over it, but he hoped for an increase now that he had two other mouths to feed. He had passed the news of his son to his mother through Emperaire, so no doubt his sister knew as well. In the message he had begged his

mother to keep the fact of his fatherhood from Louis-Auguste. Again the threat to his allowance was uppermost in his mind.

We have grounds for assuming that it was never quite the same between him and Hortense after their son was born. Her exasperation with his vague, abstracted persona, his most vivid life locked up inside himself, away from her, denying her any real access, would have driven her gradually to exclude him from real intimacy with her child, the link in a human circuit that brought her back in touch with her father and mother. If she had ever had a strong physical love for Cézanne, it was secondary now. He came and went like a cat, owing allegiance to no one. Gradually and inevitably she closed the circle. He raised no objection because he was ruled by a desire she found inexplicable: to remain aloof from the world.

Three years was to be the longest uninterrupted absence from Aix of his entire life. One can imagine his joy at being back in the Midi again. It was late spring, the landscape one that amazed Van Gogh with its tones of various tints of gold, "green-gold, yellow-gold, pink gold." The critic Robert Hughes, in an essay on Van Gogh in *Nothing If Not Critical*, speaks of Provence as "a museum of the prototypes of strong sensation: blazing light, red earth, blue sea, mauve twilight, the flake of gold buried in the black depths of the cypress; archaic taste of wine and olive; ancient smells of dust, goat dung, and thyme, immemorial sounds of cicada and rustic flute. In such places color might take on a primary, clarified role. Far from the veils of Paris fog . . . it would resolve itself into tonic declaration— nouns that stood for well-being."

He buckled down to paint immediately, a sign of his relative contentment. His mother and sisters would have fussed over him maddeningly, but he needed their support, and he could always disappear into his top-floor eyrie or tramp into the warm countryside for days at a time indulging his new obsession. The split life he was leading meant he was forced to depend on friends in Paris for news of his family. He rhapsodized to Pissarro over the health-giving aspects of the south and urged his friend to come visiting one day. He saw Pissarros wherever he looked, noticing how the countryside "recalls in a most amazing way your study of the railway barrier painted in full sunlight in midsummer." Valabrègue had turned up from Paris with a letter from Hortense saying his son was well. On June 24 he wrote at some length to Pissarro, thanking him

for having thought of me while I am so far away and for not being angry that I did not keep my promise to come and see you at Pontoise before my departure. I painted at once after my arrival, which took place on a Saturday evening at the end of May. And I can well understand all the misfortunes you have gone through. You really have no luck—always illness at home. However I hope when this letter reaches you, little Georges will be well again. By the way, what do you think of the climate of the country where you are living? Aren't you afraid it will affect the health of your children? I'm sorry that fresh circumstances have arisen to keep you from your work again, for I well know what privation it is for a painter to be unable to paint. . . . For some weeks I was without news of my little boy and I was very worried. . . .

From the papers I learned of Guillemet's great success and of the happy event of Groseillez, who has had his picture bought by the administration after it had been given a medal.

At this point he can't suppress a little spurt of malice. "Well, this proves that if one follows the path of virtue one is always rewarded by man, if not by art."

I should be happy if you could give me news of Mme. Pissarro after the birth, and if you could let me know whether there are fresh recruits at the Société Coop. But naturally you must not let this interfere in any way with your work.

The Cooperative was a new organization of artists, independent of the Impressionists, though the latter made up the larger part of the membership.

Getting into his stride with new work—and even when he seems idle he's now able to tell himself that periods of apparent fallowness are in fact movements of gestation—he is all at once knocked sideways and amazed by a request from that old reactionary, Gibert, curator of the Aix museum, who has been driven by curiosity to see Cézanne's latest canvases after reading of them in the Paris newspapers. The former pupil complies, philosophically resigned to the situation, telling Pissarro about it later in the same letter:

When the time nears I'll let you know of my return, and what I've been able to get out of my father, but he'll let me return to Paris. That's already a lot. In these last days I've seen the director of the

Aix Museum, who wanted to see with his own eyes how far the peril to Painting actually went. But, on my protesting that by the sight of my productions he'd not gain a correct enough idea of the evil's progress and he must see the works of the great criminals of Paris he replied, "I'll be able to get a good idea of the dangers run by Painting if I see your attempts." Whereupon he came, and when I told him for example that you replace modeling by the study of tones, and tried to make him understand by reference to nature, he closed his eyes and turned his back. Still, he said he understood and we parted, each satisfied with the other. But he's a good chap who has urged me to persevere, because patience is the mother of genius etc.

I almost forgot to add that Maman and Papa ask me to send on their affectionate greetings. A little word for Lucien and Georges, who I kiss. Regards and thanks to Mme. Pissarro for all the kindnesses to me during our stay in Auvers. A good fistful of handclasps for you, and if wishes could make things go well, be sure I wouldn't fail to make them. Wholly yours, Paul Cézanne.[17]

In his good-humored account of Gibert's visit his increasing confidence in himself comes through. Pissarro had done wonders for his morale and he felt at last that he was on the right track. This conviction held firm to the end of his life, as did his courage. There were bitter attacks ahead in plenty, and the indifference of his contemporaries remained a constant. He burst out furiously from time to time against the judgments of fools, he fell into sloughs, lost his way, and left canvases abandoned or smashed them to pieces in sudden rage at his failure to "realize." But he had discovered the boon of solitude, crucial to him if real progress was to be made. After each failure, when whatever it was he pursued eluded him, he set ferociously to work again, even though to outsiders his painting was so agonizingly slow that it looked to them like demoralization, doubt, defeat. In fact he had begun to understand the necessity for him of slow development. The hot passion of his youth was over but a secret momentum carried him forward. His "unreasonable doggedness" was bearing fruit, if only in his own eyes. The impulse to self-immolation that gripped Van Gogh so tragically toward the end had died down in Cézanne, leaving him with something strict, a reverential approach, as if to something holy, that nothing was allowed to hurry. Rejections became steadily more irrelevant, a distraction from the harmonies that were always beckoning and

consoling. Gauguin would one day call him polyphonic, "a student of César Franck. He's always playing the grand organ. . . ."

Gibert's mild response, negative though it was, makes his successor's reaction even more incomprehensible in the years ahead. Henri Modeste Pontier refused to allow any of Cézanne's canvases to enter the museum during his lifetime. He died in 1926, and by then Aix could no longer afford them. It took the French state until 1984 to consign eight small paintings to the Musée Granet.

Offstage was always Louis-Auguste, a small man casting a massive shadow. We have to take Cézanne's sardonic humor into account when reading that "he'll let me return to Paris." This was a man of thirty-five with a mistress and child. What was he really saying? The next sentence, "That's already a lot," gives us the clue: he was being allowed to return to Paris with his allowance intact, and for all we know, increased. His father's bourgeois instincts made it impossible for him to give money freely, and after all where was the cash return? How long must he wait for his peculiar son to show some signs of success? It is easy to overlook his forbearance, and the steady emotional pressure from his wife and daughter on Cézanne's behalf has to be remembered too. What he liked was getting his money's worth, if only by exerting his authority, acting the tease, playing on his son's fears. One can hear behind Cézanne's anxious words his father's scathing, ironical voice. In the letters there are no messages to his father, but he unburdened himself without inhibition to his mother, the keeper of his secrets within the family. He was grateful for her blind faith in him, and took great care to nourish her support.

On September 24, back again in Paris, he wrote cheerfully to his mother, telling her that for several days

> the weather has been bad and very chilly. But I'm not suffering and I've got a good fire. I'll be glad to get the box you're sending, you can always address it rue de Vaugirard 120. I expect to stay there till January. Pissarro hasn't been in Paris for a month and a half. He's in Brittany, but I know he has a good opinion of me, who have a good opinion of myself. I begin to find myself stronger than all those who surround me, and you know the good opinion I have of myself hasn't come without clear thought. I must always keep working, not to arrive at some high finish, which begets the admiration of imbeciles. And this effect that is commonly so much appreciated is only the result of a skilled craftsman and makes inartistic and vulgar any

work born of it. I mustn't seek to finish anything except for the sheer pleasure of making truer and more full of knowledge. And you may be sure there always comes an hour when one imposes oneself and one has admirers far more fervent, more convinced than those who are pleased only by an empty appearance.

This is a bad time to sell pictures, all the bourgeois are grumbling at letting their pennies go, but that will stop. My dear Mother, greetings to my sisters. Best wishes from M. and Mme. Girard, and my thanks. Wholly yours, your son Paul Cézanne.[18]

He wrote as though he were single, making no mention of Hortense or his son, simply because he knew that his father opened all letters addressed to his wife—as he did anyone else's mail, come to that.

In Paris, a wealthy newcomer, Gustave Caillebotte, had joined the ranks of the hard-up artists who were pondering their next move against the art establishment. An inheritance from his father had left him a rich man. He had entered the Beaux-Arts, then met Monet and Renoir and fallen under their spell, promptly abandoning the academic scene. Generous to a fault, he bought Impressionist pictures to help out his new friends. He achieved fame later as a collector and patron, not a painter.

The motivating force behind the first Impressionist group show had been Monet, who was now as financially hard-pressed as most of the others. The artists' union or Cooperative, organized by a certain Alfred Meyer, one of the exhibitors at the 1874 exhibition, was therefore a stopgap. Cézanne and Guillaumin were urged to join by Pissarro, and did so. Then on March 24, 1875, another experiment was tried. Monet, Renoir, Pissarro, and Morisot decided to auction their work collectively at the Hôtel Drouot. All the event provided was another jamboree for the spectators, hooting with laughter as each painting was held up. At one point the disorder was such that the auctioneer sent for the police. Some journals made sympathetic noises, but Albert Wolff in *Le Figaro* wrote, "The impression made by the Impressionists is that of a cat walking over the keyboards of a piano or of a monkey that has laid hands on a paint box." Victor Choquet put in a first appearance at this sale, speaking up for artists without joining in the fray. Rewald in his biography describes him as having "the spirit of the true collector, preferring to make his discoveries for himself, taking as his guide only his own taste and pleasure, never thinking of speculation, and wholly uninterested in what others did or thought." After the 1874 show, which he

hadn't attended, talked out of doing so by friends, he wrote a fan letter to Renoir and asked if he would consider painting a portrait of his wife.

Renoir, eager like Pissarro to help his comrades, sensed that in Choquet he had met someone who would appreciate Cézanne. He took the collector to the modest Père Tanguy, the little color dealer who now had a tiny lodging at 14 rue Cortot. Tanguy had grim tales to tell of his misfortunes since 1870. A naively passionate revolutionary, he had fought in Paris with the Communards, was taken prisoner by government forces and sentenced to the galleys. After two years he was released, then refused entry to Paris for another two. He owned a few Cézannes, obtained as payment for paint and canvases.

Choquet, intrigued, bought one of the earliest *Bathers*. He thought it would look splendid between one of his oils by Delacroix and a Courbet, then had second thoughts, worried over his wife's reaction. He asked Renoir to bring it round as if it belonged to him. If he left it behind as if by mistake, "Marie will have time to get used to it before I admit it's mine."

It was this purchase that led to the first meeting of the two men. Cézanne and Choquet hit it off at once. From the painter's point of view there was nothing to fear from this man, whose genuineness was so obvious. But what united them almost at once was their shared passion for Delacroix. Choquet hurried to display his treasures, spreading oils, watercolors, and drawings over the carpet. The two men went down on their knees to look at them more closely. They were soon exclaiming and clapping their hands, both with tears in their eyes. Later, Cézanne said to the collector, "Delacroix acted as intermediary between you and me."

◆ The year 1875 is a blank so far as Cézanne's movements are concerned. All we know for certain is that he moved from rue de Vaugirard to the Île-Saint-Louis. Guillaumin was here too: he had taken over Daubigny's old studio at 13 quai d'Anjou. None of the others bothered to try for official recognition any more, but Cézanne never stopped submitting, knowing perfectly well what the outcome would be. A watercolor of the Jas de Bouffan went in to the Salon of 1875 and was rejected as usual.

Why did he keep on? Gerstle Mack advances a plausible enough explanation and yet omits to mention the most obvious reason, a never-ceasing desire to win his father's approval. "In spite of the radical

innovations he introduced into his painting," says Mack, "innovations that were to affect in some measure the work of practically every important painter who came after him, Cézanne himself was far from being a revolutionary at heart. As a man he was as conservative in his ideas as any solid bourgeois. He was not one of those fire-eating rebels who love insurrection and conflict for their own sakes, but a timid sensitive soul with a profound respect for authority. Though his work was uncompromising in its nonconformity to the rigid academic conventions of his day, his spirit was never that of the missionary or the doctrinaire reformer. . . . Cézanne felt—for some years at least—that all his work was incomplete without the jury's stamp of approval."[19] And yet for all that he was an arch-revolutionary in spite of himself, one who studied the Old Masters endlessly and desired above all else to be included in the great tradition of Western figurative art. His utterance about trying to do Poussin again out of doors came from his Latin mind, as surely as his classicism arose from the Mediterranean landscape out of which he sprang.

Guillaumin and Cézanne were seen painting together on the quays. Once or twice Cézanne appeared as a listener at the Nouvelle Athenes, a hermit figure who clearly wanted to be left alone. He was fond of his son, now and for the rest of his life. The little lad, a mobile three-year-old, investigated his father's canvases while the painter watched, amused. "My son tears open the windows and chimneys; the little beast knows perfectly well it's a house."

He and Zola were it seems no more in contact than during the time at Auvers. Only the great deal of buried love that existed on both sides enabled their friendship to continue. Zola had gone off to Normandy in August with his family. He was badly in need of a break: his insomnia night after night had left him drained and empty. Friends urged him to take a seaside holiday, and Flaubert's advice was to "Do nothing!"

The break wasn't a success. He was a southerner and hated the cold grey Atlantic waves crashing onto the shore. It wasn't possible to bathe. His wife and mother got on each other's nerves. By the autumn of 1875 he was back in Paris, unpacking a few notes for his novel of a working-class family, a slice-of-life portrait that brought the money pouring in. *L'Assommoir* would be the first of his best-sellers. The slang term *assommoir*, used by the poor for the roughest kind of drinking den, was also a word for the poleax used to stun cattle before slaughter in an abbatoir. It couldn't have been more appropriate. In this novel Zola set out quite deliberately to stun the public. As Graham King

remarks, in France in the 1870s working people were as foreign as savages to most readers. The story chronicles the descent into drunkenness of a lame washerwoman, Gervaise, whose misfortunes are a consequence of her own good-natured, easygoing style. When her lover Lantier deserts her and her two children (one of whom is Nana, later the heroine of an even more sensational success), she marries Coupeau, a roofmender. Disaster strikes after a few years when he falls from a high roof, only breaks a leg but becomes a sponger and drunk, soaking up his wife's earnings from the hand-laundry business she has managed to establish by means of a loan. Lantier comes back into Gervaise's life as a lodger, and her slide downward accelerates sickeningly.

The intense controversy the novel aroused soon had all Zola's previous titles reprinting. Henry James complained of the "ferociously bad smell which blows through *L'Assommoir* like an emanation from an open drain and makes the perusal of the history of Gervaise and Coupeau very much such an ordeal as a crossing of the Channel in a November gale."[20] Zola, needing a new image to go with his reputation as a fearless realist and to cloak his innate timidity, invented a persona for himself by inserting "expressions of calculated inelegance" into his conversations and by delivering his opinions on current topics with uncompromising force. "I believe in living in a constant rage against pretense and deceit and the mediocrity which surrounds us," he announced. Privately he lived a life "as prosaic as a retired grocer."

During the eighteen months when we lose sight of him, Cézanne painted nearly thirty canvases. They were paintings of all kinds; some done in the garden of the Jas de Bouffan and others in Paris or its environs. There were flower pieces, landscapes, still lifes. The famous Cézanne apples appeared in all their glory in a still life of seven rosy fruits filling the entire space, each one touching the next with an intimacy he hardly ever allowed his figures, glowing together in a sumptuousness that made them emblems of paradise.

A self-portrait, the treatment splendidly assured and sweeping, shows his bald cranium and heavily clothed shoulders posed against the baroque swirls of a cream and rose wallpaper. The tense angle of his head suggests detachment, if not suspicion, the expression enigmatic, the eyes seeking to evade the spectator. For all that the brushwork exudes tremendous confidence and awareness of the artist's worth.

A swirling, struggling *Bacchanal* (*La Lutte d'amour*), filling its four couples and its trees and clouds with baroque animation, has stimulated a good deal of analysis in recent years. Mary Krumrine points to it

as conclusive proof of Cézanne's misogyny. But we have moved on from the "sarcastically sexual fantasies" such as *The Rum Punch*, and the violent murders, rapes, and abductions that came earlier still. The twilight narratives, *The Picnic* and *Pastoral* and *Temptation of Saint Anthony*, will find echoes in the bathers to come, but in entirely different settings and transfigured by a new vision. The ideal nude of art will be obliterated, but its replacement is hardly the "gleam of light and warmth and life" as described by Sicket. The man-woman dialectic will continue in endlessly new interpretations.

*Bacchanal* once belonged to Renoir. By no stretch of the imagination can one see him painting it, though he did attempt a version, as charming as this is savage. Cézanne has moved his problematical males and females to an arcadian landscape, but one which is as violently agitated as the figures within it. Four men are throwing themselves on four women on a river bank, flanked by high trees, their foliage shaking madly. The mythical spirit of ecstatic joy so evident in Venetian art has been replaced here by animal battling. A black dog leaps up on the left to emphasize the animality. The bacchanals of Titian and Poussin are full of drinking, dancing, and joyous love play. No one is playing here. The struggle between each pair is desperate and unremitting. These aren't derived from Greek mythology but from a private iconography which is utterly modern. The adoration of womanhood has given way to an urge to violate it.

Yet strangely there is nothing oppressive here. For one thing, the background is suffused with the same passion that animates the figures, to paraphrase Cézanne's own words in a letter to Zola, commenting on his friend's novel *A Page of Love*. The backgrounds in the book seem, he went on, "to be alive and to participate in the sufferings of the living characters." In his picture the scene is throbbing with violence and yet somehow the artist has detached himself. Instead of painting a solitary crime he has chosen to show an action of all men.

It is an imaginative work and demonstrates his compositional power and his invention. With no models in front of him, the vitality has to come from inside himself. He finds metaphors for the battling figures in the forked branches of the trees on the left. The whole thing looks amazingly free, as if the wind of fury and intoxication is blowing naturally through it.

"Such projections," comments Gotz Adriani somewhat dogmatically, "reflect with absolute clarity the personality, the sensibility, and the compulsive entanglements of a man entirely isolated as an artist,

who was never to escape from the control of his family, and even as an old man in his native Aix suffered under the bigoted benevolence of his sister. . . . For in the alienation of the sexes is revealed nothing less than Cézanne's own lack of human relationships. His tumultuous compositions derived their authenticity from an expressive volition born of torment and repression."[21] No mention here of the part played by Hortense in his life, or the enduring relationship with his son.

To add to the mystery, this was the time of the Bathsheba series, lyrical oil sketches celebrating the beauty of woman. One of the most entrancing, the curvaceous nude reclining under a tree, accompanied by her attendant, is calligraphic in its delight. The curves are repeated in the background by the profile of a mountain, and recall Provence, or more specifically Mont Sainte-Victoire. Mary Krumrine manages to introduce the idea of voyeurism and illicit love by quoting from the story of Bathsheba: "From the roof [David] saw a woman washing herself; and the woman was beautiful to look upon."

The small bather paintings begin now. In one, five nudes are at the water's edge, one lying down, one sitting, two standing, and one in the water up to her thighs. On the left is a striding female who will often reappear, here making her debut. Also the recurring theme of baptism is first introduced. A figure with arm raised over bent head suggests the rite, and in such scenes a triangular composition often appears. Cézanne may well have copied Poussin's *Saint Jean baptisant le peuple*, for instance, with its triangular arrangement. Haussoulier's *La Fontaine de Jouvence* was praised by Baudelaire in his review of the 1845 Salon, in which the group at the fountain are described:

> In the middle of the second [plane] stands a nude woman; she is wringing from her hair the last drops of the health-giving and fertilizing stream. A second woman, also nude, and half recumbent, seems like a chrysalis still clothed in the last shift of its metamorphosis. Delicate of form, these two women are vaporously, outrageously white; they are just beginning to reemerge, so to speak, into life. The standing figure is in the strong position of dividing the picture symmetrically in two. This almost-living statue is admirably effective.[22]

Mary Krumrine, highly sensitive in her exploration of the bathers' evolution, understands very well the process by means of which these chrysalislike paintings came into being. "Given what we have already learned," she writes, "about Cézanne's unique way of working—assem-

bling and constructing works on the basis of personal memories and visual and literary images drawn from works by others—we might almost predict that we would find here parts from the first Temptation of St. Anthony combined with parts from a Baptism and a Fountain of Youth."[23] We begin to realize how transitional the mid-1870s were for Cézanne.

His distortions of the female body and face have led many to see his women as ugly. Victor Hugo had derided the ugliness of Delacroix's women, so Baudelaire had heard, "but M. Victor Hugo is a great sculptural poet whose eyes are closed to spirituality." Cocteau has remarked cleverly that art must be ugly first, then beautiful afterward.

Often there are several variations of the same group of bathers. The three males in some distress to the left (traditionally the "evil" side) of *La Baignale* are gathered around a tree. The tree's lowest branch snakes sinuously, undulating as if to indicate three blurred female bathers in the distance on the "good" right side of this *paysage moralisé*. As one of the men reaches up to the snaky branch, his two companions recoil. One falls to the ground and cowers, twisting away. These tense fearful males recall Genesis, and such works as Masaccio's *Expulsion from Paradise*. As a very young man, brooding romantically, Cézanne asked the equally perplexed and torn Zola in a letter: "Haven't you ever seen—even in daydreams—as if through a mist, graceful forms and impalpable beauties whose ardent charms, dreamed of by night, are no longer visible by day? They seem to smile at me as I stretch out my hand toward them. . . ."[24]

# 9  HIDE AND SEEK

Another offering went to the 1876 Salon, a yearly ritual that would go on and on. A note to Pissarro, dated April 1876, merely said, "I almost forgot to tell you that I have received a certain letter of rejection. That is neither new nor surprising—I hope you are having good weather, and if possible a successful sale."

The "sale" refers to the second exhibition of the Impressionists, organized by his friends in April at the Galeries Durand-Ruel, 11 rue Peletier. The question of Cézanne's failure to take part remains unanswered to this day. He had plenty of canvases to send in. The show this time was slimmed down: only nineteen artists took part, and the Impressionist element was more dominant. Did he decide not to participate because of the harsh treatment and ridicule meted out by the critics in 1874? One could even imagine him smiling grimly at Louis Leroy's satirical attack, his mordant humor tickled by the landscapist driven raving mad by so many horrible "impressions" and in the end seeing impressions everywhere, even the uniformed guard at the door rearing up to horrify him. He had opponents among the exhibitors, but warm personal friends too, who wouldn't have stood for any attempt to exclude him. Rivière suggests that his refusal had to do with the fact that the exhibition took place in the gallery of a private dealer, which may have put Cézanne off, since he either wanted to show his work in the official Salon or in a completely independent show. But Durand-Ruel was one of the few dealers sympathetic to the new movement, and

Rivière's explanation doesn't make much sense. Only John Rewald seems to have considered that Cézanne may not have taken part because his father had helped defray expenses incurred in the 1874 exhibition and possibly objected to doing so again.

Choquet lent canvases by Renoir, Monet, and Pissarro this time. There was no shortage of derogatory reviews, but several of the younger critics actually went out of their way to understand the point of view of the artists. This second show, like the first, was timed to open a month before the Salon. Albert Wolff of *Le Figaro* waded in with

> The rue St. Peletier has had bad luck. After the burning down of the Opera (on October 28, 1873) a new disaster has fallen on the district. Five or six lunatics, of whom one is a woman, a group of unfortunates obsessed with ambitious folly, are showing their work there. There are people who will roar with laughter at them. For my part I find it sad. . . . It is an appalling spectacle of demented human vanity.[1]

Theodore Duret defended them, if mildly, and Degas's friend, the novelist Edmond Duranty, issued a pamphlet, *The New Painting*, in which he affirmed that the new men had "recognized that full strong light changes the color of tones, that the sun reflected by objects tends by force of its luster to bring them to that luminous unity which bases its seven prismatic rays on a single colorless burst, which is light."

A month or so later a Salon review by Mario Proth paid grudging tribute to the artists behind the new movement. Something indeed was happening in the art world.

> It is moderately disturbed, it moves with some heaviness, but it does move. . . . The exhibition of the Impressionists has risen one notch, it is true, in the public's appreciation. One has sincerely and deservedly applauded their courage: those interested in art went to visit them, the press examined their works. Among them were discovered, if not real talents, at least potentialities, promises of talent, something like green apples, very green ones, and which may possibly ripen if they don't carry the original worm and if the sun offers them life. Some of them have stopped us for an instant and have even astonished us. Might one already apply to them, with a slight variation, the charming words of Nodier concerning women:

"When one astonishes the public, the public becomes interested, and once it becomes interested one isn't far from pleasing it. . . ."[2]

Cézanne went in early June to l'Estaque and spent most of the summer there. He painted a landscape and made Choquet a present of it. Whether he was alone or had his family with him is unclear. Hortense made no bones of her dislike of the provinces, its isolation and dullness. She preferred Paris, and in the future would insist on staying there while Cézanne went to the Midi alone. As well as that, there was always the strain of having her and the child with him so close to home, exposing him to the risk of discovery by his father: perhaps another way of saying that the whole business of being part of a ménage was far from ideal for him.

Nevertheless there must have been peaceable, quiet times, periods of reasonable contentment. There are many drawings of his boy at various stages that testify to his attachment. As for Hortense, presumably he accepted from the beginning that his work meant nothing to her. Yet many portraits over a long span of years show that she was willing to sit for him, in spite of finding out soon enough how arduous that was. The portraits speak of the subjection of this woman whose personality was anything but submissive. And just as he accepted her indifference with regard to his work, so she came to terms with his strange working habits, his tendency to hide from callers, his longing for solitude. Neither, it seems, was she too alarmed by his sudden screams of rage when a painting went badly.

The projection of a girl that may have been her is a charming oil sketch for one of his bather compositions. We have to go forward a few years for an acknowledged *Madame Cézanne*. If we are to judge by the expression of the face, disillusion has long ago set in. All the same there is a touching respect for the vulnerability of feminine nature in this exquisitely simplified image, the head sadly tilted like the icon of a saint. The eyes are unfocused, dreamily unaware or resigned, the hypnotic oval of the face almost shadowless, the cheeks faintly stained with red. The body has been caught and hidden inside a high striped dress, dark with grey vertical stripes—only four broad bands. Hortense was a brunette. Her dark loosened hair falls to her shoulders with the same lifeless reverie depicted by her expression. The descending vertical line of a wall corner to the left of her head helps to gauge the head's tilt. Meyer Schapiro, characteristically perceptive and eloquent, says of this

*227*

delicate portrait, "It is as if he transferred to his wife his own repression and shyness. . . . The bands of the dress contribute a soft wavering current of feeling channeled to the head and prolonged in the silhouette of the hair."[3]

Before transferring his field of action to l'Estaque, Cézanne had spent a month or so in Aix, no doubt to placate his family. From there he dashed off a letter to Pissarro giving his reactions to the press clippings, catalogs, and newspapers Choquet had sent two days before concerning the show at Durand-Ruel. Among other things he saw the long attack in *Le Figaro*

> by *seur* Wolff. It was M. Choquet who obtained for me the pleasure of thus having some news. From him too I learned that Monet's *La Japonaise* has been sold for 2000 francs. According to the papers it seems Manet's rejection at the Salon has caused a sensation and he is exhibiting his work at his own house.
>
> Before leaving Paris I met a certain Authier, I've sometimes mentioned him to you; he's the lad who signs articles on painting as Jean-Lubin. I told him what you'd shown me about yourself, Monet, etc. But (as you've doubtless since heard) the word he meant to put was initiator, not imitator: which totally changes the article's meaning. For the rest, he told me he felt obliged, or at least thought it proper, not to belittle the other painters at Durand's too badly. You understand why.
>
> Blémont's article in *Rappel* shows a much better sense of things despite too many reservations and a long preamble in which he gets lost a little too much. It seems to me your blue is condemned because of your mist-effect.[4]

Zola, living increasingly now in a primarily literary world, had withdrawn to some extent from Cézanne and his circle of painters. He stayed silent publicly once again so far as the exhibition was concerned, just as he had done in 1874. His new novel, *His Excellency Eugène Rougon*, happened to come out at the same time as the second Impressionist show. Fame and fortune were just around the corner for the novelist working away furiously at his sensational *L'Assommoir*— the title refuses to translate into English. Albert Wolff wrote approvingly of Zola as a born writer "who lacks tact, I agree, but his work is of very great interest and incontrovertible value."

Digging in for at least a month in l'Estaque, Cézanne found himself dreaming of enticing Pissarro to the south. He wrote more fully than was usual for him in what he hoped was a persuasive manner, ending his letter of July 2 with a startling reference to the radical and anticlerical papers he had been reading: startling because of his aloofness from politics and society in general. At l'Estaque he was close to Marseilles and remembered the brutal repression of the Communards there during 1871. Jack Lindsay remarks that commentators have turned a blind eye to this letter, but it is there in full in Mack's biography.

He begins with a sly reference to the grey of the north which may be lowering Pissarro's spirits, detecting in the other's letters

> the imprint of depression. Pictorial matters don't go well. I'm afraid you are morally influenced somewhat in grey; but I'm convinced it's only a passing thing. I'd rather not talk of impossible matters, yet I always make plans quite impossible to realize. I'd imagine the country where I am would suit you wonderfully. There are some famous botherations, but I think they're purely accidental. This year it's rained weekly two out of seven days. Which is astounding in the south. Such a thing has never been seen.

> I must mention that your letter came to catch me at l'Estaque on the seashore. . . . I've started two little motifs with a view of the sea: they're for M. Choquet who spoke to me about them. It's like a playing card, red roofs over the blue sea. If the weather turns propitious I may carry them through to the end. So far I've done nothing. But motifs could be found which would need three or four months' work, as the vegetation doesn't change. Olives and pines are the trees that always keep their leaves. The sun is so frightening here that it seems to me as if objects were silhouetted not only in black and white but in blue, red, brown, and violet. I may be mistaken but this seems to me the antipodes of modeling. How happy our gentle landscapists of Auvers would be here—and that arse of a Guillemet. As soon as I'm able I'll spend at least a month in these parts, as it's necessary to do paintings of at least two meters in size, like the one you sold at Faure.

The landscapes he had done at l'Estaque during the war, vigorous and rapid expressionist works, psychologically truthful but like safety

valves, were about to give way to paintings in which he looked at the Provençal landscape with Pissarro-influenced eyes. The impetuous *couillarde* style, the thick pigment literally modeling the volumes, would be replaced by Pissarro's way of modeling by tones.

Monet, now in funds after selling a painting for the fantastic price of two thousand francs, was hard at work planning a third group show, this time without the collaboration of Durand-Ruel, but with the support of his wealthy Argenteuil neighbor Gustave Caillebotte. Cézanne's letter to Pissarro indicates his serious reservations concerning Alfred Meyer's Cooperative. In his opinion the man is rushing ahead too fast. Emotionally overheating he becomes a little incoherent, but his general meaning is clear: he suspects Meyer's motives and wants to shake him off.

> If we have to exhibit with Monet, I hope the exhibition of his Cooperative will be a flop. You'll consider me a low dog possibly, but one's own affairs come first before all else. Meyer, who hasn't got in hand the elements of success with the Cooperative, seems to me to be turning into a shitty stick and trying, by advancing the date of the Impressionist show, to damage it. He may tire out public opinion and produce confusion. First, too many shows seem bad to me; secondly, people who may think they're going to see impressionists will see only Cooperatives. Cooling off.—But Meyer must be all out to harm Monet. . . .
>
> I give you these ideas, perhaps somewhat crudely, but I haven't got a lot of subtlety at my disposal. Don't mind that, and then on my return to Paris we can discuss the matter, and run with the hare and hunt with the hounds. So if the impressionists serve as a useful set-off for me I'll exhibit with the best works I have, and something neutral with the others.

For once we see Cézanne proposing a rather devious strategy ("run with the hare and hunt with the hounds") that he no doubt saw as simply pragmatic. Behind it all was his goal of the Salon, despised but desired. He ends his musing by swerving briefly into the political arena. And there is a lightly delivered but ominous remark to do with the hostility of the locals, perhaps resentful of his outlandish appearance and workless state.

> My dear friend, I'll end by saying that as some of us have a common tendency, let's hope that necessity will force us to act in concert and

that self-interest and success will strengthen the ties that goodwill too often wasn't able to consolidate. Lastly, I'm very glad M. Piette the landscapist is on our side. Remember me to him. Regards to Mme. Piette and Mme. Pissarro, love to all the family, a firm handclasp, and fine weather for you.

Just imagine, I'm reading the *Lanterne de Marseilles,* and I must subscribe to *Religion Laique.* How's that? I'm waiting for Dufaure to be knocked out; but from now on to the partial renewal of the Senate, there's lots of time and how many dirty tricks. Wholly yours, Paul Cézanne.

If the eyes of the folk here could emit murderous glances I'd have been done for long past. My head doesn't suit them. P.C.[5]

Dufaure, minister of justice under Thiers, was a name that stank in the noses of the radicals. After the government recaptured Paris it was Dufaure who issued the orders to have thousands of Communards shot out of hand. Ribbons of blood stained the Seine for weeks afterward.

Cézanne was back in Paris by the end of August. Zola had been having a tumultuous year. Serialization of *L'Assommoir* in *Le Bien Public* had run into trouble, readers canceling their subscriptions en masse. Publication was halted on June 6. Then on July 9 *La République des Lettres* continued with the serial. Zola answered the storm of protest in a preface to the first edition of the book, calling *L'Assommoir* the most chaste of all his books. "I have often had to point out sores far more frightful. It is the style which has shocked. It is the words which have angered. My crime has been to write a novel using the language of the people." He added primly, "If only it were realized that the bloodthirsty and ferocious novelist is merely a worthy citizen, a man of studious and artistic tastes, living quietly and soberly in his little corner. . . ."[6]

The third show of the Impressionists opened its door to the public on April 4, 1877, in a suite of rooms at 6 rue le Peletier. The street was the same as last year, but the new quarters were located on the second story of an empty house that was in the throes of renovation. Behind the financing for the exhibition was Caillebotte. He was only twenty-eight but had already prepared a will bequeathing his growing collection to the Luxembourg, predicting with accuracy that "in twenty years or more" the Impressionists would have secure reputations. But, in the words of Robert Hughes, "Who in 1890 would have predicted that the obscure and clumsy Cézanne would cause a revolution in values that

would oust the 'impeccable' diction of Bouguereau from the history books?" As it was, the Caillebotte bequest to the state gave officials in charge of government museums a perplexing problem: how to extract some works and reject others they couldn't stomach. Caillebotte himself died in 1894; he had even predicted that he would die comparatively young. His brother was left to engage in a long-drawn-out battle with the state.

Renoir wanted the public to be told at the outset what to expect, and so it was. The show was called "The Impressionist Exhibition." Anyone who came couldn't say they hadn't been warned. More than 240 oils, watercolors, and drawings were hung in the high spacious rooms, a bigger display than either of its predecessors. But this time, though there were more items, the number of artists was reduced to eighteen. The more conventional artists had dropped away, leaving an exhibition that was far more homogeneous.

The hanging committee was made up of Renoir, Monet, Pissarro, and Caillebotte. They obviously wanted to give Cézanne every encouragement after his defection the previous year, and allocated him the finest place in the entire show. He exhibited sixteen canvases: five still lifes, portraits of Choquet and a woman, a study of *Bathers*, a *Tiger* (after Delacroix), and three watercolors (one of flowers, plus two landscapes). His address was given as 67 rue de l'Ouest, his age thirty-eight. He must have felt that this time at last he would be taken seriously. Monet showed his *Gare Saint-Lazare* and *Dindons blancs*, while Renoir contributed *La Balancoire* and, in the grand central salon, his *Le Bal du Moulin*. In the same large space were big landscapes by Pissarro, pictures by Berthe Morisot, and all Cézanne's canvases. The next largest room contained Sisley, Pissarro again, Monet, and Caillebotte. In a little gallery at the end were Degas and the watercolors of Berthe Morisot.

The reaction of the public this time was more subdued, with plenty of curiosity but much of it of a more sympathetic kind. "Even those who had come to criticize halted before more than one picture in admiration," reported the *Siècle*. The *Courrier de France* concluded that "one might think the hostility that the impressionists stirred up by their early works was perhaps due to the clumsy and maybe brutal expression of a profound astonishment." Georges Rivière issued four numbers of a little review, *L'Impressioniste*, to cover the duration of the show. In the second number, published April 14, he makes his mark as probably the first writer to discern—at a remarkably early stage—the classical tendency of Cézanne's maturing art, increasing in grandeur as

the Mediterranean landscape of his native ground sustained him. Evidently Rivière was impressed by the artist's newfound power to transform without romanticizing. He begins indignantly, "They come to M. Cézanne's works in order to laugh their heads off. For my part, I do not know of any painting less laughable than this. . . ." He goes on to proclaim that

> M. Cézanne is, in his works, a Greek of the great period; his canvases have the calm and heroic serenity of the paintings and terracottas of antiquity, and the ignorant who laugh at *Bathers*, for example, impress me like barbarians criticizing the Parthenon.
>
> M. Cézanne is a painter, and a great painter. Those who have never held a brush or pencil claim that he does not know how to draw, and they have criticized him for imperfections that are actually a refinement, obtained through tremendous knowledge. . . .
>
> His landscapes have a dominating majesty, and his still lifes, so beautiful, so exact in the relation of tones, have a solemn quality of truth. In all his paintings the artist produces emotion because he himself experiences in the face of nature a violent emotion that his craftsmanship transmits to the canvas. . . .[7]

The small portrait in the show of *Choquet Seated* is unique in that the personality of the sitter is subservient to the forms, no more or less important than the chair or desk or the rug under the sitter's feet. This is Cézanne moving tentatively toward the realization of his objective for the very first time, though he was far from recognizing yet the enormous distance he had to travel, or what a price he would have to pay for the "fidelity to nature" which became his gospel. Monet's declared aim of painting only "your own naive impression of the scene before you" would always be seen by Cézanne as an impoverishment. The light of the south demanded something altogether more lucid, concrete, graspable, of such physicality that it connected him to the body of the world, no less. Later his statements would refer obsessionally to this striven-for intention to "make of Impressionism something more solid and durable, like the art of the museums," "to become classical again through nature," "to redo Poussin after nature."

The latest Choquet has none of the grandeur of the earlier superb head, which filled the space and was full of romantic dedication and fervor, the work of an artist-poet like that of his idol Delacroix. Here, in contrast, Cézanne's friend and champion sits cross-legged and is quietly receptive, a mild man in a domestic setting, his legs in one plane and his

turned torso in another, facing the observer. He rests his left arm over the back of his chair and locks the fingers of his hands together. His face tells us nothing, beyond a certain passivity as he submits to the will of the painter. His mouth is touched with red, a prim dab.

Critics have commented on the inlaid horizontal and vertical strips of color banding the whole flat surface of the canvas, the touches of color so densely and intricately fitted together that they resemble marquetry or mosaic. In fact the colored marquetry of the desk behind Choquet, golden and glowing, strikes us before we realize that it camouflages the structure of the desk itself. There is much deliberate obscurity in what seems at first to be a simple portrait painted brightly and attractively in bright touches of yellow, red, and light grey. Gradually we recognize strangenesses. The pattern of the rug under the sitter's feet has been deliberately broken up, the bits flying apart. Behind Choquet's head and touching his left shoulder are two of his framed pictures. Below his knees, the blackish band at the base of the wall reaches the legs at one level and then continues beyond the chair back at a different one. The difference isn't great: it is meant to create instability in the eye of the viewer. This tilting and upsetting will become more pronounced in future years. Walls and chairs come to rest in his paintings but are never static: the universe is in motion.

The idea governing the picture is made clear by the interlocked hands resting over the chair back. Objects at different depths are to be united on one plane. A person can be treated in the same way as a still life: why not?

Closely linked to this new approach, where the very fabric of the paint creates light and atmosphere, is the portrait of *Madame Cézanne in a Red Armchair*. Not included in the exhibition but painted around the same time, this masterpiece has the highly structured quality of the *Choquet*. Its great color scheme drenches the entire canvas in sumptuous red, yet the only red object is the armchair with its round bulging shapes, behind the woman's head and swelling down her left side until it slips out of the picture. The wall behind it is an earth green, carrying a wallpaper pattern, widely spaced, in the repeated shape of a cross with the center omitted. The woman leans to the left—more insistence on the mobility of everything—in her blue-grey jacket, fastened together by a bow touched with green, looking silky. The voluminous skirt of her dress has broad vertical stripes, delicately flecked with greens and green-yellows. The hands are joined on the lap. The serene holding of the head, the topknot of the hair cut off by the top edge of

the canvas, seems a visible sign of the harmony of the whole, like a linchpin holding everything in equilibrium. The bright face is without interest in itself, a mere mask of resignation. The German poet Rilke spoke in a letter to his wife of standing before this painting and understanding that the red armchair is "a personality in its own right." A vermilion tassel dangling from the left armrest has behind it a wide band of greenish blue. The two main hues, blue and red, form alliances everywhere in splendid combinations. So many elements are combining and participating that the color vibrates and pulses, and nothing is finally still. Rilke exclaims almost desperately of this picture, *"It's as if every place were aware of all the other places."* [8]

Georges Rivière's response to a "Greek" *Bathers* could well be a reference to the largest and most ambitious of Cézanne's figure compositions in this decade. Heroic in conception, the painting poses four nudes, two of them male and two indeterminate figures, one with its back to us on the far left. A panoramic landscape is given a monumental aspect by the craggy outline of Mont Sainte-Victoire in the background. The mystery nude with back turned stands with one arm raised, folded over the head in the temptress pose first used in the *Temptation of Saint Anthony*. But no one is being tempted here. By the figure's side, exaggerating its uprightness, is the vertical image of a fountainlike tree.

At the right a male bather stands with one foot in the stream that bisects the picture and curves round at the right, almost in a circle. He turns his head and looks at the viewer over his shoulder. In the foreground a broad-chested man stands frontally, his head lowered as he steps forward into the water, his feet reflected in it. Another nude lies on the grass in the foreground. Like the long-haired figure in the distance, separated from her clothes by the reclining nude, this one is also androgynous. The right arm is raised over the head in a female gesture of protection. At the front edge of the canvas are a round straw hat and a white shirt. There is disquiet, created by these nudes tensely waiting and posed in opposite directions. The bathing was profound for Cézanne, the water evoking rituals of cleansing and baptism, and the "boundless joy" he had tasted with Zola and Baille when they were alone and free and "found an escape from the matter-of-fact world in their unreasoning worship of trees and hills and streams."[9]

Roger Fry is illuminating in his effort to penetrate Cézanne's complex artistic nature when he writes that "he seems indeed hardly to arrive at the comprehension of his theme until the very end of the

work; there is always something still lurking behind the expression, something he would grasp if he could. . . . He is so discreet, so little inclined to risk a definite statement for fear of being arrogant; and he is so immensely humble; he never dares trust to his acquired knowledge; the conviction behind each brush stroke has to be won from nature at every step, and he will do nothing except at the dictation of a conviction that arises within him as the result of contemplation.

The modest flow of sympathy aroused by this show was short-lived. After the first day or two the general press swung in to the attack; the behavior of the visitors changed from amused tolerance to the kind of hooting mockery seen before. R. Ballu, in *La Chronique des Arts de la Curiosité*, dismissed all the artists without exception: "You must see them to imagine what they're like. They show the most profound ignorance of drawing, composition, color. When children amuse themselves with paper and colors they do better. Levert, Guillaumin, Pissarro, Cordey, etc. do not deserve to have anyone pause before their works."

Leroy in *Le Charivari* warned his visitors not to linger before the portrait of Choquet if they were accompanying a pregnant woman, otherwise the infant may contract yellow fever before its birth. Perhaps stung by the puerile level of some of this reviewing, Zola broke his silence and weighed in with a short article on the show. He praised Monet as the most outstanding exhibitor, then went on: "Next I wish to name M. Paul Cézanne, who is certainly the greatest colorist of the group. There are, in the exhibition, some Provençal landscapes of his that have a splendid character. The canvases of this painter, so strong and so deeply felt, may cause the bourgeois to smile, but they nevertheless contain the makings of a great artist." He went on to draw attention to the work of Renoir, Morisot, Degas, Pissarro, and Caillebotte, and concluded: "The proof that the Impressionists constitute a movement is that the public, though laughing, throng to their exhibition. One counts more than 500 visitors a day. That is success. . . ."

On the same day the critic O'Squarre reported in *Le Courrier de France*, "The lion of criticism has become gentler. The wild beast has drawn its claws and one might think that the hostility which the Impressionists met at the debut was only the clumsy and somewhat savage expression of a profound stupefaction." This rosy view came before Paul Mantz, art critic of *Le Temps*, told his readers, "They have

closed eyes, a heavy hand, and superb contempt for technique. There is no need to concern oneself with these chimerical minds who imagine that their casualness will be taken for grace and their impotence for candor. . . ."[10]

Cézanne was still at the top of a blacklist that editors of art magazines consulted when they commissioned articles on Impressionism, asking writers not to consider him. Victor Choquet had devoted all his spare time to the exhibition, striving to persuade visitors of Cézanne's originality. Theodore Duret wrote admiringly:

> He was worth seeing. He became a sort of apostle. One after another he took the visitors whom he knew or approached others to try and make them share his admirations and his pleasure. It was an ungrateful role. He got nothing but smiles or mockery. M. Choquet was not discouraged. I remember having seen him try thus to persuade well-known critics and hostile artists who had come simply to run the show down. This gave Choquet a reputation, and whenever he appeared people liked to attack him on his favorite subject. . . . Many were amused by Choquet's enthusiasm which they considered something like a gentle insanity.[11]

The upshot of this exhibition was no different from the previous ones: a little more recognition gained, but buyers were if anything scarcer than ever. Cézanne was in Paris and would sometimes appear at the gallery in the rue le Peletier, avoiding the rush hours. The best time for him was late afternoon after the crowd had gone. He would have the almost empty rooms to himself. Either he sat on a bench by himself or with friends, say Choquet, or Pissarro or Renoir. He sat gravely and silently, a man with no illusions, too clearheaded to be deceived by Choquet's well-meaning encouragement.

Most of the Impressionists were very hard up. The exceptions were Berthe Morisot, who was a wealthy woman, Caillebotte, and Cézanne, whose small allowance was more than enough to survive on, since he was such a thrifty nature. Monet, Pissarro, and Renoir were obliged to sell pictures in order to live and provide for their families—often for as little as thirty or forty francs apiece. Guillaumin, with a family to support, lived on the salary he earned as a clerk in local government. Sisley, in abject poverty most of the time, was sometimes actually starving.

The painters in most need tried to raise money through another auction, this one held at the Hôtel Drouot. This did no better than before. One dealer, Durand-Ruel, still kept buying up their work very

cheaply for the next year or two, until his storerooms became cluttered with unsold canvases. The joint exhibitions went on, the group holding shows in 1879, 1880, 1881, and 1886. But Cézanne never took part again. A projected exhibition in 1878 would have included at least one work by him; a letter to Zola asks his friend to send in a still life that hung in Zola's dining room—it was probably *The Black Clock.* Then the show was postponed till the following year. By then Cézanne had made up his mind not to take part. His lame excuse to Pissarro in 1879 that the forwarding of canvases was a problem for him wouldn't have convinced his mentor, who was wise enough not to probe.

He kept in touch with a few friends from now on but could no longer be counted a member of any group. Dealers, critics, collectors, and the circulators of art world gossip lost track of him. As he dropped out of sight, his reputation as a monster of modern painting died with him, to such an extent that many thought he was in fact dead. A few years before his death his son mentioned names to him that brought back those far-off days. The old man was deeply touched

> by the kind of memories of me that Forain and Léon Dierx have been good enough to retain: my acquaintance with them goes back quite a long way. With Forain, to '75 at the Louvre, and with Léon Dierx to '77 at Nina de Villars' in the rue des Moines. I must have told you that when I dined at the rue des Moines there were present at the table Paul Alexis, Franck Lamy, Marast, Ernest d'Hervilly, L'Isle Adam, and many others, and the lamented Cabaner. Alas, how many memories have been swallowed up in the abyss of the years.[12]

The informal dinner parties at the house of Nina de Villars were among the very few social events attended by Cézanne—that is, if you could call them events. She was young, pretty, an accomplished pianist, and had a taste for bohemia and the company of artists. She kept a sort of open house on certain evenings. Meals were informal and sometimes chaotic. One story tells of Cézanne arriving, ringing the bell, and being frightened off by a maid who opened the door dressed in a negligée. He met Cabaner there, the penniless musician he had encountered in the street years before, unwrapping the landscape under his arm and then giving it to him because he was so moved by the young man's enthusiasm. Vollard described Cabaner as "a good fellow, something of a poet, a fair musician, a bit of a philosopher." He was consumptive, eking out an existence as a piano player in a café.

Imaginative, gifted, but too feckless to get anywhere, he was a Catalan, sickly looking, cynical, who never wavered in his belief in Cézanne. He amused the company with his sardonic tongue, saying things like "My father was much the same sort of man as Napoleon, but less stupid."

*L'Assommoir* was now a roaring success, reprinting thirty-eight times in 1877 alone. A forgotten Cézanne would in the future be writing to a successful Zola, as much in the literary swim as the painter was out of the artistic one. Jack Lindsay draws a parallel between Zola's achievement in *L'Assommoir* of a new sort of style—where the author disappears into the work to create what he calls a "textual unity"—and the new concepts of space and objects in interrelation that Cézanne was slowly developing, realizing as he did so that his breakthroughs came when he somehow short-circuited his consciousness and lost himself in the motif. The correspondences are somewhat tenuous, and yet the close relations of the two men over so many years make us willing to consider them.

Cézanne's painful shyness and ingrained fear of women often left him isolated, liable to withdraw into a corner or act antisocially. Yet his letters have much warmth and spontaneous affection. Now he retreated again into himself, preferring the friendship of such undemanding characters as Cabaner and Tanguy. More than one writer has pointed out that it was Tanguy, more than anyone else, who kept his name alive and his work on view after the well-meant attempt to launch Cézanne had failed. During his self-imposed retreat following the exhibition there was only one place where his canvases could be seen and that was in the color merchant's tiny shop at 14 rue Clauzel. Tanguy had already accumulated a number of his pictures, and over the years acquired more. All that the homely little radical could give him in exchange for them were tubes of pigment.

As a genuine Communist Tanguy felt obliged to help hungry artists, and though this didn't apply to Cézanne, he fed many painters and beggars, as well as taking pictures in place of cash. His wife told him he was a fool, but provided what meals she could all the same. The brilliant colors of the Impressionists were to him like the brave flag of the new heaven on earth he hoped would one day come to pass: browns and blacks and the despised bitumen were for him the colors of the hated bourgeoisie.

A good many of the canvases Cézanne left with Tanguy were pictures he hadn't been able to complete satisfactorily. If he had hung on to them he would have hacked them to pieces in due course. Tanguy

had no space to display paintings, but when friends and critics called in and asked to see the latest Cézanne he would bring out what he had and stand them on chairs or against the walls. Younger painters who had never met Cézanne were influenced in this way by Tanguy, or by word of mouth. If Cézanne did come to hear of these admirers we have no knowledge of it.

Among these young painters who came in the next decade to look at the Cézannes stored away in Tanguy's shop were Gauguin, Émile Bernard, and Van Gogh. Cézanne's extreme slowness in later years as he built up his pictures with long pauses between each mark of the brush was at the opposite pole to Van Gogh's feverish rapidity. Vincent, toward the end of his life, was dashing off two or three paintings a day. The two men met only once, and it was fitting that it should have been in Tanguy's shop. The time, somewhere between 1886 and 1888, when Vincent left for Arles, has been described by Émile Bernard in the *Mercure de France* in December 1908:

> One afternoon when Cézanne came to Tanguy's, Vincent, who had lunched there, met him. They chatted together, and after having talked about art in general they began on their own individual ideas. Van Gogh thought that he could not explain his theories better than by showing his pictures to Cézanne and asking his opinion of them. He exhibited canvases of various kinds, portraits, still lifes, landscapes. Cézanne, whose nature was timid but violent, said after he had inspected them all, "Truly you paint like a madman!"

Nothing could be more ironic than the fact that Père Tanguy, a poor man of absolutely no consequence in the world's eyes, should have been instrumental in presenting Cézanne on the world stage. Vollard only became aware of Cézanne because of Tanguy's collection. The opinion-changing one-man show Vollard organized in 1895 laid the foundations of a real reputation at last.

◆ Between 1877 and 1886 occur more letters from Cézanne to Zola than at any other period. They provide virtually the only map we have which gives the painter's movements in any detail, as well as giving us the only clues to his inner life. He had come to accept that Zola, while not exactly losing faith in him as a painter, had no real conception of what he was trying to do, and so the correspondence steers clear of art and painting in general. But the personal confidences, appeals for

advice, and disclosures of his private affairs show how firm the friend-
ship still was and how unhesitatingly he trusted Zola when he found
himself in a fix. He simply assumed without even pausing for thought
that the now-famous novelist would drop whatever he was doing and
give him concrete help, if that was what he needed.

In 1877 Zola took a break from his labors and went south with his
family. He could well afford it, pocketing 18,500 francs of royalties
rolling in from *L'Assommoir*. He went to l'Estaque. It was impossible, as
always, for him to stop working, but he worked on his new novel, *A
Page of Love*, at a leisurely pace and luxuriated in memories of his boy-
hood and youth. "The country is superb," he reported to a friend.
"You'd perhaps find it arid and desolate, but I've been reared in these
rocks and in these stripped wastes, so that I'm brought to tears on see-
ing it all again. The very smell of the pines evokes all my youth." As he
had been on good terms with Cézanne's mother in the past, he made a
point of going to see her.

Cézanne had gone out to Pontoise and was painting at Pissarro's
side in his kitchen garden. He worked at Auvers, under the eye of Dr.
Gachet, who entered him in his journal. He set up his easel at Chanti-
lly and then at Fontainebleau, working on the banks of the Seine and
the Marne. He worked with Guillemet at Parc d'Issy-les-Moulineaux
for a spell. In Paris Pissarro introduced him to a broad-shouldered
young stockbroker and amateur painter by the name of Gauguin who
was employed in the Banque Bertin. He had been studying in the
Académie Calarossi. Dissatisfied with conventional painting he was
cultivating the Impressionists, in spite of having had a canvas hung in
last year's Salon. For an aspiring artist he was extraordinarily confident,
not to say cocky. He seemed to think that Cézanne's appearance and
scatological humor were affectations, but nevertheless acquired one of
his paintings—probably from Tanguy at a knocked-down price—and
some of Pissarro's.

Cézanne's slovenly clothes amused Duranty, who said as much to
Zola in a letter. "Cézanne appeared a short while ago at the little café
on the Place Pigalle in one of the costumes of olden times: blue jacket,
vest of white linen covered with the strokes of brushes and other
instruments, battered old hat. He made quite an impression."[13] In
other words he looked distinctly old-fashioned and tramplike, as
bohemians used to look. It was perhaps all part of his desire to live
apart, to be of no account, deliberately characterless, to be allowed to
"work in silence."

From Paris we find him writing on August 24 with a message for Zola to pass on to his mother. As usual he was afraid of his letters home falling into the hands of Louis-Auguste. He wanted his mother to know that he needed nothing

as I mean to pass the winter at Marseilles. If, when December comes, she'll take on the job of finding me a quite small lodging at Marseilles with two rooms, not dear, in a quarter however with not too many murders, she'll do me a great favor. She could have a bed brought there and what's needed for sleeping, two chairs, which she can take from her house at l'Estaque to save too many heavy expenses. Here the weather, I must inform you, the temperature, is very often refreshed by munificent showers—style of Gaut of Aix.

I go daily to the Parc d'Issy where I make studies. And I'm not too badly satisfied, but it appears a profound desolation reigns in the Impressionist camp. Pactolus [gold] is not exactly flowing into their pockets, and studies wither on the walls. We live in a very troubled period, and I don't know when poor painting will regain a little of its luster. Was Marguery less desolate on his last excursion to Tholonet? And have you seen Houchard, Aurélien? Apart from two or three painters I've seen absolutely nobody. . . . For a month and a half Daudet's new novel has been appearing in the *Temps*, yellow posters stuck up even at Issy, have informed me. . . . Are the sea baths doing Mme. Zola good, and you, do you cleave the salty waves? My regards to everyone and a cordial handshake for you. *Au revoir* then when you return from the sunny shores. I am the painter thankful for your kindness.[14]

Four days later he had changed his mind, writing again to Zola "to tell my mother not to trouble herself. As a matter of fact the arrangement would appear to be too difficult to carry out. I give it up. All the same I still count on going to Aix either in December or about the beginning of January." He adds that he went to Tanguy's the previous day and "found dear Emperaire there."

By the evidence of these letters he was in reasonably good heart, able to joke about quarters free of murders and to take a rise out of the pompous Aixois poet Gaut, whose style the three Inseparables had found so absurd when they were discovering Hugo and Musset. Now and then he would be caught unawares and tripped up by a misery out of nowhere "that as suddenly as a gust of wind casts everything into

darkness." One recalls Jean Genet's declaration that genius is despair overcome by rigor.

Early in 1878 Cézanne went south. Eighteen letters to Zola in this year enable us to keep track of his doubling to and fro, his endless dithering and the ludicrous difficulties he got himself into as he tried to keep his affairs secret from his father. Undoubtedly Hortense would have preferred to stay in Paris—rural life put a damper on her lively spirits—but Cézanne's meager allowance meant that his family had to go with him.

The pantomime began when he installed Hortense and little Paul in an apartment at 183 rue de Rome in Marseilles and then started flitting—if we can use such a word for the distances he had to cover on foot—between there and l'Estaque, where his mother rented a house, and Aix. One tries hard not to laugh at the antics of this man of thirty-nine who had gone south in order "to savor the most perfect tranquility" as he tried to turn up for meals at Aix like a dutiful son and act calmly. He was a bad liar and Louis-Auguste was no fool. The evasive maneuverings of his out-of-work son drove him mad, though he was probably too proud to confront him directly. Instead he played a cat-and-mouse game, waiting his chance. Too many people knew Cézanne's secret—his mother and sisters, and most of his friends in Paris. Louis-Auguste had already opened letters that virtually gave the game away.

Cézanne had lied so often that he was in the miserable position of having to go on lying blindly, knowing it was now probably useless. His father, only in ignorance of the details, was casting round for a way of ridding his inept son of unwanted dependents. Cézanne's paralysis before his father was to some extent a disability of his own invention. His son had made Louis-Auguste huge and black, a frightening authority figure who reared over him in imagination like a toppling wall. What struck terror into him above all else was that this was the man on whom he relied for the one thing that made his life as a painter possible, and without painting how could he exist? Feeling as he did that his father controlled him absolutely, how could he ever be a free spirit? He suffered the inner maladjustment of an exile who came back again and again but could never be happy again as he once was. He knew that his claim to live at his father's expense was not something he could ever justify. He was permitted to come home, to walk about in the town, but only as long as his father allowed it. If his father uncovered his circumstances, as he seemed now on the point of doing, he could stop his

allowance completely and Cézanne would be forced to find some kind of employment. And how impossible that was for a man virtually unemployable!

He poured out his fears to Zola, the one friend he knew would stand by him, the only person who understood how unfitted he was for anything except painting. On March 3 he appealed to Zola directly, fearful of soon finding himself forced to obtain

> some resources by myself, if however I'm capable of it. The situation between my father and myself grows badly strained, and I'm threatened with losing my allowance. A letter written to me by M. Choquet, in which he spoke of Madame Cézanne and little Paul, has definitely given my position away to my father who was anyhow on the lookout, full of suspicions, and who has nothing more urgent to do than to unseal the first letter addressed to me, though it bore the superscription: Mons. Paul Cézanne, artist painter.
>
> So I appeal to your benevolence toward me to ask you to look round in your circle and use your influence to arrange something, if you consider it possible. The break between me and my father isn't yet complete, but I don't think I'll spend another fortnight without my position being fully settled. Write (addressing your letter to M. Paul Cézanne, *poste restante)* and tell me what decision you've reached as to my request. Kindest greetings to Mme. Zola and a firm handclasp to you. I write from l'Estaque but return to Aix this evening.[15]

During this crisis he was forever tramping enormous distances—it was about eighteen miles from l'Estaque to Aix—in an effort to arrive in time for the all-important family dinner. From this letter it looks as if he were contemplating making a clean breast of everything, more or less resigned to losing his allowance. His father, adept at the use of threats which he rarely carried out, was talking of a reduction of his allowance to a hundred francs, either as a ruse to get rid of his son's shadowy "dependents" or to flush him out. Zola wasted no time in advising his distraught friend to smooth his father and avoid a showdown at all costs. He may or may not have known of Cézanne's financial fix. An IOU for 2,174 francs had been given to Tanguy for painting materials, since Cézanne's allowance didn't stretch to more than supporting himself and his family. Yet he must have been told by his mother that the elderly Louis-Auguste had already transferred his estate to his children as a way of avoiding inheritance taxes. Apparent-

ly Cézanne was fearful of claiming his legitimate share, suspecting a legal snag inserted by his father to derail his claim.

To compound his dilemma, mail arrived from Paris, forwarded from his apartment there by a shoemaker with whom he had left the key. Relatives of Hortense had been staying there during the World's Fair of 1878, giving the impression that Cézanne was "hiding women in Paris." Even the despairing painter could see how ridiculous it all was. "It's beginning to resemble a vaudeville," he wrote in exasperation to Zola.

The struggle with his father, by a son who would eventually "absorb" him, taking over a substantial part of his wealth and exhibiting many of his characteristics, even owning up to a long-held admiration for him, went on for the whole year. The giveaway letter from Choquet had not mentioned Hortense by name, so he was able to pass off the reference to the little boy as having nothing to do with him. His embarrassment was so obvious that it was clear he was lying. Furious, his father resorted to employing someone to follow his son around as a way of tracking down Paul's "encumbrances."

Numa Coste told Zola in a letter that the old man in his eightieth year knew that "Paul has a brat. He said to someone who questioned him: 'It seems I have some grandchildren in Paris; I'll have to go and see them some day.' " Cézanne's painter friend Villevielle bumped into the retired banker one day in the street and was told point-blank, "You know I'm a grandfather." Villevielle expressed astonishment. "What do you mean? Paul isn't married." "No?" the old man retorted. "He was seen coming out of a shop with a rocking horse and other toys. You're not going to tell me they were for himself?"

The old fox, who had all his faculties intact, had evidently got this much from his informant, but why not more? Probably he stopped short of wanting to find out everything, and on his home ground there was always the risk of scandal. It is likely too that he had genuine warm feelings for his son, who after all was showing himself to be as strong-willed in pursuit of his aims as he, the father, had been. And, though he would never have admitted it, the thought of grandchildren in the world must have stirred his pride.

Little is known of Madame Cézanne, but Paul got his shyness from her and certain morbid traits, and his mother's mind was subtle and impulsive like his. Physically too she resembled him, dark and tall, big-boned, her face thin. Marie with her calm personality and her unswerving efficiency took after her father. She was his favorite. Cézanne felt

from the beginning that he had an ally in his mother. She had no understanding of what he was trying to do, but in her dark intensity, hidden from her husband, she grieved over her anxious son and always wanted to help him if she could. They were connected secretly through her responsiveness and his need, which she understood without words. She had met Hortense at l'Estaque and didn't really like her, but her grandson she adored. Both she and Marie, but especially Marie, with her hatred of any impropriety, tried to persuade Cézanne to reveal the truth to his father and to marry Hortense. This kind of direct action was totally beyond him.

He seemed to hope that if he kept on obstinately bluffing and denying, his father would give way out of sheer weariness. Zola had generously offered to tide his friend over financially for as long as was necessary. Cézanne wrote gratefully on March 28, indicating that for the moment at least the pressure on him had lessened. He agreed with Zola that

> I shouldn't renounce too impulsively the paternal allowance. But judging by the snares laid for me, and from which I've so far escaped, I foresee that the great argument will be about money and the use I should make of it. It's more than likely I'll not get more than 100 francs from my father, though he promised 200 when I was in Paris. I'll then have recourse to your kindness, all the more because my little boy has been ill for the last fortnight with an attack of typhoid fever. I'm taking all precautions to stop my father from gaining absolute proofs.
>
> Excuse me for the following comment. The paper of your envelopes and notepaper must be heavy: at the post I had to pay 25 cms for insufficient stamping—and your letter held only one double sheet. When you write, would you please only enclose a single sheet folded in two. If as a result my father doesn't give me enough, I'll turn to you in the first week of next month, and I'll give you the address of Hortense, to whom you'll be kind enough to send it. Remember me to Mme. Zola. I clasp your hand, Paul Cézanne.

It's clear from this how hard-pressed he was during these lean months, and clear too in these complaints—they weren't the first—of having to pay overweight on letters that he was his father's son, equally as frugal as the old man and just as reluctant to spend money on himself.

◆ He had got wind of another Impressionist show and was in fact invited to a planning meeting at the rue Lafitte, but the way things were it was impossible for him to extricate himself from Aix. Instead he asked Zola to send in the still life of the black clock and shell which he had in his home, before learning that the show had been abandoned. In his next letter (which carried no date) he explains that he hasn't got far in his reading of *A Page of Love*, the new novel Zola had sent him, inscribing the copy affectionately as always. This was because of the illness of his mother, who had been in bed

> ten days, her condition is most serious. I stopped reading at the end of the description of the sun setting over Paris, and of the growth of reciprocal passion between Hélène and Henri. It's not for me to praise your book; for you can reply like Courbet that the conscious artist awards himself just praises in another manner than those coming from outside. So what I say is only to make you understand what I can perceive of the work. It seems to me a picture more gently painted than in the previous work (*L'Assommoir*), but the temperament or creative force is always the same. And then, if I don't commit a heresy, the progress of the passion between the heroes is more consistently graded. Another observation, which seems to me correct, is that the places, by their way of painting, are impregnated with the passion that agitates the persons, and thus make more a body with the actors and are less dissociated from the whole. They seem to be animated, so to speak, and share in the sufferings of the living beings. Further, according to indications in the papers, this book will be at least a literary success.[16]

We have already seen how, in his picture *Bacchanal*, or *The Struggle of Love*, the trees and clouds are caught up in the intoxication of the battling couples, swirling around them as if the storm of desire has infected them too. And significantly he uses the word "painting" to describe the treatment of places in Zola's novel. Once again the close relation of the two men comes over in Cézanne's grasp of the other's poetic intention. The allure and promiscuity of Paris are linked to the doomed adulterous lovers by means of lyrical "word paintings" of the city:

> The heavens were aflame with glory. On the far horizon the landslide of chalky boulders that lay across Charenton and Choisy-le-Roi had become a mass of carmine blocks edged with shining

lacquer; the flotilla of small clouds swimming slowly in the blue over Paris put out crimson sails; while the film of white silk hung above Montmartre seemed all of a sudden to be a net of gold mesh, ready to catch the stars as they appeared. The city lay outspread under this blazing vault, yellow, streaked with long shadows. . . .[17]

Cézanne would have identified readily enough with the themes of temptation, middle-class hypocrisy, and fear of sex, never for long absent in Zola's work. In this letter also crops up his first use of the term *temperament*, linked here with "creative force" and to be given much personal emphasis in the years to come. Baudelaire made use of the term as early as 1865, writing of Manet, "He will never be able to fill in the gaps in his temperament; but he does have a temperament and that is the important thing." Temperament was a vital ingredient, imparting a personal stamp and a crucial energy. It was what Cézanne found lacking in the mediocre work of so many of the academics. They may have had intellect, craftsmanship, knowledge, yet for him the vital spark he called temperament was lacking.

On April 4 Cézanne was writing to tell Zola that he had dodged off on Tuesday a week ago to go and see his sick boy in Marseilles, found him better, and then was faced with a thirty-kilometer walk back to Aix so as not to miss dinner, and to avoid the wrath of his father. "I was an hour late."

Ten days later he was writing again: somehow he had missed Zola's letter. "Thanks for sending twice. I write under the paternal eye." He mentions in passing that Villevielle's pupils were making things unpleasant for him as he went by. "I'll have my hair cut, it's perhaps too long." It was another instance of his timidity. Rather than protest or ignore he preferred to conform, at least outwardly.

He included a story to illustrate what it meant to live in the provinces, where people see "with professors' eyes." He was on his way to Marseilles by train, with M. Gibert as traveling companion. The train ran close to Alexis's house deep in the country and a stupendous motif

unfolds on the eastern side: Ste. Victoire and the rocks dominating Beaurecueil. I said, "What a fine motif." He replied, "The lines are too well-balanced." With regard to *L'Assommoir*, about which by the way he spoke first, he said some very sensible and eulogistic things, but always from the angle of technique. Then, after a long interval, "It would have been good to have studied well," he went on, "to have passed the École Normale." I mentioned Richepin.

He said, "He has no future." . . . And yet in a town of 20,000 souls he is beyond doubt the one who most and best devotes himself to art. I'll be very wise, I don't know how to be clever. . . .

In May—again too agitated or distressed to date his letter—he asked for another sixty francs to be sent to Hortense at the same address as before, apologizing for interrupting the important man's work and asking wistfully for news of "the artistic and literary situation." Trapped in the south, twisting and turning to avoid the "snares laid for me" by his father, he must have seen Paris as increasingly attractive, somewhere he could disappear into and live in freedom and anonymity.

When he wrote again, on May 8, he was able to speak with some relief about his mother, and maybe it was the lifting of this burden that had enabled him to finish Zola's novel. She was now out of danger and had been getting up

for the last two days and that comforts her a lot, and she has better nights. For a week she was very worn out. But now I hope the fine weather and good care will put her quite on her feet again. I only fetched your letter yesterday evening, Wednesday, which explains the long gap between your dispatch of it and my reply. I thank you for the news of my little canvas. I understand very well that it can't be accepted, because of my point of departure, which is too distant from the end to be attained, that is the representation of nature.

I've just finished *A Page of Love*. You were indeed right to tell me it couldn't be read as *feuilletons*. I hadn't at all grasped the links, it all seemed cut up, while on the contrary the working out of the novel is done with a great skill. There is a great dramatic sense in it. It's really regrettable that art matters aren't better appreciated and that it's necessary to attract the public by retouching, without harming it it's true. I read your letter to my mother. She joins me in sending greetings.[18]

The contest with his father was by now wearing them both down. In June Cézanne asked for a further sixty francs and tried to soften the impression he was giving of the autocratic Louis-Auguste, adding for good measure a note of self-abasement that may or may not have been genuine. He was in no mood for humor, and there's no doubt he did see himself as incompetent in practical matters, "feeble in life" as he used to put it—which is not to say that he was always unconscious of the effect his helplessness had on others. "Here is again," he wrote,

"my monthly prayer to you. I hope it doesn't bore you too much and that it doesn't appear too indiscreet. But your offer relieves me of so much embarrassment that I'm taking advantage of it again. My kind parents, who are really very good to an unfortunate painter who has never known how to do anything, are perhaps a bit stingy, it's a slight fault which is no doubt excusable in the provinces."

In July, making yet another plea for sixty francs, he gave a new address for Hortense. He had moved her to cheaper lodgings, at 12 Vieux Chemin de Rome. He reported what news there was, in the hope of interesting the magpie mind of Zola, telling him that Giraud, the landlord of the little house rented by his mother at l'Estaque, had been incarcerated in an asylum but was now discharged. He was on the point of going to l'Estaque himself to try to settle to some painting. He kept an eye on the local political scene and was diverted by an item that was congenial to his anticlerical stance. At Marseilles, he recounted, "A certain Coste junior, municipal councilor, distinguished himself by flourishing his stick over clerical shoulders."

The days of tremendous heat had arrived. Then came the disastrous letter from the landlord of his Paris rooms complaining that strangers were occupying the apartment. His father pounced on the letter and thought he had the proof he needed. In fact the shoemaker to whom Cézanne had given the key was Antoine Guillaume, an old friend of Hortense's family.

For some reason his mother had taken a different house at l'Estaque, having been given notice at the other place. "I'm at Isnard's," wrote Cézanne, "next door to Giraud's." Toward the end of the month he felt in better spirits, at any rate sufficiently to be able to contemplate his plans for the following year. "I think I shall spend the winter in Marseilles, and work there, returning to Paris next spring, perhaps in March; at that season the atmospheric conditions here won't be favorable and I shan't be able to make the best use of my time out of doors. Moreover I should be in Paris in time for the exhibition of painting."

He meant the Impressionist show scheduled for the spring of 1879. He didn't intend to take part in it, but he was as keen as ever to keep abreast of the work of his old comrades. Obviously there was no animosity or falling-out behind his decision not to exhibit work himself.

Zola's new novel interested him more than usual because of its lyrical descriptive passages. As always he did his best to interest himself in the characters and plot, but if he told the truth the naturalist school wasn't to his taste, which was predominantly classical. Gasquet com-

mented that he was all his life a great reader, though he read "very slowly, almost painfully." In old age he still had whole passages of the Latin verses he had learned at school committed to memory. Apuleius, Virgil, and Lucretius were his favorites, as well as the novels of Chateaubriand, Hugo, Stendhal, and Balzac. He was acquainted with Kant and Schopenhauer and the criticism of Sainte-Beuve. His favorite modern poet remained Baudelaire. He knew *Flowers of Evil* almost completely by heart: his battered, well-thumbed copy was literally in tatters. Like the poet he saw the beautiful in its juxtaposition with the terrible, and as he aged, and withdrew more and more to the cave of his studio, he identified with Baudelaire's "Old horse who stumbles with each step," as time stealthily and inexorably engulfed him.

He loyally passed on compliments he heard along the way that he knew would be music to Zola's ears, only too aware of his friend's deep sense of insecurity, for all his commercial success. Dipping into a volume of plays Zola had sent him, he expressed surprise at the "fine and vivid dialogue" and predicted a triumph in the theatre which never came to pass. He went on to say, "I met Huot the architect, who enthusiastically praised your entire series of the *Rougon-Macquart* and told me that it was highly thought of by people who know about such things. He asked me if I ever saw you: I said 'Sometimes'; and if you wrote to me. I said, 'Recently.' Stupefaction—and I rose in his estimation. He even gave me his card and an invitation to visit him. So you see it is useful to have friends. . . ."[19]

Just as things seemed a little calmer he was tripped up by another mishap, again so foolish that it slipped into farce. Hortense's father had written to his daughter as Mme. Cézanne. The Paris landlord forwarded it to the Jas de Bouffan, and Louis-Auguste seized it. In hot water again, the harassed painter violently denied everything. Hortense wasn't mentioned by name in the letter and "I insist it's addressed to some woman or other." This was so patently absurd that one can imagine the old man laughing in his face: which he may well have done.

In a postscript to this account he wrote the good news to Zola on September 14 that the domestic skies had brightened at last. He had been hinting at a possible reconciliation with his octogenarian father before this, but the cause of his "more tranquil frame of mind" was something quite extraordinary: "*Nota-bene*: Papa gave me three hundred francs this month. Unheard of. I think he has been making eyes at a charming little maid we have at Aix. Mamma and I are at l'Estaque. What a result!"

Apparently his parents had changed their address in Aix and were about to live "behind Marguery, more or less." His mother went home—it was vintage time, and she had to attend to the removal—leaving him to his own devices. The family were now at a flat near the central market at 32 rue Ferrari and he was going there himself to sleep each night, then traveling back to l'Estaque the next morning to work. His plan was to stick to this routine for the entire winter. He was making soup and about to eat it alone when Zola's next letter came, and made a point of mentioning what soup it was (*soupe au vermicelli à l'huile*), the kind so much appreciated by Lantier in *L'Assommoir*.

Then comes a savage outburst directed at Marseilles, extending by inference to include the denial of the instincts, the triumph of the cash nexus and the steady concreting-over of everything worthwhile:

> Marseilles is France's oil capital, just as Paris is the butter capital. You have no idea of the overweening conceit of this ferocious population. They have but one instinct, that of money. It's said they earn a lot, but they're very ugly. From an external angle intercourse is effacing the most salient features of the types. In a few centuries it will be quite futile to be alive, everything will be flattened out. But the little that survives is still very dear to the heart and the eye.[20]

He had spotted Marion—now at thirty-two a professor of geology—from a distance, "on his way to the Faculté des Sciences," and wondered if he should go and see him, though "he doesn't appear to be sincere in art, perhaps in spite of himself."

A letter from Caillebotte in Paris that had gone astray reached him at last. From it he learned his friend's loss—his mother had died—and hastened to send his condolences, writing mysteriously that "I well know the aching void caused by the disappearance of people we love." So far as we know he had not yet suffered any bereavement. He urged Caillebotte to concentrate on his painting "as being the surest means of diverting our sadness." The use of "our" is either a slip of the pen or else it touchingly confirms for us the consolation he derived from his art.

The tension may have eased so far as Cézanne was concerned, but that wasn't to say that all was plain sailing now for him. Would it ever be, for someone so anxiety-ridden? Hortense went off alone to Paris at the beginning of November, leaving him with his boy to look after. His mother must have come over to help—she would have been delighted—but that only meant more worry: his father might easily have paid

a surprise visit. His great age was the only factor in Cézanne's favor. Again he was financially strapped, forced to ask for Zola's help as he was "in the kneading-trough," in other words a mess, "but hope to get out of it." "Hortense," he wrote on November 4, "is in Paris on urgent business and I beg you to give her 100 francs if you will be kind enough to advance me this sum."

On November 20 he thanked his old friend for advancing the money. Apart from hearing that Hortense had received it, he had heard nothing for some time. The bad weather had put a stop to his work for the present, so he was reading, and perhaps making some of those delightful pencil studies of his rapidly growing boy. He was a tender father who endlessly spoiled his son. Any bad behavior he forgave in advance, telling him when he was a teenager, "Whatever mischief you may get into, I shall never forget that I am your father."

"I have bought a very curious book," he tells Zola, "a web of observations of a delicacy which escapes me sometimes, I feel, but what anecdotes and true incidents.—And conventional people call the author paradoxical. It's a book by Stendhal, *History of Painting in Italy*, no doubt you have read it, if not permit me to recommend it to you." He had read it in 1869, though not carefully enough. Now he was rereading it for the third time.

He was beginning to realize that any understanding he may have thought he had reached with his father was shaky, if not illusory. He had been lulled into a sense of false security after the old man's little flirtation had "loosened his purse strings." It was a relief when Hortense came back in mid-December to install herself again at rue Ferrari, as he told Zola on December 19. He had been living on tenterhooks, afraid his father "might have caught us unawares." He even began to wonder if there was some conspiracy

to give my position away to my father. My blasted fool of a landlord is mixed up in it too. It was more than a month ago Hortense got the money I begged you to send; and I thank you, she needed it badly. In Paris she had a little adventure. I won't confide it on paper, I'll tell you when I come back—besides it isn't important. Finally I think I'll stay here some months and leave for Paris near the start of March. I expected to taste the most complete tranquility here, and on the contrary a lack of entente between me and paternal authority makes me only the more tormented. The author of my days is obsessed with the idea of freeing me. There's only one

way of doing that, and that's to stick another 2 or 3000 francs a year on me, and not make me wait till I'm dead to become his heir. For I'll finish before him, that's certain.

As you say, there are some very beautiful views here. The point is to render them. It's hardly my line. I've begun to see nature a bit late, though that doesn't prevent it from being full of interest for me.

I wish you all a happy Xmas. Next Tuesday I shall go to Aix for two days. When you write to me, please address it still to l'Estaque.[21]

We are reminded here that at the age of forty he still regarded himself as primarily a figurative painter. And here is the specter of early death to which he often refers in later letters to Zola. Yet he was in good health, not hypochondriacal, and the diabetes that would begin to afflict him ten years from now was, so far as we know, showing no symptoms. As this miserable year drew to a close it is hardly surprising that he should have sounded such a somber note.

◆ For Zola the story was very different: it had been a year of triumphant consolidation. He had broken through to fame and a long-sought prosperity. It must have seemed to him that Cézanne was sinking slowly out of sight, bogged down in domestic difficulties that would have made him shake his head and smile.

He was turning into a rather portly figure, clamped gloomily into the strictly regulated doses of work which was his life-support system. He smiled rarely, his mouth in the black beard—grown to convey a look of virility—pouting a little like a sullen child. Henry James in his review of *Nana* said disdainfully that "M. Zola disapproves greatly of wit; he thinks it is an impertinence in a novel, and he would probably disapprove of humor if he knew what it was."

Since the summer he had been consoling himself with a new acquisition, a small country house on the Seine near Médan. Cézanne had written to congratulate him on the purchase, seeing it as a useful stopping-off place for exploring unfamiliar terrain. No one could have been more indifferent to the owning of property. "I've bought a house," the novelist wrote to Flaubert, "a rabbit-hutch, between Poissy and Triel, in a charming spot on the banks of the Seine. Nine thousand francs. I tell you the price so that you won't be too much impressed.

Literature has paid for this modest retreat, which owns the merit of being far from a station and without a single bourgeois neighbor." But in fact it wasn't as remote as all that. A village of about two hundred folk was nearby and the railway ran through the grounds.

With the flow of wealth generated from *L'Assommoir* he had moved his Paris base to a spacious apartment occupying two floors of a house in the rue de Boulogne. There he gave his acquisitiveness free rein, filling the rooms with an incredible assortment of Venetian furniture, Turkish divans, Indian sculpture, and Louis XIV chairs. "The rooms gave the impression of some medieval tent pitched simultaneously in several countries; everywhere there were sumptuous curtains and ancient tapestries. Suits of armor were jammed into niches. An aviary was installed in the dining room. The bedroom boasted a splendid Louis XIII bed, hung with rich folds of Genoese velvet. On the first floor was Zola's study, so densely hung with heavy plush curtains that it seemed always in twilight. The novelist, enthroned on a big carved rosewood chair, sat behind an enormous Dutch table ten feet long, from where "he could contemplate an extensive collection of gee-gaws, each of which had its nominated position on the work-table."[22] On the wall hung his many Impressionist canvases, presided over by his portrait by Manet.

It was partly the claustrophobia induced by this museumlike mass of possessions that had given him the desire to find a place in the country. It didn't seem to occur to him that the vulgar opulence of the Second Empire, denounced with such energy in his great chronicle, was being mirrored by his own ostentation and bad taste. As for not being able to see a single bourgeois neighbor from the windows of his house at Médan, he was now displaying many of the characteristics of the middle classes he castigated in his books—their avarice, their sterile marriages, and their skill at living behind a façade. His loving marriage was in fact a business partnership, expertly managed by Alexandrine, a void from which he escaped by loading himself with ever heavier work loads. And his career was not exactly turning out as he would have wished. As his popularity grew, his stock fell in the estimation of the literary establishment. After Vizetelly introduced him to England with his translating and publishing, doing his best to promote him as the French Dickens, Tennyson coined a word to express his contempt for the novelist's "wallowing," writing in his *Locksley Hall, Sixty Years After* (1886):

Rip your brothers' vices open, strip your own foul passions bare;
   Down with Reticence, down with Reverence—forward naked—
   let them stare. . . .
Set the maiden fancies wallowing in the troughs of Zolaism,
   Forward, forward, ay and backward, downward too into the
   abysm.[23]

Soon he was adding wings to what had at first been no more than a large cottage. On the right he built a huge study rising two stories high. Later, to house the spreading heaps of bric-a-brac, he built the Nana Tower, named after the best-seller that had paid for it. Carved Buddhas, medieval chests, and Japanese screens and scrolls accumulated—he had seen the tasteful Goncourt collection of oriental art on visits to their home and was intent on emulating them. The walls of his enormous study went up so high that he needed a gallery and a spiral staircase to reach the top shelves of his library.

On Sundays he opened his house to his friends, who now included Huysmans, Maupassant, Turgenev, and of course Flaubert. It was a new fan of the novelist, a writer named Henri Ceard, who had brought along on a second visit the young black-haired, sharp-faced Joris Huysmans. The jovial member of the circle was the husky Maupassant, fun-loving and devoted to sports. But it was Flaubert who remained Zola's father figure. Massive in stature, with an extravagant yellow moustache, he used Zola's Sunday afternoons as a stage on which to hold court. Larger than life, he was everything the secretly insecure Zola wished to be.

For Cézanne the storms of 1878 were followed by an undeclared armistice: perhaps we should call it an uneasy peace. How this was achieved, whether it entailed concessions or just simply happened, is anyone's guess. It is hardly surprising if, as seems likely, the old banker slackened his grip during the few years he had left. At any rate, in the years prior to his father's death, Cézanne's modest allowance was apparently no longer under threat. The immediate result of this lessening of tension was a marked increase in his output. Sixty-eight pictures are listed as belonging to the next five years.

The endless strain of the past year was interrupted briefly by his meeting with the painter Monticelli, who had left Paris for good in 1870 and come home to Marseilles. When Van Gogh finally decided to head south his first thought was to make for Marseilles, simply because Monticelli's rich colors, glowing like jewels on dark velvety

backgrounds, had captivated him when he saw his works in his brother Theo's collection. He felt a kinship with him, imagining his fate as very like his own. By then Monticelli had died in Marseilles, condemned as a drunkard and in poverty. Possibly he killed himself. Like Vincent, he also fell in love with a cousin, Emma Ricard, and her refusal made him contemplate becoming a monk. Stories of him standing drunkenly at his easel were, Van Gogh thought, Jesuitical lies. He pictured him to his sister as "dreaming of the sun and of love and gaiety" in his last days.

It would be fascinating to discover that Cézanne sought Monticelli out on his own initiative, without the intermediary he usually relied on to smooth the path to anyone new, and to allay his suspicions. No one knows how the friendship started, or how long it continued. There are no letters, no witnesses. To find him Cézanne penetrated the narrow lanes behind the Church of the Réformes, climbed the slope of the cours Devilliers, and then went on climbing the stairs of a crumbling old house to reach a chaotic attic. Monticelli was fifty-five, with a red beard "and a dignity that his short legs could not mar." Very poor, he had once been a dandy, which would have struck a chord with Cézanne and evoked Baudelaire, who saw the dandy as exhibiting "the spirit of opposition and revolt." Dandyism, the poet thought, was a product of transition, "when democracy is not yet all-powerful, when the aristocracy is only beginning to crumble and grow old. . . ."

Monticelli's effulgent little canvases spoke of an elegance he had once known but now could only dream about. Music stimulated him, especially opera and the gypsy bands in cafés. He painted by candlelight after night fell. By the time Cézanne met him he had withdrawn from the world and the insults of critics. There were plenty of things with which the younger painter could identify. He admired the little man's heroism. Once again a friendship was sealed by a mutual love of Delacroix.

Grateful for each other's company they wandered around Marseilles together. Once they went roaming off into the hills carrying knapsacks, smoking pipes in farm doorways, making up for lost time by talking endlessly. Cézanne declaimed Apuleius or Virgil, just as he had done in his youth, while Monticelli dashed off rapid brush sketches.

Comradeship for Cézanne was something precious, linked to those mysterious substances he distilled from ancient history, from the Greeks, the Stoics. It was best guarded and kept secret, which was perhaps why no one came to know of this experience. Certainly Gasquet

wasn't told of it directly but heard of it by chance from the painter Lauzet, who engraved a sequence of Monticelli's works for an album.

Cézanne felt a brotherhood that he was often too shy to express. For him the word "brother" had a resonance: there was something sacred about it. It was Gasquet again who learned that Cézanne kept absolutely secret a friend he had in the rue Ballu in Paris. The fellow was a cobbler whom he helped out financially when times were hard, sitting in his poky shop contentedly for hours without saying a word.

# 10 "A WORSHIPED BEING"

To 1878 belong the first two versions of his *Three Bathers*, though they may have been painted a little earlier—dating Cézanne's work is always approximate. Certainly he produced another variation in 1879. Mary Krumrine refers to these big cumbersome females, rough as trees, ungainly figures it would be impossible to call beautiful, as the "Matisse group." Regarded at the time—or rather when shown for the first time by Vollard—as "an affront to art," the canvas had the shock of a profound revelation for the young impecunious Matisse. In 1899 he was staying at Toulouse, walking by the Garonne and being reminded of the little picture by Cézanne that he had been so taken with at Vollard's just before leaving Paris. What struck him particularly was its raw visual truth, and the way in which "everything was so well arranged, where the trees, the hands, were of equal value with the sky."

Unable to get the picture out of his mind, Matisse got in touch with a painter friend, Albert Marquet, and asked him to purchase it on his behalf. The price, twelve hundred francs, was hard to find, and even harder to justify. Yet no matter how short of cash he was, he could never bring himself to part with the picture.

Why did this small canvas seem so far-reaching, so revolutionary, why did it—and others like it—transform figure painting in modern art? All Matisse could say was that the picture "has sustained me morally in the critical moments of my venture as an artist; I have drawn from

it my faith and perseverance."[1] Extraordinary claims. When he donated his cherished painting to the city of Paris, this was all he was prepared to say by way of explanation. He called Cézanne "a sort of god of painting," and wrote on another occasion that he owed to Cézanne the realization "that one can express the same thing in several ways. After a certain time Cézanne always painted the same canvas of the Bathers. Although the master of Aix ceaselessly redid the same painting, don't we come upon a new Cézanne with the greatest curiosity?"

He even went so far as to say that Cézanne was "at the source of his art." And compositions of his such as *Le Luxe* and *Nu debout*, and the series of four monumental reliefs *Nu de dos*, all owe a debt to Cézanne.

Henry Moore on his first trip to Paris in 1922 saw Auguste Pellerin's Cézanne collection and it made a tremendous impression, especially the big triangular bathing composition of nudes lying on the ground "as if they had been sliced out of mountain rock. For me this was like seeing Chartres Cathedral." Then in 1960 he bought one, the smaller *Three Bathers*, only about a foot square, "but for me it has all the monumentality of the bigger ones of Cézanne." He was delighted to find that the type of woman Cézanne favored was the type he himself preferred: "Not young girls but that wide, broad, mature woman. Matronly."[2] He saw at once the possibilities for sculpture in each of the figures. He demonstrated just that, first of all for a television film, modeling the individual figures in plasticine, then casting them in plaster on a rough plinth, giving the maquettes the same spatial relationship as in the picture. He was in fact reversing the process by which Cézanne had arrived at his composition, when studies he made in the Louvre from antique and baroque sculptures were pressed into service as models for his figures. Moore understood, as did Cézanne, that copying with intense concentration made you aware of what you saw, just as painting the same subject again and again led you to its uniqueness. When Hermione in *Women in Love* asks Birkin why he is copying a Chinese drawing of geese instead of doing something "original," he answers, "I want to know it. One gets more of China, copying this picture, than reading all the books."

But for all Moore's rapport with the ungainly mature women Cézanne liked to paint, he passes over, as one would expect a sculptor to do, the context in which the figures are placed. Cézanne's constant theme is the body in a state of nature. To this end he deliberately blurs the boundaries between the human beings and their surroundings. But the great pastoral tradition of Giorgione or Titian, for instance, is

being ignored. The ideal harmony their works convey has no place here. If he is painting paradise, it is not the Arcadia of tradition. The rough-hewn figures, animated but ugly, could never belong in the antique world of nymphs and shepherds. So what are they meant to represent? What are they saying?

The viewer feels himself forced back to an age before painting and sculpture, before tradition, and certainly before the archness of his immediate predecessors, back in fact to the beginning, to the virginity of the world. In Hardy's *Tess of the D'Urbervilles* we read of Angel Clare seeming "to discern in her something that was familiar, something which carried him back into a joyous and unforeseeing past, before the necessity of taking thought had made the heavens grey." Sometimes Tess seemed to him "a soul at large," sometimes "a whole sex condensed into one typical form." Cézanne seemed to believe, like Hardy, that something other than the mind was needed to comprehend and grasp the whole, and only by representing the inwardness of the body could this whole be realized.

In these bather paintings the act of creation is left visible in the clumsy-looking, primordial figures. It is as if the earth and trees and plants had given birth to them. These creatures, with no names and no personalities, have been allowed, in his own words, to "germinate from the paint." Now we see, says Gottfried Boehm, "where the 'beauty' of the picture resides." Cézanne summed up this phenomenon when he said, in a celebrated phrase, that it was "not a matter of modeling objects but of modulating the surface."[3] Another critic, Kurt Badt, striving to describe the strange amorphousness of Cézanne's bodies, sees them as in a state of becoming, with the promise of renewal that this implies. Their shapeless ambiguity has to do with the fact that they are not yet born. Nature is pregnant with them.

Boehm gives us a valuable clue to what is going on by his awareness that for Cézanne the body is "not a preexistent fact which the artist reproduces, in whatever style, using the means of anatomy, proportion, and psychological plausibility." On the contrary, for him the body— like the apple, tree, cloud, sky, star—is the outcome of a struggle to get back to its existence as a separate entity, stripped of personal emotion. The Arcadian nude of divine proportions is being shoved aside and replaced by a naked body seen as "a collection of impulses." This startling phrase of Boehm's could have been written by Lawrence.

Let us look at this key painting a little more closely. First, in the earliest versions, the triangular composition of one seated nude, a

standing nude in the center, and a kneeling one to the right is reminiscent of rites of baptism Cézanne would have seen and probably copied—knowing of his deliberate borrowings as we do. Poussin's *Saint Jean baptisant le peuple* has a Baptist standing in the center, flanked by a seated figure on the left (the "evil" side) preparing to be cleansed and a kneeling convert on the right. The woman on the ground—and there at her feet is the pool of water—with her back to us has her left arm raised to ward off an intruder or voyeur indicated only by a dab of red and a black gash in the trees at the edge of the canvas above her. The Baptist figure steps to her left as she faces us, her right arm extended over the bowed head of the kneeling convert. As the variations develop, the rigid pyramidal structure—which Roger Fry suggests may have sprung from the painter's inhibitions—relaxes. The left-hand woman is no longer on the ground nor looking up apprehensively at the threat lurking in the trees. The intruder has gone. The first of the new versions transforms this nude on the left into a giantess, striding powerfully into the picture with her right arm raised, thick curls cascading down her back and dangling in front of her body. She is huge, fearsome, ugly, exuding primitive energy.

One source may have been the Dido in Virgil who led her followers forward and "towered over all the other goddesses." The arching trees have changed in character, their branches rooted in the air, forming a bower or cave. Cézanne has dispensed with narrative, as if he had no further use for it. These women live for themselves, in their own right. Mary Krumrine is reminded of Zola's Flore in *La Bête humaine*, who "held up her powerful head, with its thick mop of curly fair hair coming down low on her forehead, and from all her strong, supple being there emanated a savage willpower. . . . She was a virgin warrior, scorning the male. . . . Drawn up to her full height like a graceful statue, swinging along on her strong legs, she advanced with long unhurried strides."[4]

But there is nothing remotely graceful about this shaggy creature, storming into the picture and dragging a white sheet with her. In the final version things have calmed down. The woman at the left with her back to us has halted, the white cloth hanging from her left hand in a smooth column. Her hair is no longer in wild disarray. The central Baptist figure is in the water up to her thighs, looking down thoughtfully into it, her arms relaxed at her sides. The black-haired woman sitting on the ground at the right is peacefully "wringing from her hair the last drops of the health-giving and fertilizing stream," to quote

again from Baudelaire's praise of a painting by Haussoulier, *La Fontaine de Jouvence*. Something has been resolved: peace reigns. This is the canvas that Matisse saw and couldn't be without.

◆ At the end of January 1879 a letter arrived for Victor Choquet from Cézanne, who was still at l'Estaque but restlessly eager to get back to Paris. He would be setting off in early March with his "little caravan" and the query was not for himself but for a "compatriot," probably Monticelli.

> May I ask you to be kind enough to get some information for me? It is this—always provided of course that you can obtain it without too much bother and inconvenience, otherwise I can ask the good Tanguy, which I should have done had I not thought I should get more satisfactory and complete information from you. . . . I should like to know how to set about having a picture reach the administration of the Beaux-Arts for the purpose of submitting it to the approval of the jury.

But what he really wanted to know was whether "the gentle administration" would send the painting back to the artist, who lived far away in the provinces. It was understood that this returning of the work—he was taking it for granted that it would be rejected—would be at the artist's own expense. He referred to Hortense as "my wife," as Choquet knew her very well.

In early February he wrote again to thank Choquet for telling him what he wanted to know, adding with his usual sardonic bite, "I think my friend will have every reason to be satisfied with the preemptory and imprinted way in which the higher administration acts toward its subordinates." Choquet had told him in passing of some success of Renoir's, which he was glad to hear. Whatever the worries of Madame Choquet were, Hortense, he assured him, "on whom rests the burden of attending to our daily food and who well knows the trouble and bother it causes, sympathizes . . . and sends her kindest regards, as does your humble servant." As for the little lad, he ended indulgently, like the doting father he was, "he is terrible all along the line and is preparing trouble for us in the future."[5]

He wrote in the same month to Zola after reading in *Le Figaro* of the success of *L'Assommoir* on the stage. With the collaboration of two dramatists the novel had been rewritten as a script for twenty-nine

actors in ten scene changes. Failure had followed failure in the theatre until now. This time he triumphed. The critics were hostile but the public liked it and it ran for three hundred performances.

At the end of March Cézanne was at last back in Paris. He was no sooner there than he talked of going to Melun, where he hoped to settle for a long stay. He wrote evasively to Pissarro about the forthcoming Impressionist exhibition, preferring, he said, to "avoid the turmoil caused by the disturbances in transporting my few canvases." The truth was that he had hopes of sneaking into the Salon with the help of Guillemet, his old friend and sympathizer, who was this year on the jury. He had paid him "an insinuative little visit," only to learn that Guillemet's efforts had been in vain. Renoir and Sisley had also decided not to exhibit with the Impressionists in the avenue de l'Opera, hoping like Cézanne to have their work hung officially.

He had an arrangement to see Zola at his town apartment on May 10, but Zola had left for the country some days before and he wondered if he had misunderstood. He went again to the rue de Boulogne on June 10 and presumably caught him. He paid his first visit to Médan shortly after, and kept his impressions to himself. By June 23 he was back again at Melun. He was adept at missing trains but this time all was well. "I arrived unbespattered at Triel station, and my arm, swung up and down through the carriage door as I passed your house, must have revealed my presence on the train—which I didn't miss. Meanwhile I got, Friday I think, the letter addressed to me care of you, thanks; it was a letter from Hortense. In my absence your book of essays *My Hates* arrived here, and today I've just bought *Le Voltaire* to read your article on Vallès. I've just read it and think it magnificent. The book *Jacques Vingtras* had roused much sympathy in me for the author. I hope he'll be pleased."[6]

Cézanne had been much taken by the series of articles by Vallès that he read in *Le Figaro* in 1861. These had made his name. "Sunday of a Poor Young Man," with its account of a young man from the provinces bleakly enduring the loneliness of his days and nights in Paris, would have gone straight to his heart. Jules Vallès was an unrepentant revolutionary. He was born at Le Puys, son of a professor, and came to Paris in 1849. He would have known Zola during his time as a journalist on *L'Événement*. After the war he fought with the Commune, fleeing to England when the government forces triumphed. At the time of Cézanne's letter he was still there.

*Jacques Vingtras* was an autobiographical novel in three parts: *L'En-*

*fant, Le Bachelier,* and *L'Insurgé.* It charts the evolution of a revolutionary emerging from a middle-class background. Zola reviewed it in *Le Voltaire* in the following terms: "I want this book to be read. If I have any authority, I demand that it be read. Works of such vigor are uncommon. When one appears it must be placed in everyone's hands." But he had misgivings, not about the book but its author. He thought he should concentrate on his talent for writing instead of wasting his energy on political agitation. Vallès retorted that writers like Zola, Flaubert, and the Goncourts with their exposures of corruption and injustice were socialists without knowing it. Later be asserted: "The man who says he has no political opinions confesses to one all the same. He is the collaborator and accomplice of those who hold the whip hand, who have their heel on the country's throat."

Jack Lindsay maintains that Cézanne, swayed by such staunch socialists as Pissarro and Tanguy, was now more politically rebellious than even Zola, and that his outright sympathy and admiration for Vallès shows it. This is to strain the facts. There is no evidence of any real involvement in politics during Cézanne's lifetime. Undoubtedly he was moved by the candor of this humane man, but he would also have been attracted by the book's originality. The effect of the writing, decades ahead of its time, "is achieved," says Lindsay, "solely by the placing of the rapidly evolving and contrasted moments."[7] There was little or no authorial comment and no polemic. Events were allowed to speak for themselves. Cézanne would have been struck by the parallels with his own experiments, and especially by the spare and winnowed style.

Cézanne's phobia about touch, linked by one or two writers to the school incident where he was hit suddenly from behind and pitched down the stairs, first became problematic in this decade. Pissarro and his wife did their best to keep their children from suddenly coming into contact with him. Lindsay draws attention to a passage in Vallès's *L'Enfant*—a boy carrying his dog which has died is jostled from behind, so that "I almost rolled with it down the stairs," and thinks Cézanne would have been reminded of his own staircase fall.

Away from contact with his few friends in Paris, Cézanne became a prolific letter writer in Melun. He tells Zola apologetically on September 24 that since leaving Médan last June "nothing has happened." Each day was similar to the one before. But there is one thing, and this is why he is writing: could he have three seats for *L'Assommoir,* still on at the Ambigu Theatre? Perhaps Hortense had been applying pressure, bored to distraction in Melun. He wants tickets for a definite date,

October 6, and for some reason sees this as causing immense complications for Zola. Such arrangements always threw him into confusion. He had been ill, "a renewed attack of the bronchitis I had in '77." Scraping around for news he mentioned that his father's old partner at the bank had died. However, both his parents were well. He ends on what must have been a familiar refrain for Zola. "I am still striving to discover my right way as a painter. Nature puts the greatest obstacles in my path."

In contact again a few days later he thanks his friend for the tickets and for an invitation to Médan. The autumn countryside astonished him, with its profound silence, a region heavy with trees that were now about to start setting fire to the leaves, sorrowful and mute. "But these are feelings that I can't express, it is better to feel them."

After seeing the play he wrote dutifully to give his reactions. The greatest compliment he could think to pay was that he stayed awake. For someone who went to bed around eight every evening this was no mean achievement. His seat was excellent, the actors remarkable. On a large screen covering the theatre curtain he saw announced the next installment of Zola's new novel, *Nana*.

Evidently Zola had the decorators in. Cézanne, looking forward to his next visit to Médan, commented humorously, "Heartiest thanks, and write to me when my colleagues with the large brushes have finished."

◈ That winter was a ferocious one. By mid-December he was snowed in, with no prospect of a thaw. He reported a frost of twenty-five degrees. The cold was of such a powerful reality that it blotted out all thoughts of the previous summer. "And what is still less amusing, I am unable to obtain fuel." If he ran out of coal by Saturday as he expected, he would be forced back to Paris.

He was not averse now in his painting to using photographs as aids: they were useful to someone like him, who worked so slowly. He may have made use of one for his *Melting Snow*, done near Melun. A canvas painted that summer, *The Bridge of Maincy*, now famous, combines the delicate gradations of light and hue that he had learned from the Impressionists with something purely his own. It bears the evidence of his sense of order that will become progressively more marked from now on, as his instinct for nature's underlying order runs counter to any melting diffusion of light. The secluded footbridge framed by

trees and water and based on a mirror image, turns Impressionism with its aim of making the visible fugitive into something classical, as authoritative as the art of the Old Masters. And we can see him here beginning to articulate something that would take him more and more into uncharted territory, a quality that the British painter David Bomberg would explain to his classes as "the spirit in the mass."

A superb self-portrait, a portrait of a boy, and the first of the great still lifes of Cézanne's middle and late years have been assigned to this year or the year after. Altogether there are over thirty self-portraits: only Rembrandt produced so many. For someone so increasingly concentrated on objectivity, this need to scrutinize himself at regular intervals is puzzling. Of course it solved the model problem. The bald man, his dark hair gathered blackly toward the back of his head and over the ears, gazes at us implacably, as if challenging us to see him as anything but an object. One returns the gaze uneasily: one is under threat. "Forget about me as a person," say the eyes, flat as stones. "I'm nothing, of no interest, stop putting yourself on to me." The bulky, high-domed head accuses us. We are looking in the wrong way. As with all mature Cézannes, we are forced back to a lost beginning. Under our eyes this nonperson takes on its own weird presence if we will only let it.

The hunched shoulders, the thick beard burying the mouth painted in the same darkish green tones as the coat, give a first impression of someone cornered and at bay. Then we notice the eyes, one dully inert and shadowed, the other receiving the light, and wonder if we are being introduced to the painter's doubleness, a strange duality that would explain a great deal if we could only fathom it. The doppelgänger who cropped up so insistently in his early paintings may have stopped haunting him because it has been subsumed.

This strongly structured skull, so tangible that it looks there to be touched, "seems hammered and sculpted from within," "reinforced by the ridges of the eyebrows; but from there, pushed forward toward the bottom, shoed out, as it were, hangs the face, hangs as if every feature had been suspended individually, unbelievably intensified and yet reduced to utter primitivity. . . ."[8] The poet Rilke is here trying to reconcile the bewildering fusion of inhuman abstraction and animal alertness in this portrait which stares with unblinking eyes. Rilke could only compare its expression with the objectivity of a dog, catching sight of itself in a mirror and thinking: there's another dog. He uses the word humble, but one shies away from applying it to a man who was at times so embittered at coming near to breaking through, so enraged by his failures.

So there is something cold and hard as a stone about this portrait, something stiff with loneliness and fear that makes people uncomfortable, and yet residing within it, behind it, soaking the wallpaper, the meditative spirit of a man coming home to himself. The starred lozenges and big open diagonals of the wallpaper pattern, echoed subtly by the zigzag of his lapel, have the effect of providing the head with a halo. The color scheme is grave and subdued, only the cranium and face lit for us with the simplicity of an icon. The duality of the eyes is repeated in the contrasts of light and dark, geometric and organic, hidden and revealed, juiciness and austerity.

In his *Still Life with Compotier* the question at once arises: what is the purpose of these objects that are obviously not to be used in daily life, the fruit not for eating, the wine not for drinking? The idea and the will, above all the instinct are more visible here, if a little stiffly, than later on, when he became the first grand master of still life. The critic Robert Hughes writes, "The typical still life of earlier days—the seventeenth-century Dutch table, say, cascading with parrot tulips and gold beakers, fur, fruit, fish, feather, and dewdrops—was a symbol of appropriation. It declared the owner's power to seize and keep the real stuff of the world." And Cézanne could not have been more of a contrast, with his indifference to possessions. It was as much as he could do to keep hold of a wife.

Writers have said that the overriding attraction of still life for him was the opportunity it gave him to avoid people, who disturbed him so much in his life and in art. It is true that in the painting of still life he was in complete charge of what was before him. He could choose, rearrange, as he never could in front of a landscape. And once arranged the composition was stable. He went to enormous pains to get everything as he wanted it, even to the extent of using artificial fruit and paper flowers to defeat time and decay. Louis Le Bail describes how he went about it: "The cloth was draped very slightly upon the table, with innate taste; then Cézanne arranged the fruits, contrasting the tones of one against the other, making the complementaries vibrate, the greens against the reds, the yellows against the blues, tipping, turning, balancing the fruits as he wanted them to be, using coins of one or two sous for the purpose. He brought to this task the greatest care and many precautions. . . ." So it has to be borne in mind that irregularities of perspective, deformed ovals, cloths rearing unaccountably, walls on the slide, all the oddities that occur in his work and his alone, were there to satisfy his inner eye, just as the precariously balanced objects were

arranged to tip something within him in the direction he wanted; and perhaps to acknowledge slyly that life itself was precarious.

Lawrence, who regarded the still life compositions as Cézanne's greatest achievement, hammered away in his essay at what he saw as the bitter struggle of the artist's life. "The way he worked over and over his forms was his nervous manner of laying the ghost of his cliché, burying it. Then when it disappeared perhaps from his forms themselves, it lingered in his composition, and he had to fight with the *edges* of his forms and contours, to bury the ghost there. Only his color he knew was not cliché."

In his hands the intimate genre of the still life became work of a grand order, full of density and force. The scale of images ranged from tight counterpointed colors to baroque compositions dominated by tablecloths that soared and sank in crevices like mountain landscapes. "Cézanne made a living thing out of a teacup," wrote Kandinsky, "or, rather, in a teacup he realized the existence of something alive. He raised still life to the point where it ceased to be inanimate. He painted things as he painted human beings." And vice versa. He understood, and came to say when pressed—though his pronouncements about painting were, one suspects, always reluctant—that things must not be reproduced but interpreted. Balzac had foreseen, as Zola never did, says Rilke, that in painting it was possible to come upon something overwhelming, altogether too huge for one man to handle. It was the fate of this timid mouse of a man, "feeble in life" as he kept saying, to begin a real revolution in the direction of substance and the living body of the world that no one since has been able to carry forward.

"I paint still lifes," he is supposed to have said to Renoir. "Women models frighten me. You've got to be on the defensive all the time."[9] Yet his paintings of bathers became a lifelong obsession, as did his preoccupation with the inwardness of things. "Our clothing depraves form," Diderot had written. Cézanne's effort to liberate himself through nakedness went on unceasingly, and was coupled with his dream of a lost nature being recovered.

In still lifes such as *Still Life with Compotier,* no one was going to "put one over on him" or put their hooks into him while his guard was down. He had nothing to fear: there were no ulterior motives, no intrusive "personalities." Nor was there any need for him to declare love, to make judgments. His peculiarities went unobserved, his insularity wasn't being condemned. He was endeavoring to present these fruits, this chest, this cloth, these grapes in the dish as they were, leaving out

entirely his feelings about them. His tormenting indecision died away. How could one be mistrustful in front of apples whose greens and reds do no more than talk quietly among themselves, and where one comes to realize that a painting is a place where something happens among the forms and colors, if one tries not to meddle or intrude one's wishes.

Yet something is out of kilter in this picture that is otherwise so plainspoken and factual. The compotier has been slightly distorted to harmonize with the fruit. Not only has its ellipse been flattened but its pedestal is off center. These are the sort of things that led people to say he couldn't draw or that he had an eye defect. "A line drawn around the six apples on the cloth," notes Schapiro, "would describe the same curve as the opening of the compotier. If we replace it by the correct perspective form the compotier would look banal: it would lose the happy effect of stability and masculine strength."[10] So here the artist is engaged in his endless fight, rescuing objects from banality, from the cliché.

The knife is subtly angled to reinforce the line of the all-important tablecloth with its complex of folds. The compotier is paired with the wine glass, the green apple nestling in the cloth on the left with the larger red apple nosing at the edge of the same cloth to the right. A thick dark gash in the foreground, which is perhaps the shrouded keyhole of the chest, stabilizes everything and fastens verticals to horizontals. Behind the dish and glass is the freely painted foliage of the blue wallpaper, singing its own plangent song. When Rilke speaks of the "good conscience of these reds and blues and greens," of being educated by their truthfulness, and in the end being indebted to them, "as if they were doing something for you," one begins to grasp the extent of Cézanne's achievement in these apparently straightforward and simple still lifes. Gauguin came to own this canvas and admired it passionately.

The *Portrait of Louis Guillaume* presents us with a conundrum, as do so many of Cézanne's portraits. Are the masklike faces meant to convey his lack of interest in them as human beings, or do they express a determination not to let them impinge on him with their egos that which was tiresome and stale and known? He shouted at his models, "Be an apple!" What he wanted was for them to be still and silent, just physically there. He was after the apple in the person, that mysterious all-roundness and containment, so much more interesting to him than what they thought of themselves or the impression they were trying to create.

Louis Guillaume was the son of Guillaume the shoemaker and his wife, friends of Hortense's family. The young boy sits mutely and is no problem for the painter. He is docile to a fault, far too shy to have anything to say or to express secondhand opinions. The expressionless, rather sweet face reflects—if it reflects anything—his state of puberty. Behind it are feelings too obscure and unformed to be seen by anyone, observed by an artist only too aware of his own subterranean life. The striking abstraction of the head and body, like the somber blue color scheme, are Modigliani-like, reminding us of Cézanne's Italian origins. The portrait's primitive directness, utterly conscious and understood, projects us into the twentieth century.

Again we have Cézanne's refusal to accept what everyone else takes for granted. The stillness of the face and head and the immobile body, telling us eloquently that the boy is totally absorbed in his troubling, sad self, is contradicted by a strange twisting of the features, so slight as to be almost unnoticed by our modern eyes. The air of inner strain this imparts is repeated in the knotted cravat which, says Schapiro tellingly, "isolates the head from the body." This simple and yet highly original invention, linked subtly to the face, is echoed by the shadowy, half-submerged leaf figuring on the wall above the boy's shoulder to the right. The vertical dark folds of the clothes and the severe dark cap of the hair somehow contribute to the atmosphere of reverie and buried disquiet. On the evidence of this portrait alone it could never be said that Cézanne had no wish to draw near to his fellow human beings.

This was the time of his discovery of watercolor, first as a means of working quickly and freely, whereas in oil he was compelled to labor with agonizing slowness. Later he came to accord watercolor a more distinctly separate role. The wonderful freshness and sparkling luminosity of his last oils owe a great deal to his watercolor experiments. He clearly loved the spontaneity of the medium, its encouragement of a delicious floating world. The color modulations for which he later became famous were first achieved in watercolor. So was the unity he craved, guaranteed in a sense by the ever-present whiteness of the paper ground.

Cézanne's movements in 1880 can be followed without much difficulty. Eight letters went to Zola, still his main correspondent. He hadn't moved from Melun when he received his copy of *Nana*. Zola's friend Paul Alexis has a story of the novelist asking him one day for

information on prostitutes: "Tell me, Paul, how does one pay a street woman? Does one settle the bill before or after?" Alexis was doubly amused, by Zola's naiveté and by the fact that he was at work on the creation of a character who would turn out to be the richest and most powerful prostitute in Paris, "a perfect mirror-image of the neurotic, hypocritical society which would fashion her."[11] Innocent or not, Zola was forging a legend. The source of this unconscious instrument of destruction was her creator's fear of women. In his notes he writes: "Without realizing it, without meaning to, she comes to regard men as fools to exploit. With her sex and odor she becomes a destructive force, destroying everything she touches, souring society as menstruating women will turn milk sour. . . . Good-natured, easygoing, sympathetic toward unfortunates. Scatterbrained, lives for today. By nature coarse and slovenly. . . . Her extravagance will consume every kind of wealth; the waste will be terrible and only ashes will remain."

Cézanne read it at one gulp and pronounced it "a magnificent book." Unaware of the novel's potential as an enormous commercial success, he was irritated on his friend's behalf at finding no articles or advertisements in any of the three little papers he took. He assumed this to be symptomatic of the conspiracy of silence he was up against himself, when the truth was that the enormous rumpus created by the book's serialization in *Le Voltaire*, begun the previous October, had gone right over his head.

On February 25 he wrote to thank Zola for letting him have a copy of Paul Alexis's *The End of Lucy Pellagrin*, and asked for the author's address so that he could say how touched he was "at this sign of friendship." Now he would have something to keep him occupied on winter evenings for a while. Another mutual friend, Valabrègue, had brought out a volume of poetry, *Petits poèmes parisiens*, and he wonders if Zola has a copy. He mentions an attack on the novelist by the feminist Mademoiselle Deraismes. She would do well to knit stockings, he says tartly.

In March he was back in Paris, once again in the rue de l'Ouest, but on the fifth floor. Zola tried to entice him with invitations to parties but he was having none of it, preferring his quiet life. He did turn up once at the salon of Zola's publisher, Charpentier: it was stuffed with celebrities and he hated it. One occasion, probably at this time, has been recorded. Cézanne had been persuaded to go to one of Zola's own parties at his spacious apartment in the rue de Boulogne. He arrived in his working clothes and was soon acting boorishly, his usual

way of registering a protest, by asking, "Don't you think it's rather hot, Émile? Do you mind if I take my coat off?" The guests in evening dress may or may not have been affronted, but Madame Zola would definitely not have been pleased.

In touch with one or two of his Impressionist friends, he was told by Guillaumin that the Impressionist exhibition was open at a gallery in the rue des Pyramides, and "rushed there. Alexis fell into my arms, Dr. Gachet invited us to dinner, I stopped Alexis from paying you his respects. May we be permitted to invite ourselves to dinner Saturday night?" He ended sentimentally, "I am with gratitude your old school friend of 1854." The close bond they had formed so long ago in Aix still held.

Restless as ever, he managed to stay at his lodgings in rue de l'Ouest for a whole year—a record for him. He thought of Plaisance, southwest of the Montparnasse cemetery in the fourteenth *arrondisse-ment*, as lying outside the city, and would speak of "coming to Paris." He was rejected as usual by the Salon, but tried to enlist the help of Zola after hearing of the treatment meted out to Renoir and Monet. The Impressionist movement had gained too much ground to be ignored, but their paintings were discriminated against by the hanging committees. Monet's landscape of an island in the Seine, *Lavacourt*, was accepted in 1880 and then "skyed" so high up the wall that it was almost invisible. Renoir had two canvases taken at the same Salon but they were relegated to an annex in the garden, hopelessly exposed to the glare of the sun. Cézanne, ever the willing go-between, approached Zola with the hope that he might comment publicly on a letter of protest written jointly by Renoir and Monet to the minister of fine arts. He had picked a bad time, and knew it—Flaubert had just died— though he could hardly have understood what a trauma this was for the novelist, who was still reeling from the death of Edmond Duranty, cofounder of the realist school and one of his closest friends. Six months later he was all but capsized by another blow: his mother died.

Cézanne's letter of May 10 shows how cautious he always was when it came to asking favors, making it clear that he wouldn't be offended by any decision of Zola's. "I need not add," he assured his friend, "that no matter what action you may think proper to take in response to this appeal it won't have the slightest effect on the friendly feeling I have for you, nor will it affect the cordial relations that have always existed between us. . . . This time I am playing the role of a mouthpiece, noth- ing more. . . ."[12]

Zola's intervention, a series of articles in *Le Voltaire* on "Naturalisme au Salon," wasn't really what the Impressionists had in mind, but it was something. With characteristic verve Zola attacked the sly methods of the hanging committee and went on to expand the "few words" asked for by Cézanne in his letter to four long articles surveying the whole of contemporary painting. "Messieurs Pissarro, Sisley, and Guillaumin," he wrote in his opening salvo, "have followed the same path as Monsieur Claude Monet . . . they have devoted themselves to the interpretation of nature in the neighborhood of Paris, in real sunlight, undaunted by the most unexpected effects of color. Monsieur Paul Cézanne, with the temperament of a great painter who is struggling with technical problems, is closer to Courbet and Delacroix. . . ."

Then came his unwelcome strictures on the very group he was defending, which may have been crass of him but were not so much the stab in the back they seemed as another example of Zola's disappointment. Unreliable as an art critic, he had been hoping for a "social" art, the equivalent of his naturalism, with a breadth of theme and a humanity which to him was being ignored in favor of brilliant discoveries that led nowhere. For this reason he misunderstood what had already taken place. Impressionism, though not a spent force, was at the climax of its forward movement. Masterpieces by Berthe Morisot, Renoir, Pissarro, and Cézanne had already appeared, and the genius prophesied for the future was there under his nose, perhaps too close and familiar to be recognized. He summed up the movement's success and failure in ringing terms, oblivious of the undercurrent of destructions running beneath all truly modern painting:

> The great misfortune is that not a single artist of this group has powerfully and definitively applied the new formula which is followed by all of them, scattered throughout their works. . . . They are the forerunners, the man of genius is not yet born. We can see clearly what they are after, we approve; but we look in vain for the masterpiece which will impose the formula and force all heads to bow in admiration. . . . They are still unequal to the task they have set themselves, they stammer without being able to find the right word. . . . Nevertheless their influence is immense, for theirs is the only possible evolution, they are advancing into the future.[13]

This view wasn't one he had suddenly arrived at: his discontent had been growing for some considerable time. The main burden of his complaint was that the painters lacked stamina and depth, their work

was too hasty, they were too easily satisfied. In fact they affected a disdain for "the solidity of long-meditated works." Obviously he was thinking of his own immense labors. He had confessed these reservations in 1879 in an article which appeared in Saint Petersburg in the *Messenger of Europe*. He saw the Impressionists' chief merit as signposts, pointing the way "to the great artist of the future, awaited by all the world." But he did come out in solid support of their sacrifice and dedication. "They have been treated as practical jokers, charlatans making a mock of the public and beating the big drum round their works, when on the contrary they are austere and convinced observers. What seems to have been ignored is that most of these strugglers are poor men dying in hardship, poverty, and weariness. Singular jokers, these martyrs to their beliefs."

In the same Russian journal he had published some essays, afterward collected in a book entitled *The Experimental Novel*, calling for a literature determined by scientific principles. A writer should observe nature and mankind with the detachment of an experimental scientist. This was what underlay his statement that the painters had reneged on their "new formula." Once launched into a consideration of the heady prospects in store for a literature freed from the romantic tradition he promptly projected it onto art, not to mention the structure of society itself. Nature should be the one and only subject of art, and for Zola, Nature meant Man. Where was the painter of genius who could embrace Man and Nature as the Old Masters had done: Rembrandt, Rubens, the great Venetians? Cézanne at any rate, he saw, had the temperament for greatness, and a degree of human fullness akin to Courbet and Delacroix.

Objections to Zola's confused doctrine of naturalism, from England and America, were not long in coming. One of the most virulent, an essay by W. S. Lilley in the *Fortnightly Review*, saw "The Naturalist Revolution" as an attack on sentiment, imagination, and poetic idealism, and went on to equate the naturalist novelist with the vivisector:

Art must disappear from the novel and the drama. The science of the vivisector is to take its place. . . .

We live in an era of vivisection. And the voice of reason is ineffectual against that ghastly shibboleth, as it was against the vomiting of the emetic era, the evacuation of the purging era, the depletion of the bleeding era, the poisoning of the mercurial era and the iodine of the potassium era. . . .[14]

The person least put out by Zola's critique in *Le Voltaire* seems to have been Cézanne himself. He had used the term "true Impressionists" in his letter asking for Zola's assistance and clearly considered himself one of their number. Yet it wasn't long before he was beginning to distance himself from "the impressionist gang," whom he thought were in need of "a leader and ideas." He felt happier as a lone wolf.

On June 19 he asked to be remembered to Madame Zola, whom he thanked for the great heap of rags she had given him, for cleaning his brushes and maybe to keep himself clean too. Often he would get in a frightful mess when absorbed in work, his hands, clothes, and face smeared with colors. "I go to the country every day to paint a little." Anticipating some hot weather round the corner he thought he would like to come to Médan for a bout of painting, "if you will not be upset by the length of time I may take over it."

He had seen the luckless Solari, who had called three times in succession to Cézanne's Paris address and each time failed to find him. "Tomorrow, Sunday, I shall go and shake hands with him. Nothing goes well for him. He can't get fate to smile on him. How many lucky chaps with less energy make good." But the man endured, and he for one was thankful for that. He added curiously his thanks for an "eternal father," as if to say that one should never depend utterly—though of course he did—on the whims of an earthly one. He was comparing Solari's fate with his own similar one, drawing comfort from the man's refusal to admit defeat.

He still hadn't heard from Zola by July 4. Apprehensive and touchy, he wonders if he is really welcome: he wouldn't dream of coming to Médan if this meant being a nuisance. "I venture to ask for a few words to let me know how things stand." His excessive suspiciousness had surfaced again. He thanked Zola for the second time for the articles in *Le Voltaire*, "in my own name as well as in that of my colleagues." Zola would have smiled at the quaint formality. Monet had sold some canvases, his friend added, and Renoir was having portraits commissioned.

If there was a misunderstanding concerning his visit it was easily cleared up. Once there, he was glad he had come. He stayed in the Zola household for several weeks in August and got down to some painting. "Paul is still here with me," Zola wrote to Guillemet on August 22. "He is working hard. . . ."

This year a volume of stories by Zola and his friends was published, centered on various aspects of the Franco-Prussian War, called *Les soirées de Médan*. The authors grouped together in the anthology were

Huysmans, Hennique, Alexis, Maupassant, and of course Zola himself. Cézanne, acknowledging his copy, said he would be entertained by it in his quiet evening hours. He went on, in the rather tortuous and formal style he fell into sometimes when he had nothing to say: "I beg you to be the interpreter of my feelings of artistic sympathy, which bind together all sensitive beings—in spite of the difference in their mode of expression—to your colleagues when you see them, and thank them for joining with you to offer me this volume which I feel to be of substantial and nourishing substance. He signed off, "Yours with deep affection, the Provençal in whom maturity has not preceded old age," a sardonic reference, no doubt, to Zola's call for maturity in *Le Voltaire*. But the childlike helplessness and despair it evokes was a trait we have come across already, one he often harped on and magnified.

He was shocked to read in a newspaper of the death of Zola's mother in October, and wrote tenderly to his heartbroken comrade. Since François Zola had died prematurely his wife had built her life around Émile. She had expressed a wish to be buried in Aix by the side of her husband, and her son went there for the funeral. "I'm at your disposal," wrote Cézanne, "for anything I can do. I well understand the sadness of your misfortune, nevertheless I trust that your health will be affected by it as little as possible. . . ."

With his intimate knowledge of Zola he understood what a paralyzing effect this loss might well have. The solace of work was no use any more. The dread of death gripped the writer so powerfully that he transmitted it to his wife. He and Alexandrine would lie awake at night, afraid to put out the light. He suffered hallucinations, seeing his mother's coffin being lifted out of an upstairs window at Médan because the staircase was too narrow—he had memories of his father's coffin and the struggle to get it downstairs when he was a boy. He stopped work on his next novel with its mocking title *Joy of Life*, gave up his journalism, and was unable to concentrate on anything for more than a few hours. It took him until the spring of 1883 to open the notes of his abandoned novel. "But *Joy of Life* was something else for Zola, too: an inner debating forum for a problem which had come to obsess him ceaselessly—the very elemental question of whether life was worthwhile or not. Perhaps he would discover," comments Graham King, "like the philosopher Kierkegaard, that though life may be understood backwards, it must be lived forwards."[15]

How much of his misery was apparent to Cézanne when he stayed again at Médan in autumn is hard to say. He was always made warmly

welcome there, and enjoyed meeting Zola's entourage, regardless of whether or not they thought him an odd fish. It's hard to believe that someone so shrewd and alert would have been unaware of the amusement created by his directness in the midst of these sophisticates. He even thanked Zola at one point for giving him the opportunity to meet such "remarkable" people. There may have been a sardonic edge, but he did have a social side and could be surprisingly gregarious if he felt secure, as he always did at Médan. He found and deeply appreciated the moral support there that Zola provided. On the walls were his canvases, as they were at the rue de Boulogne, together with Monet, Manet, and Pissarro. Zola didn't give a damn what his guests thought, whether in their opinion the Cézannes had "no value," as someone remarked, or not. Cézanne was far from being a naive fool, and though his taste ran to a simple life he was able to make allowances for the pretentious surroundings in which he found himself. He didn't feel a ridiculed painter there; he was the novelist's friend, put at his ease and welcomed with affection.

Anyone he couldn't stomach he was able to escape by taking himself off to paint. He gave a man called Busnach a wide berth. This crass, vulgar individual was the one who had adapted *Nana* and *L'Assommoir* for the stage. You were a nobody when this "great man" was around, Cézanne said bitterly. He was used to being one, but not at Médan. When such people upset him he either made himself scarce or gave vent to vulgarity of his own, which Zola understood well, seeing it as no more than a mask for his innate timidity and discomfort. Or he would fly suddenly into a rage and then disappear. One of these tantrums erupted when he was painting Madame Zola in the garden. He had posed her on the lawn serving tea. The picture went wrong and he started cursing away to himself. Guillemet made things worse by cracking a joke. Cézanne broke his brushes in half, tore holes in his canvas, and went off shaking his fist.

He had the use of Zola's boat *Nana*, rowing across to an island in the Seine and setting to work on a view of Médan dominated by the chateau with its dormer windows. Gauguin came to own a Médan canvas, probably buying it from Tanguy for a song. A story went with it, which he got either from Pissarro or from Cézanne himself in one of his rare expansive moods:

Cézanne paints a glittering landscape with an ultramarine background, and heavy greens and ochres of silken luster; the trees are

in a straight line and through the entwining branches may be seen the chromes sparkling on the limewash of the walls. Crackling Veronese greens indicate the garden's superb foliage, and the grave contrasting note of the violaceous nettles in the foreground orchestrates the simple poem.

The pretentious shocked passerby looks at what he thinks is a lamentable daub by an amateur and, a smiling teacher, says to Cézanne, "You are painting."

"Certainly, but so little."

"Oh, I can see that. Here, I'm a former pupil of Corot, and if you'll allow me, with a few deft touches I'll straighten all this out for you. Values, values—that's all that counts."

And the vandal impudently puts some stupid strokes on the glittering canvas. Dirty greys cover the oriental silks. Cézanne explains, "Sir, you are fortunate, and when you paint a portrait you probably put highlights on the nose-top as on the rungs of a chair."

He takes up his palette and scratches out with his knife all the mess that the gentleman has made. Then after a silence he lets out a terrible fart and turning to the gentleman he says, "What a relief."[16]

The passerby, on an island that Cézanne with his boat has been able to reach, is difficult to explain, until one realizes that Gauguin has mistaken the house in the landscape for Zola's. There are enough reports of Cézanne's behavior when exasperated for us to take the episode as accurate. His *View of Médan*, a strip of river and then the bank and the straight fence of trees, houses and chateau arranged frontally, is a good example of his newly evolved approach. He's not concerned with recession, there are no diagonals, the densely packed and stacked forms take shape in a network of strokes, parallel diagonal pigment applied thicker in some parts than others, the marks essentially rhythmic. The vertical and horizontal lines of the composition, meeting in a grid structure, dividing the canvas into smaller areas, are being developed with an awareness of the canvas's shape and its corners. The conventional method of roughing out and blocking in was being replaced by his way of working "all over at once," so that every mark he made as he concentrated intensely altered his perception of the whole. It was agonizing but fruitful, a humbling before nature, a servitude that allowed the life to move in and out of its own accord and yet be held and realized. His "desire for a fully concrete universe" was slowly forging a personal style.

The legend of Cézanne as a wild man of art was starting to circulate. If he put in an appearance at the Café de la Nouvelle-Athènes, where Manet, Monet, and the others met, it would be in his bespattered working gear. When the writer Duranty commented that "These are dangerous manifestations" it was from apprehension: he knew all about the malicious gossip and exaggerated assumptions that were distorting the artist's reputation. George Moore, who patronized the café in 1879, had evidently heard the circulating gossip and drew his own conclusions. He would have been surprised to see Cézanne at the Nouvelle-Athènes, for he was

> too rough, too savage a creature and appeared in Paris only rarely. We used to hear about him—he used to be met on the outskirts of Paris wandering about the hillsides in jackboots. As no one took the least interest in his pictures he left them in the fields. . . . It would be untrue to say that he had no talent, but whereas the intention of Manet and Monet and of Degas was always to paint, the intention of Cézanne was, I am afraid, never very clear to himself. His work may be described as the anarchy of painting, as art in delirium.[17]

If he knew about these slanders, the question arises: why did he behave in a way that could only substantiate them? Now that he no longer exhibited he had no witnesses, as it were, to his solid progress. His paintings, hidden away in his studio or at Tanguy's, might not have existed for anyone except a few close friends. These friends knew perfectly well that he could be violent and that some of his early work was bizarre, and no doubt they did their best to counter the rumors flying around. As for the victim, he seemed indifferent. If they did anything, they simply confirmed what he sometimes felt himself to be, a pariah. In a morose part of himself he embraced the worst and was deeply suspicious of the best.

On April 12 he was asking another favor of Zola. Again he was trying to do something for someone more unfortunate than himself. Cabaner, the musician and poet, was destitute. To raise funds for him it was proposed to organize a sale of pictures donated by "your humble servant" and Manet, Degas, Lamy, Pissarro, Guillemet, Cordey, and so forth. He wanted Zola to write a preface to the catalog as he had done last year for Duranty's widow after the death of the writer. "For no one doubts that the simple weight of your name will be a great attraction for the public, to attract amateur collectors and advertise the sale."

Zola readily agreed but asked for a little guidance. How free was he to say what he thought? "Must I say that he is ill, that he is in the south, that the sale is being held to help him? In a word, am I to mention his material difficulties? I know him very little and shouldn't like to hurt him." It was a question of "whether we can move the public to pity for his lot while speaking of his artistic struggle and his talent."

At the end of May, Cézanne, in Pontoise and seeing something of Pissarro, was thinking of walking the ten miles across to Médan "at the expense of my legs." He thought he was up to it. Zola had given him a book by Huysmans (probably *En ménage)*, which Pissarro was devouring. There is a drawing, abstracted and sculptural, that he did of a young woman sewing, in the act of posing for a painting by Pissarro.

The two men went painting together as they had done in 1873, the younger man happy to be in the company of the white-bearded painter of fifty, looking more the patriarch than ever, the man who had drawn him decisively into landscape painting. Dr. Gachet was now a mournful figure, having lost his wife six years before. It was a loss he never got over. He spent three days a week now at his home in the country and employed a governess to look after his children. Cézanne painted Cergy village, Galet hill, and the mill of La Couleuve, intriguing Pissarro with his technique of short diagonal strokes, his flattened views crowding the surface, his stark, almost brutal simplicity.

Cézanne's younger sister Rose, now married, was coming to Paris at the end of May with her sister-in-law and her husband Maxime. The painter was expected to guide them around. Not exactly looking forward to the prospect, he told Zola wryly, "You can see me piloting them through the Louvre and other places with pictures."

The visit over, he reported that his sister had had to cut short her stay after a few days because of an attack of rheumatism. He was working "a little, but with a good deal of flabbiness." He had been showered with books by Zola as usual and was plowing through *The Experimental Novel.* The piece on Stendhal he thought especially fine. In Paris again he found waiting for him "the book that Rod had been kind enough to send me, which is easy reading." This was Édouard Rod, a Swiss writer he had met on one of his trips to Médan. He mentioned a visit to Versailles, "the city of the great king," to show his sister and her husband the fountains. Then in July he was alarmed to hear that Alexis, whose jolly nature always put him in a good mood, had been wounded in a duel with a journalist, Delpit, after an insulting article had been published about him. Later he was relieved to see Alexis in Paris, com-

pletely recovered, and was shown the article which had so upset him. He went back to Pontoise again and was eager to return to Médan in October. After that he would probably spend some time in Aix.

While at Pontoise he had met the circle's latest recruit, Gauguin, still an amateur painter. Obsessed with art, he set aside a third of his income of forty thousand francs as a stockbroker for acquiring pictures. Gauguin had come with his wife to spend his vacation with Pissarro and learn as much as he could from him. He did his best to ingratiate himself with the wary Cézanne, who didn't care for the man's sarcasm. Nor would he have been pleased to read the letter Pissarro got from the wealthy amateur after he got back to work: "Has M. Cézanne found the precise formula for a work that everyone will accept? If he should find the recipe for compressing the extravagant expression of all his sensations into a single and unique process, I pray you to make him talk in his sleep by administering one of those mysterious homeopathic drugs, and come at once to Paris to tell me of it." This lighthearted note would have been bound to fill Cézanne with alarm. Here was someone out to get his hooks into him: either that or he was being regarded as a buffoon. In fact Gauguin was one of Cézanne's earliest and most genuine admirers. The talk between them had obviously touched on Dr. Gachet's homeopathy. Jack Lindsay points out that the term "sensation" in Gauguin's letter was being used frequently now by Cézanne.

A crude caricature of Cézanne appeared this year in the character of Maillobert, in Duranty's posthumous novel *The Country of the Arts*. The narrator, a young artist, arrives at Maillobert's studio:

As I went to knock, I heard a parrot inside. I knocked. "Come in," someone cried with an almost extravagant accent. Hardly was I in when a cry burst out inside me: "But I'm in a madman's house." I was quite flabbergasted by the place and the person.... The painter, bald, with a huge beard, looking simultaneously old and young, was himself, like his studio's symbolic genius, indescribable and sordid. He gave me a lavish greeting, accompanied by a smile I couldn't define, sly and imbecile. At the same time my eyes were assaulted by so many vast canvases hung on all sides so terrible in color that I stood petrified. "Ah ah," said Maillobert, with a nasal drawling accent, "Monsieur is a connoisseur of painting? There are my little palette-scrapings," he added, indicating his most gigantic canvases. At this moment the parrot's voice rang out, "Maillobert is a great painter."

"He's my art critic," the painter told me with a disturbing smile. . . .

Then, as he saw me look curiously at a set of big pharmaceutical pots with abbreviated Latin inscriptions: Juiqui. Aqu. Still. Ferrug. Rib. Sulf. Cup., "That's my paint box," Maillobert told me. "I make the others see that I arrive at true painting with drugs, while they, with their fine paints, make nothing but drugs."

My eyes were riveted on an immense picture high up, which represented a coalheaver and a baker clinking glasses before a naked woman, above whose head was written COOPERATION. When I say a coalheaver and baker it's because Maillobert told me that such were these naked persons: the one slashed out in white, the other in brown. The three figures were colossal, twice life-size, executed on a completely black background, in the midst of broad jostling strokes in which vermilion, Prussian blue, and silver-white carried on a furious war. Big eyes with a glittering point struck up out of each head. Still, an arm here, a bit of hip there, a knee some-where else, were treated with a certain power. "It's the expression of civilization," Maillobert told me. "We have to satisfy the philoso-phers who are always crying after us."

I was next drawn to a series of portraits, portraits without faces; the heads were a mass of strokes from which no feature emerged. But on each frame a name was written, often as strange as the painting: Cabladours, Ispara, Valádeguy, Apollin, all disciples of this master. "He's a great painter," cried the parrot, who seemed to sense the moment when he should intervene.

"He's right," the painter said vehemently.

At this moment two of his friends turned up, bearded, black, dirty. I asked myself: Can he be the head of a school of mystifiers? They contemplated the master's works as if seeing them for the first time. "How bold it is! what energy!" they cried. "Courbet and Manet are only small fry next to that."

Maillobert smiled, brightening up. . . . He dipped a spoon in one of the pharmaceutical pots and took out a real trowelful of green, which he applied to a canvas where some lines suggested a land-scape. He turned the spoon round; and if hard put one could make out a meadow in what he had just daubed on. I noted then that the paint on his canvases had a thickness of almost a centimeter and formed valleys and hills on a relief map. Evidently he believed that a kilogram of green was greener than a gram of the same color.[18]

As promised, Cézanne stayed with Zola for a week at Médan and then headed for Aix. Telling Coste this, Zola brought his friend up to date on Baille, the third of the Inseparables, now a thoroughgoing bourgeois with a rich wife, about to achieve renown for his firm, which supplied the War Ministry with binoculars.

It was two and a half years since Cézanne had last set foot in Aix. His aged father had stopped pressuring him, and in any case he had nothing to worry about: Hortense and the little boy were left behind in Paris. Life in the Midi had no appeal for Hortense, whereas the provincial atmosphere didn't bother Cézanne. On the contrary it suited his secretive nature, and mostly he stayed at the Jas de Bouffan, seeing no one. When he moved it was for other reasons to do with an inner discomfort. "Why can't one sit still?" Lawrence asked of himself. He didn't know why, but he couldn't, and neither could Cézanne. Paul Alexis, on the other hand, suffered from the constriction of the place whenever family reasons compelled him to go there. "It seems to me that I am at the bottom of a well!" he moaned to Zola. "Neither air nor sun, intellectually speaking. *Ouf!* . . . here no one talks about literature, or, if they do talk about it, it's enough to make your hair stand on end. A year here will make me stupid or insane."

Before long Cézanne slipped away to l'Estaque. By the end of February he was ready to go back to Paris. From l'Estaque, "homeland of the sea urchins," he wrote gratefully to thank Paul Alexis for sending him a copy of his "biographical book." *Émile Zola, notes d'un ami* was devoted mainly to the youth of Zola and Cézanne. He was at a loss to say how moved he was, how profoundly it had affected him, sending him back on a wave of longing to "the memory of past things." But before he could read it he had to retrieve it from "the impure hands of those related to me." He continued to speak of "they" but it was very probably his father who had opened the parcel. Without mentioning it, "They stripped it of its envelope, cut the pages, went through it in every sense while I was waiting under the harmonious pine." He makes the act sound malevolent, an indecent assault. He found out, no doubt from his mother, demanded it back, and was now reading it, tossed to and fro on a whole sea of mixed emotions. He particularly savored the verses of "him who indeed wished to continue as our friend." These poems by Zola that Alexis had included were hardly literature but for Cézanne they were like icons of those lost days of eternal brotherhood.

"Don't tell him—he'd say I'd fallen into the treacle. But this is *entre nous* and very confidential."

Before he boarded the train for Paris he had a visit from Renoir, who went to l'Estaque hoping to work and promptly fell ill with pneumonia. He had only just written to his dealer Durand-Ruel to say how charmed he was by the landscape. "As it is very beautiful here I am stay-ing another fortnight," he wrote blithely. "It would really be a pity to leave this lovely country without bringing something back. And the weather! The spring with a gentle sun and no wind, which is rare in Marseilles. Moreover, I ran into Cézanne and we are going to work together."

When he became ill, Cézanne took good care of him. Writing to Choquet, Renoir tried to express his gratitude. "I can't tell you how kind Cézanne has been to me. He mobilized his whole family to help me." He was having to stay put in the Midi while he recuperated, and spoke of the farewell dinner for Cézanne, who was about to leave for Paris. He couldn't get over the excellence of the food he was served. Madame Cézanne gave him ragout of cod. "I think it must be the ambrosia of the gods rediscovered. One should eat it and die." When he eventually reached Paris himself he carried with him a beautiful watercolor of bathers, and a story to go with it. He was with a friend, Lauth, who was suddenly taken short. Renoir spotted some paper fluttering near a tree, which turned out to be "a most exquisite watercolor that Cézanne had discarded among the rocks after spending twenty sessions on it."

It was in Alexis's book on Zola that Cézanne first got wind of Zola's intention to write before long a novel that would be a portrait of "a painter of our time." The passage in which Alexis refers to the project may have caused him some disquiet, but he could also have wondered whether he was to be seen in a true light at last, that is if his old friend drew on his firsthand knowledge of his work and the struggle it had cost him to reach the new realization his consciousness wanted.

Zola's principal character, according to Alexis, was ready to hand. It was the painter dedicated to modernity

> who appears in *Le Ventre de Paris*, Claude Lantier. . . . I know that in
> Claude Lantier he means to make a study of the terrifying psychol-

ogy of artistic impotence. Around this central man of genius, the sublime genius whose production is paralyzed by a flaw in his nature, will live other artists, painters, sculptors, musicians, writers, a whole band of ambitious young men who set out to conquer Paris. Some fail, some more or less succeed, but they are all case histories of the sickness of art, variations of the present neurosis. Naturally Zola will be compelled in this book to lay friends under contribution and to record their most typical characteristics. As far as I'm concerned, if I find myself in it—and even if I'm not flattered by it—I promise not to sue him.[19]

He was joking, but that was before the book existed. When Zola's imagination moved into top gear his pen was liable to find everything grist for his mill. The character of Jory in *The Masterpiece*, mocking and without scruple, was based on Alexis and must have strained their friendship.

By the end of February 1882 Cézanne was poised to return to Paris. He thanked Zola for a work of criticism, *Une Campagne*. He would like to drop in at Médan again, but would call first at the rue de Boulogne to see if Zola was there.

He had a reason for leaving the Midi again after only four months. His ambition was about to be realized: he was going to have a picture in the Salon. The circumstances were humiliating but he didn't seem to care: he still had a terrible hankering for the seal of approval which only the Salon could confer. Not that this stopped him from consigning that conservative institution to the devil, calling it the Salon de Bouguereau. Cabanel and Bouguereau were the chiefs of official art. Catalogs of the Salons reeked with mediocrity, bearing titles such as *First Caresses, The Sugar Plums of the Baptism, Grandmother's Friends, Woman Tied to the Tree from Which Her Husband Has Been Hanged*, and so on. Historical paintings abounded, or in the case of Bouguereau an endless supply of prettified nudes. Nietzsche in 1876 had already expressed his contempt for this "commemorative contemplation of the past." Nature could be negated, he warned, and art killed by art. They "mask themselves as doctors, whereas actually they behave like poisoners. Thus they explain . . . why they so insistently reject everything that is offered them in art as real nourishment." Why produce anything great, when that which is great exists already? Behind the mask their motto was "let the dead bury the living."

Cézanne, knowing all this perfectly well, nevertheless dreamed of

approval. He had spent his life hiding behind his mother and sister and unbending father, and perhaps he imagined that an "official" success would give him the strength to face them once and for all with the raw truth of himself. In 1882 Guillemet belonged to the jury. There was a ruling which enabled each jury member to introduce into the Salon one picture that nobody could challenge. It was supposed to be the work of a pupil of the sponsor. So it was that Cézanne appeared for the first—and only—time in the place for which he had such love-hate, as an apprentice to the facile Guillemet. He had sent in a *Portrait of Monsieur L.A.* This could have been Cézanne's early portrait of his father Louis-Auguste, a painting Guillemet had once admired. A journalist of the *Dictionnaire Véron* deigned to notice it, commenting on "this beginner's work painted at great expense of color." He thought the shadow in the eye socket and on the right cheek showed promise.

After this miserable foray Cézanne abandoned his long siege and hugged obscurity. He went to Médan for five weeks in the autumn. By November he was back in Aix at the Jas de Bouffan. He hardly stirred from the place and so met no one apart from Gibert, director of the museum, Dauphin, "with whom we went to school," and little Baille, Baptiste Baille's younger brother. These two were both solicitors: the latter stank in his nostrils as having all the makings of "a nasty little legal blackguard." He was perhaps thanking his stars that fate hadn't condemned him to the legal profession, as his father had once wished. He thanked Zola for his new book *Pot bouille*, and ended his brief note, "There is nothing new here, not even the least little suicide," a reference to the suicide of their friend Marguery, who died spectacularly after diving from an upper gallery of the Palais de Justice in Aix to the floor below. He too was a solicitor.

On November 27 he wrote in some agitation to the novelist asking for advice on the making of a will. His premonition of an early death was tormenting him once more, but anything in the slightest degree practical threw him into confusion, which was why his son became later on so essential to him. He wanted to leave half his money to his little boy and the other half to his mother. It seems odd that he should make his mother a major beneficiary, since she was already well provided for. Hortense, with no money of her own, was not even to be named. His fear of acknowledging her existence had gone on too long for him to abandon the pretense now. It's possible that he had come to some arrangement with his mother whereby she had agreed to look

after Hortense in the event of his death, but as there was no love lost between the two women this is unlikely.

In January 1883 he was back in Aix after a bout of painting at l'Estaque, where he had rented a little house and garden just above the station in the Quartier du Château. He was at the foot of the hill, rocks and pines rising behind him. He had beautiful viewpoints here, "but they don't quite make motifs." All the same, climbing the hills at sunset he could see Marseilles laid out gloriously in the distance, and the islands, "the whole, bathed in evening light, having a very decorative effect."

He wrote to Coste to thank him for the periodical *L'Art Libre*, which was clearly to his taste. "I appreciate the generous impulse with which you take up the defense of a cause to which I am far from being a stranger," he wrote elaborately, ending "your compatriot and I'd dare to add confrère."

Books from the unstoppable Zola kept rolling in. He had got over his acute depression and was in full spate again. The new novel was *Au Bonheur des dames*, the eleventh volume of the Rougon-Macquart saga. Renoir, about to have an exhibition, had asked for the return of two landscapes which he had left behind after his 1882 visit. Aix, Cézanne reported, was transformed after snow had fallen "all day Friday." The countryside looked beautiful, though the snow was already melting. Then he mentioned casually that his sister Rose and her husband had been in Aix since last October, where she gave birth to a little girl. The birth of a granddaughter had delighted his mother, but the threat of a disruption of his peace at the Jas had produced "outcries" and apparently he had put the young family off. What his mother felt isn't clear. His sharp-tongued religious sister Marie took his side.

Renoir's dealer, Durand-Ruel, was gambling on the Impressionists—the only dealer prepared to do so—by renting an empty gallery on the boulevard de la Madeleine for four months. He held one-man shows of the work of Monet, Renoir, Pissarro, and Sisley, but fought shy of Cézanne, though Pissarro and Renoir must have urged his inclusion.

Manet died suddenly on April 20 after having a leg amputated. Cézanne, very upset, and plunged into gloomy thoughts once more concerning his own future, made a special journey to attend the funeral. Manet was fifty-one. Cézanne himself was only forty-four but looked ten years older, bald and grey-skinned, hollow-eyed with anxiety. A few days later he was back in the south and planning to stay put

until January of next year. A letter to his old friend Solari in midsummer included the good wishes of his "wife" on the occasion of the marriage of Solari's daughter. Hortense had joined him at l'Estaque with their "frightful" offspring, young Paul, now eleven and at times a holy terror.

1883 saw the publication of Huysmans's eagerly awaited book on modern art. Pissarro attacked him for leaving Cézanne out entirely, something he found quite preposterous. He asked indignantly, "Why is it you don't say a word about Cézanne, whom all of us recognize as one of the most astounding and curious temperaments of our time and who has had a very great influence on modern art?"

Huysmans was quick to reply. His answer reflects the opinions and misconceptions about Cézanne held by Zola's circle at Médan:

> Let's see. I find Cézanne's personality congenial, for I know through Zola of his efforts, his vexations, his defeats, when he tries to create a work. Yes, he has temperament; he is an artist; but in sum, with the exception of some still lifes, the rest is to my mind not likely to live. It is interesting, curious, suggestive in ideas, but certainly he is an eye-case, which I understand he himself realizes. . . . In my humble view the Cézannes typify the impressionists who didn't quite bring it off. You know that after so many years of struggle it's no longer a question of more or less manifest or visible intentions, but of works which are real childbirth, which aren't monsters, odd cases for a Dupuytren Museum of Painting.[20]

Dupuytren was the founder of a medical museum of anatomy. Over the damning "eye-case" hovers the cant phrase "he couldn't draw" that critics were repeating well into the twentieth century. He happened to lack, says Roger Fry, "the comparatively common gift of illustration . . ." Of course he could draw, but how else explain those ugly women? Those squashed ellipses on the tops of dishes and vases?

Zola, unlike his entourage, didn't go along with Huysmans's judgments in every respect. He was silent on the subject of Cézanne but didn't agree with him about Courbet and Degas. "I'm not for throwing Courbet on the scrap heap or for calling Degas the greatest modern artist," he objected. Degas was a nice talent, but in his opinion somewhat constipated. He went on to declare his current position. "The more I see and the more I detach myself from merely odd viewpoints, the more I feel love for the great and abundant creators who produce a world." He criticized Huysmans for letting himself be swayed by liter-

ary theories only applicable to "the school of Gérôme, modernized." He was turning away from the Impressionists after exhorting them in vain to produce what he called "a world." Once again Zola and Cézanne seem counterparts of each other. These were essentially Cézanne's objections to the Impressionists, as he tried through his Mediterranean sense of truth, sensual and rich, to deliver the Garden of Eden he carried around whole and live inside himself. As one writer has put it, Cézanne's difficulties are those of the first word.

Some years later Huysmans changed his tune. Won over by Pissarro, he spoke of Cézanne as the "too much ignored painter" in an article for *La Cravache* in 1888, going on to say that Cézanne had "contributed more than the late Manet to the Impressionist movement." In a book the following year he devoted a whole chapter to the so-called "eye-case."

Two beautiful canvases which may well have been painted in this year are a portrait of Hortense, called *Madame Cézanne*, and *Still Life*. In the first, the egglike oval of the face is as abstracted as that in his portrait of Louis Guillaume, and as in the previous work he seems to have projected his own hesitations and timidity onto the woman. This portrait is for once a purely Impressionist painting, with that kind of exquisite delicacy in a light key, the grey tones nurturing the tender blossoming spirit. The image of Hortense as a sensitive, meditative woman, her head inclined sadly to the left, joining a dark vertical that is there to measure the distance her head has moved, gives us a portrayal at variance with the picture we have formed of her. Unlike other portraits of her, the hair hangs loose, falling and losing itself in the shoulders of the dark striped dress. A slight sourness in the downturned mouth reminds us that this is the woman who found herself with a man fundamentally alone in life, for reasons she never cared or was able to fathom. The picture wavers up before us, up the swaying lighter stripes of the dress to the enclosed neck and to the pathos of the slanted head with its sadly blurred eyes. It is like the artist's anima manifesting itself, his secret feminine "inferior" self floating into view, as if summoned up by the inner life of the woman he has come to know so well.

The *Still Life* presents us with an arrangement that could not be simpler or more deliberately composed. The objects, the wall of the bureau, the green jug with its cream base, the platter tilting as if about to slide, the mottled yellowy apples, the crude block of the table, and the all-important surging sea of the tablecloth, are sounding the chords of an orchestration, mirroring melodies of extraordinary sub-

tlety. Backing everything is the smoldering dark brown bureau, reminiscent of the somber backgrounds of his earlier style. The whole harmony is compact, masterful, at rest, and yet implying in its deep sonorous passages an awareness of the slipping universe beyond the canvas. The controlled chaos of the rearing waves of the tablecloth dominates the center of the picture, writhing and falling fantastically. Somehow Cézanne's contradictory desires to create stability and to show that nothing is immobile triumph here, in this harmonized rhapsody that is so full of refinements.

He was becoming steadily more isolated, a solitude broken into briefly by Monet and Renoir who had been staying together at Genoa and called on Cézanne at l'Estaque before heading for home. This was toward the end of December. He joined up with Monticelli for walks a time or two, and that was all. Then in the new year, thanking Zola for the copy of his *Joy of Life*, a novel he had been following in serial form in *Gil Blas*, he said he had heard from "good old Valabrègue" who had arrived at Aix. He hurried round to see him and they toured the town together, swapping memories as they walked. All very pleasant, "but how very different our feelings are! My head was full of the idea of this country, which seems to me so exceptional."

◈ Cézanne is hard to keep track of in 1884. Only two letters went to Zola. He painted a view of l'Estaque, one of many, from a high point looking down on buildings, an arm of water, rocky hills on the far side undulating along the horizon like the rough body of the earth itself laid out to rest. Figures in his landscapes were rare; there are none here. Nothing moves except the smoke puffing greyly from a factory chimney at the water's edge to the left. Following the direction of these grey plumes our eye discovers "the finesse of the far-off jetty" at the right, diagonally pointing. Such is the care with which all the details are integrated that the rightness of the tiny red-roofed house on the shoreline facing the jetty, and below this the high chimney rising from the rigid block of buildings in the foreground, its top aligned with the sharp triangle of an inlet, is hardly noticed. The painting is united in its various parts by small vibrant touches, the reds and oranges of fields inhabited by buildings, the hermetic blue that is pure Cézanne, the diaphanous sky, the hills bending as if in response to the gentle press of the air all casting a spell of peace that makes one imagine the sea breathing inaudibly like some huge animal. "Without paths or human figures,"

writes Schapiro, "the world is spread out before his eyes, a theme for pure looking; it invites no action, only discernment." Sunny, but not gay or cheerful, it is "a balance of warmth and coolness, the momentary and the timeless, the stirring and the stable, in perfect harmony and fullness." [21]

His lonely contemplation of nature had its rewards and moments of ecstasy, but he often stumbled and despaired, feeling the inadequacy of what he was able to achieve. In a mood of near despair on November 27 he tried to unburden himself to Zola, writing with painful clumsiness of his art. He saw it as "changing terribly in its outer form and . . . assuming all too strongly a poor, miserable aspect while at the same time the ignorance of harmony is being revealed more and more in the discordance of the coloring and, what is even worse, in the deadness of the tone." He broke off to exclaim in self-mockery, "After moaning, let's cry Long Live the Sun, which gives us such beautiful light." He had reached the point where radical changes of approach were being demanded of him and he wondered if he had the strength and vision to meet their challenge. He was moving forward, but fearfully. Zola, who had been the recipient of these doubts so many times before, must have been more than ever convinced that his old comrade's problems were insoluble. Fond though he was of him, he was close to giving up on Cézanne. And the Impressionists were no longer in his eyes a force to be reckoned with.

Pissarro on the other hand was unshakable in the faith he had in his former pupil. As hard up as ever, he tried to buy a Cézanne canvas whenever he could manage it. "If you want to learn to paint, look at Cézanne," he said to his sons. Gauguin was another admirer who didn't give up on "that misunderstood man." Up against it financially in 1884 after turning his back on his career to devote himself to art, he told his wife, "I am attached to my two Cézannes, which are rare of their kind, for he has completed few such, and one day they'll be very valuable indeed." And on January 14, 1885, he wrote in a letter, "Look at Cézanne . . . whose nature is essentially mystical and oriental (his face is like an old Levantine's), his form has all the mystery and oppressive tranquility of a man lying down to dream, his color has the gravity of his oriental character; he is a man of the Midi and spends whole days on the tops of mountains reading Virgil and gazing at the sky. His horizons are lofty, his blues very intense, and his reds have an astonishing vibrancy."[22]

Gauguin was possibly the first to see the artist as a kind of Moses of Aix. In 1907, when Rilke was being pierced to the core of his being as he went round the Autumn Salon in the Grand Palais—it had two rooms set aside to commemorate Cézanne—he stopped before a picture of Mont Sainte-Victoire and said, "Not since Moses has anyone seen a mountain so greatly." Conducted round by the painter Paula Becker, being taught by her "the art of seeing," he paid homage to the Provençal artist as one of his tutelary spirits. Landscapes by him, he exclaimed memorably, had all the succulent freshness of fruit broken open. He saw Cézanne as being united with his work as totally as a saint with God.

These romantic, indeed exalted images of Cézanne have to be set beside one of the strangest episodes of his life, on the face of it too banal to be anything but true. He fell ridiculously in love. He had been laid low with an attack of neuralgia, as he told Zola in March 1885, thanking him at the same time for a copy of *Germinal*. Now the pains in his head had eased and he could think lucidly again and take quiet walks on the hills.

Then suddenly he was in turmoil. Apparently he had become infatuated with a maid at the Jas, Fanny, a strapping girl who could lift a wine cask and was said to be "just like a man." Nothing remotely like this had ever happened to him before. No one knows what the young woman was like, or what she made of the tortured formality of the love letter he roughed out on the back of a drawing—that is, if she ever received it:

> I saw you and you permitted me to embrace you. From that moment a deep disturbance has continued to agitate me. You will excuse the liberty that a friend, tormented by anxiety, takes in writing to you. I do not know how to qualify this liberty which you may find a very great one, but how can I remain under the oppression that bears me down? Is it not better to express a feeling than to hide it away? Why, I've told myself, keep silence over what torments you? Is it not a relief to suffering to let it find utterance? And if physical pain seems to find some abatement in the cries of the sufferer, is it not natural, Madame, that moral griefs should see a consolation in the confession made to a worshiped being?
>
> I know this letter—the hasty and premature sending of which may seem indiscreet—has nothing to recommend me to you but the goodness of . . .[23]

293

The draft to the faceless "worshiped being" tails off unfinished. In acute distress and pain he turned for help to the one man he trusted, the one who had never refused him. Would Zola take in letters for him, he begged, and forward them to an address "which I'll give you later"? He was a desperate man. Was he actually in touch with Fanny by letter, imploring her to reply to him? And what was he asking of her? The entanglement is shrouded in mystery. Brief and violent, it seemed no sooner in full swing than it was over, nipped in the bud perhaps by the ever-watchful Marie. After a few months, silence descends on the affair. Before that, there is the spectacle of Cézanne the timid rabbit scuttling frantically from one hole to another, aided by the patient Zola.

The first SOS on May 14 begs a favor (permission to use Médan as a postal address for possible illicit letters) "which I think is tiny for you, yet vast for me. . . . I'm either mad or in my right senses. *Trahit sua quemque voluptas!* I appeal to you and implore your absolution; happy are the wise. Don't refuse me this service, or I don't know whom to turn to." He added an ironic postscript, sounding the note of pathos with which Zola was only too familiar: "I'm helpless and can do you no service, but as I shall die before you I'll put in a word with the Almighty to get you a good place."

He was being funny but also deeply serious. Though he hated priests he had never stopped going to Mass. As with everything else he was ambivalent about religion, afraid of getting into its clutches. He called it "moral hygiene" and spoke mockingly of taking his "slice of the Middle Ages." He regularly fell asleep during church services, complained of an organist who played off-key, and told his son scathingly, "I think that to be a Catholic one must be devoid of all sense of justice but have a good eye for one's interests." Asked once by Paul Alexis why he was a churchgoer he exclaimed, "It's fear! I feel I've only a few days left on earth—and then what? I believe I'll survive and don't want to risk roasting in *eternum.*" Then there were the customs and prejudices of this provincial town exerting pressure on this fundamentally conventional man to conform. He submitted readily enough, both to his environment and his zealous sister Marie, who had no intention of letting him neglect the salvation of his soul. And it's true that even away from home he went regularly to Mass. Even so, the malicious glances followed him when he walked the streets of Aix, glances aimed at his "idle" hands and something curious emanating from his person that he could do nothing about.

How much did the family know about his love affair? One rumor

has it that the girl was sacked by Marie. Unable to cope with any kind of atmosphere, it's no surprise to see him fleeing north with his family—young Paul was now thirteen—to spend a month with Renoir at La Roche-Guyon, a village on the Seine between Véron and Mantes. But he was far too agitated to settle to painting. He liked Renoir very much, but Zola was his confidant and he longed to talk things over with him. The moment he arrived he sent a note to Paris asking for any letters to be readdressed to him at the Renoirs'. Zola hadn't yet moved to the country for the summer. On June 27, fretting and desperate, he asked to be told the moment the novelist was about to move. Then "when you're settled there, please let me know," he pleaded hopelessly. "The desire for a change of scene is tormenting me somewhat. Happy are faithful hearts!" He thanked Zola for "obliging me about my letters from Aix."

He hung on with his unfaithful heart for another week, hearing nothing, before sending a further abject note. "Owing to fortuitous circumstances, life here is getting rather difficult. Will you tell me if you can take me in?" Three days later the reason for Zola's apparent silence dawned on him: he had asked Zola to write to him in care of Poste Restante at La Roche instead of at the Renoir house. "I must ask you to forgive me. I'm a great arse. I thank you a thousand times."

Zola had finally got to Médan but for some reason wasn't quite ready to receive guests. "What's going on?" he asked. "Your note has upset me considerably. Can't you wait a few days? In any event keep me informed and let me know if you have to leave La Roche, since I want to know where to write to you when my house is finally available. Be philosophical, nothing goes as one would like. I too am much upset at the moment. So until soon? As soon as I can I'll write to you. Affectionately, Émile Zola."

His wife was unwell. Cézanne's uncomfortable circumstances had it seems been brought about by the Renoirs hearing of his "affair" and finding themselves with divided loyalties, not wanting him to desert Hortense.

More last-minute appeals came for the preoccupied novelist. "If you should receive a letter from Aix, be good enough to address it *poste restante* and send me a line to let me know, making a cross in a small corner of your letter."

On edge, he decided to move out—always his solution to unbearable situations. "I leave today for Villenes. I shall go to the inn," he wrote on July 11. Villenes was quite close to Médan. He was doing

nothing, getting steadily more bored. He thought of an excuse to see Zola briefly: could he borrow the boat *Nana* for a painting expedition?

Two days later he reported, "Impossible for this festival week to lodge at Villenes. Neither at the Sophora nor at the Hôtel du Nord. I clasp your hand, I'm at Vernon, Hôtel de Paris. If my canvases are sent to you, please have them taken in and kept at your place." After another two days he announced in despair, "I can't find what I'm looking for in the conditions in which I find myself. I've decided to leave for Aix as soon as possible. I'll pass by Médan so as to clasp your hand there. I confided to your care some papers I'd like to have; if they're in Paris, could your servant fetch them one day when he goes to the rue de Boulogne? Goodbye and thanks in advance. You'll forgive me once again for coming to you in the existent circumstances, but another seven or eight days to wait seems a very long time to me."

He had forced himself to make a decision at last. Then he was dithering again. He would take up Zola's suggestion and

> come to Médan on Wednesday. I'd have liked to be able to carry on with painting, but I was in the utmost perplexity; for since I must go south I concluded the sooner the better. On the other hand it would perhaps be better if I wait a little longer. I'm caught in indecision. Perhaps I'll get out of it.[24]

Finally he was reunited with his friend on July 22, their first meeting for nearly three years. It was to be their last. Paul Alexis was there also. Zola had put on a great deal of weight: he was forty-four inches around the waist, which made him look even shorter. He was to leave soon to go with his wife to Mont-Dore for the cure, then in September to visit Aix. Later they abandoned this plan, put off by news of an outbreak of cholera in Marseilles and worries about his wife's fitness to travel. Zola's hypochondria had intensified over the years. He suffered constantly from insomnia and from periods of black depression, and since the death of his mother he had leapt more than once from his bed "in a state of unavoidable dread." Now he thought he might have diabetes. Yet after his accidental death he was found to be unaffected by disease. His ailments all came from "the infirm sickly ultra-nervous side of him." Edmond Goncourt wrote of him giving the impression of a sufferer from heart trouble. He would sit in an armchair talking mournfully of "kidney trouble, gravel, palpitations . . ."

Back in the south, it was probably to escape the reproaches of his family as well as the reminders of his abortive romance that Cézanne

took himself off every day to Gardanne, an ancient and rather run-down little town five miles from Aix. Its shabby old houses, the doors and windows dirty, paint peeling, climbed in a narrow street to the summit of a hill that was crowned by the ruins of an old church, not much more than the bell tower remaining. It was high summer. Even at evening the stones breathed warmth. When the town slept, the night was completely soundless everywhere. The morning silence would be broken by roosters, a dog beginning to bark.

The place became a favorite among his motifs. Soon he moved there with Hortense and their son, renting a small apartment. Able to write freely, without fear of having his replies intercepted, he told Zola, "I'd have replied sooner, but the clods which are under my feet and are like mountains to me, have distracted me." Lindsay suggests that the clods or lumps are not his father but an alliance of women, namely Marie, his mother, and Hortense. Five days later he wrote cryptically out of the isolation imposed on him, "It's the beginning of the comedy. I wrote to La Roche-Guyon the same day as I sent you a line of thanks for thinking of me. Since then I've had no news at all; besides, for me, it's the most complete isolation. The brothel in town, or another, but nothing more. I pay, the word is dirty, but I've need of repose, and at that price I ought to get it. I beg you then not to reply, my letter must have come at the right moment. Thank you and please excuse me. If only I had an indifferent family, everything would have been for the best."[25]

The mystery of his brief turbulent affair, now undoubtedly over, is not likely to be solved. It is believed that Fanny held on for some years to a painting he gave her of a corner of the Jas with outhouses. Eventually, lying ill in hospital, she sold it for next to nothing to a welfare worker "who seems to have had some idea of its value."

The square houses clustered around the small hill at Gardanne, interspersed with a tree or two, the slopes studded with the squat towers of three old mills, the farmhouses beyond and the Mont du Cengle, a foothill of Mont Sainte-Victoire, yielded a whole series of paintings. The cubic forms of the buildings with their edges locked into one intricate mass led him to a near abstract manner of landscape art. The mountain he was later to paint so obsessively was not peaked, from this viewpoint, but more of a jagged bank or plateau, its heavy mass blocking off the horizon.

Unless his words to Zola were simply bravado, his mention of visits to a brothel may mean that he was retaliating against what he saw as

the intolerance of his womenfolk. No evidence has come to light suggesting that he ever made use, either before or since this time, of prostitutes. If he took himself off to Marseilles, the most probable place for someone wanting the cover of anonymity, it is still hard to imagine such a shy man, with his aversion to physical touch, getting himself over the threshold of a brothel.

◆ Those who say he was indifferent to people should look again at the portraits. He loved his mother, his son, and when he heard of the death of Zola he shut himself away in his studio and wept all day. To achieve a portrait was to defy his own isolation, to put himself back in touch with those who unnerved him so much. Very different from Van Gogh, he was at any rate like him in one respect: when he couldn't face people he turned to nature, which, says Rilke, exhausted his love in the act of making the picture, leaving no residue. To paint someone as if they sat before him shorn of personality, like the apples of his still lifes, struck people as ludicrous. "It is this limitless objectivity," writes Rilke, "refusing any kind of meddling in an alien unity, that strikes people as so offensive and comical in Cézanne's portraits."[26] He painted Hortense again and again, partly of course because of her availability as a model. He painted some of the most impersonal self-portraits we have, as if sneaking sideways looks at someone else, or else looking like the meek obedient dog of his work, as Rilke puts it—the dog of that master which never let him rest, allowing him only to lie down in the evening at eight and go to Mass on Sundays. He was prematurely on the way to being the old man walking alone, provoking children to call after him and occasionally throw stones.

The *Self-Portrait with Palette* relates to this year or the year after. The painter is positioned behind his easel and palette like someone walled in or barricaded against intruders. The whole is saturated with a multiplicity of correspondences. The head is blockily in keeping with the rectangular easel and palette. Various devices contribute to the insistence on a lack of depth, so that the surface plane of the canvas has an integral part to play. The strict organizing of objects and figures into something meant to endure, like a building, with that air of abstraction and unassailable stability, was embraced with ardor later on by the Cubists, who, some would say, missed the point and took the severity as a statement in its own right. In this self-portrait the man, a prisoner of his art, is making clear that his servitude is voluntary. He isn't disinte-

grating in a welter of edges and planes but is monumentally there, and there to stay. What looks at first viewing like a denial of feeling is in fact an intensely personal declaration, an avowal of love. His solitude is his salvation. The work he has so often cursed, slashed, and repudiated, rewards him now he has stopped forcing his will on it and submitted. The eyes are unfinished because his absorption in his task is total: he sees with his forehead, his chest, with his whole body. Stoical like his beloved Greeks, he expresses the deep relief of the artist who finds himself paradoxically not condemned, now that he has chosen not to be free. The freedom that has brought him such fears is banished. The palette, flattened out and attached to his thumb, has become part of his body. To ensure that this key significance is not missed, Cézanne unites the vertical edge of the palette and the sleeve, literally welding the former to the arm. On the right, the tips of his brushes are lined up with the edge of his coat. Even the indentation of the beard on the cheek corresponds to the thumb's shape on the palette.

The bluish-black of the coat and beard is one of Cézanne's unique blues. Rilke breaks out in rapture when he contemplates his blues. Someone should write a biography of the color blue, he says, "from the dense waxy blue of the Pompeiian wall paintings to Chardin and further to Cézanne." Then he is away, glorying in Cézanne's "dense quilted blue," his "thunderstorm blue," "wet dark blue," "juicy blue."[27]

As frequent a sitter as Hortense was young Paul. Because his son was such a handful, impossible to restrain when he was very young, lots of the portraits are drawings and studies of him at all ages. Rembrandt painting his son Titus expresses the same blind love. We see the lad asleep, reading, drawing, smiling cheekily at his devoted parent. A charming, comical portrait of him at thirteen or so, probably when he was attending the local school in Gardanne, shows him posed chubbily in a curly-brimmed hat and blue jacket against a joyous background, glancing with impish assurance at the artist-father.

What are we to make of the abstractly musing solitary figure who fills the space of *The Bather*, a major painting of this time, conceived in the studio from something imagined. It departs from the new advances he is making now in landscape and still life, forcing us to remember and seek connections with his early narrative pictures such as the *Temptation of Saint Anthony*. But is there another, less obvious link, with his self-portraits? Is this youthful bather in a vaporous landscape, merging as he stands there into sky and water, really Cézanne himself, that is to say an expression of his solitary state as this mysterious figure contem-

plates the forward motion of his bare foot? In Cézanne's canvas the bent arms and jutting elbows "call out luminosities and turbulence in the adjoining sky like the angels fluttering about a holy figure in old art," writes Schapiro in his eloquent analysis.[28]

The landscape and figure are treated similarly, using the same treatment, the same free spotted color. It is as if they are meant to be regarded as aspects of each other. The angled arms echo the sloping rock crossing the picture behind the figure's upper thighs at the right. Other versions from the same period of single male bathers show them gesturing strangely in a diagonal pose, the left arm pointing downward, the right raised over the head. In this contemplative one, the advancing left knee is touched with red as it becomes surrounded by the green earth behind it.

The head and torso is in the sky, the body from the waist down is on the earth. Avant-garde artists of the early twentieth century, sculptors and painters, were entranced by this figure drawn without preconceptions, unconnected to the past and devoid of banality.

The monumental bather represents, according to recent critics, a fusion of the spiritual and material, the sacred and profane, the kind of union he was attempting earlier in paintings with a temptation theme. It recalls the aims of the medieval alchemists, with their conception of a being incorporating heaven and earth. Most striking is the marriage of the great vertical bather to his world. Like all symbolic work that isn't facile, this one awakens complex feelings for which one lacks a language.

A still life of the mid-eighties that has become justly famous is *The Blue Vase*, full of those unique blues so beloved by Rilke. The blue gets everywhere; the plate, the touches on the table, the wall rising mistily behind, the bouquet itself. It's a mysterious essence, an overflowing ecstasy, a substance that blesses everything it touches. The tall narrow vase with its wavy mouth—echoed by the scalloped edge of the plate— leans slightly to the left, a characteristic we have come to expect, another sign that what is apparently fixed is in flux, moving and alive as he intuitively felt them to be. Objects around the vase include three apples, their delicate outlines not quite enclosing their color. Their placing is exquisite, like the mirroring of music.

Cézanne often went to paint at Montbriant, to a property owned by his brother-in-law Maxime Conil. It lay a few miles southwest of Aix, set on a fairly high hill, commanding a view of the wide and long Arc valley as far as the great bulwarks of the distant Mont Sainte-

Victoire. At Bellevue in the vicinity he painted a farmyard and pigeon tower, as well as the house at Montbriant. Somewhere between the two places he found an ideal vantage point, a small wood on a hill. From the edge of that he overlooked the valley and the truncated cone of the mountain which came to be such an emblem of majesty and repose for him. He loved the deep space afforded by his motif, with its large masses and broad planes, cut across by the railway and the viaduct beyond, its light arches leapfrogging in a pure horizontal. The mountain changed in color as he worked, from dull grey to soft blue and shades of pink. What he called "the conformation of my country" was all here, spreading out from his feet, rich and firm in the Mediterranean light, quickening his southern blood. Born in this land of the sun, he was moved by its physical splendor. No landscape of the north ever stirred him so much.

In spirit he had now taken leave of the Impressionists, even finding Pissarro, who had fallen in with the pointillist technique of Seurat, a disappointment. "If he had continued to paint as he did in 1870," Cézanne said sadly, "he would have been the strongest of all." He found fault with Manet's "poor feeling for color" and didn't care for Renoir's "cottony" landscape effects. He held on to the gains he had made through the Impressionists but saw his task as "making out of impressionism something solid and durable like the art of the museums."

# 11 "ON THE MARGINS OF LIFE"

T*he Masterpiece*, Zola's novel about a contemporary painter, had been serialized in *Gil Blas*, and at the end of March Cézanne received his copy. Writers have pointed to this book as the cause of the final break with Zola, but was it? There is much conflicting evidence. Cézanne acknowledged receipt of the novel on April 4, 1886, with a handful of cool, courteous words that some have seen as proof that he hadn't taken offense. "My dear Émile," he writes, "I have just received *L'Oeuvre* which you were kind enough to send me. I thank the author of the *Rougon-Macquart* for this good evidence of his thoughtfulness, and ask him to allow me to clasp his hand in memory of bygone years. Wholly yours, under the spell of past times."

A little stiff, but nothing here to suggest the recoil of a wounded soulmate. Yet little time has elapsed, and this was a man who moved slowly: a slow reader, we are told. Joachim Gasquet, a young man unsympathetic to Zola and therefore not likely to show him in a good light if he could help it, gives an account of what Cézanne said to him toward the end of his life:

> The early chapters of the novel always moved him profoundly; he felt in them an extraordinary truthfulness, almost unqualified and intimately touching to himself, who recaptured in those pages the happiest hours of his youth. When the book changed direction later on with the character of Lantier threatened with madness, he understood that this took place according to the necessity of the

plan, that he himself was entirely out of Zola's mind, that Zola in short hadn't written his memoirs but a novel that formed part of an immense carefully worked-out whole. The character of Philippe Solari, set out in the guise of the sculptor Mahoudeau, was also much altered to suit the plot, and Solari did not dream, any more than Cézanne did, of taking offense.

His admiration for Zola never faltered. And Zola, when I saw him in Paris fifteen years after *L'Oeuvre*, spoke to me of his two friends with the most profound affection. This was about 1900. He was still fond of Cézanne, in spite of his sulkiness, with all the warmth of a great brotherly heart, "and I am beginning," he told me, "to have a better understanding of his painting, which I always liked, but which eluded me for a long time because I thought it was frenzied, whereas it is really incredibly sincere and true."[1]

Much of the confusion concerning the genesis of his character Claude Lantier has been created by Zola himself. How close in fact is the connection with Cézanne? Because Lantier is laboring over a huge canvas very like Manet's famous *Lunch on the Grass* a number of the late Manet's admirers linked the character with him. But Manet had been rich, and Lantier is a half-starved and neglected artist, though he is, as Manet was, the leader of a dissident group. When the book came out, most of the Impressionists were upset, yet none of them thought to identify Lantier as Cézanne. Renoir was affronted by what he saw as the inaccuracy of the scene. "What a fine book," he said, "he could have written, not only as an historical record of a very original movement in art but also as a human document . . . if, in *L'Oeuvre*, he'd taken the trouble to relate what he'd seen and heard in our gatherings and our studios. . . . But, at root, Zola didn't care a damn about portraying his friends as they really were: that is, to their advantage." Renoir didn't want a work of fiction, plainly, and the hybrid that the novel was only added insult to injury.

Monet thought the book would damage them as a movement and hold them up to ridicule. He protested to the author, "I've been struggling a long time now and fear that at the very moment we're getting somewhere our enemies will use your book to confound us." He went on, "You were purposely careful not to have any of your characters resemble any of us but, in spite of that, I'm afraid our enemies among the public and the press will identify Manet and ourselves with failures, which is not what you have in mind, I cannot believe it."[2]

The truth was that Zola had in mind a painter who was potentially a much bigger man than Manet, someone with the same kind of soaring ambition as himself, in other words the all-embracing genius he had been exhorting the Impressionists to deliver from within their ranks. He wanted a romantic realist, a grand architect fired with poetry, the sort of figure he had himself dreamed of becoming, with the grand flamboyancy and voluptuous majesty Cézanne had so admired in his baroque heroes and once wanted to emulate. So that when Degas observed icily that Zola was trying to put down painters and exalt the superiority of literature over art, he was missing the point. Zola, faced with the belittling of his hero by a comparison with Manet, tried to make his position clear. All he managed to do was confuse the issue further and insult Degas into the bargain. George Moore describes the occasion: one evening, after a large dinner party

> given in honor of the publication of *L'Oeuvre*, when most of the guests had gone and the company consisted of *les intimes de la maison*, a discussion arose as to whether Claude Lantier was or was not a man of talent. Madame Charpentier, by dint of much provocative assertion that he was undistinguished by even a shred of the talent which made Manet a painter of painters, forced Émile Zola to take up the cudgels and defend his hero. Seeing that they were all siding with Madame Charpentier, Zola plunged like a bull into the thick of the fray and did not hesitate to affirm that he had gifted Claude Lantier with infinitely larger qualities than those which nature had bestowed on Edouard Manet. This statement was received in mute anger by those present, all of whom had been personal friends and warm admirers of Manet's genius, and cared little to hear any word of disparagement spoken of their dead friend. It must be observed that Zola intended no disparagement of Manet, but he was concerned to defend the theory of his book—namely that no painter working in the modern movement had achieved a result equivalent to that achieved by at least three or four writers working in the same movement, inspired by the same ideas, animated by the same aestheticism. And, in reply to one who was anxiously urging Degas' claim to the highest consideration he said: "I cannot accept a man who shuts himself up all his life to draw a ballet-girl as ranking coequal in dignity and power with Flaubert, Daudet, or Goncourt."[3]

On the face of it the identification of Claude Lantier as Cézanne in real life is not in doubt. The novel's other characters all have easily

identifiable real-life models. Zola's outline for the novel included a list of memories:

> My youth at school and in the fields—Baille, Cézanne—All the memories of school, comrades, professor, quarantine, we three friends—out of doors, hunting, swimming, walking, reading, the families of my friends.
>
> In Paris. New friends. School. Arrival of Baille and Cézanne. Our Thursday reunions.—Paris to conquer, walks.
>
> The museums.
>
> The various lodgings—Chaillan—the cafés; Solari and his marriage.
>
> The studio of Cézanne. The stays at Bennecourt—the Thursday reunions continue.

When he comes to an analysis of his character he drops the pretense that he is creating fiction and uses Cézanne's first name instead of Lantier's:

> Not to forget Paul's despair; he always thought he was discovering painting. Utter discouragement, once ready to drop everything: then a masterpiece, nothing but a sketch, quickly done, and which rescues him from his extreme discouragement. The question is to know what makes him powerless to satisfy himself: he himself primarily, his physiognomy, his breeding, his eye trouble; but I would like our modern art to play a role, our fever to want to do everything, our impatience in shaking traditions, in a word our lack of equilibrium. What satisfies G [Guillemet] does not satisfy him; he goes further ahead and spoils everything. It is incomplete genius, without full realization; he lacks very little, he is a bit here-and-there due to his physical makeup; and I add that he has produced some absolutely marvelous things, a Manet, a dramatized Cézanne, nearer to Cézanne.[4]

It looks conclusive. The theme of the novel is to be "incomplete genius," which is how he has regarded Cézanne for the past twenty-five years. But all is not what it seems. Let us remember what a *folie à deux* their relationship had in a sense become over the years. These two men, united in their youth, were so alike and yet so divergent in their natures. They both had Provençal childhoods. Their timidity before women and about sex was extreme. The memories of a period shared with Baille was a source of inspiration for them both and led to

Cézanne's obsessional series of bathers in virginal settings, the pillars of trees in hidden groves rising to interlaced branches like the rib vaulting in churches.

As they developed, their differences became marked. Zola used his writings to dominate and conquer, and with his stronger will he succeeded. Cézanne turned away from a world which would have given the lie to his art if he had become famous. For all his dread of failure and his insecurity in the face of life, he was no match for Zola's hungrier ego. A need for affirmation led Zola out into the kind of social whirl that was anathema to Cézanne, always retreating where his friend advanced.

Nevertheless, they were inextricably bound together. They lost contact from time to time but nothing that could be called an outright quarrel ever took place. One was successful on behalf of the other, just as the other was a genius for them both, taking endless pains in the face of the world's natural indifference, its dismantling of all forms. Vollard reports Cézanne as saying, "No harsh words ever passed between us. It was I who stopped going to see Zola. I wasn't at my ease there any longer, with the fine rugs on the floor, the servants, and Émile enthroned behind a carved desk. It all gave me the feeling that I was paying a visit to a minister of state. He had become (excuse me, Monsieur Vollard—I don't say it in bad part) a dirty bourgeois."[5]

The painter's way of life was now more austere than ever. He was devoid of social ambition. Zola, on the contrary, reveled in the wealth brought by his fame. A sybarite, he liked to fill his house at Médan with guests. The constant coming and going helped to distract him from his fears and fantasies. Cézanne, initially happy to be there, was really like a fish out of water. Everything made him conscious of his outsider status, his baggy workaday clothes, his Provençal accent which he exaggerated, needing a mask for his morbid shyness and discomfort. He went around subjecting others to his painful silences and fixed stares. He was once turned away from Zola's door, so he told Vollard. "One day a servant told me that his master was not at home to anyone. I don't think the instructions were meant for me in particular." All the same, it stung. He was only too aware of slights and sneers. Young Gasquet believed that "a smile exchanged between a servant and Zola at the head of a staircase, one day that Cézanne was late in arriving at the house loaded with packages, his hat crooked, drove him away from Médan forever."

It becomes clear that Claude Lantier is a composite, for the author joins himself to the image, which becomes double, just as both he and Cézanne shared common characteristics to a remarkable extent. Writing of Lantier's nature as "always unsatisfied, tormented because his genius will not flower . . . a creative artist with too vast an ambition to put all nature on to one canvas," Zola is speaking for them both, of his own epic cycle of novels which never convince him of their rightness and of Cézanne's struggles to execute ever larger canvases of cohorts of nudes posed on the banks of the river Arc.

Graham King realizes that there are really three manifestations of *The Masterpiece*'s creator: "Zola himself, as Sandoz the journalist and writer, somewhat idealized; Zola the artist, as Bongrand, suffering the agonies of artistic creation, and, in Claude Lantier, Zola the explorer into his own subconscious."

It seems probable that Zola had the young Hortense in mind when he described Christine, the friend, model, and wife of Lantier, who appears on the hero's doorstep in a thunderstorm: "A tall, supple, and slim girl, still a little thin in body but exquisitely pure, young, and virginal. Already rather full-breasted, with a slim waist. . . . A brunette with black hair and black eyes. The upper part of the face very gentle, with great tenderness. Long eyelids, pure and tender forehead, small and delicate nose. When her eyes laugh, exquisite tenderness. But the lower part of the face is passionate, the jaw is a little prominent, too strong. . . ."

Guillemet was another protester, though apparently not because he appeared in the novel as the rather slippery character Fagerolles. He was, he wrote to Zola, dismayed by "a very gripping but a very depressing book, all in all. Everyone in it is discouraged, everyone

> works badly, thinks badly. Persons endowed with genius or failures all end by doing poor work; you yourself, at the book's end, are completely frustrated and depressed; it is pessimism, as the word is fashionable. Reality is not so sad, fortunately. When I began to paint I had the pleasure and honor of knowing the wonderful pleiad of modern geniuses: Daumier, Millet, Courbet, Daubigny, and Corot, the most human and pure of them all. They all died after producing their best work and all their lives they moved forward. You yourself, whose friend I am proud to be, do you not always progress and is not *Germinal* one of your finest works? In your latest book I find only sadness or impotence.

As for the friends who take up your Thursdays, do you consider they end as badly—I mean to say as courageously? Alas, no. Our good Paul is putting on weight in the lovely sunshine of the south, and Solari is scratching his gods; neither one thinks of hanging himself—very fortunately. Let's hope, by God, that the little gang, as Mme. Zola calls it, doesn't try to recognize themselves in your uninteresting heroes. . . .[6]

Whether or not Cézanne and Zola tried deliberately to avoid each other in future years, a reconciliation nearly took place, according to Vollard, but was spoiled by the malice of a "friend." The painter, at work on a landscape, suddenly heard that Zola had been seen in Aix. "Without even taking time to pack up my things I rushed to the hotel where he was stopping; but a friend I met on the way told me that someone had asked Zola the day before, 'Aren't you going to take a meal with Cézanne?' and that Zola had answered, 'What good would it do to see that failure again?' So I went back to my landscape."

One thing is certain: a fathomless relationship had ended. The break was complete and irreparable. Zola's widow, asked why the two men had dropped out of each other's lives completely, said, "You didn't know Cézanne. Nothing could make him change his mind."

After 1886 Zola's name disappeared from the letters Cézanne wrote to others. His famous obstinacy and fierce pride had slammed the door. A Mediterranean dignity kept it shut. Several years later, when a young student asked Zola to identify the characters in *The Masterpiece*, he wrote in reply, "What good would it be to give you names? They're those of failures whom you would hardly know, I think."

Cézanne's recent infatuation for Fanny, together with his old father's failing health, gave renewed force to the pressures of Marie and his mother on him to marry. Marie was the prime mover, unable to rest while her brother lived in sin. He caved in at last, marrying Hortense at a civil ceremony at the Aix *mairie* on April 28, 1886. His witnesses were his brother-in-law Maxime Conil, Louis Barret the ropemaker, and two clerks, Jules Richaud and Jules Peyron. The marriage deed was signed by Louis-Auguste and his wife. The artist's son, now fourteen, was there. As Cézanne and Hortense had been living together for fifteen years the ritual was no more than a formality. Cézanne took his witnesses for a celebratory lunch while the family escorted Hortense to the Jas

de Bouffan. A religious ceremony followed the next morning at the church of Saint-Jean-Baptiste on the cours Sextius.

The cat now well and truly out of the bag, it remained to be seen how warmly or otherwise the old man would receive his daughter-in-law and grandson. The boy was cherished, the "foreign" woman at best tolerated, with undercurrents of dislike. The feeling was mutual as far as Hortense was concerned. The marriage only served to finalize the long-lasting estrangement between the ill-matched couple. Outnumbered, Hortense spent more time with her son in Paris, where she was most at home. Cézanne established himself at the Jas, always his headquarters in a way. His mother and Marie were the women who counted in his life. He succumbed now to the powerful will of his devout sister. Victory was hers. He had allowed himself to be redeemed in the eyes of the Almighty after her ceaseless "Marry her—why don't you marry her?" had been dinned into him for so long. And at least he had now legitimized his adored son.

He had given up hoping for the kind of matrimonial equilibrium that Zola had it seems achieved, with the benefits that might have been expected to flow from it. Frosts had cut down his love tendrils. But the great heritage of the earth lay all around him, waiting for someone to gather in its fruits. Afflicted by "weak health and a spell of unseasonable weather," he wrote in May to Choquet from Gardanne, where his son was at school, trying in his letter to counter his bleak feelings by pledging himself anew as nature's servant. He had no wish, he told his loyal supporter, to sound heavily solemn,

> but since Delacroix served as intermediary between you and me I'll allow myself to say this: that I'd have wished to own that intellectual equilibrium which characterizes you and permits you to attain with certainty the proposed end. Your good letter, added to that of Madame Choquet, witness to a great equilibrium of the vital faculties. So, as I'm struck by this need, I discuss it with you. Chance has not endowed me with a similar disposition, it's the only regret I have about things of this earth. As for the rest, I've nothing to complain of. Always the sky, the things without limits, attract me and give me the opportunity of looking with pleasure.
>
> But as for the realization of wishes for the simplest things, which seem as if they should come of their own accord, for instance, contrarious fate would apparently be involved so as to impair success: for I had some vines, but unseasonable frosts have

come to cut my thread of hope. Whereas my wish would have been to see a fine sprouting, so I could wish that your plantations flourish and a vegetation finely develop, green being one of the gayest colors and doing the most good to the eyes. To conclude, I must tell you I'm always busy painting and there are treasures to be gathered from this country here, which hasn't yet found an interpreter on the level of the richness it unfolds.[7]

"Always the sky," the overarching realm of the spirit, always art beckoning with its torches of green fire, its blossoming, the endless desirability of its revelation under the sun. Always the tree in new leaf, the new flame, the consummation that brings peace.

It could well have been Hortense's complaints of her treatment at the Jas that forced him to take an apartment in the boulevard de Forbin where she was able to be the mistress of her own establishment. It was located at the bottom of the old town in Aix, a street with four rows of plane trees. Jules Peyron, one of the witnesses at his wedding, sat for him now and then, and if he wanted male company he met him and the local doctor in a café in the evening. His geologist friend Marion, who still painted for pleasure, called in occasionally on Sundays. On his forays into the country, sometimes lasting for days at a time, he used a donkey he had bought, loading his equipment on it. Stubborn as his master, it disobeyed him more often than not, trotting too far in front or deciding not to budge. Contests of wills always discouraged Cézanne: it was easier to give in. On his longer expeditions he ate with peasants and slept in their barns, just as Van Gogh, an artist as yet unknown to him, had been doing in Holland.

His work stalled a little after the shocks and setbacks of 1885–1886. The emotional turmoil he had been plunged into through Fanny, then by Zola's novel, and finally by the charade of his marriage, almost led to a loss of direction in his painting. In *Chestnut Trees at the Jas de Bouffan*, a favorite subject, one can see him attempting to resolve the wavering feelings of that time and put them to use. The rising verticals of the bleak leafless trees, the thin disconnected branches spreading and seeking one another as if lost, the dimmed presence of the distant mountain, are rescued from dissolution by the broad band of green ground at the base, the horizontal stone wall, and the simplified blocks of the house at the left. In the process of achieving calm against the odds he discovers, notes Meyer Schapiro, a principle of Muslim art in

the tracery of lacy ornamental lines raised above the solid green and stable forms on the ground.

His compatriot Monticelli had suffered a stroke the previous November. He died on June 29 of this year. At about the same time Cézanne went to Paris. As always he called on Tanguy, who now had canvases by Van Gogh and Gauguin among the steadily increasing clutter of unsalable work. His pricing was primitive. Large Cézannes went for one hundred francs, small ones for forty. If a canvas depicted a number of studies he was willing to slice it up and sell individual bits to hard-up enthusiasts, according to Vollard. Poor as he was, he still couldn't resist trying to help those even poorer than himself. Because he couldn't bear to part with certain pictures he put high prices on them to discourage a sale. In 1885, in danger of being evicted, he had appealed to Cézanne, who owed him four thousand francs. He would unwrap a canvas for someone he favored, prop it up on a chair, and after a reverential pause, exclaim, "Look at that sky, that tree, it's come off, hasn't it?" At times he was a little paranoid, afraid of being re-arrested, in his innocence seeing the Impressionists as revolutionaries like himself, and their work inflammatory.

Though Cézanne didn't stay long in Paris before retracing his steps there are gaps in his movements from now on, the documentary record provided by the correspondence with Zola being no longer available. It is known however that in the summer he stayed for a while with the Choquets at Hattenville in Normandy. Choquet had been feeling for-tunate, saved from financial anxieties by a legacy, until the sudden death of his only daughter devastated him. Cézanne painted another portrait of him, this time out of doors against a background of green foliage, before returning to the south. Then Renoir came south, taking up the invitation Cézanne had extended a year before when he was in the throes of his crisis. He rented part of Montbriand from Cézanne's brother-in-law and was there several months.

He must therefore have been there when Louis-Auguste died on October 23 at the age of eighty-eight. The strange dance Cézanne and his father had led each other had come to an end at last. When the estate was administered, Cézanne received 400,000 francs. At the age of forty-seven he was now wealthy. He went around saying that because of his father's genius he now had an income of 25,000 francs, ample for the maintenance of his wife and son as well as for his own simple needs. After forty-seven years fearing he might be disinherited he was a free

man. No wonder he was glad to join in the chorus of praise for the dead father. Gasquet heard him still continuing this glorification as his own life drew to a close. "Ah, there was a man who knew what he was about when he earned me an income. . . . Tell me, what should I have become without it? . . . One must love one's father. Ah, I shall never love the memory of mine enough. . . . I didn't show it to him enough."[8]

The sagacity, astuteness, and self-confidence he had pitted himself against while his father was alive he now saw as virtues in his own son, who soon took on the role of advisor in practical matters, taking over that side of life which had always defeated him, where he had felt so weak and helpless. He had nothing to fear now from his father, that was true, but one thing he would always regret and grieve over. There was no way in which he could ever please his father. In fact there had never been a way. In the old man's eyes he had always been a failure.

After the death of Louis-Auguste, says Cézanne's niece, he abandoned his upstairs studio and used the spacious salon on the ground floor, spreading chaos everywhere: "flowers, fruits, white cloths, on the chimneypiece three skulls, an ivory Christ on an ebony Cross—grandmother's Christ, it still exists."

Though he had turned his back stubbornly on the Paris scene, he went back in 1888—it is hard to be sure when. Usually his returns to the city were a sign that he had not given up hoping for a breakthrough, in spite of all the obstacles stacked against him. He may have kept away until now, thinks Jack Lindsay, because of the wound inflicted by Zola's novel, in spite of his refusal to admit to himself that he felt betrayed, exposed to everyone as "that Claude Lantier character." He lodged in a gloomy old house on the quai d'Anjou, number fifteen, on the north side of the Île Saint-Louis. He hadn't lived on the island before, and it's an odd coincidence, or further evidence that the two were still enmeshed, when one recalls that Claude lived at this very spot in *The Masterpiece*. On the other hand, the quiet quarter was one favored by painters. Guillaumin was at number thirteen. Daumier lived at number nine for seventeen years. Meisonnier had a watchtower built there in medieval style. And not only painters were attracted. Baudelaire had lived once at the Hôtel Lauzun, number seventeen.

He dug himself in and didn't budge from the quai d'Anjou for the next two years, only fleeing to Aix from time to time and disappearing on solitary expeditions to Chantilly or along the banks of the Marne. Sometimes he could be found in a studio he leased in the rue du Val-de-Grace. Zola described the island and the river life on the doorstep

of Claude's location in his novel. Claude and Christine strolled around the quays and stood against the parapet looking down at "the dredger whose buckets grated against their chains, the floating wash-house which resounded with the hubbub of a quarrel, and the steam cranes busy unloading the lighters. . . . They went round to the point of the island, strolling more leisurely still to enjoy the solitude and tranquility which the old historic mansions seem to have implanted there." Coming back, they saw in a flash of lightning "the straight, monotonous line of old houses bordering the narrow road in front of the Seine. It blazed upon the panes of the high, shutterless windows, showing up the melancholy frontage of the old-fashioned dwellings in all their details; here a stone balcony, there the railing of a terrace, and there a garland sculptured on a frieze."[9] However strained the relations may have been between Cézanne and Hortense he kept painting her and she remained a favorite sitter, presumably because of her willingness to stay motionless for long periods. He went on painting her portrait in the late 1880s and into the 1890s. An unfinished canvas enables us to see his approach, the strokes going on as thin as watercolor, the features modeled with delicate tones. Behind her is a low wall, above it a small branching tree, its trunk angled in harmony with her body, the hands clasped submissively. The lively and talkative woman she really was has been submerged in the inert pose and expressionless face. Plants to her right cascade down the wall, conveying a softness absent in the more severe portraits where she appears against a plain background, her oval face inscrutable as a Buddha.

Paintings and drawings of his son, now coming to the end of his teens, kept multiplying. A full-length drawing has him standing assertively, one foot thrust forward, one hand on his hip as if to say, "How do you like my new waistcoat and breeches?" Perhaps to illustrate his son's rapidly changing persona he portrayed him, again full length, striding vigorously forward as Harlequin in *Mardi Gras* under swagged drapery, attended by a Pierrot whose right hand is lifted furtively behind Harlequin's oblivious back. The face of Harlequin however is slyly knowing, the eyes swiveling downward toward the clown. The son of the shoemaker Guillaume stood in for Pierrot, and it is believed he fainted one day after being made to hold his pose for hours on end. Cézanne's son enjoyed fancy dress and amateur theatricals in his youth, which may have encouraged his father to attempt this subject, uncharacteristic though it is. And indeed it is stamped with his own somber vision. As well as expressing his approval for the cocky

extrovert his son is becoming, the proudly moving figure has some-thing incongruous, almost sinister about it, as if the playful drama being enacted is in reality an interior one, obscure as a dream and vaguely menacing.

The same enigmatic air pervades another study of adolescence, *Boy in a Red Vest*, one of a series of paintings and watercolors of an Italian peasant boy produced during this period. But unlike his son, this boy droops where he stands, negated by his sadness and doubt. The brilliant red waistcoat, shading into violet, far from being assertive, is only there to underline the dilemma of a body in the full flood of young life and yet imprisoned inside its clothes. In Rembrandt, in Titian, the person lives vitally under the clothes. Here the boy is covered up, unhappily shrouded and brought to a halt. His pliant limbs are constricted too by the powerful drapes, curving away at the right and pouring straight down in a brown waterfall on his left. His left arm, beautifully balanced and tilted, bends against the straight folds, hand on his hip and the other hanging irresolute in the pose of the classical nude. One critic speaks of the same means being employed in this picture as in those by Rembrandt in his greatest portraits, where an "intensification by contrast" adds to the range and depth of the psychology. Not that psychological portraits were ever Cézanne's real concern. By coming face to face with an image of his own buried self, that part of himself struck dumb by a feeling of its inadequacy, he was perhaps seeking to free himself from its domination. Even this is to overlook his main aim, wonderfully realized—the achievement of sonorous color and a powerful, subtly thought-out composition, making capital out of weakness and investing sadness with haunting grace. The eyes—as so often in Cézanne portraits—are virtually blind, in this case unfocused and blurred, the mouth a mere flick of the brush in a faint wavy line, as rudimentary as the wings of a distant flying bird drawn by a child.

He called on Tanguy when he wanted to sit quietly in a corner and enjoy unsophisticated "boring" company; he studied at the Louvre, and perhaps went home with his head full of impressions from Tanguy's collection of canvases, that Émile Bernard has said was considered a chamber of horrors or a museum of the future, depending on the viewer.

Just when it seemed he was entirely forgotten he popped up in a piece by Huysmans in *La Cravache*, an article later incorporated in his book *Certains*. It was recognition of a sort, if hardly contributing to a fair assessment. The age which was at last to recognize and embrace

Cézanne's art was still a long way off. Huysmans insisted on perpetuating the myth of the wild man of art, dealing with him in conjunction with a minor artist, C. Tisson, and a Sunday painter, Wagner. Huysmans confessed himself baffled by a mixture of originality and incoherence in the artist's work, alive at least to the

> strange, real truths, splashes of color of remarkable veracity, shades in linen which are the vassals of the shadows cast by curving fruits here and there in credible charming blues, which make these canvases creative when referred to the usual still lifes hacked out of repulsive bituminous blocks against incomprehensible backgrounds. Then these open sketches of landscapes, attempts which have remained in limbo; efforts whose freshness has been spoiled by touching up; lastly childish barbaric beginnings, astonishing equilibria; houses tottering over as if intoxicated; distorted fruit in drunken bowls; nude women bathing, insanely outlined with the fervor of a Delacroix for the greater glory of the eye without refinement of vision or delicacy of touch, lashed to a fever of dashed-on screaming color, standing out in relief on a canvas loaded to overbalancing point.[10]

He finished by depicting the sick figure of Zola's creation, an artist in travail, woefully lost and, by implication, doomed. "He is a revealing colorist, who has contributed more than the late Manet to the impressionist movement, but an artist with sick eyes, who in the wild misconceptions of his vision has discovered the premonitory symptoms of a new art."

◆ It was in this year that Cézanne and Van Gogh met at Tanguy's. Cézanne, who had long ago abandoned the *couillarde* fury of his 1866 paintings, was taken aback by the Dutchman's violence and passion. A major gain was the access he now had to something that the Mediterranean faun in him was, in all too rare miraculous moments, able to reach and be in touch with. He left blanks in watercolors, windows for this new thing to come through. The shimmering tenderness of his landscapes, with an evolving technique of light touches and airy strokes that went beyond impressionism, since its goal was definition and inwardness, came from an intuitive consciousness that was now fully awake, that now and then bore strange and tender fruit. Everything, he felt now, was animate. He was trying to capture the anima of the whole

picture by making himself responsive to the myriad things in it that were each alive in their own way. It was extraordinary when it worked, terrible when the thread snapped and he fell into a void, his brush poised for the next intuitive dab that would affect the whole, and the clue horribly lost. Better to smash the thing and wait for another moment. Chekhov, a firm believer in ascetic discipline, said once, "Painting a landscape is impossible without spirit or rapture, and rapture is impossible on a full stomach. If I were a landscape painter I'd lead an all but ascetic life." He added humorously, but more than half in earnest, "If monasteries accepted the irreligious and permitted abstention from prayer I'd become a monk."

Van Gogh was only too aware of the beauty and potency of the few Cézannes he had seen at Tanguy's, and the few that his brother Theo had collected and kept for himself. Writing to Theo after coming back from the shore of the Mediterranean near Arles, where the sea had the colors of mackerel—by which he meant changeable—he reflected on something puzzling about Cézanne that he wanted to fathom, eager as always to learn from others. "I'm thinking of what Portier used to say," he wrote in June 1888, "that seen by themselves the Cézannes he had didn't look like anything, but put near other pictures they washed the color out of everything else. He also used to say that the Cézannes did well in gold, which means that the color scheme was pitched very high. So perhaps, perhaps I am on the right track, and I am getting an eye for this kind of country. We must wait and make sure."

He reminded himself of where he was, and went on: "The country near Aix where Cézanne works is just the same as this, it is still the Crau. If coming home with my canvas I say to myself, 'Look! I've got the very tones of old Cézanne,' I only mean that Cézanne like Zola is absolutely part of the countryside, and knows it so intimately that you must make the same calculations in your head to arrive at the same tones. Of course if you saw them side by side, mine would hold their own, but there would be no resemblance."

In early August, struggling with the nonstop mistral, Van Gogh is struck by something that suddenly seems obvious: "All the same, I think that the continual wind here must have something to do with the haggard look the painted studies have. Because you see it in Cézanne too." And from Saint Remy, incarcerated in the asylum and recovering from "abominable nightmares," he tells Theo, "For yes, you must feel the whole of a country—isn't that what distinguishes a Cézanne from anything else?"[11]

In that first summer in Provence, up to his ears in work, maddened by ditches full of irises, a little town surrounded by fields of yellow and purple flowers, someone tells him in an antique shop of a painter by the name of Monticelli. He writes to Émile Bernard "like a machine out of gear," hoping the act of writing will be restful for him. "If you saw my canvases, what would you say of them? You won't find the almost timid, conscientious brush strokes of Cézanne in them. But as I am now painting the same landscape—though at a slightly different spot—there may well remain certain connections in it in the matter of color. What do I know about it? I couldn't help thinking of Cézanne from time to time, at exactly those moments when I realized how clumsy his touch in certain studies is—excuse the word—seeing that he probably did those studies when the mistral was blowing. As half the time I am faced with the same difficulty, I get an idea of why Cézanne's touch is sometimes so sure, whereas at other times it appears awkward. It's his easel that's reeling."

His use of the word "clumsy"—instantly amended—is rich coming from Van Gogh. But what a different criticism is that which issues from esteem. How sad that the two painters, so close on the ground, should have never joined forces and painted shoulder to shoulder as comrades, as Pissarro and Cézanne had once done. Alas, both men were morbidly suspicious of people's motives for wanting to associate with them. And one remembers the disastrous consequences when Van Gogh, yearning to alleviate his loneliness, enticed Gauguin down to share his yellow house in Arles.

Another letter to Bernard that year tries to coax a comment from him on the contrast between the two artists. "As I know how much you like Cézanne, I thought these sketches of Provence might please you; not that there is much resemblance between a drawing of mine and one by Cézanne. . . . But I too very much like the country they [Monticelli and he] have loved so much, and for the same reasons: the color and the logical design."

With unconscious irony he speculates on the advantages of the other's marital state, unaware of the facts and probably echoing Zola's belief, expressed in *The Masterpiece*—a novel he knew from cover to cover—that marriage was the essential condition for an artist who wanted to produce solid, regular work. "Cézanne is a respectable married man," he wrote earnestly to Bernard, "just like the old Dutchmen. If there is plenty of male potency in his work it is because he doesn't let it evaporate in merrymaking."[12]

Cézanne had slipped back to the south and was there when Renoir traveled through Provence. Whenever he felt dissatisfied or blocked he could never sit still, even though the Midi was the only place where he felt rooted. Even there he was soon itching to get on the move. A storm passed through his veins, vibrations full of unrest. Rather than wanting to get to another place it was an eagerness to get away from where he happened to be. Paris would sicken him; the people he knew there suddenly lacked substance. Then at Aix he would miss the current of creativity he felt thrown off by the sheer number of artists gathered together in close proximity.

Renoir, calling on his friend, couldn't get over the advances he saw in the other's work. Generous to a fault, he wrote admiringly, "How does he do it? He can't put two touches of paint on a canvas without success." Not that Cézanne was more satisfied than he had previously been. What he strove for was always just that fraction beyond his reach. Once, painting in the hills with Renoir, he caught sight of an old woman approaching with her knitting, clearly intent on a chat. "Look at that old cow coming," he yelled, beside himself, grabbing his equipment and making off at speed.

He was always glad to see Renoir, and asked him to dine at the Jas one day. Renoir loved country food, especially the "good fennel soups" Cézanne's mother made. The evening was ruined by a lighthearted derogatory remark Renoir let slip about bankers. To Renoir's amazement his friend took offense, losing his temper completely, with his mother saying with approval, "Really, Paul, in your father's house!" Renoir, too upset to stay at the Jas, took himself off to a house he leased nearby.

In 1889, in Paris again and on the Île Saint-Louis, Cézanne was represented by a painting, *The Suicide's House*, at the Exposition Universelle. How this came about is made clear by Vollard, who wrote, "Here again he was accepted through favoritism or more accurately by means of a bargain." Choquet had lent the show an item of furniture, one of his antiques, with a condition attached: a painting by Cézanne had to be shown. "Needless to say the picture was skied so that nobody save the owner and the painter ever noticed it." But this modest appearance may have prompted the article by the critic Roger Marx, one of the first to champion his work. On July 7 the artist wrote to thank him "for your kindness in taking an interest in me." Then in

November he was writing again, this time to Octave Maus in Brussels in response to an invitation to exhibit work in 1890 with an independent group of artists, *Les Vingt*, together with Segantini, Sisley, Van Gogh, and others. First, though, he had to refute an "accusation of disdain with which you charge me in connection with my refusal to take part in painting exhibitions. I must mention in this relation that as the numerous studies to which I have devoted myself have given only negative results, and as I feared too well-justified criticism, I had resolved to work on in silence till the day when I feel capable of theoretically defending the result of my attempts. But in view of the pleasure at finding myself in such good company I do not hesitate to modify that resolution. . . ."[13]

In fact the sudden invitation out of the blue had come like a bombshell. The shock overcame his reservations and he accepted. He got Choquet to send in *The Suicide's House* for him, and submitted a study of *Bathers* and another landscape, one of Auvers. He was unwilling to expose any recent landscapes.

Alas, for him the show was a waste of time: his work went unnoticed. The canvases by Van Gogh, however, caused an uproar. One of the Belgian artists, Henry de Groux, threatened to pull out his pictures rather than have them in the same room as this Dutch barbarian. He insulted two of the guests of honor, Signac and Toulouse-Lautrec, and was promptly expelled.

Cézanne, restless as ever, went shuttling back and forth between Paris and the Midi. A few months in one place and he'd be on the move again. Ambivalent about most locations, his inability to settle was now made worse by deteriorating health. Fearing an early death he worked even harder, at his easel by six in the morning and staying there, with a short break for lunch, till sundown. He was fifty-one, his hair turning white. A doctor had diagnosed diabetes, which, since its onset was recent, he was able to control by a diet that was apparently not a rigorous one.

While in the south he moved from one old haunt to another; from Aix to Gardanne, from Gardanne to l'Estaque, and from l'Estaque back to Aix. When he was based in Paris he rambled around the country, in the hamlets of Fontainebleau and Chantilly and in remote villages on the banks of the Seine, the Marne, and the Oise. Intensely irritable if someone mentioned a teacher at the Beaux-Arts or a member of the Institute, he was liable to fly into a rage if noises in the street upset his concentration. Driven out of the house on the quai d'Anjou by some such disturbance he went to lodge for a while in the avenue

d'Orléans, near the place where he had lived in the rue Beautrellis thirty years ago. But not for long. It is hard to know whether Hortense objected or was simply resigned to this unending series of uprootings. Certainly she would have been accustomed to it. Between 1896 and 1900 he kept shifting from one studio to another around the edges of Montmartre. Indifferent to his surroundings, he was satisfied if he had proper light and a quiet district.

Anything could make him break camp. It was after Choquet's death that he went to live in the avenue d'Orléans. He had lost one of his most loyal supporters.

The Cézanne family nickname for Hortense, probably derisive, was The Queen. Remembering this, Cézanne's niece acknowledged that, though Hortense was little mentioned in Aix, "she is not without qualities, she has an equanimity of humor and a patience proof against anything. When Cézanne isn't asleep she lectures him at night, and that goes on, sometimes, for hours. Her mother-in-law, who feels no special tenderness for her, recognizes her patience: and then she has given him a son." Cézanne was renowned for his ability to fall asleep after work at the drop of a hat. A friend in Aix made a drawing of him slumbering, inscribing it: "*Chut*! Cézanne's asleep!"

*The Great Pine*, done in 1890 or the year after, was painted at Montbriand at his brother-in-law's place. It stands as a symbol of heroic youth, the Homeric force of his and Zola's aspirations in the eddying currents of the Provençal air of those days bending the trunk visibly as it rises. Up goes the pillar of sap through splintered branches to the great triumph of dense foliage, shaken like a banner by the wind and spreading across the whole strip of sky. The tree is planted naively and yet profoundly in the center of the canvas, the orange bands of the ground sloping away from its drama, the other smaller trees swaying to the left as if subjugated and in awe of this giant, leaning their thin trunks away from it. The nineteen-year-old Cézanne, already mourning his lost paradise in a letter to the absent Zola in 1858, begged him not to forget "this pine which protected our bodies with its foliage from the heat of the sun . . ." and memorialized it further in a poem five years later:

> The tree shaken by the fury of the winds
> Stirs its stripped branches in the air,
> An immense cadaver that the mistral swings . . .[14]

If he was forced to stay put, he took refuge in himself, an old solution that had become a way of life. Émile Bernard quotes him as saying

sadly, "Isolation, that's what I'm meant for. At least then nobody gets the *grappin* into me." But escape wasn't always possible. Hortense's father had died. It was necessary for family reasons to go to the Jura and she made this her excuse for spending some time in Switzerland. Cézanne agreed to the trip, then soon wished he hadn't. The Swiss countryside left him unmoved, though he was driven to attempt two landscapes. He thought so little of them that he left them behind at the hotel in Neuchâtel. "There's nothing but *that*," he used to say in disgust about Switzerland, and point at the sky.

Passing through the Swiss cantons he visited Berne, Fribourg, Vevey, Lausanne, and Geneva. He made another attempt at painting landscapes at Besançon. Walking with his wife and son through the streets of Fribourg he was so frightened by an anti-Catholic demonstration that he bolted like a terrified horse. Hortense became alarmed when he failed to turn up at the hotel that evening. She looked everywhere for him, but in vain. A letter from Geneva solved the mystery of his whereabouts, but why had he been so terrified? It is hard to believe it was on account of his piety. More probably the sight of a disorderly mob packing the narrow street panicked him. As we have seen he had a dread of being trapped and accidentally pushed against.

He had inside him his freethinking father and his need to be embraced and consoled by a great mother, one jostling and contradicting the other. His attitude to God was frequently sardonic, sometimes downright sacrilegious. But with his worsening health and his premature fears of aging he turned to the church as a prop. "The nearness to death," Tolstoy wrote, "is the best argument for faith. . . . Better to accept the old, time-honored, comforting and childishly simple faith. This is not rational, but you feel it."

Cézanne got angry with God now and then as he did with everyone else, at times amusing himself in the process. Vollard says that "Cézanne didn't restrain himself from packing the Good God off to all the devils at the least mishap, at least when he didn't find a victim near at hand to let his anger loose on." Once he had to abandon a portrait when fog descended and obscured the light. "So, with his fist raised toward the window . . . miming a man in fury but already amused at what he was going to say, he cried, 'That chap up there is happy, he has all the dreamed-of time to give himself up to his orgies of color.' " Yet to take Zola's atheistical stand, or to call the Christian God "a crime against life," as Nietzsche did, would have been beyond him.

Old Louis-Auguste had predicted long ago that his daughter Marie

would be devoured by the Jesuits, as his son was devoured by painting. Cézanne's niece didn't see it that way. "It wasn't so; Marie, very shrewd, gives at times alms for good works, but she knows how to keep her property." Cézanne liked to put it absurdly by saying, "As I'm a weak character I lean on my sister Marie, who leans on her confessor, who leans on Rome."

In an effort to feel in control of his material life, and encouraged by Marie, he divided his income of 25,000 francs into monthly portions, and then divided these parts into three, for himself and his wife and son. Young Paul, now nineteen, showed no artistic aptitude whatsoever, but displayed a flair for practical matters, to the amazement of his doting father. He was considerate enough to make allowance for his father's peculiarities, such as his aversion to touch, only taking his arm after saying, "Pardon, you'll allow me, Papa."

Hortense was finding her allowance insufficient in Paris, alarming her cautious husband with demands for increases. He acted against her at last, no doubt again aided and abetted by Marie (who may even have come up with the idea) by reducing her allowance in order to bring her to heel. This meant she couldn't afford to stay in Paris and had to return to Aix where he could keep an eye on her. But he had no intention of living with her any more than he could help; she cramped his style to an insufferable extent. Instead he found a flat for her in the rue de la Monnaie when she arrived with her furniture. She, for her part, didn't see why she should put up with the chilly atmosphere at the Jas, where he felt most comfortable.

For all his reclusiveness he had his expansive moments, when he astonished his friends by talking exuberantly with a gush of feelings. "It does me good," he would say, "I'm happy to loosen up." Paul Alexis found him in such a mood after his return from Switzerland, and sent a report to Zola, who had been asking for news of his estranged friend. Alexis, who always hated to be stranded in the south, wrote, "This town is dreary, desolate, and paralyzing. Coste, the only one I see fairly often, isn't much fun every day. . . . Fortunately, Cézanne, to whom I found my way back some time ago, puts some spirit and life into my daily round. He is at least vibrant, expansive, and alive. . . . During the day Cézanne paints at the Jas de Bouffan where a workman serves as his model and where one of these days I shall go and see what he is doing." He added a caustic note on the painter's "conversion" to the faith of his mother and sister.

Zola must have been asking around among his friends for anything they could tell him, for at the same time Numa Coste was writing to impart what the novelist knew already, better in fact than anyone else:

> How to explain that a rapacious and tough banker could produce a being like our poor friend Cézanne, who I have seen recently? He is well and physically solid, but he has become timid and primitive and younger than ever. He . . . lives on one side, his wife on the other. And it is one of the most touching things I know to see this good fellow retain his childlike naiveté, forget the disappointments of the struggle, and obstinately continue, resigned and suffering, the pursuit of a work he cannot produce.[15]

The still lifes of the 1890s announce a master, able to create grandeur from groupings of the humblest of objects. His approach is different from that of any other painter before or since. We are fooled into thinking that what we see is plain reality, for it is not. In *Still Life with Apples* it is clear beyond doubt why he distrusted methods that weren't of his own devising. He was seeing something else, and he was refusing the ready-made solution for an utterance which only mattered to him. When his intuition triumphed, what riches he felt descending on him! And by such apparently simple means. In this case a few yellowy red apples, a cup and saucer, a round table top, a pair of tongs, a common earthenware plate, a piece of card. These were the things that he forced again and again to be beautiful, as Rilke puts it, making them "stand for the whole world and all joy and all glory," doubting all the time whether he had succeeded.

The oddities in this canvas are many, and they are all deliberate, nothing to do with the calumny about his not being able to draw, nothing to do with his eyesight. Nor was he combining different viewpoints of the same object, the trite explanation given later for his distortions and suppressions, and the excuse seized on by the cubists for their own experiments. Here is the emergence of that Cézanne who would influence the modern movement to come in its "every turn and twist." For instance, the plate under the six apples leaves off continuing its oval on the right and just disappears. The saucer beneath the eccentrically shaped cup has two ellipses, the left smaller than the right. Behind the plate and its little pyramid of apples the sweeping dark curve of the table suddenly contracts. The dark stem-ends of the apples

make a pattern which seems somehow significant, the more one looks. The axes of the different forms shift to accommodate one another as they would never do in reality—but this is a *felt* reality.

*Still Life with Peppermint Bottle* has an abundance of sumptuous rhythms rarely seen in Cézanne. But nothing in the way of solidity and weight has been sacrificed. The curves of the intricately blue drapery with its black patterning sway the eye of the onlooker and create majesty. Above this to the left is a white cloth, fantastically writhing under the peppermint bottle with its swelling neck and the noble protuberances of a flask, in front of which stands a single wine glass. Splashes of bright color scattered throughout the canvas are the apples, the red label of the bottle, and its red-banded neck ending in a cork. The curves of the big flask are flattened on the left, harmonizing with the vertically placed bottle as it aligns itself with the severe vertical of the wall. The wall seems about to move, to slide, and in fact all the objects appear to be daringly in motion.

Who else would have juxtaposed, in his *Still Life with Plaster Cupid*, the commonplace objects seen in any kitchen, apples and onions, with works of art? It is like saying there is no difference, that only their presentation matters. And then another question arises: these artworks within the art are several times removed from the original reality. The figure filling the center of the picture in a white column of rounded bodily curves is a cast of Puget's *Cupid*, one of the sculptures he often studied. His sketchbooks are full of such studies. Half seen, that is to say sliced in half by the canvas edge at the top left, is the lower half of a study by Cézanne of *The Flayed Man* after Michelangelo, another cast, only this time further derived by the study and the painting of the study for the purpose of this picture. What are we being asked to consider here if not the lie of art itself, its illusionism? But this is to misunderstand Cézanne's intention, which is always to stress the relatedness of objects brought together, whether abstracted or as natural as an onion. In the common light that falls on them they become something else, participating in one another's reality. And after all this is the interior of the painter's studio, with propped canvases, one of which is set behind the Cupid, slanting away behind its back and also leaning subtly to parallel the axis of the statuette. This is where such alchemy happens as a daily occurrence. When the balance for which he was always striving, in this case the fat, soft round curves of the plaster figure balanced against the swarthy sprouting onions and rosy apple, came about, he felt the peace that was born from bringing the two sides of

the duality into equilibrium. It was what he might have called the realization of his soul, from which all aliveness sprang. He likened it to a "folding of hands."

Those few who saw him when he slipped into Paris would spot him hurrying down a street in an old tam-o'-shanter he had taken to jamming on his head. In 1894 he dug in for a while, taking lodgings in the Bastille Quarter that he knew so well. His behavior out of doors was now unpredictable. Guillaumin and Signac, strolling on the quays one day, saw him in the distance coming toward them. He confused them by his gestures, until they realized he was asking them to ignore him. To oblige him they crossed over to the opposite pavement. Another time he found himself nearly face to face with Monet in the rue d'Amsterdam. He had no quarrel with Monet but "lowered his head and dashed off through the crowd." Renoir, for all his esteem and friendly disposition, was unnerved at the thought of calling on his old friend in Aix after his last experience, and gave him a wide berth.

◆ Little by little he was being talked about, by the young rising painters especially, many of whom thought he was permanently holed up in the south like a hermit. Some even thought he was dead, or believed his name was an assumed one, the pseudonym of a famous painter who didn't want to own up to experimental work. A group of the new generation beginning to be influenced by him, if obliquely, were the Nabis, followers of Gauguin, who would say in his cheerfully impudent manner as he marched off to paint, "Let's do a Cézanne." He could have told them that the Aix mystery man wasn't a myth, but he had taken himself off to the South Seas. Those curious enough to want to see the work firsthand had to be content with those examples stored at Tanguy's. One went there, said Émile Bernard, as to a museum, to see the few sketches by the unknown artist who lived in Aix, dissatisfied

> with his work and with the world, who himself destroyed these studies, objects of admiration though they were. The magnificent qualities of this true painter appeared even more original because of their author's legendary character. Members of the Institute, influential and avant-garde critics, visited the modest shop in the rue Clauzel, which thus became the fable of Paris and the conversation of the studios. Nothing seemed more disconcerting than these canvases, where the most outstanding gifts were coupled with a

childlike naiveté. The young felt the genius, the old the folly of the paradox; the jealous saw only impotence. Thus the opinions were divided and one passed from profound discussions to bitter jeers, from insults to exaggerated praise. Gauguin, confronted by their daubed appearance, exclaimed, "Nothing looks more like a daub than a masterpiece!"[16]

The mystery attaching to the invisible painter was enhanced by the presence of little Tanguy himself, this thickset elderly man with a grizzled beard and large beaming dark blue eyes, who peered at visitors over his glasses and then looked down at an uncovered canvas brought out from a cubbyhole "with all the fond love of a mother." Asked for information he could tell them nothing definite, trotting out quaint comments which only added to the legend. Cézanne, he would say happily, was never satisfied with what he did, he always gave up before he was finished. When he moved house he left his canvases behind, when he painted in the country he abandoned them in the fields. He worked with painful slowness and there was nothing accidental in what he did. He would end proudly, "Cézanne goes to the Louvre every morning."

The good man died in 1894 of cancer of the stomach. His collection was auctioned to help his widow. Six Cézannes fetched a total of nine hundred francs. Vollard the dealer bought five at these knocked-down prices. Since 1892 there had been a little flurry of critical attention, headed by Georges Lecomte, who treated the artist with sympathy in his book *L'Art impressioniste*, and this had been stimulated by essays and a short biographical sketch by Émile Bernard, who spoke of Cézanne opening "a surprising door to art; painting for its own sake." These expressions of interest had alerted the hard-up Vollard, who couldn't get Tanguy to part with his Cézannes and pounced the moment he was dead.

Gustave Geffroy, an influential critic and writer, and one of the painter's most prominent defenders in years to come, decided after the Tanguy auction and the sale by Duret of his collection, which included three Cézannes, that the time was right for an appraisal of the artist. It appeared in *Le Journal* on March 25, and for once was unstinting in its commendation. It was in fact the only tribute without ifs and buts that he had ever received. Cézanne didn't approach nature with a theory of art, stressed Geffroy, or with the intention

of submitting it to some preconceived law, to some personal aes-
thetic formula. And yet for all that he is not without a plan, a con-
vention, an ideal. However they do not derive from art, but rather
from his ardent curiosity and his desire to possess what he sees and
admires. He is a man who looks closely around him, who is intoxi-
cated by the spectacle before him, and wants to record that intoxi-
cation within the limited space of the canvas. He sets to work and
searches for the means of accomplishing this transposition with the
greatest possible truth."[17]

This astonishingly respectful tone, not to mention the intelligence,
must have made heady reading for the wary Cézanne. In the third vol-
ume of his *La Vie artistique*, published the same year, Geffroy rein-
forced his comments with an outline of this bizarre individual's career.
"We could define him as a person at once unknown and famous, with
only rare contacts with the public and seized on as an influence
by . . . the seekers in painting, known only by a few, living in wild iso-
lation, disappearing, reappearing abruptly before the eyes of his inti-
mates. . . . It is an unforgettable sight, Renoir has told me, Cézanne
installed at his easel, painting. He was truly alone in the world, ardent,
concentrated, attentive, respectful. . . . At times he went off in despair,
came back without the canvas that he'd abandoned on a stone or the
grass as the prey of wind, rain, sun." He applauded in his work "a deep
sensibility, a rare unity of existence. Surely he lived and lives a fine
inner *roman*, and the demon of art dwells in him."[18]

The painter living "on the margins of life," as Geffroy put it, wrote
a brief note of appreciation from Alport on March 26. The two were
yet to meet. "*Monsieur*, I read yesterday the long study that you devot-
ed to throwing light on my efforts in painting. I wish to express my
gratitude for the understanding I find in you."

He went back to Aix, then in the New Year was back in Paris, writ-
ing to thank Geffroy for a book of his, *Le Coeur et l'esprit*, which the
critic had inscribed for him. In the spring he asked Geffroy to sit for
him. The portrait is one of his finest, though it caused him such
anguish that he insisted afterward that he'd abandoned it. He went to
Belleville for three months almost daily to paint the distinguished
author in his study, seated at a large worktable strewn with papers in
front of bookshelves covering the wall. He undertook the project after
much vacillating. As the days lengthened and got warmer he finally

took the plunge and committed himself, signing himself in another note, "Paul Cézanne, painter by inclination."

Eighty sittings later he threw in the towel, asking for his easel, brushes, and paints to be sent back to him and explaining that the enterprise was beyond his powers, he shouldn't have undertaken it. Geffroy begged him to reconsider and he went back and struggled for another week. But he'd convinced himself that it was useless to continue: he gave up again and left for Aix, leaving the portrait with the sitter.

To us it seems completed, in fact a triumph. Again, as with so many of his portraits, the face is of little consequence. The problem for him may have been to do with the strong personality of Geffroy, whose mind couldn't help imposing itself. Cézanne was happier with common people, men and women who sat passively and didn't intrude their egos. Telling the important critic to "be an apple" wouldn't have worked. Schapiro notices how contrived and yet paradoxically natural the portrait looks. The logically propelled man is contrasted with a crowded room in some chaos, the shelved books with their orange and yellow spines leaning this way and that, the figure posed with his arms spread as though repressing a need to work. His head is stiffly set, the whole figure forming "an immovable pyramid" stamped with purpose. Half out of the picture to the left is the little feminine statuette, a plaster cast after Rodin, its bent arm corresponding to the bent left arm of the man, its soft image an emblem of the anima which responds to painting. Also on the table, a tulip in a blue vase leans over the right wrist and continues the axis of the writing arm.

In spite of the artist's violent reaction the two men were in accord for most of the time, respected each other enormously, and found plenty to talk about. Monet, whom Cézanne liked and admired, cropped up. "The sky is blue, isn't it?" Cézanne said. "And it was Monet who first noticed it." Another day he called Monet "the greatest of us all. Monet, why I add him to the Louvre."

The two went together to a tavern by the Saint Fargeau, and often Cézanne lunched with Geffroy and his mother and sister. One thing which did upset him was the other's friendship with the statesman Clemenceau. He told Geffroy with his usual blend of pathos and perversity, "It's because I'm too weak . . . and Clemenceau couldn't protect me. Only the Church can protect me." It wasn't that he was averse to finding Clemenceau's anticlerical jibes amusing, but they scared him too. What he needed, from whatever source, was support, *appui*. From this need came the strength of his response to Geffroy's article. As

Monet wrote to a friend, "How unfortunate that this man should not have more support in his existence. He is a true artist who has too much self-doubt. He needs to be bolstered up. . . ."

◆  He was fifty-six and looked in his late sixties. Tall for a Provençal, florid, with piercing eyes, his beard was now almost white and turning fine, the hair around his bald pate the same, his face mobile, rugged, almost peasantlike. Terribly emotional in spite of his bouts of rudeness, he twitched sensitively, roared with laughter unexpectedly, and lapsed into moodiness in the space of a few minutes. Accosted by someone who tried to say how enthusiastic he was about his work, he took his hand, trembling, and said, "I'm a plain man, you mustn't pay me compliments and tell me polite lies." There was a sweetness about him that was always bewildering those accustomed to his rough manners.

He was in touch again with an old painter friend, Francisco Oller, helping him with cash and storing some of his canvases in his studio. He also settled Oller's account at Tanguy's.

He went to paint at Giverny, near Vernon. The attraction was Monet, who had been living there for eight years. He stayed at an inn but was always welcome at Monet's house. In November, with Cézanne still in the vicinity, Monet invited some guests to meet him. It was an uneasy Monet who made the introductions: Cézanne's mood was fluctuating wildly. Clemenceau, Geffroy, Rodin, and the writer Octave Mirbeau were all charmed by this man who grew ever more sociable and confidential. Monet hadn't even been sure his friend would turn up, writing to Geffroy beforehand, "I hope Cézanne will still be here and be one of us, but he is so singular, so timid about seeing new faces that I'm afraid he'll keep away despite all the wish he has to know you."

He did come, and was at once overwhelmed by Rodin, who greeted him sincerely and shook his hand. "A man decorated with the Legion of Honor!" Gasquet speaks of being told by Cézanne of his encounter with Rodin at Druet's café-restaurant in the place de l'Alma. "He has genius . . . and he has a full purse," the painter told his self-appointed Boswell. "He arrived with his blouse splattered with plaster and sat next to the building workers. He's a sly fox, and his remarks shut them all up. But I love what he does. He's intense. People don't understand him yet, or if they do it's for the wrong reasons."

Getting excited over lunch at Giverny he started to lash out, though more in sadness than in anger, at those painters he suspected of stealing

from him. The chief villain apparently was Gauguin. Monet knew all about Cézanne's distrust of Gauguin, which was shared to some extent by Pissarro. "Never mention Gauguin to Cézanne," Monet used to say. "I can still hear him shout in his southern accent, 'That Gauguin, I'll wring his neck.' " Over lunch he was making fun of himself and venting his spleen at the same time as he explained to Mirbeau, "I had a little sensation, a tiny little sensation—it was nothing in particular. But it was my own little sensation. Well, one day M. Gauguin took it from me. And he went off with it. He trailed the poor thing about in ships . . . across America . . . Brittany and Oceania . . . across fields of sugarcane and grapefruit . . . to the land of Negroes and I don't know what else. How do I know what he's done with it?"[19]

It was a good performance, but like all his jokes it had an undercurrent of reproach. Another occasion, again arranged by Monet at Giverny, which was meant to cheer Cézanne up, went badly wrong. With the best of intentions, Renoir, Sisley, and other trusted friends gathered to wish the downcast painter well. Monet tried to put into words the feelings of them all by saying how happy they were to be able "to tell you how much we love you and how much we esteem and admire your art." To his dismay he found Cézanne glaring at him. "You too are making fun of me," his friend cried in a shaking voice. He turned on his heel, grabbed his overcoat, and dashed off. He left unfinished canvases at the inn where he'd been staying, which Monet forwarded to Aix. A letter from there stiffly attempted to make amends. "So here I am back again in the south," he wrote mournfully, "which I ought, perhaps, never to have left, to fling myself once more into the chimerical pursuit of art. May I tell you how grateful I was for the moral support I found in you and which served as stimulus for my painting." He wrote again on July 6, 1895, to say that he was alone with his ill mother. Marie, after an altercation of some kind, had removed herself and was living in a flat in Aix.

Isolated, brooding over imagined slights and stung by everything, from "high-handed manners" to the memory of laughter which may or may not have been at his expense, he fell out with Oller, who had thought he was traveling to Aix with Cézanne, only to find himself stranded on the platform. Cézanne had gone without him. Finally the Cuban got to the Jas, expecting to be met by an apologetic friend. Instead Cézanne was in a foul mood, arrogantly denouncing everyone, even that "old fool" Pissarro and the "sly" Monet. There wasn't one amongst them who had guts, he shouted, stamping around violently.

The two men saw something of each other for the next two weeks, until Oller rashly ventured some advice in "a tone of authority." In a letter that was a strange reversal, invoking his father as a man deserving the greatest honor and respect, he told Oller not to come again. Even the tolerant Pissarro was aghast at Oller's account of the episode. Writing to his son Lucien he said Oller had received "a terrible letter. Indeed it's a variation of what happened to Renoir. It seems he's furious with us all." Meanwhile the bitter exchange of letters between the insulted Cuban and Cézanne continued, until Oller was asked on July 17 to fetch his stored canvases from the rue de Bonaparte and told he was released from "repaying the money I advanced you and everything else." Oller was convinced that Cézanne was mad. "Isn't it sad and a pity," lamented Pissarro to his son, "that a man endowed with such beautiful temperament should have so little balance."

Mary Cassatt, daughter of a Philadelphia banker and a friend of Degas, encountered him at this time and paints a rather different picture. Labeling him curiously as "a celebrity" and the inventor of Impressionism, she is startled to find herself confronted by

the man from the Midi whom Daudet describes: "When I first saw him I thought he looked like a cutthroat with large red eyeballs standing out from his head in a most ferocious manner, a rather fierce-looking pointed beard, quite grey, and an excited way of talking that positively made the plates rattle." I found later that I had misjudged his appearance, for far from being fierce or a cutthroat he has the gentlest nature possible, *comme un enfant* as he would say. His manners at first rather startled me—he scrapes his soup plate, then lifts it and pours the remaining drops in the spoon; he even takes his chop in his fingers and pulls the meat from the bone. He eats with his knife and accompanies every gesture, every movement of his hand with that implement, which he grasps firmly when he commences his meal and never puts down until he leaves the table. Yet in spite of the total disregard of the dictionary of manners he shows a politeness towards us which no other man here would have shown. He will not allow Louise to serve him before us in the usual order of succession at the table; and he is even deferential to that stupid maid, and he pulls off the old tam-o'-shanter—which he wears to protect his bald head—when he enters the room. I am gradually learning that appearances are not to be relied upon over here. . . ."[20]

According to another witness he stopped Vollard from telling him about a news item in the paper, not wanting him to go on within earshot of the maid. "But she knows all that well enough," Vollard protested. "You can even be sure she knows a great deal more about it than we do." "Possibly," Cézanne said, "but we'd better pretend that we don't know she does." His *pudeur* before women was the reverse side of his fear of them, and a strange contrast to his use of scatological language when among men.

There is the rough draft of a note to a color merchant at Melun, dated September 21, 1895, which shows how unchanged he was, still as thrifty as ever in spite of his inherited wealth. He had been over-charged by one and a half francs on some canvases, he maintained, and expected a refund when he was next passing through.

Plagued by increasing worries about his health he went to Vichy in 1896 to take the waters, staying with his family for about a month and painting a little. From there he journeyed to Talloires, bringing back a few canvases, including a brilliant *Lac d'Annecy*, the forms fragmented and faceted in his new daringly free style. He wrote to Joachim Gasquet, the young poet who was the son of one of his old schoolmates, and to his old friend Solari. In both letters he complained about the tameness of the scenery "as we have been taught to see it in the albums of young lady tourists." To Solari he confessed that he was as ever incessantly restless. In Aix he felt he'd be better off somewhere else. Once there, wherever that was, he wished he were in Aix again. "Life is beginning to be sepulchrally monotonous for me. To keep myself busy I am doing some painting, it isn't very amusing, but the lake is all right with great hills all around it. . . . It doesn't compare with our own country, though it's well enough in its way.—But when one has been born down there, it's all up, nothing else is worth much."

Back home in the south, he went on an excursion in November with Solari, his son Émile, and Emperaire. Later, Émile Solari provided one of Cézanne's first biographers with a record of the jaunt.

We visited Bibémus, a country house with wonderful outbuildings. Old stone quarries have left strange caves in the neighborhood. Cézanne, tall with white hair, and Emperaire, small and deformed, made a weird combination. One might have imagined a dwarf Mephisto in the company of an aged Faust. Further on, after crossing a considerable stretch of ground planted with small trees, we found ourselves suddenly facing an unforgettable landscape with

Ste. Victoire in the background, and on the right the receding planes of Montaiguet and the Marseilles hills. It was huge and at the same time intimate. Down below the dam of the Zola Canal with its greenish waters. We lunched at St. Marc under a fig tree on provisions got from a roadmenders' canteen. That night we dined at Tholonet after a walk over the stony hillsides. We returned in high spirits marred only by Emperaire's tumble—he was a little drunk and bruised himself painfully. We brought him home.[21]

Poor Emperaire with his twisted back was prone to accidents, but nothing would put him off. Nevertheless, for a more ambitious trip they had to leave him behind. They wanted to ascend the great mountain itself, which wasn't so much dangerous as exhausting, and took at least three hours of hard climbing. Cézanne had climbed it often enough in his youth, but now he was diabetic, and fifty-seven. Solari was only a year younger. They reached the village of Vauvenargues near the base of the mountain, sleeping in a room hung with clusters of smoked hams dangling from the beams. At daybreak they started the climb. Solari's son happened to notice how blue the green bushes along the path looked in the morning light. "The rascal!" Cézanne said, pretending to be annoyed. "He notices at a glance, when he's only twenty, what it's taken me thirty years to discover." Émile Solari sat having lunch with them on the summit in the ruins of the chapel of Calmaldules, where Walter Scott located an episode in his novel *Anne of Geierstein*, and heard the two men speaking of it and reviving memories of their youth. A fierce wind was blowing nonstop.

Going down, Cézanne stopped to see if he could climb a small pine by the roadside. He had to give up. "We used to be able to do that so easily," he said to Philippe, his voice full of regret.

# 12 TOWARD THE PROMISED LAND

Nowhere in Cézanne's letters of the time is there a reference to the controversy caused by the Caillebotte bequest, when the government was faced in 1895 with a dilemma: whether or not to accept the collection of contemporary paintings which the rich Caillebotte left to the state. Caillebotte's prophecy had come true. He had forecast in 1876 that twenty years would see the Impressionists accepted by the public. This had happened. Now the diehard painters were forced to mount a rearguard action to save the sacred Luxembourg from being sullied by sixty-five examples of Impressionist "rubbish."

The aged Gérôme fired the first shot in the *Journal des Artistes*: "Caillebotte? Didn't he used to paint himself? I know nothing about it. I don't know these gentlemen, and I know nothing about this bequest except the name—there are paintings by M. Manet among them, aren't there?—and by M. Pissarro and others?—I repeat, only great moral depravity could bring the state to accept such rubbish—they must have foolishness at any price; some paint like this, others like that, in little dots, in triangles—how should I know? I tell you they're all anarchists—and madmen."[1] Roujon, director of the Beaux-Arts, and Bénédite, curator of the Luxembourg, ranged themselves alongside the reactionaries, though without the authority to flout public opinion openly. Caillebotte's heirs took them on, and this tedious wrangle lasted until 1908.

The heat and clamor generated by this warfare encouraged the astute Vollard to consider putting an end to Cézanne's obscurity with a one-man show. Vollard had been waiting in the wings for some time, foiled at first by Tanguy's refusal to part with his treasures. First, though, he had to track down his quarry. No one seemed to know where he was. Someone thought he'd been seen painting in the forest of Fontainebleau. Vollard combed the area, village by village. Nothing. Then he heard that Cézanne had a studio near Avon. The owner of the studio said yes, Cézanne had rented it, but had gone back to Paris. The address? He had no idea. Then he did recall something: the street bore the name of a saint coupled with an animal's. Vollard, now more keen than ever, combed the Paris street directory and finally came up with rue des Lions-Saint-Paul. He found the street, inquired from door to door, and at last located him at number two. His son was at home, and presumably Hortense. The elusive painter had left for Aix.

The son wrote to his father and Cézanne's consent came back. Renoir, who was using Vollard at the time, applauded the dealer's enterprise and said a show was long overdue. He deplored his friend's neglect, calling it a national disgrace. Cézanne, changing his mind a dozen times about the whole affair and affecting a lack of interest, agreed to the show at last and sent nearly 150 canvases, rolled up to facilitate their transportation since the stretchers took up too much space. The exhibition opened in November at 39 rue Lafitte. It attracted enormous attention, much of it hostile. Vollard had put one of the *Bathers* in the window, together with another study of nudes. The figures were naked men and caused either outrage or laughter. The *Journal des Artistes* sounded a note that Cézanne must have found only too familiar, expressing concern for the shock to viewers inflicted by "the nightmare of these atrocities in oil which even eclipse the legally authorized effronteries." Vollard tells of a commotion at the door one day. A husband had brought his wife along to teach her respect for him, and she was protesting, "How could you punish me like this?"

The press as a whole was reasonably moderate, while Cézanne's admirers had their faith in him vindicated by this spread of work. Pissarro wrote to his son, "My enthusiasm is nothing compared with Renoir's. Even Degas has succumbed to the charm of this refined savage. Monet, all of us . . . are we wrong? I don't believe so. The only people who don't yield to Cézanne's charm are precisely those painters and collectors who have shown us by their errors that their sensibilities are defective."[2]

One reaction would have been hard for Cézanne to swallow. Thiebault-Sisson, critic of *Le Temps*, whom Cézanne must have met at Médan, wrote as if he were lamenting the fate of Claude Lantier. "He remains today as he has always been, incapable of self-judgment, unable to derive from a new conception all the profit that cleverer people would have derived from it: in a word, too incomplete to be able to realize what he himself had first seen, and to produce his full measure in definitive works."

The most distinguished of his defenders was Geffroy. On November 16 in *Le Journal* he stood by the judgment he had already made, in even more laudatory terms, hailing "this traditional painter enamored with those he regards as his masters" who is at the same time "a scrupulous observer like a primitive anxious for truth" . . . "supremely sincere, ardent and ingenuous, harsh and subtle." He was destined for the Louvre, he declared.

Vollard at any rate was well pleased. Now that his artist was properly launched he made a pilgrimage to Aix in 1896 in order to secure more pictures and to meet the painter for, as he believed, the first time. In fact Cézanne had visited his gallery two years before to see an exhibition of Forain's.

As soon as he came face to face with the painter he recognized him. He began to collect various Cézanne stories that intrigued him, which ended up in due course in his volume on the artist. Canvases that had been attacked for one reason or another and left mangled in the garden were put on the fire by the gardener. One that survived was a still life, seen by Vollard hanging in the branches of a tree. Cézanne had flung it from the studio window in disgust. His household left this alone, since they'd seen the painter prowling under the tree with a long pole. Vollard, walking in the garden with Cézanne and his son, listened to the painter saying to the young man, "Paul, we must get down the *Apples*—I think I'll work on that one some more."

Something else which struck Vollard on this visit was the absence in his studio of the "artistic plunder" so many artists accumulated: one thinks of Rembrandt. On the floor stood a big box stuffed with watercolor tubes. Some apples "posing" on a plate were in a state of putrefaction. Pinned on the walls were cheap engravings and poor photographs of pictures by Poussin, Delacroix, Courbet, Rubens, and Forain.

At dinner he was in good spirits, expounding his doctrine of a submission to nature. "The main thing, Monsieur Vollard, is to get away

from the school—from all schools. Pissarro had the right idea, but he went a little too far when he said they ought to burn all the necropolises of art."

Vollard, feeling sure he would pick up discarded Cézannes around the town while he was there, put the word about that he was in the market for canvases. Before long someone appeared at his hotel with an object wrapped in a cloth. He sold the picture for 150 francs, which inspired him to trot back to his house with the dealer to inspect several more magnificent Cézannes. Vollard paid a thousand francs for the job lot, then on the way out was nearly hit on the head by a canvas that had been overlooked, dropped out of the window by the man's wife. All the pictures had been gathering dust, half buried in a pile of junk in the attic.

The following year he asked his new client to paint his portrait. Cézanne arranged an appointment at his studio in rue Hegesippe-Moreau in Paris and started work. He built a rickety throne on a packing case, balancing a kitchen chair on it. The ordeal began at eight in the morning and continued without a break till 11:30. When Vollard arrived Cézanne would lay aside *Le Pelerin*, according to him his favorite journal because it "leans on Rome." Vollard saw that the studio was even more austere than the one in Aix. The penny reproductions he had seen on the walls there had been left behind. Instead, a few of Forain's drawings clipped from newspapers and turning yellow had been nailed up.

The operation nearly ended in disaster at the very start when Vollard drowsed off and lost his balance. Chair, packing case, and he crashed to the floor. In a rage Cézanne yelled at him, "Does an apple move?" From then on Vollard drank plenty of black coffee before sessions. After 150 sittings the portrait was abandoned. Two little spots of bare canvas on the hand remained uncovered. Cézanne promised to attend to them another time. If he couldn't find the exact tone, he warned, he might have to start all over again. Vollard trembled at the thought. "The front of the shirt isn't bad," was all his tormentor would say before returning to Aix.[3]

His landscapes had now entered a final phase. The further he advanced into his last years the more daring his work became. There is drastic simplification, the few clear objects building to a composition of epic grandeur. "Life is all inclusion and confusion," wrote Henry James in the preface to *The Spoils of Poynton*, "and art . . . all discrimination and selection."

An idiosyncrasy that had become steadily more pronounced in the 1890s was his insistence on a barrier in the foreground of the picture, preventing the spectator from entering, forcing him to look, to concentrate. As well as this there was his liking for clenched intestinal forms, closely coiled trees, roots, ravines, overlapping and knotted. In the *Road at Chantilly* the path forward is obstructed by a fence, the landscape frontally presented. Elsewhere there are massive steep rocks, a pit or a quarry, or a pool of water. The ground beyond these obstacles is often broken, uninviting, inaccessible. This habit can be seen as a metaphor for his own isolation, or the expression of his desire to return to an Arcadia lost to him. But this is a painter of extraordinary tenderness who builds up his reality by repeated sensuous touches, each acutely aware of the last. His brushes seem to award every object with the final skins they have been yearning for. These touches are nothing less than acts of worship, acknowledging the presence of something operating subterraneously that dwelt in plants, inanimate objects, and all natural phenomena.

Cézanne, whose inability to bear people close to him was more an illness than a character trait, overcame his paralyzing fear of others by confronting in art what he found impossible to deal with in life. Painting had become his means of survival. He painted like someone who had discovered that the Garden of Eden was being carried around inside him, and all of us. The poet Gerard Manley Hopkins coined the word "inscape" for that aspect of a thing which makes up its essential unity of being, the very essence of itself, involving, he found, a kind of obliteration of that which separates the self and what it contemplates. The uncanny feeling one has when confronted by a Cézanne derives from this sense of being looked at as one looks.

The few painters who worked alongside him (Renoir, Pissarro, Sisley) were astonished by the intensity of his concentration, his effort to get into harmony with nature and his humbleness before it. To his observation he brought all the openness and receptivity he could muster. The dark energy pulsing through his landscapes and still lifes contradicts the commonplace familiarity of the objects and scenes, radiating back meanings in a two-way flow that Hopkins tried to convey by his statement, "What you look hard at seems to look hard at you." The stir of the soul that a late Cézanne painting brings about in an onlooker comes from its lovely freshness, the colors quick with rippling life, every part in touch with every other part, and all of it instinct with a perception of the uniqueness of what he saw.

The one-man show staged by Vollard may have been for him and for the young generation of painters and a few enthusiasts the artistic event of the year, but for Cézanne it had come too late. His Provençal distrust soon reasserted itself. What was real would always be the insults, frustrations, and rejections, the exasperation of a powerful father, his friend Zola's disloyalty, the closed door of the Salon. In April 1896 Numa Coste made a report to Zola:

> I have seen recently, and still often see, Cézanne and Solari, who have been here for some time. . . . Cézanne is very depressed and often the prey of melancholy thoughts. He has some self-satisfaction, however, and his work is finding sales to which he hasn't been accustomed. But his wife must have made him do quite a lot of foolish things. He has to go to Paris or return thence according to her orders. . . . He has rented a cabin at the quarry above the dam and spends the greater part of his time there.[4]

It looks from this as though Marie had stopped acting as a barrier between him and Hortense. He was still happiest at the Jas, caring for his ailing mother. Out in the country he had seen roadmasters playing cards in their hut, and at the Jas he posed peasants and day-laborers in a reenactment of the scene for his painting *Cardplayers*, and for another of men smoking their long clay pipes. These anonymous sitters were now his main subjects for portraits, a further indication of his desire to turn his back on the fashionable world. A peasant woman was pressed into service as a cook, while her son appeared in a painting showing a youth seated at a table, head propped on his hand in classical pose, gazing past a skull on the table. He found the skull "a beautiful thing to paint," and where compositions show floral patterned wallpaper or carpet there is as much sensuousness in the curves of the skull as in those of the flowers. Marrying life with death and flowering with decay was becoming a favorite theme, the autumnal tones reflecting Cézanne's growing preoccupation with his own mortality. So did one of his finest portraits, *Old Woman with a Rosary*, painted in homage to Rembrandt. Gasquet believed the sitter was an elderly nun who had fled a convent. Cézanne took her in and gave her work as a servant. The bowed old woman in a white cap grips her rosary with both hands as if she would sink to the ground and die without it. "Once old age has caught up with us," the painter said to his niece a few years later, "we find support and consolation in religion alone." The somber blues and greys and

the stoical image of the human condition the nun represents are like a testament to the painter's view of himself, turning at bay as old age and death approach, distressed by the infirmity of his aged mother.

Yet the young men who now began to approach him and listen to him with respect damped down his misanthropy to some extent. One of the first and most persistent of these we have noted already, the ambitious Joachim Gasquet, who aspired to be a poet. Cézanne appreciated his tactful approach and allowed himself to be cultivated by this passionate follower of Mistral. And after all he was the son of an old friend, Henri Gasquet the baker. Henri was a neat little man, well set up and respected in the community, his lips and chin shaven and his cheeks "aristocratically ornamented" with symmetrical sideburns. He wore spotlessly white cravats and looked like a councilor. In the portrait Cézanne did of him this is how he appears, tipped to the right in accordance with the painter's intuitive feeling for the flux of change.

When Joachim came into Cézanne's life in 1896 he was twenty-three and had just married. Perhaps it was because these youthful admirers were nearly all writers and poets that Cézanne let his guard down and felt able to trust them, at any rate to some extent, though the encounters were sometimes fraught. Émile Solari, the son of his old friend, who intended to be a novelist, went for country walks with Cézanne. Joachim, after he had ingratiated himself, introduced him to some of his literary colleagues such as Jaloux, Aurenche, and the poet Leo Larguier. "If I was interested in being with you," the artist told Louis Aurenche in 1902, "it was egotism, since I found myself with new friends in the wastes of this good town of Aix. I was unable to open my heart to anyone here."

So at the root of his surprising willingness to be befriended by the young was the same loneliness that drove him to paint the solitary nature of bathers, whether in groups or isolated on an earth he had once rejoiced in with others. Kurt Badt writes of a crucial time in the painter's life "when he realized he was fated to remain a lonely man." From then on "he felt impelled to record pictures from memory, the idyllic representations of an irretrievably lost association. . . . He was asserting that he had broken through the deadly menacing circle of his isolation and had gained a new understanding of the existence of the world by virtue of accepting his loneliness."[5] Fashioning oak groves in memory of his youth as a tree worshiper and peopling them with figures that looked like dryads, inseparable from trees, he was recreating

a time when ancient Provence was dense with chestnut and oak and elm, when the whole of Europe was forest.

Edmond Jaloux, who met Cézanne for the first time over lunch at Gasquet's, remembers the painter coming in with "an exaggerated air of prudence and discretion." He looked like a well-to-do peasant, sly and formal at the same time. His eyes were small and piercing, a little ferrety, his moustache drooping, his goatee military-looking. His nasal, slow speech had something careful and yet caressing about it. Louis Aurenche, also meeting him in Gasquet's house, thought how unhappy he seemed, standing there silent and confused, intimidated by the company. "His globular eyes stared anxiously at one after the other of us. If he said something to Madame Gasquet he would suddenly stop in mid-sentence and go red, afraid he might have let slip a coarse word. He excused himself and left before three so as not to be late for vespers."

Joachim Gasquet first set eyes on the painter sitting at a café table on the Cours Mirabeau, listening passively while Solari, Coste, and Gasquet *père* chatted to him. Night was gathering under the great plane trees, the Sunday crowd coming home

> from the band concert. It was a serene provincial evening. His friends talked to one another, he himself listened and watched with crossed arms. With his bald head, his long grey hair still abundant at the back, his short beard and thick moustaches, like those of an old colonel, which hid his sensual mouth, his freshly shaven cheeks and ruddy complexion, he might have been taken for an old retired soldier, were it not for his huge bulging forehead, the piercing eyes, which at once gripped you and never let go . . . and his reddened skin. That day a well-cut jacket covered his body, the robust body of a peasant and a master. A low-cut collar exposed his throat. His black cravat was neatly tied. Sometimes he neglected his appearance, going about in sabots and a ragged hat. When he thought about it he was well dressed. That Sunday he had probably spent the day with his sister.[6]

Young Gasquet went forward, as his father had promised to introduce him to his old school friend, the painter "who was scoffed at by the whole town." Foolishly he began to trot out some words of flattery. Cézanne flushed and began to sputter. Then he slammed his fist down on the table and shouted, "Don't you make fun of me, young man!"

The glasses rattled. Everything fell over. I don't think I've ever been more embarrassed. His eyes filled with tears. He took hold of me with both hands. "Sit here—is this your son, Henri?" he asked my father. "He's charming." The anger had left his voice, which was now kind and gentle. He turned to me. "You're young, you don't understand. I don't want to paint any more, I've given up everything. Listen to me. I'm an unhappy man, you mustn't hold it against me—how can I believe that you see something in my painting . . . when all those fools who write nonsense about me have never been able to perceive anything? What a lot of harm they've done me. It's the Ste. Victoire in particular that has struck you, isn't it? That picture pleases you—tomorrow I'll send it you—and I'll sign it too.

He was as good as his word. The canvas, one of the finest of the *Sainte-Victoire* series, now belongs to the Courtauld Institute, London.

He took the young man for a walk in the darkness there and then, along the boulevards at the edge of the town. Gasquet couldn't get over the painter's willingness to pour out his feelings. Moved by the lonely old man's desire to open his heart, he went back to see him. The following week he saw him every day. Each time Cézanne seemed to be bubbling over with some secret excitement. He took his eager young admirer to the Jas de Bouffan to show him

his pictures. We made long excursions together. He'd call in the morning; we wouldn't return till dark, wearied, dusty but enthusiastic, ready to start again the next day. It was an enchanted week, during the course of which Cézanne seemed to be reborn. He was like a drunken man. I think the same simplicity created a bond between my ignorant youth and his clear rich wisdom. All subjects of conversation were alike to us. He never spoke of himself but said he'd like to give me the benefit of his experience, since I was just on the threshold of life. He regretted I wasn't a painter. The countryside thrilled us. He showed me, and explained at length, the beauty of all his conceptions of poetry and art. My enthusiasm refreshed him. All that I brought him was a breath of youth, a new faith that made him young again. . . . He wanted to paint portraits of myself and my wife. He started one of my father. He gave it up after the first sitting, lured from the studio by our expeditions to Le Tholonet, to the bridge over the Arc, or meals, washed down with old wine in the open air. It was spring. He drank in the countryside with delighted eyes. The first pale leaves moved him deeply. Everything touched

him. He'd stop to look at the white road or to watch a cloud float by overhead. He picked up a handful of moist earth and squeezed it to bring it closer to him, to mix it more intimately with his own rein-vigorated blood. He drank from the shallow brooks.

"This is the first time I've seen the spring," he said.[7]

Then came the inevitable lurch into reaction and self-loathing. First the excess of high spirits after breaking out of his defended priva-cy, the brimming over of delight, the spring fever, and then the sicken-ing plunge into a knowledge of his exposure, the despair of feeling he had betrayed the unopened bud of himself, that no one had seen.

The dislocating withdrawal took the form first of all of megaloma-nia. He was a genius, he was the only living painter worth the name, he said violently, then clenched his fists and relapsed into angry silence. He went home gloomily as if under a cloud, or as though fleeing some blow about to fall. "He refused to see me at the Jas de Bouffan. For several days I called without result. Then I got this letter: 'Dear Sir, I am leaving tomorrow for Paris. Please accept my kind regards and sin-cere greetings.' "

That "Dear Sir" was a frightened slam of the door, an end to the illusion of a youth recaptured. It was the noncommunication of a man sealed away from the cruelty of false spring, false release. Gasquet was understandably baffled.

It was April 15th. The almond trees round the Jas, where I wan-dered about trying to conjure up the departed painter's image, had lost their blossoms. The friendly outline of the Pilon de Roi shim-mered, pale against the evening sky. It was there among these fields, these orchards and these walls, that Cézanne always painted. Suddenly on the 30th I met him coming back from the Jas with his knapsack on his shoulder, going toward Aix. He hadn't gone away after all. My first impulse was to run after him. He was walking as if crushed, sunk into himself, overcome, unseeing. I respected his solitude. An immense sorrowful wonder took hold of me. I bowed to him. He went on without seeing us, at any rate without return-ing my salute.

On that same April 30, after avoiding Gasquet and his wife, the crushed Cézanne hurried to make amends and to abase himself. It's an astonishing letter, full of angry shame and awash with self-pity as he drags out the "inner man" for the other's inspection:

Dear M. Gasquet, I encountered you at the bottom of the Cours this evening. You were accompanied by Mme. Gasquet. If I'm not mistaken you seemed very angry with me. If you could see me as I am inside, the inner man, you wouldn't be so. Don't you then see the sad state to which I am reduced? Not master of myself, a man who doesn't exist—and it is you who want to be a philosopher, who want to end by annihilating me? But I curse the various clowns who, to produce an article for 50 francs, have drawn the attention of the crowd to me. All my life I have worked so as to reach the point of earning my own living, but I thought one could produce well-done painting without drawing attention to one's private existence.

Certainly an artist desires to raise himself intellectually as much as possible, but the man should remain obscure. The pleasure should reside in the study. If it had been given me to realize, I should have stayed in my corner with a few studio-comrades with whom we used to go and booze a bit.

He mentions Emperaire, who hasn't got anywhere in the world,

but that doesn't stop him from being a bugger of a lot better than all those messers with medals and decorations that make one sick. And you want me at my age to have faith in anything. Besides I'm as good as dead. You are young and I understand that you wish to succeed. But as for me, what remains for me to do in my solitude is to be all submission, and were it not that I love enormously the configuration of my land I wouldn't be here.

But I've bored you enough like this, and after I've explained my situation to you I hope you'll no longer look on me as if I'd committed some violation of your security. I beg you, dear sir, on account of my great age, to accept all the good wishes I should like to make for you.[8]

The need for him to be "all submission" he sees at times in terms of defeat. Hence his action after painting the eloquent expression of it in the image of the old woman with her rosary. He threw the canvas down in a corner, Gasquet tells us, where it became thick with dust and trampled on. "One day I recognized it, I found it against the stove, under the coal scuttle, receiving from the zinc pipe a slow drop of steam vapor every five minutes. I don't know what miracle kept it intact."

As soon as Gasquet received Cézanne's letter "I ran to the Jas. As

soon as he saw me he opened his arms. 'Let's say no more about it,' he said. 'I'm an old fool.' "

Though the somewhat exalted young poet tended to express himself fulsomely, Cézanne had reason to be grateful for Gasquet's enthusiasm and ready response, and the rapid oscillation from despair to remorse rings true.

He was painting workers, peasant-laborers and gardeners and cooks with more frequency, but then he had always preferred common people for models. In his early years he made use of Uncle Dominique and his cronies. He felt at home with them, simply because they couldn't help being themselves. They made no demands. They represented the concrete reality and enduring structure that he sought in his art. He was no Van Gogh, his heart throbbing with the dream of brotherhood as he responded to the working-class society of Arles. Cézanne belonged to the world of the small peasant and accepted its meanness. These people could be stingy and callous and so at times could he. More than ever now he was his father's son, earth-rooted like him, bitterly opposed to change. Near the end of his life he said, "I love above everything people who have grown old without doing violence to customs, who've let themselves go along with the laws of time. Look at that old café-owner, what style! Look at that shop-girl, certainly she's pretty. But in her hairstyle, her clothes, what a banal lie!"

Yet he was split away from humanity, bearing the stigma of the artist. From the very start his young comrades expected something original from him. His emotional life seemed retarded, and he remained always in some sense immature as a man. For all that he was seen as an original. Clym in Hardy's *Return of the Native* is such a man. The force of life showed up in him. "As is usual with bright natures, the deity that lies ignominiously chained within an ephemeral human carcass shone out of him like a ray." Cézanne could identify with the peasants, but fundamentally he was born out of the passionate Provençal earth. The dark struggle of its hills and pastures, bursting into the exultation of blossom and dying back, went on in him. Unable to live like others he tried to transform himself as the body of the earth did, throwing up its plants and trees, breeding new life in a stupendous drama that mattered more than the people who moved obliviously among it. His instinct was always to draw close to it, to the black source that might destroy him or enrich him, if he ever did succeed in being truly reunited with it. Did he understand that his feared and adored womankind was part and parcel of this fathomless nature, its tireless fecundity working through them as surely

as its enormity and terrific action raged in the leafy woods and streams, clanging against the flanks of mountains, turning the forests and valleys bronze and the air like ice—did he in fact know too much? He must have known too that the crucial part of every life is buried beneath the ground like dark roots as his was, sunk in the wild heathland of Provence that was eternal, full of the most extraordinary activity, belonging to something that united earth and sky and was immeasurably greater than the little lives clustered in the towns and villages.

By all accounts his son was oblivious to his father's cleaving passion for the earth. It comes as no surprise to find him advising Cézanne to paint female nudes since they were more salable. He was becoming, if temporarily, a loafer, easily satisfied and out for a good time. Gradually though he took over the management of his father's affairs. Vollard's fee was 10 percent of all he sold, and the son took 10 percent of the balance. Vollard tells of a large picture of a peasant in the painter's studio that had been stabbed with a palette knife in several places, and put the attack down to Cézanne's anger at finding that his son was staying out at night. The artist's brother-in-law, Maxime Conil, was a wastrel who plowed through his wife's inheritance and ran debts up everywhere, and Cézanne could have been afraid of a similar fate in store for his son. Whatever else the youngster was he was undoubtedly canny, with a grasp of money and property values like that of his late grandfather. His father would say indulgently, "The lad will work as soon as he wants to."

◈ In May 1896 Zola used the opportunity afforded by a review of the official Salon in *Le Figaro* to detach himself once and for all from the painters he had championed thirty years before. The article, really an attack on the excesses of impressionism, and called by Geffroy "a sort of victory fanfare played as a funeral march," is the one in which he describes Cézanne as *"un grand pientre avorté,"* an utterance that has been held against him ever since. The truth is that Zola went out of his way not to savage his friend as he did the others, and in any case his main targets weren't the painters he had once defended but their converts. Everyone was hard at work churning out facile imitations of Manet, Monet, and Pissarro. "O, the ladies who have one blue cheek in the moonlight and the other one vermilion under a lampshade! O the horizons with blue trees, red water, and green skies! It is dreadful." Visiting the Salon again, suddenly the Salon of thirty years ago came back in a rush, when he was twenty-six, had just joined *Le Figaro* and was

intoxicated with youth, with truth and the intensity of art, drunk with the need of asserting my beliefs with knockdown blows. . . .

Yes, thirty years have passed and I have somewhat lost interest in painting. I had grown up virtually in the same cradle as Paul Cézanne; one is only now beginning to discover the touches of genius in this abortive great painter. I mixed with a group of artists, Fantin, Renoir, Guillemet, and others whom life has dispersed and strewn on different stages of success. And in the same way I continued along my path, separating myself from the studios of my friends, taking my passion elsewhere. . . .

Let us assume that I slept for thirty years. Yesterday I was still pounding with Cézanne the hard pavement of Paris in the fever of conquering it. Yesterday I went to the Salon of 1866 with Manet, Monet, and Pissarro whose paintings had been summarily rejected. And after a long night I awaken and go to the Salon. . . . O amazement! . . . What strikes me first is the clear, dominating tone. Everything is by Manet, Monet, Pissarro! Formerly when one of their canvases was hung in a room it made a hole of light among the others. It was the window open to nature, the famous open air that came in. And nowadays there is only open air, everyone followed my friends after having insulted them and me. Well, so much the better. Conversions are always pleasing.

What doubles my astonishment is the fervor of the converts, the abuse of the clear tone, which makes certain works look like laundry discolored by extensive washing. New religions, when admixed with fashion, are terrible in that they exceed the bounds of common sense. And when I see this diluted, whitewashed Salon with its chalky insipidity I almost begin to long for the black, bituminous Salon of yore. It was too black, but this one is too white. . . . The seeds that I saw sown have sprouted, have borne fruit of a monstrous kind. I recoil in fright! Never have I been more aware of the danger of formulas, the pitiful end of schools when the founders have done their work and the masters have gone. . . .

I awaken and shudder. Was it really for this that I fought? For this bright painting, these spots, these reflections, this decomposition of light? . . . But it is very ugly, I find it repulsive. . . . And when I left the Salon this year I asked myself whether the task I had once performed was a bad one.

No, I did my duty, I fought the good fight, I was twenty-six, I was with the young and the brave. That which I defended I would

defend again, for it was the daring of the moment, the flag that had to be planted on enemy territory. We were right only because we represented enthusiasm and faith. . . . And if the road we opened up has become trite, this is because we widened it in order that the art of a period might pass over it.[9]

If Zola, the fighter who wrote out of moral indignation, was unreliable in artistic judgment and never glimpsed under his own nose the "genius of the future" he called for, it would be wrong to say that he stopped seeing the painter as a force rising dark and potent out of that domain which had cradled them both. His old friend was never far from his thoughts. Two years after his article he told Gasquet that he always felt for Cézanne "in spite of his sulkiness, all the friendship of a big fraternal heart."

The painter's mother died at the Jas in October 1897 at the age of eighty-two. Despite her increasing querulousness her son had always cared for her tenderly and without complaint. "He went driving with her," writes Gasquet, "took her to the Jas to sit in the warm sunshine. He carried her, light and frail as a child, from the carriage to her chair in his own strong arms. He told her countless stories to amuse her." Losing her was a body blow. Also it plunged him into the kind of practical problems that he detested and was never able to solve. Apart from his reluctance to take responsibility for the running of the Jas de Bouffan—or indeed the running of anything if it could be avoided—it is hard to see why he came to part with a place he loved so much. Marie was now in charge of her brother's affairs in Aix and put the house up for sale. The situation was complicated by the debt-ridden Conil's need for money. He was now a compulsive gambler. There could have been other factors, such as the expense involved in the upkeep of the large property with its vineyards and staff, and the fact that he would have been alone there. Hortense had always been made to feel unwelcome there and for years had refused to go near it.

Only a month before he had turned down, with fine dignity, an invitation to dine with Gasquet and his wife. "I sup at my mother's and the state of lassitude in which I find myself at the day's end doesn't permit me to present myself in a proper aspect before others. You must then excuse me. Art is a harmony parallel with nature: what do those imbeciles think who tell you that the artist is always inferior to nature?" Under the courtesy of this ran a growing irritation with Gasquet, whose verbose writings and effusive flattery had begun to weary

him. "I must be more sensible," he excused himself on another occasion, "and realize that at my age illusions are hardly permitted and they will al-ways destroy me."

He rented an old stone farmhouse at Le Tholonet and worked there in solitude. He met Solari one Sunday as a break from the monotony. "You'll find me about 8 a.m. in the quarry where you made a study the last visit but one."

Then in January 1899 poor Emperaire died, after a lifetime without even the hint of recognition. Cézanne did what he could to help the family in their dire circumstances. As for himself, he appreciated what Vollard was doing for him in the way of sales but was afraid the dealer might get hold of work he considered incomplete or inferior, and made a bonfire of doubtful canvases. The dealer's motives were too craven, he thought. "He's up to something, something criminal."

In the papers he had been reading of the Dreyfus affair which had divided the nation against itself. An army captain, Alfred Dreyfus, was found guilty at the end of 1894 of passing military secrets to Germany. Zola was approached to lend his support to those pressing for the Jewish captain's release. Like other campaigners he was convinced of the man's innocence, suspected a conspiracy, and believed anti-Semitism to have a bearing on the case. Georges Clemenceau, owner of the radical *L'Aurore*, opened the pages of his newspaper to Zola. The novelist, always fearless in moral battle, wrote an open letter, *J'Accuse!* This famous document went to press on January 13, 1898. Dreyfus had been on Devil's Island for three years.

By indicting the army and its generals Zola knew he would be liable to a writ for defamation. At the Court of Assizes in Paris on February 7 he lost the case. He was abused in the press and by ugly crowds threatening his home. The poet Mallarmé hailed Zola's intervention as "the heroism of a man who found the strength to emerge so courageously after a lifetime of activity that would have exhausted anyone else."

Zola's case went down with heavy expenses for himself. To escape sentence he took refuge for a while in England. From Russia, Tolstoy added his considerable support, as did Mark Twain in America. Although Dreyfus was eventually pardoned by President Loubet, his name was never cleared. The only comment on Zola's involvement that Cézanne was heard to make was "He's been sold a pup."

That summer he went to Montgeroult near Pontoise, to paint and see something of Pissarro. Louis Le Bail, encouraged by Pissarro, called on Cézanne. Once again Cézanne succumbed to the admiration

of a young man. They went painting together, with the old painter humbly asking if he could share a motif that Le Bail had come across. The youngster's painting was well advanced and Cézanne started from scratch on a large canvas. A peasant girl went past, stopped to look, and said of Le Bail's canvas, "That one is really beautiful." Cézanne, badly upset, did his best to avoid his young friend the next day. When Le Bail asked if he had given offense in some way, Cézanne said, "You should pity me. . . . Truth comes from the mouths of children."

The two men were lodging at the same inn at Marines. It was understood that Le Bail should call on Cézanne at three after his nap. Whether or not the young man entered the room and touched the old painter to wake him, or simply knocked and walked in to find Cézanne half asleep, the damage done was sufficient to produce an angry letter: "Sir, the rather discourteous manner in which you took the liberty of entering my room is not calculated to please me. In the future please see that you are announced.—Please give the glass and the canvas left in your studio to the person who comes for them." What his admirer thought of this flea in the ear has gone unrecorded, though by then he was probably used to the old man's eccentricities. When they were at work together another time, Cézanne was approached by two riders on horseback who were keen to talk to him. They went off when he growled at them; one was Baron Denys Cochin, owner of several Cézannes. Hearing this later upset the painter so much that he wrote to Le Bail asking him to straighten things out.

Back in Paris in December he answered a letter from old Henri Gasquet with its "good remembrance" and its evocation of the forty years they had known each other. After a longish absence he was feeling appreciative again of Joachim, saying so to his father, expressing full support for the "movement of art" the young Gasquet and his friends were developing. He had to admit that he was rejuvenated by their young blood. "You have no idea how life-giving it is to find around one a youth that agrees not to bury one on the spot." Grieving over his lost mother he expressed his deep respect for Henri's still-living mother, "who, in the house, is the mother of the wisdom you represent." Just to speak of mothers made his language tortuous and difficult. "It's impossible for emotion not to come on us in thinking of that time now flowed away, that atmosphere that has been breathed without one doubting it, and which is beyond doubt the cause of the existing spiritual state in which we find ourselves."

While his mother was alive he could always turn to her. She was his

touchstone, approving the woman in his own body. In contented, confident men the balance of sex, male and female, saves them from obsession. Cézanne, unwilling to leave adolescence, obsessed by desire, was forced to be more aware than most of the body's dread of itself. He fell back into a lonely voluptuousness, unable to move or act. Turning to art for release, his aim became the woman's aim of completion. Trapped in his own physique, scarcely knowing the wife he lived with, he transferred his need to be self-complete to the woman's goal of equilibrium, stability, oneness. The mystery that possessed him became the lost earth that his art celebrated. For him there was no choice. Only the undiscovered law of an unknown nature could console him. It was a voyage that never ended. The most satisfying and perfect thing about Cézanne's art is its architectural stability and completeness. The astonishing thing about it is that it joyously escapes the static and joins the motion of the wheeling cosmos: the rustling of leaves on the oaks, the whistling of blackbirds, the great heaps of water crossing the sky in clouds, the swarming figures of the constellations.

When the Jas de Bouffan was about to be sold he tried to buy a farmhouse at Le Tholonet, the Château Noir, but the owner refused to sell. Instead he rented a room in the empty buildings. It was a curious arrangement, and the truth was he didn't know where he wanted to be. For a permanent base he rented the upper part of a house in the rue Boulegon in Aix, where his father's bank had once been. He lived on the second floor and had a studio in the attic. His sister found him a housekeeper, Madame Brémond, a stout cheerful body of about forty, who made sure he kept to his diet and tried to get rid of the paint from his clothes. The drably furnished rooms were papered with dull wallpaper, stained with age and damp in places. Marie was living in some style in a select quarter of the town near the Church of Saint Jean de Malte. Gasquet wrote piously that Cézanne's wish was to be "a monk like Fra Angelico, so that his life might be ordered once and for all, and freed from all cares and anxieties he might paint from dawn to dusk, meditating in his cell, never to be interrupted in his meditations." The image is altogether too beatific to be real.

On his way to the Château Noir he often made use of an ancient dilapidated victoria in faded red velvet, harnessed to a pair of docile white horses. When it got steep he would sometimes get out and walk, still talking to the elderly coachman, saying things like, "The world doesn't understand me and I don't understand the world," and "Look at those blues, the blues under the pines." Once he made the driver a

gift of a canvas, who said, "Thank you" respectfully, and then left it behind. Another time, under a fierce sun, they were toiling up a steep incline. The coachman had nodded off. Gasquet relates that Cézanne sat innocently rubbing his eyes as the driver woke up, to give the impression that it was he who had been sleeping.

The road to Le Tholonet leads east from Aix in the direction of Sainte-Victoire. The rising and falling, frequently bending road takes a sharp turn at one point and a majestic view opens up, clear to the foot of the distant mountain. A gentle curve further on meets a path climbing to the left and disappearing into the forest. The path provided Cézanne with one of his favorite motifs. As well as the Sainte-Victoire beyond he could glimpse the Château Noir that he was to paint so many times.

The place had been built about twenty years before and consisted of two separate buildings set at right angles to each other. From the main building two lines of pillars, part of an orangerie that was never finished, extended to the west wing, giving the complex the aspect of ruins or a folly. The style of the place was curious. It had narrow Gothic windows and steeply tilted roofs. A legend went with the strange structure, that was intended to be much larger. The tale goes that it was built by a coal merchant who painted it black—hence the name. Yet there was nothing black about it, and neither was it a château. It was built of the yellow Bibémus quarry stone, as were the aristocratic houses and churches of Aix. In Cézanne's canvases it has a fiery incandescence, orange-gold, rising out of the blue-green of shrubbery gone wild.

◈ Vollard had noticed a large *Bathers* in the painter's studio when he visited. There would always be one from now onward. His dream of painting nudes, male and female, using models posed in a wood or on the banks of a stream, would never be acted out. He knew perfectly well that doing so would have scandalized the neighborhood. As for having a naked model in his studio, he explained to Vollard what he meant: "Oh, I'll only engage a very old hag." He once said to d'Arbaud, "Look here, you see women, bring me some photographs." He made do with studies of classical sculptures he had done, and a book, *The Nude in the Louvre*, a collection of photographs of paintings and sculptures. As he told Émile Bernard,

As you know I've often made sketches of male and female bathers which I'd have liked to execute on a large scale and from nature. The lack of models has forced me to limit myself to haphazard glances. There were obstacles in my way—for example, how to find the proper setting for my picture, a setting which wouldn't differ much from the one I visualized in my mind; how to gather the necessary number of people; how to find men and women willing to undress and stay unmoving in the positions I determined. More, there was the difficulty of carrying about a large canvas, and the thousand difficulties of favorable or unfavorable weather, of a suitable spot in which to place oneself, of the supplies needed for the execution of a work of considerable dimensions. So I was forced to abandon my project of doing over Poussin entirely from nature and not made up piecemeal from notes, drawings, and fragments of studies. . . .[10]

Feeling the need for a place of his own he bought a plot of land in November 1901 and commissioned an architect in Aix to design and build a studio just as he wanted it. The land was halfway up the hill at Les Lauves, half a mile to the north of Aix and with a view of the town spread below, along the horizon the barricade of mountainous slopes. Before building could start a cabin had to be pulled down. Mourgues the architect, left to his own devices, went ahead and created a fussy villa decorated with wood balconies and glazed ornamental tiles, which the outraged artist promptly ordered to be stripped off again.

Cézanne loved trees. There was an olive tree in front of the site, really in the way, but he got the builder to construct a low wall around it for protection. The tree was old, like him. Gasquet, if we can believe that romancer, reports that Cézanne spoke of it as his friend. "It knows everything about my life and gives me excellent advice." (The wall is still in place, the garden a neglected and tangled jungle. An American writer, James Lord, made valiant efforts in 1951 to have the studio purchased as a memorial museum, keeping the contents intact just as the painter had left them. He raised the necessary funds through an appeal and then ran into difficulties. No one in France wanted to assume responsibility for its future maintenance. The national museums pleaded poverty and so did the local municipality. Today it is maintained, but a shortage of staff keeps it closed for half the week. Somehow this seems as fitting as the dust and disorder of the interior.)

The house is on two floors, with small rooms on the ground floor

and the floor above entirely occupied by a big studio, thirteen feet high and twenty-five feet square. Its north wall is all glass. Beside this huge window is a long narrow slit for large canvases to be lifted in and out. On the opposite wall tall windows look out on Aix and the misty blue of the Chaine de l'Étoile mountain range in the far distance.

Because the house is built on the steep slope of the hill the studio floor is nearly level with the ground to the north. In front of the building is a wide terrace, and dropping down beyond that a garden ending at a narrow canal. The site, matted with brambles, was soon transformed by an old gardener, Vallier, who planted flowering shrubs and fruit trees and made winding paths between them.

Cézanne never in fact lived there, always going back to Aix to sleep. Sometimes he set out on the uphill climb at five in the morning to escape the heat, as there was no shade. Now and then he had food sent up. If the heat was too great he worked under a linden tree on the terrace in front of the studio.

During the very hot weather he would wait till four in the afternoon before going in his carriage to outlying motifs. It was a time he loved, when the air over the fields had stopped vibrating. By six the shadows were longer, the air limpid, the horizon sharpened, and in the foreground there was a sumptuous glow, steeped in quietness. Those who came afterward to make pilgrimages to this and other locations have called it "the hour of Cézanne."

As always this master of self-concealment bewildered observers with the sweetness of his nature, which switched with such alarming speed to suspicion and rage. The worst paroxysms were always brought on after he had failed to realize something that was nearly "there." He was aware of time running out, of being the victim of his overwrought concentration and tenacity. If he was a priest of the earth, he was a cursing as well as a devout one. "It's so good and so terrible to attack a blank canvas," he said once. Gasquet, a witness who was determined to give a blow-by-blow account, said that one must have seen him at work

> painfully tense, his whole face a prayer, to imagine how much of his soul he put into his task. His whole body trembled. He hesitated, his forehead was congested as if swollen with visible thought, his body strained, his head sunk between his shoulders, his hands quivered until they began to paint, when they became strong, determined, and tender in their certainty of touch which was always from left to right. He would then step back a short distance and

354

again direct his eyes on the objects. They would wander round the objects slowly, linking them together, penetrating them, making them their own. They were terrible as they fixed themselves on a point.

"I can't tear them away," he said to me one day. "They are so stuck to the point I'm looking at that it seems as if they were going to bleed. Tell me, do you think I'm going mad?"[11]

His agonizing slowness of execution had become progressively more extreme over the years. Even back in the days with Pissarro at Auvers, working beside him, he had sometimes stood absolutely motionless under the spell of his own contemplation. A peasant confided to Pissarro one day, "Sir, you've got an assistant there who isn't doing a stroke."

Gasquet once went with a young friend to join Cézanne in the hills at Tholonet. They caught sight of him by the Bibémus quarry, weeping with rage over a canvas he had ripped to pieces. The mistral was blowing. A fierce gust caught the canvas and whirled it aloft. They ran to retrieve it. Cézanne threatened them with his clenched fists. "No, no, leave it!" He ground the canvas underfoot with his boots, sat down and let out heartrending sobs. "Go away, can't you?" he shouted at them. Between the lines of Gasquet's account his shocked pure poet's soul stands aghast before this idealized old man hurled down by his own bitter chagrin. He had failed, on the point of getting there, the yearned-for wholeness cruelly withheld. To have young men standing by with all the time in the world was too much. The disgrace of giving way publicly under strain and the cry of pain at the humiliation of old age ran together to turn him into a child.

In Aixois circles he was regarded now as an enigma who might after all have something. News had begun to circulate of the admiration artists in Paris had for him. More impressively, he was being collected. In Aix an amateur society, Friends of the Arts, had been founded, with Villevielle as president. After some misgivings Cézanne was asked to exhibit with them. Two Sunday painters called on him. Overcome, the delighted artist offered each delegate a canvas. One man accepted graciously, the other declined because his wife couldn't stand modern art. Cézanne sent in two landscapes to their show. To avoid ridicule the society hung them over the entrance hoping no one would see them.

Cézanne sat demurely through the closing banquet, but when a speaker got up to declare, "Gentlemen, our period will be that of

Cabanal and Bouguereau," he couldn't contain himself. Jumping up he yelled, "Your Bouguereau is the greatest idiot of the lot!"

For him the path he had chosen solved some problems and created others. "If isolation tempers the strong, it is the stumbling block of the uncertain," he told Gasquet. Renunciation was now, and had been for years, his goal, though "I declare to you it's always sad to renounce living as long as we are on the earth." Made rapturous by a canvas, either a new-minted mountain landscape, linking heaven to earth, or his massive pyramid of bathers, he wrote to Vollard, "I am beginning to see the promised land. Shall I be like the great leader of the Hebrews or shall I be able to enter it? . . . I have made some progress. Why so late and with such difficulty? Is art indeed a priesthood that demands the pure in heart, completely dedicated to it?" To a young admirer he said, "My painting is getting along so-so. I sometimes have magnificent bursts of enthusiasm and even more often painful disappointments. Such is life." He swung between these two poles: was he a stammerer or a trailblazer?

Still managing to see something of the young folk who stimulated him—though steering clear of Gasquet whenever he could—he either took them home to dine or met them at the Hôtel de la Croix de Malte. One was a twenty-three-year-old conscript, a poet called Léo Larguier, who was beginning his military service in Aix. Like other invited guests, he was taken aback by the meagerness of the rooms, the walls bare of pictures, the furnishings basic. After a glass or two of wine Cézanne took malicious pleasure in deriding old friends, artists in general, anyone: "A thousand painters ought to be killed yearly." Larguier thought how strong and thick his hands were, like a house painter's. Sometimes he would suddenly grow vague, leave the room and climb up to the attic, abandoning his guest for his work.

As a token of friendship he presented Larguier with his copy of *Flowers of Evil,* its cover "bespattered with paint, with touches of red and brown, and perhaps the imprint of a finger that had leaned against the palette." On the last page he had indicated poems he particularly favored: there were eight. The fifth in the list, "A Carrion," was a poem for which he had sketched illustrations in his twenties, and in old age could be encouraged to recite it aloud. He had it by heart. This violent poem of Baudelaire's recounts a stroll the poet and his mistress are taking along a path. The poet points to a corpse rotting in the sun and reminds his mistress that she, "star of my eyes, sun of my nature," will meet the same fate, and only he with his art can redeem it:

Well, O my beauty! Tell the vermin who will eat
you with their kisses that I have preserved the form
and the divine essence of my decayed loves.

Other artists affected as strongly as Cézanne by "A Carrion" were Rodin, his exact contemporary, and Edvard Münch, of whose painting *Metabolism* and its related drawings, watercolors, and prints the Frenchman would probably not have been aware.

It was during his first year at the Les Lauves studio that a laborer doing some work there passed on the news he had read in his newspaper of the accidental death of Zola in the early hours of Monday, September 29, 1902. There is still a belief in France that he was in fact murdered by the anti-Dreyfusards, though no evidence has ever come to light. The official verdict was asphyxiation by the fumes of a coal fire in his bedroom in Paris. The chimney was found to be blocked— the Zolas had returned the evening before from Médan to a cold house, and Alexandrine had asked the housekeeper to light a fire before they retired.

She was discovered unconscious at the novelist's side, but recovered. Madame Charpentier, the wife of his publisher, walked from room to room in her apartment on hearing the news, crying out, "It's too stupid! How could he die like that?"

Cézanne locked himself away in his studio for a whole day and night, alone with his grief. The next evening he sought out Philippe Solari. The old painter and sculptor wept together. The following Sunday Cézanne attended Mass as usual at the Cathedral of Saint-Sauveur. Coming out he met Numa Coste in the doorway. The two clasped hands in the sunny square murmuring "Zola, Zola." Deprived of his father, his mother, his home, now a chasm opened beneath his feet. The loss of Zola meant a deprivation worse in one sense than all the others. He had lost the spiritual brother who had sustained and nourished him at the very beginning, before he found the courage to go to Paris. For years after that he had counted on him for the support, the *appui* that Zola had provided so unstintingly. There had been no one else.

Another young acolyte sought him out. Charles Camoin, a painter, was sent by Vollard. Years before in Vollard's gallery he had been riveted by Cézanne's pictures. The enlivened master praised the young man's talent, as Vollard had done. "Vollard sent him to me and praised him up; and he knows it all himself, the bugger." Like Larguier he had

come to do his military service in Aix. Such was Cézanne's invisibility that it took Camoin some time to locate anyone who knew where the artist lived. He arrived at the house around seven, to find the table laid for a meal but the painter absent. He thought it unmannerly to wait and came back shyly an hour and a half later. This time Cézanne had gone to bed. Called by his housekeeper, he descended the stairs with his shirt hanging outside his trousers. With old-fashioned courtesy he put the embarrassed Camoin at his ease, took him into the dining room, and sat him down for a chat. Touched by the old man's gentleness the young visitor screwed up his nerve to assure him that a new era in art was on the way, thanks to Cézanne. Camoin said later that he thought the tales of vilification, put about by Gasquet and others, slanders on his family and few friends, threatening letters, and so on, much exaggerated. In the late seventies he could well have attracted insults on account of his bohemian appearance. Now he was distinguished-looking, his beard neatly trimmed, "better and more comfortably dressed than most of the people in Aix," says Larguier, who noticed too Cézanne's extravagant use of paint when he was at work. "I paint as if I were Rothschild."

An important new friend was the established painter Émile Bernard, who had been eager to meet the elusive Cézanne since his student days. With his wife and children he broke his journey at Marseilles in 1904 on the way back from Egypt, determined to visit Aix. His reception by the old man, who came to the door wrapped in a large cape, so delighted him that he found lodgings and stayed for a month. He hung up one of his still lifes and Cézanne, noticing it, cried, "But you really are a painter!" He allowed Bernard to use one of the downstairs rooms at Lauves as a studio. Taken one day into the bedroom to examine a book, he saw a crucifix over the cot in the alcove. During the month he took down zealously all Cézanne's comments—another Boswell—until the old man had had enough, growling in irritation, "Do you know I consider all theories ridiculous." Then he went off muttering under his breath, "The truth is in nature and I shall prove it."

His face was showing the marks of his diabetes and his strength was ebbing. Most letters of these final years were to his son, who had turned out to be "a genius" at dealing with his affairs. The absent father never forgot to ask to be remembered by his son's *maman*. He went as regularly as ever to Mass, in spite of the priests, tolerated as "sticky fellows." His gardener Vallier massaged him. He complained of

his foot, his kidneys. He followed a treatment prescribed by an apothe-cary in Aix, Boissy; "It's horrible."

He was finding the heat of summer more and more of a strain, sometimes appalling, the atmosphere impossibly dusty. Writing to his son on August 14, 1906, he described an encounter by the river, where he used to bathe with Zola and Baille when they were lads. He stopped the carriage and "a poor child, very lively, who came up to me in tat-ters, asked if I were rich. Another, older, told him such questions weren't asked. When I got into the carriage to return to town, he fol-lowed me. When we reached the bridge I threw him two sous. If you could have seen how he thanked me." He signed off, "My dear Paul I have nothing to do but paint. I embrace you with all my heart, you and mamma, your old father Paul Cézanne."[12]

Toward the end he was painting with greater freedom and daring than ever before. A *Mont Sainte-Victoire*, assigned to 1904–1906, is an ecstasy of shimmering blues and greens and violets and purples, lifting the mountain into the sky and the earth to the mountain. The brush strokes ascend in unison, orchestrated like music. It is a song of victory that nothing can stop. A passionately darkened foreground acts as counterpoint to the regal mountain with its crown of pure tones in a sky that dances with joy. Sky, mountain, and land are lyrically joined, each praising the other. The broad expressionism of his early *couillarde* pictures has returned, but without the plastered paint and desperate fervor. This is a rhapsody of the most tender touches, the primal earth heaving up through sheer color, as joyous an utterance as anything from the Renaissance. A bounteous world is being proclaimed here; the dumb, pent-up forces of the earth are being given a voice.

*Le Château noir*, one of at least half a dozen, is possessed by the same passionate purpose, the force that brings us all into being. Its breathtaking simplicity is the work of a master. The depth is created without perspective or any foreshortening. The hot orange buildings, indicated by mere patches, smolder fierily, drowning in the mass of trees and dense vegetation. They have such flickering life that when one looks away they seem to move. The large rhythmical strokes swing the eye from right to left in a series of pulses that could be waves of a mysterious earth-ocean. The cubes of the building that seems roofless, half ruined, are being broken into fragments as we watch, the stepped profile slipping down into an organic body, all latent power, that will bear crops and other buildings and be always fecund, always eternal.

One of his last works is the portrait of his gardener Vallier. He paint-

ed more than one version. *Portrait of Vallier* presents him seated in pro-
file, his soft flow of beard following his shoulder and arm, his hands
crossed tranquilly on his lap, one resting on the other. The body in loose
clothing is emphatically at rest, still as a statue. Autumnal tones invest
the man's figure with mellow warmth. This plain old fellow, an aristocrat
of the spirit, is wearing a floppy broad-brimmed straw hat that has seen
better days. The features under it are indistinct; his character lies else-
where. It is hard to say what makes the image glow with the luminosity
of an icon. The living touch that pays tribute to this unassuming old
man, older than the artist, is the touch he feared so mortally from
strangers, but is here bestowed freely and with love, uniting him with
the sitter whom he allowed to massage him with his rough hands, receiv-
ing from him the touch he was unable to win from his father. Much as he
was drawn to the young he could not have wanted their brisk, confident,
soft hands. An old person pleading for young love is unseemly. Here,
before old Vallier, he could touch and be touched. The contemplative
being he has painted "offers itself," says Schapiro, "frankly and calmly."
The picture is a memorial to their intimacy.

◆ Émile Bernard was perhaps the only person to see Cézanne at
work on his *Grandes baigneuses* at Lauves—the canvas had been hauled
up through the slit in the studio wall. He watched him also working on
a still life of three skulls, the forms and colors changing day by day. If
this artist had reservations concerning his religion, he had no doubt
that regeneration took place in nature and with the help of art.
Bernard, painting in the room beneath, could hear Cézanne moving
restlessly about; or he would go down to the garden and sit there, lost
in thought, before trudging upstairs again in a hurry. He couldn't get
over Cézanne's ceaseless labor. Once he stopped to watch Bernard
working at a still life, pointing out something he thought should be
corrected. Bernard gave him his palette and he exclaimed, "Where's
your Naples yellow, where's your peach-black? Where are your raw
Sienna, your cobalt, your burnt lake? You can't paint without those."

He would go around to the Bernards' flat in rue du Theâtre, enjoy-
ing the company of their two children. After dining with them he sat in
a corner, silent and undisturbed. Bernard assumed he was preoccupied
with thoughts of his work. He noticed him gazing fixedly at the fruit,
plates, and dishes as if they were a still life he hadn't properly arranged,

or else he looked surreptitiously at his hosts' faces "in the play of light and shadow."

He saw something of old Solari, the only friend he now saw fairly regularly. They met for a meal either at Cézanne's home or at Rosa Berne's eating house at Le Tholonet. Rosa Berne's establishment, said Cézanne's niece, "is not even a village inn but only a simple grocery shop, but Rosa knows how to cook in a way that suited him. It's always *charcuterie de village*, an omelette with truffles and mushrooms, and the famous duck with onions and carrots, fruit in season, all watered with a good little white wine from the slopes of Ste. Victoire." At night neighbors would be disturbed occasionally by a great uproar from Cézanne's flat as the two old men engaged in hot discussion over art, their tongues loosened by a bottle of brandy.

He always had loose change in his pocket for when he came out of High Mass. Outside on the square was where the beggars congregated, several of them on the lookout for him. Glancing round uneasily he would get rid of his money hastily. One particular beggar would be given five francs if he was there. "That's Germain Nouveau, the poet," he once told someone in a whisper. The story went that he had roamed the countryside like a wolf, like Rimbaud in his youth—whom he was supposed to have known—then went mad and was incarcerated in an asylum. Released, he had a religious phase, and in 1898 came back to Aix where he had grown up. Cézanne told his niece that he'd been his fellow pupil at the Collège Bourbon.

Marie, knowing how free her brother was with his money after Mass, told his housekeeper to make sure he had no more than fifty centimes in his pocket when he left for church. Probably it was at her instigation that Madame Brémond gathered up his sketches of *baigneuses* and burned them one day when he was out. "Is Monsieur painting?" she was asked by a woman she knew in the market, a seller of wines and liqueurs. "Oh, such horrors, I've just come down from burning a whole heap of naked women. I can't leave them, for the family's sake."

During the week he went to Vespers. Coming out he sometimes lingered in the dim twilight in front of the basilica, discussing religion and philosophy with Georges Dumesnil, one of the faculty instructors, relishing his wit and skepticism.

Lavish as he was with alms to beggars, he could be as stingy as his father if he suspected tradesmen of overcharging him. He told his son he had fallen out with his coachman after the fellow had raised the

price of the carriage to three francs return. "I can feel exploitation everywhere."

An ugly incident to do with his phobia, and too violent for anyone to take as comic, erupted one day on rough terrain above the Château Noir where he'd gone to paint with Émile Bernard. Cézanne walked ahead. Suddenly he stumbled and nearly toppled forward. Bernard grabbed his arm and the old man shook him off in a fury and rushed away on his own. At the studio Bernard approached him, but Cézanne, "his eyes starting out of his head," cried, "I allow no one to touch me. Nobody can put his *grappin* on me." Later that evening, there was Cézanne knocking to inquire about the earache that had been bothering Bernard. He stood chatting a moment as though nothing had happened.[13]

His final months can be followed more easily than most because of the abundance of letters to his shrewd son. Always devotedly close, he was turning to him with increasing candor, affection, and a sense of growing helplessness. "My dear Paul," he wrote, "you alone can console me in my sad state. . . . I must tell you that I have the greatest faith in your feelings, which dictate to your mind the necessary measures to guard our interests, that is to say I have the greatest faith in your direction of our affairs." And more ominously, "I see the dark side of things and so feel more and more forced to rely on you and look to you for guidance." He spoke of his "cerebral disturbances" and complained of Bernard, of his "reasoner's temperament."[14]

Solari died. He had been decorating the floats for the Aix Carnival to earn a little money and caught pneumonia. That winter he had nearly finished a bust of Zola for the town library. It was unveiled on May 27, 1906, in a ceremony attended by the members of the town council, the director of the library, and the director of the Aix Academy. Madame Zola, who was there, had presented the town with a number of Zola's manuscripts. The opening speech was delivered by Cabassol the mayor, son of Louis-Auguste's old banking partner. The mayor invoked the youth of Zola, mentioned the friendship of the Inseparables, and referred to Zola's description in *The Masterpiece* of the Jas de Bouffan with its "mosquelike whiteness in the center of vast grounds." Cézanne listened in tears as the speaker told of the part played by Aix in Zola's work, hearing himself described as "the great modern painter we know." Then Numa Coste, an ailing man, rose to speak. "When Zola preceded the group to Paris," he concluded shakily, "he sent his first literary effort to his old friend Paul Cézanne, at the

same time letting all of us share his hopes. We read those letters amid the hills, in the shade of evergreens, as one reads the communiqués of a campaign that is beginning."

The painter went back to his bathers and his mountain. In the Philadelphia version of the *Grandes baigneuses*, ten years in the making and still unfinished at his death, pinheaded giantesses and overarching trees are constrained in a pyramidal structure that could be seen as an echo of the mountain on the horizon of his hometown. These nudes who are not real women are the creation of a man out to discourage our identification, as he erected barriers in the foreground of his landscapes to prevent our entry. We are shut in, stopped, made to stand still. To obstruct the spectators' progress is to make them submit to the painter's spell. This world belongs to no one but Cézanne.

Roger Fry tries to explain away Cézanne's nudes, those strange awkward bodies with their bulky contours and blanked-out features, more and more abstracted as time went on, in terms of revenge and a deliberate attempt to "outrage our notions of feminine beauty." It is true that Cézanne found our notion of feminine beauty beside the point—but revenge? Circling timorously the renowned critic—founder of that obscure purified religion Significant Form—finally comes round to Cézanne's "difficulty." He was "incapacitated" by his attitude to women: in other words by his terror of them. And this disabled him to the extent of being unable to draw from the nude model. Deprived of observations direct from nature he was forced, says Fry, to conjure up a credible image to his inner eye, in other words to make up his figures in his head. But as we've seen he had sketchbooks crammed full of life studies and was always copying from nude statuary in the Louvre and worshiping at the shrine of the great Venetians. Van Gogh once wrote, "I should be desperate if my figures were correct." Roger Fry would clearly have been happier if these embarrassing large "poesies" of Cézanne's last period, pyramids of naked women under canopies of foliage, had never been painted. He loves Cézanne "to the point of infatuation" but can't bring himself to impose these "efforts of the aged artist . . . on the world at large." The presumption is staggering. Well, we have them anyway. Do we understand them any better since Fry's time? Anita Brookner calls them great *because* they are failures. This sounds perverse, but Lawrence in his essay comes to the same conclusion, if for different reasons. The vision of a hermit burns in them as strongly as in anything else Cézanne did. He wanted grandeur, but it had to be on his terms: true to *his* life. In earlier pic-

tures like *La Femme* and *The Pasha* he takes woman as handed down through the centuries and wrenches her into parody. It is comical, but hurled at us with a howl of rage. In the grand bathers there is repose but also gloom, tremendous integrity, and the recognition that what he had conceived would remain incomplete.

As well as the big figure compositions of segregated nudes, in themselves a solution, some have suggested, to his problems with men and women confronting each other—another strategy was the use of androgynous figures, or nudes without clear sexual characteristics—there were studies of single nudes, male and female, tryouts for the various poses and gestures he wanted for the main works. A pencil and watercolor *Femme nue debout* has a standing nude with what could be Hortense's features, arms raised and hands behind her head, breasts and belly thrust forward, the brutally realistic drawing contradicted by the delicacy of the tones and the refined facial expression. Blue and green touches of a watercolor delineate a fugitive male figure diving. An oil study, *Baigneur debout, vu de dos,* is of a male figure standing with his back to us, a towel draped over his raised right arm. Another solitary figure in oils stands against a suggested waterfall of foliage, his legs dwindling alarmingly, his arms raised in the pose familiar in the temptation scene of earlier canvases, as if to further confuse the two sexes. One of the most extraordinary is the oil of a melancholy seated man under a tree, on his head white strokes suggesting a turban or cloth, looking so solitary and excluded that we have to think of it as an image of the artist's inner state. These multiplying figures of isolation, some standing, some seated, nearly always look sacrificial when they are male, and lissome in the same pose as females. In groups the women sit and stand demurely, sometimes looming and mysterious, never quite touching but near enough to convey a feeling of harmony and closeness in their overarching church of greenery. The men bathers look erect with pride in the splendor of their nakedness, but there is something fundamentally wrong. Solitary male figures in studies appear tortured, and in groups look as they are when alone, monkish and divided in themselves, each of them sealed in their own void.

His eyes sore, his brain stunned by the heat, he was forced to call in Dr. Guillaumont on August 3 "as I had a bad attack of bronchitis, and I gave up homeopathy in favor of the mixed syrups of the old school. I coughed a hell of a lot, *Mère* Brémond applied some linen

soaked in iodine, and it did me much good. I regret my advanced age in view of my color-sensations." He asked his son again to remember to send him some slippers, "those that I have are almost in holes." Obviously he could have got them locally, but it gave him pleasure to think of his son caring for him.

He was soon out of doors again and making trips to the river in the carriage he hired under protest. "I'm going to a place called the Gour de Martelly, it's on the little chemin des Milles, which leads to Montbriant. Toward evening come cows brought to pasture. There's material for study and for masses of pictures. Sheep also come to drink, but they disappear rather quickly. Some journeymen painters came up and told me they'd gladly paint as I do, but at the drawing school they're not taught it. I told them Pontier was a dirty brute and they seemed to approve."[15]

Then he changed his destination to another place in the Arc valley that was familiar to him from his boyhood. The carriage rattled along over narrow cobbled streets and crossed the place des Prêcheurs to the route de Nice. Approaching the village of Palette the coachman took a right turn and went over the single-lane bridge of Les Trois Sautets. Cézanne was in pursuit of shade. On the far side of the bridge under big trees reaching their lower branches out over the water he found the cool refuge he was seeking.

Maddened and frustrated by his enfeebled state he vented his spleen on an old enemy, the tribe of clerics. "At Sauveur Cathedral a cretin of an abbé has succeeded Poncet. He works the organ and plays wrong notes. So badly that I can no longer go to hear Mass, his way of playing music makes me absolutely sick." He mentioned a bohemian, born in Lyons, who had come to borrow a few sous from him. "He has the look of being in a frightful mess." He added a postscript, "Remember the slippers."

The previous year he had made his debut at the *Salon d'Automne* in Paris with ten canvases. A big effort was being made to expose his work to the public. The show lasted a month and brought the usual shower of abuse. *Le Petit Parisien*, for instance, likened his work to the patterns made by children folding paper over spilled ink.

Émile Bernard had been visiting Italy, and Cézanne wrote to endorse his admiration "for the most valiant of the Venetians. We both bow to Tintoretto," and he went on, tussling with a medium he always found intractable, "Your need to find a point of moral, intellectual *appui* in works that will assuredly never be surpassed puts you constant-

ly on the *qui vive*, on an unceasing quest for the means, steadily grasped, that will lead you certainly to feel through nature what your means of expression are; and the day you've reached that point you may be sure you'll find, without effort and through nature, the *means* used by the four or five great men of Venice."[16]

The painter called by one critic "an irredeemable failure" who now and then pulled off some lucky strokes was turning from oils to water-color and back again, one medium feeding and influencing the other. His watercolors were of an extraordinary delicacy and luminosity, con-tours doubled and trebled with dashes of violet, trees indicated by arabesques, studies which have entranced Rilke with their purity, the traces of color falling on the briefest of pencil sketches "like the echo of a melody." The pigments he used now in oils, diluted with plenty of turpentine, left the canvas showing through in places and made it impossible for him to decide, "being old," whether the picture was complete or not. These "incomplete" images—even more pronounced in watercolor—led him to call them abstractions, and led Lawrence to say they were "a satire on landscape altogether" by a man whose strug-gle was heroic, "the most interesting figure in modern art." The "graceful clumsiness" of his figurative compositions links him with bucolic poetry and puts one in mind of Theocritus, whose pastoral poetry he must have read.

In October, revived, in spite of various ailments, by the temperate weather, he set off for the motif. "It rained on Saturday and Sunday and there was a thunderstorm" but now "the weather is much cooler—in fact it is not hot at all." . . . "My dear Paul, for me to give you news as satisfying as you want I'd have to be twenty years younger. I repeat, I'm eating well, and a little moral satisfaction—but nothing can give me that except work—would do me a lot of good. All my compatriots are arses next to me." He remembered something: "I believe the young painters to be much more intelligent than the others, the old ones can see in me only a disastrous rival."

On October 13 he told his son to "order some white wine for your-self and your mother. . . . It has rained well . . . the weather is stormy and changeable. My nervous system is weak, only oil painting can keep me up. I must carry on. I simply must produce after nature. . . . Sensa-tions are at the root of all things. . . ."

His final letter was to a color merchant on October 17, written from his sick bed. "It is 8 days since I asked you to send me 10 burnt lakes No. 7 and I have had no reply. What is the matter? Let me have

an answer as quickly as possible, please. Accept, Monsieur, my best greetings."

Two days before that he had fallen by the roadside after a heavy rainstorm had drenched and chilled him through. Giving up, he turned for home. His feeble strength gave out. He collapsed and lay still. Yet his weight clung to the earth, unable to help it. He embraced the earth by lying there, folded into it despite himself. How hard it was to leave life! Ahead of him was the motif, the mountain he seemed to have been approaching for as long as he could remember. He had painted it over a hundred times, rising out of the plain "like some spiritual intercessor between man and the divine."

One could say that his petty economizing had proved fatal. Refusing to have a carriage he had started off on foot through the hills carrying his heavy knapsack of equipment. He was found by the driver of a laundry cart and brought back half conscious to the rue Boulegon. Madame Brémond sent for Marie and the doctor. Neither realized the seriousness of the painter's condition. Pneumonia set in, but it was five days before Marie wrote to her nephew:

> My dear Paul, your father has been ill since Monday. Dr. Guillaumont doesn't think his life is in danger, but Mme. Brémond can't take care of him by herself. You'd better come as soon as you can. At times he's so weak a woman cannot lift him; with your help it could be done. The doctor has suggested hiring a male nurse. Your father won't hear of such a thing. . . .
>
> Mme. Brémond particularly wants me to tell you that your father has taken your mother's dressing room for his studio and doesn't intend to move out of it for the present; she wants your mother to know this fact; and since the two of you were not expected back here for another month your mother can stay in Paris for some time longer. By then perhaps your father will have moved his studio.
>
> There, my dear boy, is what I think it my duty to tell you—it is for you to make your own decision. I hope to see you soon, I embrace you most affectionately, Your devoted aunt, M. Cézanne.[17]

The letter arrived on October 22, followed immediately by a telegram from Madame Brémond saying that Hortense and Paul should come at once.

Cézanne, weakening rapidly, called out in his delirium, "Pontier, Pontier," the name of the director who refused to allow his pictures in

the Aix museum. Once he called for "Paul, Paul." He died at nine in the morning of Monday, October 23, 1906, before his wife and son could reach him. Rumor has it that Hortense, unwilling to cancel a fitting at her dressmaker's, hid the telegram in a drawer until she was ready. The painter was buried beside his father and mother in the old cemetery at Aix. Victor Leydet, a senator, spoke a few words over the open grave.

Joachim Gasquet, carried away by his silver tongue, made sure in his memoir that a book, "his old Virgil," fell into the mud as the old man collapsed on that October road. It wasn't true. Cézanne escaped the cliché at his death, as he did throughout his life in triumphant moments by the simplest means, using apples and kitchen plates and a wine bottle that could have come out of his own shabby coat. In an age of iron he was something sensual, with new eyes. He made looking, says a modern artist, the equivalent of touching. Here at last was a man, mistrustful as his father, who spent his life learning to be honest with himself. In the name of this honesty he made an art stripped of everything except the unseen made corporeal and solid. He went to nature like someone going to Mass, a little man held in the arms of a great embrace, so that he was brought step by step toward the promised land. Sometimes it was leaves and shadows, sometimes a land of sun beckoning, and sometimes death.

# CHRONOLOGY

| | |
|---|---|
| 1839 | Paul Cézanne born January 19 at 28 rue de l'Opera, Aix-en-Provence. February 22, baptism at Church of Sainte-Madeleine. |
| 1841 | Marie Cézanne born July 4 at 55 cours Mirabeau, Aix. |
| 1844 | Louis-Auguste Cézanne and Anne-Elizabeth Aubert married January 29, Aix. |
| 1844–1849 | Cézanne at primary school, rue des Épinaux, Aix. |
| 1848 | Bank of Cézanne and Cabassol established June 1 at Aix. |
| 1849–1852 | Cézanne at the École Saint-Joseph in Aix. |
| 1852–1858 | Cézanne at the Collège Bourbon in Aix. Friendship with Zola and Baille. |
| 1854 | Rose Cézanne born June 30 at 14 rue Matheron, Aix. |
| 1858 | Zola leaves in February for Paris. In July Cézanne fails at the baccalaureate; passes on November 12. From November works at the Drawing Academy in Aix. |
| 1859 | Cézanne studies law at Law School, Aix. His father purchases the "Jas de Bouffan." Zola spends holidays in Aix. Called for military service but father buys him a substitute. |
| 1861 | Abandons his law studies. Visits Paris from April to autumn. Paints portrait of Zola. Meets Pissarro at Atelier Suisse. Returns to Aix discouraged, enters his father's bank. Works again at Drawing Academy in free time. |
| 1862 | Leaves his father's bank. Friendship with Numa Coste. Returns to Paris in November. Fails examination for École des Beaux-Arts. |
| 1863 | Probably in Paris for entire year. Exhibits at the Salon des Refusés. At Atelier Suisse meets Guillemet, Oller, and Guillaumin. |
| 1864 | Rejected by the Salon. In the summer returns to Aix. |

1865    Most of year in Paris at 22 rue Beautrellis. Rejected by Salon. Returns to Aix in autumn. Friendship with Valabrègue, Marion, and the German musician Morstatt. Zola publishes *La Confession de Claude*, dedicated to Cézanne and Baille.

1866    Back in Paris in February. Rejected at Salon, writes letter of protest to director of fine arts. Zola publishes Salon reviews in *L'Événement* and pamphlet dedicated to Cézanne. At Bennecourt in July with Zola, Valabrègue, Baille, Solari. In Aix from August to December. Begins to work out of doors.

1867    From January to June in Paris at rue Beautrellis. Rejected by Salon. Zola defends him in press. Summer in Aix, returns to Paris in autumn.

1868    Rejected by Salon. From May to December in Aix, works at the Jas de Bouffan. Friendship with Alexis. Sometimes paints in company of Marion.

1869    About this time meets Hortense Fiquet in Paris. Rejected by Salon. Zola begins work on huge Rougon-Macquart series.

1870    Witness at Zola's wedding, May 31. Lives at 53 rue Notre-Dame-des-Champs. Franco-Prussian War begins July 18. Goes back to Aix, then to L'Estaque with Hortense. Zola joins them briefly. Cézanne avoids call-up. Third Republic proclaimed September 4. Cézanne's father retires from bank.

1871    Armistice signed January 28. Paris Commune from March to May. Cézanne back in Paris in autumn, lives at 5 rue de Chevreuse. In December moves to rue de Jussieu, opposite the Halle aux Vins. Emperaire stays briefly with him.

1872    Hortense gives birth to a son January 4, christened Paul Cézanne. All three transfer to Pontoise, where Cézanne works with Pissarro in open air, living at the Hôtel du Grand Cerf across river from Pontoise.

1873    Stays at nearby Auvers-sur-Oise for whole year. Friendship with Dr. Gachet. Zola publishes *Le Ventre de Paris*, basing a character, the painter Claude Lantier, on Cézanne.

1874    Takes part in first Impressionist group show, April 15 to May 15, exhibiting three paintings. Returns in June to Aix and is back in Paris by autumn, at 120 rue de Vaugirard.

1875    Part of year in Aix. Meets Choquet through Renoir, paints Choquet's portrait. In Paris lives at 15 quai d'Anjou near Guillaumin, an occasional painting companion.

| | |
|---|---|
| 1876 | Rejected by Salon. Lives in Aix and l'Estaque most of year. Abstains from second Impressionist group show. |
| 1877 | Lives at 67 rue de l'Ouest in Paris. Shows sixteen paintings at third Impressionist exhibition. Abused by critics, Rivière the notable exception. Works again with Pissarro in Pontoise, and at Auvers, Chantilly, Fontainebleau. |
| 1878 | Works in Aix and at l'Estaque for whole year. Financially hard-pressed because of father's opposition. Helped by Zola. Rejected at Salon. Zola buys country house at Médan. |
| 1879 | In l'Estaque until March, then Paris. Intervention by Guillemet but still rejected by Salon. In Melun from April to December. Visits Zola at Médan. |
| 1880 | In Melun till March. In Paris rest of year at 32 rue de l'Ouest. Visits Zola in Médan, meets Huysmans. |
| 1881 | With Pissarro in Pontoise, lives at 31 quai de Pothuis. Meets Gauguin. His sister Rose, just married to Maxime Conil, comes to Paris with her husband and visits Cézanne, who returns to Aix in November. Caricature appears in Duranty's posthumous novel. |
| 1882 | Is joined at l'Estaque by Renoir, whom he nurses during attack of pneumonia. In March lives in Paris at rue de l'Ouest. Gains entrance to Salon as "pupil" of Guillemet. At Médan five weeks during autumn. Returns to Aix, works at Jas de Bouffan, and makes will. |
| 1883 | In Provence for most of year, but attends Manet funeral in Paris, May 4. In l'Estaque and Marseilles from May to November. Friendship with Monticelli. |
| 1884 | Remains at Aix and countryside around. Young Signac buys a landscape by Cézanne at the color merchant 'Tanguy's. |
| 1885 | In l'Estaque and Aix till May. Agitated by mysterious unrequited love affair. To escape situation flees to Renoir with Hortense and their son at La Roche-Guyon during June and July. Visits Zola at Médan, back to Aix in August. Works there and in Gardanne for rest of year. Zola at work on *L'Oeuvre*. |
| 1886 | In Aix and Gardanne most of year. Zola brings out *L'Oeuvre* in March. In April Cézanne writes final letter to Zola. In same month, April 28, marries Hortense in Aix before his parents. On October 23 his father dies aged eighty-eight. His son inherits considerable wealth. |
| 1887 | Probably in Aix most of year. |
| 1888–1889 | In Paris, quai d'Anjou. Paints at Chantilly and other sub- |

urbs. Choquet manages to have Cézanne's *Maison du pendu* shown at the Paris World's Fair. Spends second half of 1889 in Aix. Renoir visits. Cézanne is invited to exhibit with the Belgian group, Les XX, in Brussels.

1890    Lives on avenue d'Orléans, Paris. Shows three pictures in Brussels. Visits Switzerland for five months with his wife and son. Returns to Aix in autumn. Begins to suffer from diabetes.

1891    In Aix at beginning of year, sees a good deal of Alexis. Later leaves for Paris. Vacillates over showing at the *Salon des Indépendants*—decides against.

1892    In Aix and then Paris, 2 rue des Lions-Saint-Paul. At Mennecy, forest of Fontainebleau. The painter Bernard issues pamphlet on Cézanne.

1893    In Aix and Paris. Works in Fontainebleau forest.

1894    Aix and Paris. Visits Monet in Giverny during autumn: meets Clemenceau, Rodin, Gustave Geffroy, and Mary Cassatt there. Departs abruptly for Aix. Death of Père Tanguy, whose belongings are auctioned: canvases by Cézanne fetch between 45 and 215 francs. The dealer Vollard, prompted by Pissarro, hunts out Cézanne to organize first one-man show.

1895    In Paris, rue Bonaparte. Paints portrait of Geffroy, unfinished. Autumn in Aix, trips to Bibémus quarry and Mont Sainte-Victoire with Solari and his friend's son. One hundred and fifty canvases go to Vollard for show in December.

1896    In Aix meets the young poet Joachim Gasquet, son of a schoolmate. Zola comes to Aix but the two do not meet. Cézanne in Vichy during June, then in July and August on Lake d'Annecy. In autumn lives in rue des Dames, Montmartre.

1897    At 73 rue Saint-Lazare in Paris till April, May in Mennecy and Fontainebleau forest. Vollard buys contents of entire studio. From June in Aix. His mother dies October 25, aged eighty-two. Cézanne silent on Zola's stand during Dreyfus affair.

1898    Most of year in Aix, working near Château Noir. In autumn at 15 rue Hégésippe-Moreau in Paris. Paints near Pontoise, advises young painter Louis Le Bail.

1899    In and around Paris. Portrait of Vollard. Returns to Aix in autumn. Jas de Bouffan is sold and Cézanne attempts to buy Château Noir. When his offer is turned down he rents 23 rue Boulegon in Aix. Choquet dies and his Cézannes realize

an average of seventeen hundred francs. Cézanne exhibits three canvases at Salon des Indépendants.

1900     From now on he rarely leaves the south. Three canvases shown at the Paris Centennial Exposition.

1901     At the Salon Maurice Denis exhibits an "Hommage à Cézanne." Cézanne shows two canvases at the Salon des Indépendants and one with the group of La Libre Esthétique in Brussels. Buys land on a hill overlooking Aix to build a studio.

1902     While studio is under construction works at Le Tholonet and Aix. Spends time on Gasquet's estate near Aix. Visits Larguier family in the Cévennes. At Maurice Denis's insistence shows three canvases at Salon des Indépendants. Zola dies in Paris, September 29.

1903     Works in new studio. Seven paintings by Cézanne shown at the Secession in Vienna. Death of Pissarro in Paris.

1904     Visited in Aix by Émile Bernard, who writes new article on Cézanne. Last visit to Paris, paints in Fontainebleau forest. Exhibits at the Salon d'Automne in Paris and nine paintings with La Libre Esthétique in Brussels. The dealer Bernheim visits Cézanne in Aix.

1905     Visited by Maurice Denis and K. X. Roussel in Aix. Shows ten canvases at the Salon d'Automne.

1906     The German collector Karl Ernst Osthaus calls to buy for his museum. Shows a view of *Château Noir* with Société des Amis des Arts in Aix, calling himself in catalog "pupil of Pissarro." Ill with bronchitis in August. Exhibits ten paintings at the Salon d'Automne. Dies October 22 at 23 rue Boulegon in Aix.

# NOTES

## 1. CAESAR'S PROVENCE

1. Ambrose Vollard, *Cézanne*, New York, 1937.
2. Joachim Gasquet, *Cézanne: A Memoir with Conversations*, London, 1991.
3. Lawrence Durrell, *Caesar's Vast Ghost: Aspects of Provence*, London, 1990.
4. Friedrich Nietzsche, *Beyond Good and Evil*, London, 1973.
5. Gasquet, *Cézanne: A Memoir with Conversations*.

## 2. FAMILIES

1. Theodore Zeldin, *France 1848–1945*, Vol. I, Oxford, 1973.
2. Émile Zola, *The Conquest of Plassans*, London, 1986.
3. Gerstle Mack, *Paul Cézanne*, New York, 1935.
4. Émile Zola, *The Masterpiece*, London, 1992.
5. Gasquet, *Cézanne: A Memoir with Conversations*.
6. Mack, *Cézanne*.
7. *Ibid.*
8. Gustave Coquoit, *Cézanne*, Paris, 1919.
9. Zola, *Conquest of Plassans*.
10. *Ibid.*

## 3. CALL OF THE WILD

1. Zola, *The Masterpiece*.
2. Gasquet, *Cézanne: A Memoir with Conversations*.
3. *Ibid.*
4. Zola, *The Masterpiece*.
5. Jack Lindsay, *Cézanne, His Life and Art*, New York, 1972.
6. *Ibid.*
7. Paul Cézanne, *Letters*, London, 1941.
8. Émile Zola, *Correspondance*, Paris, 1929.
9. *Ibid.*
10. Cézanne, *Letters*.
11. Zola, *Correspondance*.
12. *Ibid.*

13. *Ibid.*
14. *Ibid.*
15. *Ibid.*
16. Graham King, *Garden of Zola*, London, 1978.
17. Zola, *Correspondance.*
18. *Ibid.*
19. *Ibid.*
20. *Ibid.*

4. SECRET AFFINITIES

1. Charles Dubuisson, article in *Paris-Midi*, January 2, 1925.
2. Coquoit, *Cézanne.*
3. Cézanne, *Letters.*
4. Zola, *Correspondance.*
5. Mack, *Cézanne.*
6. Lindsay, *Cézanne, His Life and Art.*
7. Zola, *Correspondance.*
8. *Ibid.*
9. *Ibid.*
10. Meyer Schapiro, *Cézanne*, London, 1988.
11. Storm Jameson, *Speaking of Stendhal*, London, 1979.
12. Cézanne, *Letters.*
13. *Ibid.*
14. Zola, *The Masterpiece.*
15. Georges Rivière, *Le Maître Paul Cézanne*, Paris, 1923.
16. Zola, *Correspondance.*
17. Cézanne, *Letters.*
18. *Ibid.*
19. Zola, *Correspondance.*
20. Jean Renoir, *Renoir, My Father,* London, 1962.
21. Lindsay, *Cézanne, His Life and Art.*
22. Gotz Adriani, contribution to *Cézanne, The Early Years*, ed. Lawrence Gowing, catalog, London, 1988.
23. King, *Garden of Zola.*

5. PURSUED BY FURIES

1. John Berger, *The Moment of Cubism*, London, 1969.
2. Gasquet, *Cézanne: A Memoir with Conversations.*
3. Coquoit, *Cézanne.*
4. King, *Garden of Zola.*
5. Jameson, *Speaking of Stendhal.*
6. Zola, *The Masterpiece.*
7. Lindsay, *Cézanne, His Life and Art.*
8. Vollard, *Cézanne.*
9. Émile Zola, *Thérese Raquin*, London, 1962.
10. Émile Zola, *Mes haines*, Paris, 1866.
11. *Ibid.*
12. Cézanne, *Letters.*
13. Zola, *Correspondance.*
14. Cézanne, *Letters.*

15. *Ibid.*
16. *Ibid.*
17. Lindsay, *Cézanne, His Life and Art.*
18. Schapiro, *Cézanne.*
19. Lindsay, *Cézanne, His Life and Art.*
20. Théodore Duret, *Les Peintres Impressionistes*, Paris, 1922.
21. D. H. Lawrence, "Introduction to These Paintings," *Phoenix*, London, 1936.
22. *Ibid.*

## 6. THE WOMAN UNDERNEATH

1. Zola, *Correspondance.*
2. Lindsay, *Cézanne, His Life and Art.*
3. Zola, *Thérese Raquin.*
4. Mary Louise Krumrine, *Paul Cézanne: The Bathers*, London, 1990.
5. *Ibid.*
6. Lindsay, *Cézanne, His Life and Art.*
7. Cézanne, *Letters.*
8. *Ibid.*
9. *Ibid.*
10. Honoré de Balzac, *Oeuvres complètes*, Paris, 1925.
11. *Ibid.*
12. Émile Bernard, *Souvenirs sur Paul Cézanne*, Paris, 1926.

## 7. PRISONER OF SOLITUDE

1. John Rewald, *Cézanne*, London, 1986.
2. Zola, *Correspondance.*
3. King, *Garden of Zola.*
4. Lindsay, *Cézanne, His Life and Art.*
5. Krumrine, *The Bathers.*
6. Lindsay, *Cézanne, His Life and Art.*
7. Vollard, *Cézanne.*
8. Zola, *Correspondance.*
9. *Ibid.*
10. King, *Garden of Zola.*
11. Zola, *Correspondance.*
12. King, *Garden of Zola.*
13. Cited in Rewald, *Cézanne.*
14. Lindsay, *Cézanne, His Life and Art.*
15. Gustave Flaubert, *The Temptation of St. Anthony*, New York, 1980.
16. Mary Tompkins Lewis, contribution to Gowing, *Cézanne, The Early Years.*
17. Krumrine, *The Bathers.*
18. *Ibid.*
19. *Ibid.*
20. *Ibid.*
21. *Ibid.*
22. Cited in Rewald, *Cézanne.*
23. Alfred de Musset, *Poèsies complètes*, Paris, 1950.

## 8. A SECOND FATHER

1. Lindsay, *Cézanne, His Life and Art*.
2. King, *Garden of Zola*.
3. *Ibid.*
4. Cited in Lindsay, *Cézanne, His Life and Art*.
5. Cézanne, *Letters*.
6. *Ibid.*
7. Lindsay, *Cézanne, His Life and Art*.
8. Émile Zola, *The Belly of Paris*, New York, 1955.
9. Richard Verdi, *Cézanne*, London, 1992.
10. Cited in Lindsay, *Cézanne, His Life and Art*.
11. Cited in John Rewald, *History of Impressionism*, London, 1946.
12. Cited in Rewald, *Cézanne*.
13. Mack, *Cézanne*.
14. Rewald, *History of Impressionism*.
15. Lindsay, *Cézanne, His Life and Art*.
16. *Ibid.*
17. Cézanne, *Letters*.
18. *Ibid.*
19. Mack, *Cézanne*.
20. King, *Garden of Zola*.
21. Adriani, contribution to *Cézanne, The Early Years*.
22. Krumrine, *The Bathers*.
23. *Ibid.*
24. *Ibid.*

## 9. HIDE AND SEEK

1. See Lindsay, *Cézanne, His Life and Art*.
2. See Rewald, *Cézanne*.
3. Schapiro, *Cézanne*.
4. Cézanne, *Letters*.
5. *Ibid.*
6. Émile Zola, *L'Assommoir*, London, 1970.
7. Cited in Rewald, *Cézanne*.
8. Rainer Maria Rilke, *Letters on Cézanne*, London, 1988.
9. Zola, *The Masterpiece*.
10. Cited in Rewald, *Cézanne*.
11. *Ibid.*
12. Cézanne, *Letters*.
13. Cited in Rewald, *Cézanne*.
14. Cézanne, *Letters*.
15. *Ibid.*
16. *Ibid.*
17. Émile Zola, *A Page of Love*, London, 1957.
18. Cézanne, *Letters*.
19. *Ibid.*
20. *Ibid.*
21. *Ibid.*
22. King, *Garden of Zola*.
23. *Ibid.*

### 10. "A WORSHIPED BEING"

1. Cited in Krumrine, *The Bathers*.
2. Cited by Christian Geelhaar in *The Bathers*.
3. Gottfried Boehm, contribution to *The Bathers*.
4. Krumrine, *The Bathers*.
5. Cézanne, *Letters*.
6. *Ibid*.
7. Lindsay, *Cézanne, His Life and Art*.
8. Rilke, *Letters on Cézanne*.
9. Renoir, *Renoir, My Father*.
10. Schapiro, *Cézanne*.
11. King, *Garden of Zola*.
12. Cézanne, *Letters*.
13. Cited in Mack, *Cézanne*.
14. King, *Garden of Zola*.
15. *Ibid*.
16. Paul Gauguin, *Avant et Après*, Paris, 1919.
17. George Moore, *Reminiscences of the Impressionist Painters*, London, 1906.
18. Edmond Duranty, *Le Pays des arts*, Paris, 1881.
19. Paul Alexis, *Émile Zola, Notes d'un ami*, Paris, 1882.
20. Cited by Rewald, *Cézanne*.
21. Schapiro, *Cézanne*.
22. Cited by Lindsay, *Cézanne, His Life and Art*.
23. Cézanne, *Letters*.
24. *Ibid*.
25. *Ibid*.
26. Rilke, *Letters on Cézanne*.
27. *Ibid*.
28. Schapiro, *Cézanne*.

### 11. "ON THE MARGINS OF LIFE"

1. Gasquet, *Cézanne: A Memoir with Conversations*.
2. Cited by Lindsay, *Cézanne, His Life and Art*.
3. Moore, *Reminiscences of the Impressionist Painters*.
4. Cited by Rewald, *Cézanne*.
5. Vollard, *Cézanne*.
6. Cited by Rewald, *Cézanne*.
7. Cézanne, *Letters*.
8. Gasquet, *Cézanne: A Memoir with Conversations*.
9. Zola, *The Masterpiece*.
10. Cited by Lindsay, *Cézanne, His Life and Art*.
11. Vincent Van Gogh, *The Complete Letters*, Vol. II, London, 1958.
12. Vincent Van Gogh, *The Complete Letters*, Vol. III, London, 1958.
13. Cézanne, *Letters*.
14. Schapiro, *Cézanne*.
15. Cited by Lindsay, *Cézanne, His Life and Art*.
16. Bernard, *Souvenirs sur Paul Cézanne*.
17. Gustave Geffroy, *La Vie artistique*, Vol. III, Paris, 1894.
18. *Ibid*.
19. Cited by Lindsay, *Cézanne, His Life and Art*.

20. Cited by Rewald, *Cézanne*.
21. Mack, *Cézanne*.

12. TOWARD THE PROMISED LAND

 1. Cited by Mack, *Cézanne*.
 2. Camille Pissarro, *Lettres à son fils Lucien*, Paris, 1950.
 3. Vollard, *Cézanne*.
 4. Cited by Rewald, *Cézanne*.
 5. Kurt Badt, *The Art of Cézanne*, Berkeley and Los Angeles, 1965.
 6. Gasquet, *Cézanne: A Memoir with Conversations*.
 7. *Ibid.*
 8. *Ibid.*
 9. Cited by Rewald, *Cézanne*.
10. Bernard, *Souvenirs sur Paul Cézanne*.
11. Gasquet, *Cézanne: A Memoir with Conversations*.
12. Cézanne, *Letters*.
13. Bernard, *Souvenirs sur Paul Cézanne*.
14. Cézanne, *Letters*.
15. *Ibid.*
16. *Ibid.*
17. Cited by Mack, *Cézanne*.

# A NOTE ON SOURCES

The biographer of Cézanne encounters a number of problems. The first of these is the difficulty, when one seeks to link the life and the art, in dating with accuracy a great many of the paintings. Jack Lindsay, very much aware of the danger of relying on purely stylistic factors, pays tribute to the work of the late Lawrence Gowing in this respect.

To enlarge on my remarks acknowledging my debt to Lindsay, I have found no life, among the multitude of works on Cézanne since his death, that goes to the heart of the artist as his biography does, providing a perspective, critical and moving as well as illuminating, in which the man's drama can be set. John Rewald was probably the first to see the importance of the close links with Zola, and Lindsay's book shows this relationship more fully than before.

Another problem concerns the reliability or otherwise of Joachim Gasquet's testimony. His recently translated book, *Cézanne: A Memoir with Conversations*, is essential reading for all Cézanne students as well as a poignant and fascinating firsthand portrait in its own right. Gasquet, one of Cézanne's last friends and first biographers, was, Rewald tells us, "more of a poet than an historian, more an apologist than a scrupulous witness." Nevertheless his presence at the ailing painter's side in Aix, conscious always of the importance of his record as he accompanied the famous old man on walks and sat in his studio, makes his memoirs invaluable.

Other witness accounts already existed when Gasquet came on the scene, notably those by Émile Bernard, Maurice Denis, and Ambrose Vollard. What makes Gasquet's compilation unique is its intimacy as well as its insistence on giving us Cézanne's own rambling reflections. The intimacy was genuine, though the friendship ended in a falling-out, for Gasquet's father was an old schoolmate of Cézanne's. Aix provides a setting for a portrait that is Gasquet's as much as Cézanne's, and thus we need to be wary of the young poet's solipsist zeal and his own agenda. He sets out

quite deliberately in his book to present Cézanne as a classicist concerned with a return to traditional values. Gasquet was already involved in Naturism, a literary movement which had as its doctrine a belief in the reciprocity of mind and matter, and he saw in Cézanne an example of this creed in action. Though Gasquet understands and pays homage to the sense of the local in Cézanne, both in his work and in his views, all the time he is enrolling the artist in an aesthetic and political program which had no real interest for Cézanne, except that his antipathy to Parisian values became more marked in old age. Opinions differ sharply as to the value of Gasquet's account. Lindsay calls him flatly "a proficient liar," whereas for Richard Shiff the poet's text "remains remarkably suggestive for students of Cézanne's art as well as faithful to its own historical moment."

Vollard's book, *Cézanne*, should also be approached with caution. Where Gasquet is an eloquent, ambitious writer who saw himself as one of the leaders of the 1890s' Provençal renaissance, Vollard is content to throw together a mixture of biographical information and anecdote with a lazy disregard for the truth. His ragbag of a book, though interesting, has numerous examples of his unreliability.

A recent volume of great importance and complexity is Mary Louise Krumrine's *Paul Cézanne: The Bathers*. This portrait of the artist's personality, containing contributions by Gottfried Boehm and Christian Geelhaar and an illustrated glossary listing each bather composition, noting how and when each figure entered a particular work, has much vivid analytical power. Though concentrating on the bather figures which are seen in some two hundred of Cézanne's works, Krumrine's scholarly text connects many of these works with the literature of Cézanne's contemporaries, with Zola, with his tortuous reactions to women, and with the society of his time.

D. H. Lawrence's trenchant essay, "Introduction to These Paintings," in the first volume of *Phoenix*, is reprinted from the expensive *Paintings of D. H. Lawrence*, published by the Mandrake Press, London, 1929, and largely concerns Cézanne. Lawrence has no hesitation in declaring the artist to be a pure revolutionary, though without knowing it: the revolution he instigated being the introduction of something that was neither optical nor mechanical nor intellectual, namely "the unsteady apples of Cézanne." Curiously, in this essay bursting with ideas, Lawrence is silent on the subject of Cézanne's bathers.

A book I was fortunate to read just before the completion of this biography is Jeffrey Coven's *Baudelaire's Voyages: The Poet and His Painters*. The importance that Cézanne attached to Baudelaire's *Les Fleurs du mal* has puzzled many writers. Coven brings the poet and painter together, and we can now understand the significance for Cézanne of certain of Baudelaire's poems.

Mary Tompkins Lewis, in her study *Cézanne's Early Imagery*, and Mary Delcourt's *Hermaphrodite: Myths and Rites of the Bisexual Figure*, both cast light on the symbolic meanings of the bather paintings, and so complement Mary Louise Krumrine's riveting study of the painter's development.

# SELECTED BIBLIOGRAPHY

Paul Cézanne, *Letters*, London, 1941.
Richard Kendall, ed., *Cézanne by Himself*, London, 1988.
Émile Zola, *Correspondance*, Paris, 1929.

BOOKS ABOUT CÉZANNE AND STUDIES OF HIS WORK
Kurt Badt, *The Art of Cézanne*, Berkeley and Los Angeles, 1965.
Émile Bernard, *Souvenirs sur Paul Cézanne*, Paris, 1926.
Gottfried Boehm, *Paul Cézanne: Montagne Sainte-Victoire*, Frankfurt, 1988.
A. Chappuis, *The Drawings of Paul Cézanne*, 2 vols., London, 1973.
P. M. Doran, *Conversations avec Cézanne*, Paris, 1978.
Joachim Gasquet, *Cézanne: A Memoir with Conversations*, London, 1991.
Sidney Geist, "The Secret Life of Cézanne," *Art International*, XIX, no. 9, 1975.
Sidney Geist, *Interpreting Cézanne*, Cambridge, Mass., and London, 1988.
Lawrence Gowing, ed., *Cézanne: The Early Years*, catalog, Royal Academy, London, 1988.
M. Hoog, *Cézanne: puissant et solitaire*, Paris, 1989.
Mary Louise Krumrine, *The Bathers*, London, 1990.
Mary Tompkins Lewis, *Cézanne's Early Imagery*, Berkeley, 1989.
Jack Lindsay, *Cézanne, His Life and Art*, New York, 1972.
Gerstle Mack, *Paul Cézanne*, New York, 1935.
R. J. Niess, *Zola, Cézanne and Manet: A Study of L'Oeuvre*, Ann Arbor, 1968.
Henri Perruchot, *Cézanne*, New York, 1958.
Theodore Reff, "Cézanne: The Enigma of the Nude," *Art News*, LVIII, 1959.
Theodore Reff, "The Pictures Within Cézanne's Pictures," *Arts Magazine*, LIII, 1979.
John Rewald, *Paul Cézanne: The Watercolors*, London, 1983.
John Rewald, *Cézanne*, London, 1986.
Rainer Maria Rilke, *Letters on Cézanne*, London, 1988.
Georges Rivière, *Le Maître Paul Cézanne*, Paris, 1923.
Georges Rivière, *Cézanne, Le Peintre solitaire*, Paris, 1933.
Meyer Schapiro, *Cézanne*, London, 1988.
Richard Shiff, *Cézanne and the End of Impressionism*, Chicago and London, 1984.

# SELECTED BIBLIOGRAPHY

L. Venturi, *Cézanne*, London and New York, 1978.

Ambrose Vollard, *Cézanne*, New York, 1937.

Nicholas Wadley, *The Paintings of Cézanne*, London, 1989.

BOOKS OF GENERAL REFERENCE

Honoré de Balzac, *Oeuvres complètes*, Paris, 1925.

John Berger, *The Moment of Cubism*, London, 1969.

Theodore Cook, *Old Provence*, London, 1905.

Jeffrey Coven, *Baudelaire's Voyages: The Poet and His Painters*, New York, 1994.

Marie Delcourt, *Hermaphrodite: Myths and Rites of the Bisexual Figure*, London, 1961.

Theodore Duret, *Les Peintres Impressionistes*, Paris, 1922.

Lawrence Durrell, *Caesar's Vast Ghost: Aspects of Provence*, London, 1990.

C. M. Girdlestone, *Dreamer and Striver: The Poetry of Fréderic Mistral*, London, 1937.

Frederic V. Grunfeld, *Rodin*, London, 1988.

Werner Hoffman, *Turning Points in Twentieth Century Art*, London, 1969.

Robert Hughes, *Nothing If Not Critical: Essays on Art and Artists*, London, 1993.

Diane Kelder, *The Great Book of French Impressionism*, New York, 1980.

Graham King, *Garden of Zola*, London, 1978.

D. H. Lawrence, *Phoenix*, London, 1936.

Alfred de Musset, *Poèsies complètes*, Paris, 1950.

Camille Pissarro, *Lettres à son fils Lucien*, Paris, 1950.

James Pope-Hennessy, *Aspects of Provence*, London, 1952.

Max Raphael, *The Demands of Art*, Princeton, 1968.

Jean Renoir, *Renoir, My Father*, London, 1962.

John Rewald, *History of Impressionism*, London, 1946.

Joanna Richardson, *Baudelaire*, London, 1994.

Stendhal, *Memoirs d'un touriste*, Paris, 1929.

Denis Thomas, *The Age of the Impressionists*, London, 1990.

Patrick Turnbull, *Discovering Provence*, London, 1972.

Theodore Zeldin, *France 1848–1945*, Vol. I, Oxford, 1973.

Émile Zola, *The Belly of Paris* (published as *Savage Paris*), New York, 1955.

Émile Zola, *The Conquest of Plassans*, London, 1986.

Émile Zola, *L'Assommoir*, London, 1970.

Émile Zola, *The Masterpiece*, London, 1992.

Émile Zola, *Mes haines*, Paris, 1866.

Émile Zola, *A Page of Love*, London, 1957.

Émile Zola, *Thérèse Raquin*, London, 1962.

# INDEX

# INDEX

**388**

# INDEX

## A NOTE ON THE AUTHOR

Philip Callow was born in Birmingham, England, and studied engineering and the teaching of English before he turned to writing. He has since published fourteen novels, several collections of short stories and poems, a volume of autobiography, and three biographies—*From Noon to Starry Night: A Life of Walt Whitman; Vincent Van Gogh: A Life;* and *Son and Lover: The Young D. H. Lawrence*—all of which have received critical acclaim. He lives and writes in Evesham, England.